ARTISTS
IN
REVOLUTION

ARTISTS IN REVOLUTION

Portraits of
the Russian Avant-garde, 1905–1925

Robert C. Williams

INDIANA UNIVERSITY PRESS
Bloomington London

Published in Canada by Fitzhenry & Whiteside Limited,
Don Mills, Ontario

Manufactured in the United States of America

Library of Congress Cataloging in Publication Data
Williams, Robert Chadwell, 1938–
 Artists in revolution.

 Bibliography: p.
 Includes index.
 1. Arts, Russian. 2. Arts, Modern—20th century—
Russia. 3. Arts and revolutions—Russia. 4. Avant-
garde (Aesthetics) I. Title.
NX556.A1W54 1977 700'.947 76-26428
ISBN 0-253-31077-6 1 2 3 4 5 81 80 79 78 77

CONTENTS

01834

ILLUSTRATIONS

Introduction

The Russian avant-garde perished at the hands of the revolutionary army it claimed to lead into battle. Born out of the Revolution of 1905, it antagonized both the old society it helped attack and the new society it helped legitimize. Unlike its nineteenth-century European precursors—artists estranged both artistically and politically from middle-class society—the Russian avant-garde emerged during an actual revolutionary situation and therefore needed fewer surrogate battles of its own. Unlike earlier upheavals in 1848, 1871, or 1905, when the Revolution of 1917 triumphed, it found that its rebellious artistic offspring were often unnecessary and sometimes dangerous for their politically revolutionary parents. For a time the Russian avant-garde (or that segment of it which did not seek refuge abroad) helped legitimize the revolution through its artistic innovation and its political propaganda. But in the end it fell victim to that revolution.

The term "Russian avant-garde" is an invention of subsequent critics, not a phrase used contemporaneously with the sociological phenomenon it purports to define. No artist, to my knowledge, described himself as a member of a group called the "Russian avant-garde" during the period 1905–1925. Yet many artists did share a strong desire for recognized artistic innovation and opposition to accepted social and political behavior implied by the concept. Moreover, the term "Russian avant-garde" is conceptually useful, as long as the historian accepts it as a heuristic device. We shall explore that concept at some length before we begin to use it to characterize the artists whose life and work we shall examine in detail.

This book will suggest that the term "Russian avant-garde" characterizes, however imprecisely, a social, artistic, and political movement in Russia from about 1905 to the mid-1920s. In particular, the Russian revolutions of 1905 and 1917 facilitated, but did not initiate, the importing of innovative elements in Western art by those Russian artists whose provincial (and often non-Russian) background pushed them toward European modernism and Russian political involvement as a means to personal artistic success. Born in the late nineteenth century, the Russian avant-garde may be viewed as a series of three generations of artists in transition between province and city, Russia and Europe, art and politics, and youth and middle age. Urbanization, Westernization, politicization, and aging provided the matrix for the emergence of a Russian avant-garde.

The concept of "immortality," which implies an external existence and permanence not possible in a world of change, time, and death, had particular relevance for the Russian avant-garde in a number of ways. The Russian Orthodox Church had traditionally emphasized the resurrection and immortality of Christ, celebrated every Easter, and Christian themes are prominent in the work of Russian artists, even those who satirize religion. Both Russian and Western thinkers at the turn of the century were concerned with death and the possibility of immortality in an increasingly secular and scientific world devoid, they felt, of traditional religious faith. Artists, too, shared the Promethean desires of Nietzsche's *Übermensch* to make themselves gods through their creative acts and to achieve a kind of immortality through their art. The European revolutionary tradition also emphasized the resurrection of a Golden Age or the permanence of a New Age at the end of history; Claude Saint-Simon's New Christianity entailed a future "revolution régénératrice" or "definitive regeneration" of all mankind, and his disciples nominated two "popes" of the movement on Christmas Day 1829.[1] Finally, many artists in their late twenties and thirties naturally became increasingly conscious of their own death as an imminent possibility.

Few Russian avant-garde artists believed literally in immortality as the life of the soul after the death of the body. But in their art and life they were drawn to the metaphor of immortality to express needs no longer satisfied by traditional beliefs. In this they were not unique. Between 1905 and 1925 there was widespread concern with death and religious questions among the Russian intelligentsia. For the emerging avant-garde, however, death was not so much the brooding fate of symbolists and decadents of the *fin de siècle*, as a challenge to be overcome. The term "agony," as Renato Poggioli has pointed out, originally carried a double meaning of torment and striving, anguish and contest. The Greeks often used the word to suggest a death struggle, symbolized more recently by the chess game between the knight and Death in Ingmar Bergman's film *The Seventh Seal*. Poggioli ascribes to the concept of an avant-garde a quality of agonism, or agony, which entails "sacrifice and consecration," the "immolation of the self to the art of the future," and "self-sacrifice not to posthumous glory but to the glory of posterity."[2] "The agonistic attitude," he writes, "is not a passive state of mind, exclusively dominated by a sense of imminent catastrophe; on the contrary, it strives to transform the catastrophe into a miracle."[3] We shall see that precisely those artists who exhibited the greatest interest in the theme of death and immortality come closest to fitting Poggioli's definition of an avant-garde in other ways as well.

To illustrate the birth and death of the Russian avant-garde, I have chosen to write a "collective biography" of selected artists in various fields: graphic art, theater, poetry, painting, and film. Few of them fit the model I have constructed of a "Russian avant-garde" in every respect. Yet the individual differences are often as illuminating as the similarities. By "collective biography" I mean neither the statistical prosopography familiar to readers of Lawrence Stone and Sir Lewis Namier, nor a series of full-scale biographies. Rather, I have written a group of biographical essays on some artists of the revolutionary period, from about 1905 to 1925, who embody the avant-

garde qualities of artistic innovation and political involvement, for whom there is a reasonable amount of biographical data, and who share common experiences with a larger group of artists. I have organized each chapter around the life story of an individual prior to a "moment of innovation," when a combination of artistic originality and political commitment brought fame, if not fortune. I have also kept in mind that the term "innovation" may be used variously by an artist who considers his work new and original, by a contemporary public or critic, or by the art historian writing many years later. The term "moment" is also used somewhat metaphorically; innovation may occur suddenly or gradually, in isolation or under the influence of other artists.

All of these artists achieved a reputation for originality well into their adult years, that is, in their late twenties or thirties. They also fused the artistic and the political in their work, and to varying degrees, expressed a persistent concern with the theme of death and immortality in life and in art. They were in general not Russians but non-Russians drawn to Europe, not proletarian but middle-class, not atheists but religiously concerned, not young but adult when they innovated, and they were motivated as much by private emotional need as by public revolutionary commitment. These were the factors which gave to the art of the Russian Revolution its quality of the international, the personal, and even the religious. For the double process of artistic innovation and revolutionary commitment gave many relatively unsuccessful artists an opportunity to begin again, youthful in spirit, if not in fact, and immortal in artistic reputation, if not in body.

Many people helped make this book a reality. The staffs of the Hoover Institution in Palo Alto, California; the Fogg Art Museum Library in Cambridge, Massachusetts; and the Sterling Art Gallery Library of Yale University in New Haven, Connecticut, were all especially helpful. Through the financial generosity of Washington University and the American Council of Learned Societies, I have been able to visit a number of important art museums: the Nicholas Roerich Museum and the Museum of Modern Art in New York; the Neue Pinakothek and Lenbach Gallerie in Munich; the Busch-Reisinger Museum at Harvard University; the Stedelijk Museums of Amsterdam and Eindhoven, Holland, with their unusual collections of works by El Lissitzky and Kazimir Malevich; and museums in Zurich and Basle. Mr. J. M. Joosten of the Stedelijk Museum, Amsterdam, was particularly helpful in permitting me to utilize the unpublished Malevich materials in the Van Riesen Archive. Finally, Mr. John B. S. Coats, President of the Theosophical Society, kindly provided me with materials on the Russian section from the archives of the Society in Adyar, Madras, India.

My critics have also helped. At Washington University, Professor Max J. Okenfuss, Judith Willsey, and Ruth Hastie all read the manuscript and provided both intelligent criticism and careful editing. Professor John E. Bowlt read an early essay that foreshadowed this book and made many detailed and constructive comments. Professors S. Frederick Starr, Philip Pomper, Bernice Rosenthal, and Peter Scheibert all read the manuscript in entirety. Linda Henderson and Charlotte Douglas helped clarify some arcane aspects con-

cerning Malevich and the "fourth dimension." Many improvements in this book are theirs; the remaining blemishes are mine.

In addition, I owe a special debt of gratitude to the Russian Research Center of Harvard University, which has continued to provide me with a haven for research and writing. Washington University and the Kennan Institute for Advanced Russian Studies have also been generous in their support. Like the individuals mentioned above, they too deserve much credit and no blame for the results of their generosity.

Finally, this book is dedicated to Ann—critic, friend, listener, editor, and wife, who made it possible in her own way.

<div style="text-align: right">

ROBERT C. WILLIAMS
Washington, D.C.
Autumn 1976

</div>

ARTISTS
IN
REVOLUTION

*The aim of every artist is to arrest motion,
which is life, by artificial means, and hold it
fixed so that a hundred years later, when a
stranger looks at it, it moves again since it is life.
Since man is mortal, the only immortality pos-
sible for him is to leave something behind him
that is immortal since it will always move. This is
the artist's way of scribbling 'Kilroy was here' on
the wall of the final and irrevocable oblivion
through which he must some day pass.*

—William Faulkner

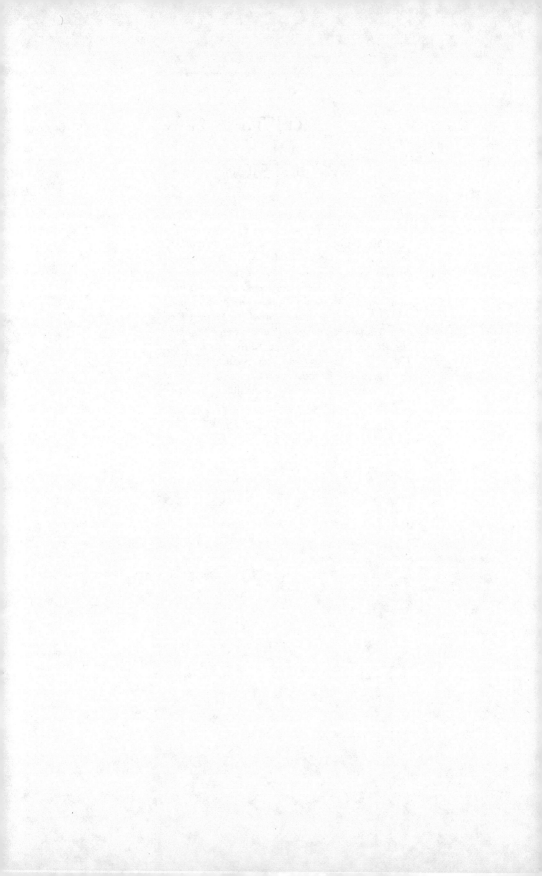

I

Innovation, Revolution, and the Russian Avant-garde

The sense of immortality may be expressed biologically, by living on through (or in) one's sons and daughters and their sons and daughters; theologically, in the idea of a life after death or of other forms of spiritual conquest of death; creatively, or through 'works' and influences persisting beyond biological death; through identification with nature, and with its infinite extension into time and space; or experientially, through a feeling-state—that of experiential transcendence—so intense that, at least temporarily, it eliminates time and death.
—Robert J. Lifton

The term "avant-garde" originally implied both innovation and revolution.[1] Around 1830 it began to connote not the military advance guard of an army, but an estranged elite of artists living on the fringe of bourgeois society. The avant-garde artist was advanced with respect to the wider public not only by his novel approaches to a particular art form, but also by his political radicalism. Saint-Simon used the term as early as 1825 to predict the leading role artists would play in his "New Christianity," a secular religion of the future, where they would "spread new ideas among men" and fulfill a "truly priestly function." Karl Marx also used the metaphor to characterize the communist party with respect to the proletariat. By the 1880s the original meaning gave way to separate connotations of artistic novelty and political radicalism: an avant-garde artist no longer needed to be a revolutionary artist, but only an artistic revolutionary, an artist committed to a revolution did not need to be innovative.

The art associated with the Russian revolutions of 1905 and 1917 shared the original avant-garde conjunction of artistic innovation and revolutionary involvement. At one extreme, the period exhibited shocking novelty and innovation in the arts, from the Paris ballet seasons of

3

Diaghilev, through the abstract painting of Larionov and Goncharova, to the constructions of Gabo and Rozanova. Yet many innovative artists were not directly involved in the Russian Revolution at all and ended their lives as émigrés in Western Europe or the United States. At the other extreme, the years from 1905 through the mid-1920s also produced an art of revolutionary commitment, from the satirical journals of 1905, through the posters of the Civil War, to the agitational theater and films of the 1920s. Many revolutionary artists, of course, were often aesthetically retrograde, returning to the nineteenth-century realism of the Wanderers or transforming their art into little more than revolutionary propaganda. Yet there were also individuals who tried to fuse artistic innovation and revolutionary involvement in their work; these are the artists who form the subject of this book.

We are concerned, then, with the intersection of innovative and revolutionary art, of aesthetic novelty and political art. The artists considered reflect a tradition going back to the revolutions of 1830 and 1848 in Europe, where the avant-garde was both artistically ahead of middle-class taste and politically or socially estranged from middle-class life. What made these artists famous was not their artistic innovation or political commitment alone, but their fusion of the two into a single art that reflected the revolutionary times around them. The artists who immortalized the revolutions of 1905 and 1917 in their art were a transitional generation between the aestheticism of the *fin de siècle* and the revolutionary constructivism of the 1920s. They shared a tension between the personal need for an artistic reputation through innovation and the wider involvement in a social and political upheaval. And they also shared a concern with immortality as artists and activists, which lent their work a peculiar intensity and ultimately brought them the fame they so demanded through revolution and its art.

I

Russian revolutionary artists of the avant-garde were not always as Russian, as revolutionary, or as innovative as these terms suggest. Citizens of the Russian Empire, they were receptive to a continuous flow of ideas and artistic influences from the West. Few were deeply committed to political activity for any length of time. Innovation within their art sometimes mattered less than their association with the revolution at a crucial moment in their lives. Yet all three of these variables have often been used to explain the emergence of a Russian avant-garde after 1905.

Initially, Russian revolutionary art appeared to be a product of the revolution itself. In the 1920s many Western intellectuals who visited Russia anticipating a "New Age" found what they had expected long

before World War I. The American writer Max Eastman characterized the Bolsheviks as "Nietzschean free spirits"; other visitors also assumed that Soviet Russia had fulfilled the cultural prophecies of Friedrich Nietzsche and Richard Wagner, bringing about a rebirth of Greek antiquity where the arts were again a festive religion that integrated man with nature and society, purifying him through periodic drama and spectacle. The dancer Isadora Duncan greeted early Soviet art as a great "wave of liberation" in the spirit of her own idealized resurrection of the Greek dance. The English drama critic Huntley Carter, a contributor to A. R. Orage's Edwardian literary journal *The New Age* and various theosophical magazines, found on the Soviet stage a revival of "popular theater" from ancient Greece, which he considered only part of a "world-wide spiritual unrest amounting to a revolution." To envious bohemians from the West who visited Soviet Russia in the 1920s, the Russian Revolution had created a new world of cosmic significance in art, which now lay open to the creative genius of twentieth-century Leonardos and Rembrandts. Only gradually did most of them realize that Lenin's revolution was not their own.[2]

The Hungarian writer René Fueloep-Miller emphasized the role of the Bolshevik Revolution in the artistic and cultural upheaval of the period in his book *The Mind and Face of Bolshevism*, published in 1926. Fueloep-Miller had studied psychology in Paris and Vienna, had fought in the Austrian army during World War I, and had come to Russia in the early 1920s in search of Dostoevsky manuscripts. To him the central feature of art and culture in early Soviet Russia was the quasi-religious nature of Bolshevism and its suppression of the individual in the name of the mass man. He compared the Bolsheviks with the Jesuits and with Dostoevsky's Grand Inquisitor. Like the Russian émigré philosopher Nikolai Berdyaev, Fueloep-Miller viewed Bolshevism as a disguised or inverted form of traditional Russian Christianity. He thought the new Bolshevik religion had a negative effect on the arts. He found the theater director Vsevolod Meyerhold to be "one of the few in Soviet Russia whose artistic talent and productive power are unquestionable" and the maker of a "quite new revolutionary style" in the theater. But most artists were propagandists for the new regime who had simply applied artistic techniques learned before the war in Europe. The "machine art" of Vladimir Tatlin reminded him of the theories of the architect Gottfried Semper; the Commissar of Public Enlightment, Anatoly Lunacharsky, he felt, had "never been able to suppress entirely a secret leaning towards the culture of the old world." In sum, Fueloep-Miller considered early Soviet art more revolutionary than innovative. "Western Europe," he concluded, "has long been acquainted with all these ideas put forward by the Russians as completely new and subversive, and even got beyond some of them many years ago."[3]

Not all Russian artists who lived through the revolutionary events of 1905 and 1917, however, were directly involved in the revolution. Students of the period soon realized that while the Bolshevik Revolution created propitious conditions for artistic experimentation for a few years, it failed to convert many members of the Russian intelligentsia and avant-garde artists to its side. Observers therefore began to distinguish the cultural upheaval of these years from the political and social revolutions, and to seek deeper Russian cultural traditions which affected the art of the revolution.

The most ambitious attempt to trace Russian revolutionary art back to long-standing Russian cultural traditions is James Billington's *The Icon and the Axe* (1966). Billington characterizes the period from 1905 to 1925 in terms of a musical metaphor—a "crescendo" and three dominant themes: Prometheanism, sensualism, and apocalypticism. "The entire emphasis on the nonliterary, suprarational arts is a throwback to the culture of Old Muscovy, with its emphasis on sights, sounds, and smells," he concludes. Within this broad historical tradition, Tatlin, Lunacharsky, and the painter Kazimir Malevich all emerge as "Prometheans"; Malevich in addition appears as a "kind of artistic prophet of the space age." Tatlin too "reflected this Promethean urge to move out and master that space." Billington characterizes the poet Vladimir Mayakovsky as the "ultimate romantic," Sergei Eisenstein's film *Potemkin* as an icon of the revolution analogous to that of John the Baptist on the iconostasis, and Meyerhold as a director who placed "fresh emphasis on the use of the gesture and the grotesque."[4] In Billington's survey, Russian culture provides a kind of vague causal explanation for the art of the revolution without a detailed examination of its nature and sources.

Other historians have emphasized the peculiarity of Russia's condition, rather than her cultural traditions. In describing the advances in Russian linguistics during the revolutionary period, Roman Jakobson noted that "the academic tribunals were far away, the fear of criticism weaker, and so greater possibilities were open for pioneering audacity." By this argument Russia's distance from Western Europe encouraged artistic innovation, even if Russian culture did not determine its nature. Other scholars have described Russia in the early twentieth century as an "international meeting ground of ideas," a place where the "ascendancy of politics over culture collapsed," and where the patronage of a "new class of rich industrialists" made possible the emergence of a Russian avant-garde, that is, a "domestic organic movement" in painting and the other arts. The English critic John Berger has observed regarding the Russians that "their backwardness has become the very condition in their seizing a future far in advance of the rest of Europe. They could transcend the European present, the present of the dehumanized

bourgeoisie. . . . It was the conjunction of the cubist example and the revolutionary possibilities in Russia that made the art of this period unique."[5]

The historian has difficulty proving or disproving such sweeping statements about Russian culture or the Russian condition of backwardness as causal explanations of the emergence of a Russian avant-garde. In Karl Popper's terms, they are "non-falsifiable," and therefore not very useful as explanations of historical reality. Few critics have tested such generalizations against individual cases. Among the artists in this book, Mayakovsky was the only ethnic Russian, and he spent much of his life demolishing icons with his antireligious poetic axe, not in worshiping them. Other Russian artists were thoroughly westernized by their years in Paris or Munich during Russia's "Silver Age" and can hardly be considered "backward." The interpretation of the art of the Russian Revolution in terms of peculiar Russian traditions and conditions thus tells us little more than the earlier interpretation based on the dramatic events of the Bolshevik Revolution and its aftermath.

In recent years scholarly emphasis has shifted to the Russian avant-garde as a "lost" movement in the arts which combined both artistic innovation and political revolution. This approach is not entirely new. As early as 1924 Trotsky, in his book *Literature and Revolution*, had coined the term "fellow-travelers" to describe those artists and writers left over from the prewar bourgeois avant-garde, whom the Bolsheviks merely tolerated as a necessary expedient. The artists of the 1920s were not really revolutionary at all, Trotsky argued, but middle-aged and westernized products of their social class, the bourgeoisie, and the residue of its artistic fringe, bohemia.[6] The westernism and middle-class origin of most Russian avant-garde artists of the period have embarrassed or limited later Soviet scholars. This has not prevented them from writing biographies of men and women who might be considered members of the avant-garde, or serious monographs on modernist art before and after 1917.[7] But such works often ignore or downgrade the social background of the artists, their contacts with the West, and their religious concerns.

In the past decade the Russian avant-garde has enjoyed considerable attention in the West. Major exhibits have made the work of Malevich, El Lissitzky, and the "constructivist" artists of the 1920s familar to a broad art public in both Europe and the United States.[8] Scholarly monographs on Russian modernism have proliferated. The late Renato Poggioli led the way in viewing the avant-garde as a useful concept which described the nexus of political rebellion and artistic radicalism in both Europe and Russia before and after 1917. For Poggioli, for example, Russian futurism in poetry and the visual arts "prophesied the coming revolution and joined hands with it." He also pointed out that

the avant-garde was a pan-European phenomenon in which Russia was intimately involved, a dynamic movement of artists united by their activism, their antagonism toward bourgeois society, their nihilism in the face of accepted values, and their agonism—the acceptance of their own ultimate ruin and demise. The avant-garde artists exalted youth, the primitive, and the childlike and attacked the Academy, the establishment, and bourgeois society in general, while proclaiming themselves a new aristocracy.

Not all artists of the period fused artistic innovation and political involvement in their work. Some were radical innovators who took little part in events around them. The composers Igor Stravinsky and Sergei Prokofiev burst upon the musical scene in St. Petersburg before World War I, but then emigrated to Europe or America in the 1920s. Neither was politically involved in the revolution. Other artists, such as the film director Sergei Eisenstein, were little known until they committed themselves and their art to the revolution. But most avant-garde artists of the period involved themselves at times in both art and politics. The painters Vasily Kandinsky and Marc Chagall achieved their artistic reputations in Munich and Paris before 1914; returning to Russia, they participated in the revolution for a brief, if exciting, period before emigrating once more in 1922. Other artists influenced revolutionary art through their students, as in the case of the painter of battles F. A. Rubot, who worked in Munich and Petersburg before World War I and whose student, B. D. Grekov, immortalized the conflicts of the Russian Civil War in his paintings of the 1920s and 1930s. Still others turned to propaganda, creating posters or films needed by the new government.

Historians of the avant-garde are studying a social group whose membership is not clearly defined: artists who proclaim themselves to be in advance of accepted styles and tastes and outside of accepted social and political behavior. Despite his suggestive analysis and his erudition, Poggioli never applies his definition of the avant-garde to any single individual who might or might not fit such a definition.[9] The Russian revolutions of 1905 and 1917, the long-standing traditions or conditions of Russian culture and society, and the emergence of an artistically and politically radical avant-garde all certainly helped characterize the period under consideration. But how? No single cause suffices to explain the great wave of artistic innovation and revolutionary commitment that typifies Russian art from about 1905 to 1925. For example, among the artists considered in this book only A. V. Lunacharsky was a revolutionary for any length of time, only Mayakovsky was an ethnic Russian (and he was raised in Georgia), and only Kazimir Malevich appears consistently in the historical literature on the Russian avant-garde. Most statements about the revolution, Russian tradition, or

the avant-garde turn out either to be unverifiable or to provide a mosaic of selected evidence whose tiles can be rearranged at will. Here we shall consider more concrete aspects of the period in the lives and work of individual artists: their provincial background, their education, Western influences, patronage, and generational change. All of these factors played a role in shaping the careers of avant-garde artists prior to a moment of innovation when they achieved an artistic reputation or lent their art to the revolution.

II

The Russian revolutions of 1905 and 1917 provided new opportunities previously denied to many artists: the non-Russian, the provincial, the young, and women. They also helped the mediocre become famous by making their art political. In Peter Gay's terms, Russian revolutionary art, like Weimar culture in the 1920s, was in part "the erection of outsiders, propelled by history into the inside, for a short, dizzying, fragile moment."[10] Revolution bred innovation. For a time all barriers were down, all ways open, anything possible. The breaking of rules became legitimate. In this environment previously unsuccessful artists could overcome backwardness through borrowing, finding novel and unknown sources for artistic innovation in the West. Innovation in turn allowed some mature artists, psychologically renewed and artistically revitalized, to become the leaders of the young. The Russian avant-garde was in part the product of previously unsuccessful non-Russian artists from the provincial towns who surmounted the cultural competition of urban centers, both in Russia and in Europe, by successful innovation.

The Russian avant-garde also included a generation suspended between art and politics, innovation and revolution. That is, there was a particularly volatile group of artists born in the 1880s and early 1890s whose emergence into adulthood coincided with the period between the revolutions of 1905 and 1917. This "futurist" generation was transitional between a generation we shall call "aesthetes," who reached maturity at the turn of the century, and a later generation of "constructivists," who were more deeply involved in the Soviet experiment of the early 1920s. The aesthetes emphasized artistic innovation; the constructivists, revolutionary commitment; and the futurists, a mixture of both in revolt against bourgeois society. We shall use these generational terms as ideal types on occasion; they do not completely define any individual artist, nor should they be confused with specific art movements (futurism or constructivism) associated with that generation. But they will provide a useful framework within which we can examine in detail the lives and works of individual artists associated with the concept of a Russian avant-garde.

The generation of the aesthetes had reached maturity by the time of the 1905 Revolution. Like Lenin and Trotsky, they were born in the 1870s, grew up during the period of repressive and russification policies of Alexander III (1881–1894), and were educated in the turbulent 1890s. In terms of social origin, the aesthetes usually came from the newly emerging Russian middle-class professional intelligentsia; their fathers were merchants, businessmen, professors, army officers, and public officials. They received a good education, often in St. Petersburg at the university or the Academy of Arts. Their intellectual world divided itself between politics and art, Marxism and idealism, the traditional critical thinking of the intelligentsia and the new European movements of symbolism and art-for-art's-sake. While many students found Marxism a scientific doctrine of the class struggle relevant to the Russia of Sergei Witte's industrialization program, others turned to a more general revolt against bourgeois society: their teachers were Nietzsche, Wagner, Charles Baudelaire, and Oscar Wilde. The aesthetes of the *fin de siècle* sought to transcend society and its banality through new values and new perceptions of truth, and to create an art that would enable a select few to see behind the veil of apparent material reality. Style and form mattered as much as content. Many artists studied abroad, particularly in Munich; several helped create the New Artists' League (*Neue Künstler-Vereinigung*) in 1909 and the Blue Rider exhibit of 1912. In St. Petersburg they attended the exhibits of Sergei Diaghilev's World of Art society (*Mir iskusstva*), which sought to unite Russian and Western modernism, and the associated "Evenings of Contemporary Music." The aesthetes helped bring Western art to Russia at the turn of the century, were radicalized or terrified by the events of 1905, and were then divided between the sanctuary of Parisian exile and the turbulence of 1917. The Revolution of 1905 found them in their early thirties; by 1925 they were in their fifties.

The second generation was that of the "futurists." Born in the 1880s and early 1890s, they reached maturity between two revolutions, a transitional generation, more politically involved than the aesthetes but less so than the Soviet constructivist generation to follow. In 1905 they were in their twenties or younger, and often still in school. Members of the futurist generation came increasingly from the provinces of southern and western Russia, and they found their way not to St. Petersburg and the Academy of Arts but more often to Moscow and its School of Painting, Sculpture, and Architecture, or the Stroganov School of Applied Arts. Both in Moscow and in Kiev they launched a series of independently financed art exhibits such as "Blue Rose," "Garland," and "Link"; in the winter of 1910–1911 various currents merged at the "Jack of Diamonds" exhibit in Moscow. But their confluence was short-lived. Many moved on to St. Petersburg, where the "Hylea" poets created a

Russian "futurism." Futurist painters showed their works in 1915 at the "0.10" and "Tramway V" exhibits. Others left for Paris, where they joined the growing international artists' colony at La Ruche. Generally, the radicalism of these artists was more in form than in political action; they broke the rules of poetic rhythm and rhyme, or of visual line and color, but rarely of society. They threw tea at audiences, read nonsense poems, and paraded on street corners with spoons in their buttonholes; but they did not throw bombs or join the Bolsheviks. For them art was revolution, and Paris was its center. Many settled there, while friends stayed on in Russia. In 1917, members of the futurist generation were in their thirties; the revolution exacerbated the tension between participation and emigration, political commitment and artistic innovation.

The generation of "constructivists" contributed an element of youth to the art of the new Soviet Russia. The Bolshevik leaders themselves were generally from the generation of 1905, the aesthetes, and the rank-and-file Old Bolsheviks from that of the futurists. But the Bolshevik success of 1917 swelled party ranks with younger members. Born in the 1890s and the early twentieth century, the constructivist generation constituted a kind of youth movement in early Soviet Russia. Many of the future constructivists came from lower-class origins and found their way to Moscow or Petrograd amid the turmoil of war, revolution, and civil war between 1914 and 1921. They grew up in a world of death and violence, and they threw themselves wholeheartedly into the revolution in art and life. Their vision of a cultural or artistic revolution was not elitist but popular; they believed that art should be created not only for, but also by, the proletariat. Some members of the constructivist generation were veterans of World War I or the Civil War; others were too young to have participated in these events, or in the 1917 Revolution itself. The aim of the constructivists was the construction of utopia. Unlike the aesthete and futurist generations, this generation, by and large, lacked direct contact with the West because of the isolation brought on by World War I.

By the early 1920s these three generations were coexistent but distinct. The aesthetes were now in their late forties and fifties, and their participation in the revolution was minimal. Some stayed on to work under the new regime, but many never returned from their post-1905 European wanderings; others returned for a few years and then emigrated once more. The futurists were more involved in the revolution than the aesthetes, but as their own revolution, not Lenin's; their newspapers, paintings, and street banners for revolutionary holidays were often more avant-garde than socialist. In the early 1920s members of the futurist generation were in their late thirties and forties. They had survived war and revolution. As they sought to extend the revolution in art, if not in politics, their innovative rebellion soon conflicted with

revolutionary unity. Of the three generations, the constructivists were most involved in the new revolutionary Russia, and least knowledgeable about the West. For them the revolution brought frequent opportunities at a remarkably young age, despite (or perhaps because of) their lower-class provincial background.

Each generation meant something quite different by innovation in their art. The aesthetes sought a new style akin to *Art Nouveau* or *Jugendstil*, decorative and delicate, sensuous and stylized, suitable for the new market provided by the well-to-do. The futurists attacked that style and attracted public attention by their revolt against the rules of form, color, and harmony. They criticized bourgeois society and the Academy but also sought a new market and audience for abstract painting, nonsense poetry, and atonal music. The constructivists rejected the art market entirely, and sought a state-subsidized mass art which would break down the barriers between art and labor, elite and masses, form and function, and artist and worker.

The revolutionary experiences of the three generations were also distinct. The aesthetes were either radicalized or traumatized by the events of 1905. The futurists substituted their own cultural radicalism for political activity during the more quiescent period before the war and were overtaken by the national disaster of World War I and the 1917 Revolution. The constructivists reached maturity only after the end of the Civil War in 1921, when the task was no longer the destruction of the old society but the celebration and construction of the new one.

III

The three generations also stamped their own specific concerns on the art of the period. The aesthetes were preoccupied with the symbolic and the religious, even the mystical, in art and in life. The futurists shared an enthusiasm for the modern and the novel that expressed itself in urbanism, the cult of the city. Finally, the constructivists added their own element of collectivism, forged in revolution, the subordination of the individual to the proletarian whole. Each of these themes emerges in the culture of the period.

Religious concerns were widespread among the aesthetes, who often thought of themselves as seers in touch with a world beyond ordinary vision. The painter Vasily Kandinsky, in his *Concerning the Spiritual in Art* (1912), prophesied a new religious abstract art that would someday raise the cultural consciousness of the masses to a higher level; the composer Scriabin articulated similar views. The painter Malevich, the poet Andrei Belyi, and the patron of the Russian futurists Nikolai

Kulbin, all shared the aesthetes' interest in theosophy, occultism, anthroposophy, and other religious movements as central to their special vision of an elite truth. The artist was a kind of priest communicating innovative perceptions of reality to an elite of viewers or listeners capable of advanced understanding. Expressing the interior soul or spirit was more important to these artists than portraying reality on the material level. The religious dimension introduced by the aesthetes persisted in the art of the postrevolutionary period, where it gave rise to a mythology of revolution that would ultimately help justify Stalinist theocracy and the destruction of artistic autonomy. But religious concerns were most respectable among the artists of the turn of the century and less so among their followers.

The futurists discovered urbanism. In part, the cult of the city was simply a logical extension of the eighteenth-century vision of the ultimate perfectibility of man and the nineteenth-century cult of progress. But it emerged most distinctly before World War I in the city poems of Alexander Blok, the graphics of M. V. Dobuzhinsky, and the painting and poetry of Vladimir Mayakovsky. The city, the skyscraper, and the machine became new symbols of the modern. Mayakovsky extolled the virtues of New York and Chicago, while Vsevolod Meyerhold placed motorcycles and automobiles on the stage. In 1914 the literary critic Genrikh Tasteven, in his book *Futurism: On the Way to a New Symbolism*, predicted a coming cultural revolution based upon the modern city and Italian futurist visions, a "great movement for the resurrection of cultural values, the creation of a new idealism, and a new acceptance of the world."[11] The futurist generation welcomed the noise, the bustle, the smoke and traffic of modernity, and brought it into their art. There were always exceptions, of course, as in the peasant poetry of Sergei Esenin or the fine-lined surrealism of A. G. Tyshler. But urbanism was a dominant theme.

The constructivists espoused collectivism. The artist could no longer exist as a member of an elite on the fringe of bourgeois society, however advanced. Art must serve the people. The idea of *sobornost'*, a collective community of Christian believers, was traditional in Russian Orthodoxy; in the nineteenth century it was overtaken by the romantic nostalgia of the Slavophiles and the peasant-centered *narodnichestvo* of the Populists. The collectivism of the revolutionary period was more dramatic. Artistically, it meant the disappearance of the individual from the work of art in favor of abstraction and non-objectivity; politically it meant the cult of the masses and the demise of the individual as a legacy of bourgeois society. In the constructivist era of the 1920s conductorless orchestras performed in Moscow, Meyerhold transformed the ancient Greek chorus into gymnasts dressed in workers' coveralls, and

Eisenstein's films made the masses themselves into a new collective hero. The individual would ultimately die; the collective was immortal and eternal.

The three generations also emphasized different techniques and forms in their art. The aesthetes were fascinated by art as myth. Inspired by Nietzsche's resurrection of Greek tragedy and Wagner's festivals at Bayreuth, they sought to transform art into ritual. The synaesthetic unity of color, sound, and smell became the basis of Scriabin's tone poems, evocative of the ecstatic and the Promethean. The Diaghilev ballet in Paris turned to Russian myth: the primitivism of Roerich and Stravinsky's *Rite of Spring*; the Muscovite nostalgia of Chaliapin's *Boris Godunov*; the carnival atmosphere of St. Petersburg embodied in Stravinsky's *Petrushka*. The futurists went on to mythologize themselves, proclaiming futurism, cubo-futurism, suprematism, and other movements for their critics and buyers. Finally, in the early Soviet period myth was utilized to legitimize the revolution through monuments, mass outdoor spectacles such as the reenacted storming of the Winter Palace in 1920, May Day parades, and films. The aesthetes sought a usable myth of the Russian past, associated with Petersburg or Moscow; the futurists immortalized themselves through lectures, exhibits, and street-corner readings or demonstrations; the constructivists mythologized the Russian Revolution, an event witnessed directly by few, and the meaning and consequences of which were still unclear to many.

The futurists introduced the technique of antagonism, the sharp juxtaposition of two objects in tension. Artistically, this meant the placement of two related but not contiguous scenes or items on canvas as in Marc Chagall's juxtaposed visions of Vitebsk and Paris, or the futurist poets' notion of word and object "displacement" (*sdvig*), or the formalist literary critics' theory that a familiar object should be made strange and new to the reader (*otstranenie*). Visual logic was no more necessary than the logic of cause and effect. Politically, antagonism could be used to great effect by juxtaposing symbols of good and evil, we and they, in a work of art. After 1917 the antagonism of futurist collages gave way to posters contrasting the muscular and heroic figures of the worker or Red Army soldier with the bloated, sinister, or ridiculous cartoon characters of Lloyd George, General Wrangel, or a *kulak* or priest. In any case, the purpose of antagonism was to shock the viewer into attention (or purchase) through innovation, contrast.

The constructivists added to myth and antagonism a third technique, agitation. The transformation of art into revolutionary propaganda by many constructivists led to the repetition of a single idea or slogan for political effect. Posters run off by the thousands exhorted the recalcitrant

to volunteer for the army, or learn to read, or feed the hungry, or contribute their labor on Sunday. The ROSTA windows of the Russian Telegraph Agency were cartoons intended for mass consumption, a visual newspaper for the illiterate. Meyerhold utilized his "biomechanics" exercises on stage as a kind of gymnastics to demonstrate motor efficiency to workers in the spirit of the Taylor System. Agitation meant that art should call forth action on the part of the viewer or listener; the viewer's response was an essential part of the work. In the context of the early Soviet period, agitation was the means by which art ceased to serve the bourgeois market and began to serve the masses.

More generally, the three generational experiences indicate a shift in art from an expression of individual autonomy to the fulfillment of social need. In this sense too there was a movement from innovation toward revolution, from the novel in art to the new in life. Not that art could not be both useful and innovative. In the 1920s Tatlin's reliefs, Rodchenko's mobiles, and Kuleshov's montage all certainly maintained the innovative spirit. But many felt that the artist should now become an artisan, builder, or engineer. The "productivists" carried this to an extreme, designing clothing, reading rooms, and stoves for the proletariat in the spirit of the prewar *Werkbund* and the postwar *Bauhaus* in Germany. Many of their schemes never got beyond the blueprint stage, as, for example, El Lissitzky's *Prouns* or Ivan Leonidov's architectural designs; only in the late 1920s were architects able to find the money and materials to realize some of their utopian projects: massive skyscrapers, parking garages, and communal apartments.[12] At the same time, they found their autonomy severely curtailed by the regime they helped legitimize.

IV

The idea of immortality provided a powerful metaphor or paradigm for the avant-garde. Artistically, the process of innovation itself may lead to a kind of immortality: an artist establishes a new style or trend which provides a reputation that will live on after the artist's death; the work of art itself is an object that will endure, whatever its perception by the critics. Innovation also makes possible periodic regeneration or rebirth by initiating another phase of artistic development within the artist's lifetime. At the painter Paul Klee wrote in 1914, "one deserts the realm of the here and now to transfer one's activity into a realm of the yonder where total affirmation is possible."[13] Such a world of total affirmation is beyond the real world and beyond death.

Revolution also provides a vehicle for immortality. The avant-garde

artist seeks to create a new work of art which will endure, bringing him permanent fame. The revolutionary seeks to create a new society that is perfect, a heaven on earth that marks an end to historical time; he may risk death in the service of that ideal, but his memory will survive and even be memorialized in the postrevolutionary generation. Participation in the exhilarating events of the revolution may also provide a sense of regeneration, of starting anew, finding a self one had not known. The avant-garde artist who combines innovative and revolutionary impulses will be doubly drawn to employ the metaphor of immortality and rebirth.

One may distinguish three views of immortality. According to the first view, derived from classical Greek and Christian thought, the world exists on two levels: on one level our life ends with the death of the body, while on the other a soul remains in another world, of which we have only intimations. A second, more secular, view of immortality is that we live on after death in the memory of others, whether or not we believe in actual immortality. Finally, there is the view that any sort of immortality is impossible, and that the greatest hope in a scientific age is longevity, the prolonging of life to its maximum span through medicine and good health. These three views coincide with the differing concerns of the three generations of Russian artists we have identified.

The traditional view of immortality in Western thought began with the Greeks. Both Pythagoras and Plato believed in the immortality of the soul, and even in the possibility of its transmigration into another body. Christianity added the more literal belief in resurrection in the timeless world of Heaven, or at least the ascension of the soul. In the nineteenth century this tradition was given new impetus by romanticism, with its emphasis on the slumbering unconscious accessible through hypnosis or the dream, a deeper level of reality beneath the waking life. The Greeks had explained death as a punishment inflicted by Zeus upon Prometheus and all mankind for the sin of disobedience; in the nineteenth century Prometheus became the symbol of creative defiance of the gods and of the urge to transcend this life. By the end of the century the cult of science had produced new countermovements of the spiritual and the occult, belief systems that provided secret doctrines revealing the spiritual world beyond death, the world of the other side. In his famous essay on *Human Immortality* (1898), William James admitted that modern science had not disposed of the will to believe in a world beyond this one and that "life may still continue when the brain itself is dead."[14] Scientism and the erosion of traditional religion spawned a new concern with death and immortality around 1900. After decades of relative silence on the subject, philosophers like James, Henri Bergson, and George Simmel were producing what one historian has

called a "reaction against the exclusion of death from philosophical reflection."[15]

The second view was that man's perfectibility constituted his immortality. Bound to this earth, he could at least improve life in some way and leave behind what he had done. "A man who lives according to the dictates of reason alone," wrote Spinoza, "is not led by fear of death but directly desires the good."[16] The eighteenth century welcomed this secular view of immortality. "Why may man not one day be immortal?" asked William Godwin in his *Enquiry Concerning Political Justice* (1793). Antoine-Nicolas de Condorcet also portrayed man's inevitable rise through ten stages of history to perfectibility in his *Sketch for a Historical Picture of the Progress of the Human Mind* (1795). Among the benefits of that perfection would be the indefinite increase of the human life span through the progress of science and medicine. What Malthus by way of pessimistic rejoinder called Godwin's and Condorcet's "very curious instance of the soul's longing after immortality" was actually a substitution of secular perfection for Christian salvation.[17]

The European revolutionary tradition shared this secular concern with immortality through perfection. The philosophes devised their own version of immortality, summarized by Carl Becker in 1931 as "the hope of living in the memory of future generations." In the words of Diderot, "Posterity is for the Philosopher what the other world is for the religious." This faith in a collective immortality of the individual through surviving memory and reputation enabled Madame Roland to announce: "Roland will never die in posterity, and I also, I shall have some measure of existence in future generations."[18] The French Revolution provided for the immortality of its heroes through hymns, holidays, monuments, and the religion of the Goddess Liberty. In the nineteenth century this optimistic faith in man's perfectibility survived in Auguste Comte's "positivist science" and its "religion of humanity." Science itself bore witness to man's unlimited power over nature. In the Comtean vision, "in Humanity, individuals are able to enjoy, in very truth, the immortality for which they long" and "as to the dead, they live on in the remembrance of other generations."[19]

Finally, there was the view that immortality could be achieved only in the form of longevity. In the Middle Ages alchemy suggested the power not only to turn base metal into gold, but also to cure all disease through the infinite power of medicine. The idea of prolongation of life embedded in Condorcet's theory of progress has already been mentioned. By the end of the nineteenth century developments in biology and immunology, fewer deaths in childhood, and an increasing life span suggested that such a dream of prolongation of life was not so far off.

Russians shared these inherited views on immortality. Traditional Russian culture emphasized the cyclical and cosmic process of rebirth characteristic of both agrarian seasonal rituals and Eastern Christianity. In the Russian calendar the resurrection of Christ at Easter was the central event and holiday. In addition, Russian intellectuals inherited the secular traditions of European thought. In the 1790s Alexander Radishchev, the well-known critic of serfdom, wrote that "life extinguished is not annihilation" and that perfection not only is man's goal on earth but "remains his goal after death as well."[20] Even the older Christian tradition remained alive, if only as a tactical metaphor, in the works of the revolutionary Populists of the 1870s. "Let the worker— Lazarus—leave his tomb forever!" wrote Peter Lavrov in a poem, "Noel" (1870); the Russian people were a collective martyr akin to Christ who "will remain crucified, bleeding, as long as he is not conscious that he is God." But the dominant tradition was that of the Enlightenment and the European revolutionary movement: immortality through the collective memory. In the words of Trotsky in 1924, "Lenin is immortal in his doctrine, his work, his method, his example, which live in us, which live in the Party he created, and in the first Workers' State of which he was the head and the helmsman."[21]

The traditional view of immortality dominated the generation of the aesthetes in Russia. In their writings they frequently returned to traditions of Platonic and neo-Platonic philosophy, the works of the Church Fathers, the Apocalypse and Revelations, and the writings of Jacob Boehme and Emanuel Swedenborg. Mysticism flourished. The poet, novelist, and literary critic Dmitry Merezhkovsky fused artistic and political visions of immortality into a single millenarian vision of a religious revolution based on Christian love. Peace on earth was one form of immortality: "to conquer force means to conquer death." In Merezhkovsky's novel *Julian the Apostate* (1895), Julian teaches men not to fear death, and propounds the ideal of "the reign of god-like men . . . eternally laughing, like the sun." Death can somehow be transcended. The true meaning of Christ and of Nietzsche's Superman is that they can achieve precisely that transcedence. The man who truly understands Christ will also be "fearless of death." Merezhkovsky also anticipated the later fascination with immortality through an act of creation; the artist too, like Leonardo da Vinci, conquers death by creativity, achieving his own form of immortality through a creative impulse made possible by bisexuality.[22] Nor was Merezhkovsky alone in a generation whose intellectual mentors shared the faith of a Tolstoi or the theosophic vision of a Vladimir Soloviev.

The futurist generation was drawn to the more secular tradition of the Enlightenment. Man might become God not literally but by God-like acts whose memory would live on. The artist himself was a kind of

god, or a Prometheus in defiance of the gods. But he was more inter-
ested in immortality by reputation than by religion. Around 1904 the
writer Maxim Gorky hinted that man might well be immortal through
his fusion with the larger collective, which would outlive him and
remember his deeds. In his play *Children of the Sun* Gorky wrote: "We
... children of the sun, born of the sun, the shining source of life, will
conquer the dark fear of death." In his novel *Confession* (1908) he
described the people as immortal. Gorky was probably the first person
to coin the term "god-building" for the new secular religion of humanity
that flourished on the left in Russia before World War I. As we shall
see, the Enlightenment tradition of immortality by reputation re-
appeared at the turn of the century in the "monist" and "empiriocritical"
writings of the Austrian physicist Ernst Mach as an idea that the self
lives on in the memory of the collective, the "I" in the "we." This notion
was well received by left-wing Russian intellectuals.[23]

Finally, the view of immortality most acceptable to the construc-
tivist generation was that of longevity. Adherents of the scientism and
atheism of the 1920s rejected the traditional view and tolerated the
secular tradition of immortality by memory, but were most intrigued
by the prolongation of life through medicine. The leading Russian
proponent of this view was the cell biologist Elie Mechnikov, director
of the Pasteur Institute in Paris. Although Mechnikov died before 1917,
his views were popular in Russia in the 1920s. Mechnikov won the
Nobel Prize in 1908 and wrote widely on popular scientific topics, ex-
pressing what he called his optimistic philosophy of man. According to
Mechnikov, modern medicine and proper diet might not give man
immortality, but they would someday prolong the human life span
indefinitely. If immortality were possible, science would provide it:
"Death," he once wrote, "is not necessarily inherent in living organisms."
For Mechnikov, the religion of the future would be based on modern
science, whose power would enable man to solve all problems, including
death.[24]

The Russian avant-garde, then, emerged at a time when the En-
lightenment tradition of secular immortality was most popular. The
religious sensibility still survived; the scientific and atheist enthusiasm
for longevity was only then becoming known. For the generation of
the aesthetes, the world still existed on two levels, the apparent and
the real, the material and the spiritual, linked by symbols; the artist was
a seer who could transcend the reality of death by penetrating the
secrets behind the veil. For the constructivist generation, the scientism
of Mechnikov provided a surrogate immortality through longevity that
grew out of the cult of progress. The intermediate futurist generation
shared the more transitional view of the "god-builders": the fear of
death, if not death itself, could be conquered, and immortality achieved

by fame and reputation preserved in the memory of the collective and of future generations. In this way the Russian avant-garde fused the artistic immortality of successful innovation and the political immortality of remembered revolution.

V

The Russian avant-garde combined artistic innovation and an involvement in political revolution in their art, their politics, and their views on ultimate religious questions, among them death and immortality. They were artists in transition and in tension, ahead of a dominant culture they disliked and predicting a cultural revolution they would lead. Ultimately, by the 1930s, they became the victims of the revolution they had in part supported and helped immortalize in their art. Nadezhda Mandelshtam preferred the term "capitulationists" for those intellectuals who supported the Bolsheviks in the 1920s and noted that "the people between thirty and forty were the most active age group in those days."[25] Not that all artists of the avant-garde were committed revolutionaries, any more than they were successful innovators. But most were, by definition, drawn in both directions. Revolution itself, both in 1905 and 1917, often provided overnight artistic acclaim for unsuccessful artists conscious of their age, as well as idealistic opportunities for rebellious youth. Perhaps it is not coincidental that the avant-garde artists who immortalized the revolution in their works were themselves at a moment in their lives that demanded success and fame to arrest the inevitable slide toward death.

The wave of Western art and culture that inundated Russia between 1905 and 1925 under the relative cultural tolerance of the Duma system and during the early Soviet years reflects the increasing ties between Russia and the West, rather than Russian backwardness. A powerful undercurrent within that wave was the persistent concern with death and immortality by artists and intellectuals after the turn of the century. Western writers then popular in Russia shared this concern. The Belgian playwright Maurice Maeterlinck was a spiritualist convinced that the self would survive death in some form. The American poet Walt Whitman filled his poetry with intimations of immortality. Another Belgian writer, Emile Verhaeren, related death and immortality in his plays to the process of revolution and the life of the modern city. Ernst Mach defined the survival of the self through the other, the collective. All of these Western writers were immensely popular in revolutionary Russia and played an important role in the moment of innovation of several artists. For Kandinsky and Malevich, Western theosophy offered a way out of the problem of death through the mysterious world of the fourth dimension, as well as a push in the direction of abstract painting.

Throughout the revolutionary period the Russian avant-garde sought and found in the West thinkers and writers who shared their own concern with artistic and personal immortality in a secular age.

The artists considered here held diverse attitudes toward death and immortality in art and life. The graphic artist M. V. Dobuzhinsky and the poster artist D. Moor portrayed death as an evil perpetrated by enemies of the revolution: the Imperial government in 1905 and the White Armies during the Russian Civil War. Their satire helped dehumanize any declared enemy of the artist, subjecting him to ridicule and contempt, thereby making him vulnerable. The director Meyerhold, influenced by the Munich director George Fuchs, suggested to his audience the unreality of death in his staging of Alexander Blok's play *Balaganchik* (The Fairground Booth), even as he feared personal death in the streets of Moscow in 1905. Lunacharsky, inspired by Mach, proclaimed socialism a religion of humanity, and found immortality through the memory of the proletarian collective. The film director Eisenstein laughed at death in the manner of Mexico's Death Day celebrations, and glorified it as revolutionary sacrifice through the sailor Vakulinchuk on the quay at Odessa in *Potemkin*. Concern with death and immortality became an important theme in the works of all these artists, helping to shape their artistic innovation and providing a metaphor for the revolutionary events around them.

The Russian artists who turned their art to political use must also bear some responsibility for the destruction of art and life by the Russian Revolution in its later years. For their shared belief in artistic and revolutionary immortality helped provide the techniques and the philosophy that would support the right of the revolution to crush its enemies, including themselves. By declaring the revolution a kind of victory over death through secular perfection and collective glorification, and themselves immortal as artistic innovators, they helped make personal death acceptable in a world without religious faith. Personal death in the name of the revolution, they seemed to imply, would assure immortality for the individual. Consciously or not, the Russian avant-garde, insofar as they deified the revolution and its heroes, helped prepare the way for Stalinism through their abortive great artistic experiment. For they declared art a religion, and themselves supreme deities with total power in the artistic universe they inhabited, unlimited by the real or the external. God is dead, they argued, and therefore the artist is free to become God. They often anticipated a leader similar to Christ or to Nietzsche's artist-Superman; they fell victims to Stalin as free artists, if not as living beings.

The essence of art is the making public of a private vision. This implied individualism flies in the face of political dictatorship, but it may also facilitate it. For the assumption that a single person may

create and manipulate a universe in accordance with his or her own will justifies both the nonobjective canvas of abstract painting and the jail cell of totalitarian politics. Once the artist commits his art to the politics of revolution, he assumes too easily that his particular vision will become the universal one. It is equally possible that his vision will become the victim of a quite different vision with an equally dehumanized and abstract goal of its own. The art of the Russian avant-garde from 1905 to 1925 was in part a process of creative innovation often inspired by Western sources which provided new opportunities for artists not yet recognized. But it was also a process of political commitment which immortalized both art and revolution in a manner that would ultimately help destroy the ideals of both artist and revolutionary.

2

From Positivism to Collectivism: Lunacharsky and Proletarian Culture

Every act of ours, the moment it is realized, is dis-
joined from us and living an immortal life of its own;
and since we are nothing else in reality than the
series of our acts, we too are immortal, for to have
lived once is to live forever.
—Benedetto Croce, *The Conduct of Life*

There are no dead.
—Maurice Maeterlinck, *The Blue Bird*

Anatoly Vasilevich Lunacharsky anticipated a revolution that would bring about a victory over death. Not that he adhered to religious orthodoxy of any kind, or believed in immortality or resurrection in any literal sense. Publicly, he became and remained a confirmed atheist. But his positivist vision of a scientific utopia run by the proletariat contained within it a basic religious and even mystical urge which ran through all of his political and philosophical writings. Socialism for Lunacharsky was not a system of economic or political ideas alone, but a form of religion; his atheism was itself a kind of faith. He believed that immortality could come about through the heroic deeds and the collective memory of the revolutionary proletariat. The body of his political philosophy was a legacy from nineteenth- and early twentieth-century positivism: the "religion of humanity" of Auguste Comte, the socialist religion of Joseph Dietzgen, the "empiriocriticism" of the German philosopher Richard Avenarius and the Austrian physicist Ernst Mach, and the "empiriomonism" of Lunacharsky's brother-in-law, the far more original thinker A. A. Bogdanov. At its heart lay a modern sense of the power of myth, mind, and self contained in the writings of Walt Whitman, the Belgian playwrights Maurice Maeterlinck and Emile Verhaeren, and the French political philosopher Georges Sorel. Out of this mixture of European and American thought and literature,

around 1909–1910, Lunacharsky created his own theory of a future "proletarian culture" that would fuse the political vision of the Bolsheviks with the artistic vision of the avant-garde. Divided between innovation and revolution, art and politics, Lunacharsky sought to unite them.

As People's Commissar for Public Enlightenment in the 1920s, Lunacharsky was the most important figure linking Bolsheviks and artists in the early days of Soviet rule. In fact, he liked to describe himself as "an intellectual among Bolsheviks and a Bolshevik among intellectuals." Subsidies for the arts, education, and publishing all flowed liberally from Lunacharsky's commissariat (Narkompros), and many writers and artists turned their pens and brushes to the support of the new regime. Still, Lunacharsky's life was beset by contradictions. Although he criticized the Russian avant-garde for being the "fruit of the unhealthy atmosphere of the boulevards of bourgeois Paris and the cafés of bourgeois Munich," he had lived virtually all of his adult life before 1917 in Western Europe, and he knew the streets of Paris, Geneva, and Florence as well as those of Moscow and St. Petersburg.[1] Lunacharsky was, in addition, a Ukrainian among Russians and an author, journalist, and literary critic among revolutionaries. Lenin found him to be a man of "French brilliance," useful to the Bolsheviks but not quite one of them; Gorky considered him "lyrically minded but muddle-headed."[2] Finally, Lunacharsky was a Marxist atheist who could never dispose of religious seeking.

Lunacharsky came of age at a time when the revisionism of Eduard Bernstein had thrown Marxism as a philosophical doctrine into theoretical disarray. After the failure of the Dutch general strike of 1903 and the Russian Revolution of 1905, a left wing of European socialism began to emphasize the myth-making, ideological, and even religious dimensions of Marxism as a belief-system capable of inspiring mass action, even if the doctrine had proven unreliable as a description of historical reality or inevitable revolution. The leaders of this left-wing dissension were mainly Dutch—the poets Hermann Gorter and Henriette Roland-Holst and the astronomer Anton Pannekoek, who had been expelled from the Dutch socialist party in 1909 and had subsequently united around the journal *Tribune*. But the dissension was European in scope, and it was partly inspired by the rediscovery of the nineteenth-century philosopher and friend of Marx, Joseph Dietzgen.

"Dietzgenism"—the view that socialism was not unlike a religion and constituted, like any other epistemology, only a relatively true description of reality—became very popular as a doctrine of direct mass action in Europe after 1905 and again during the postwar revolutionary turmoil of 1919–1920. Lenin vilified the doctrine, both in his *Materialism and Empiriocriticism* of 1909, where he condemned the "god-builders" among the Bolshevik left, and in his *"Left-Wing Communism"*: *An In-*

fantile Disorder of 1920, where he attacked the European (and especially Dutch) left for their extra-parliamentary enthusiasms for mass action and independence from Moscow. But when Lunacharsky discovered such views after the defeat of the 1905 Revolution, they had considerable appeal as a remedy for past mistakes and an exhortation for future revolution. Dietzgen's views also gave Marxism a new religious dimension. As one socialist wrote in 1907, "Dietzgenism, in solving the problems of the present life where religion is a self-confessed failure, merits greater confidence than religion in questions of the future life, of which religion makes a specialty."[3] Dietzgen's views, rediscovered around 1906 by European socialists, appear to have been a central factor in Lunacharsky's own thinking when he articulated his theory of a proletarian culture. In order to understand Lunacharsky's revolutionary vision of a proletarian culture, then, we must examine the intellectual world of Europe on the eve of the First World War.

<div align="center">I</div>

There is general agreement that an intellectual revolution occurred in Europe between about 1890 and 1914.[4] There is less agreement as to the nature of that revolution. Certainly there was a rebellion against the great philosophical systems of the nineteenth century. In physics, the ether theory collapsed in the face of the results of the Michelson-Morley experiment of 1887, which detected no apparent drift of any ether with respect to the earth. Attempts to explain the negative results of that experiment led to confusion, ended only in 1905 when Albert Einstein overthrew the Newtonian synthesis of classical mechanics with the theory of special relativity. In philosophy, at Cambridge, England, the systematic metaphysics of Hegel fell victim to the reduction of ethics to language by G. E. Moore and the reduction of mathematics to logic by Bertrand Russell. On the continent the phenomenology of Edmund Husserl claimed to provide a means whereby all experience could be reduced to its "essences" by "bracketing" everything inessential, including the unverifiable assumptions of metaphysics. Liberalism no longer sufficed as a systematic doctrine of progress centered on the protection of the individual from the powers of the state, attacked on the left by socialism and anarchism and on the right by racism and anti-Semitism. This aspect of the intellectual revolution was largely negative, a demolition of old systems and a reduction of knowledge to its supposed hard essentials, such as the postulates of special relativity and *Principia Mathematica*, and a refusal to accept a priori assumptions about the universe.

By the turn of the century science in general no longer claimed to possess a true knowledge of an absolute universe. Instead, there was a

new emphasis on the power of the human mind to reorder the universe once the ground was cleared of metaphysical debris. Einstein himself in his great *Gedanken-experiment* did not derive special relativity theory from the negative empirical results of any experiment; rather, he simply postulated the constancy of the speed of light and the principle of relativity, which together provided more consistent explanations of both past and future experimental results. The French mathematician Henri Poincaré described scientific laws simply as useful conventions in his *Science and Hypothesis* (1902); the Austrian physicist Ernst Mach dismissed the "conceptual monstrosity of absolute space" in any Newtonian sense. This questioning of old axioms and postulating of new ones was not entirely novel. In the nineteenth century, mathematicians such as Lobachevsky, Bolyai, and Riemann had created entire geometries by ignoring or negating one or more of Euclid's postulates. But now physics was describing in mathematical terms a universe which appeared nonsensical to most laymen. Einstein's mathematics teacher, Hermann Minkowski, for example, gave a lecture in Cologne in September 1908 entitled "Space and Time," where he reduced the concept of time to a mathematical variable, the fourth dimension in four-dimensional space. In an Alice-in-Wonderland sense, words such as "space" and "time" had come to mean precisely what their user said they meant. Like the velocity of a particle approaching the speed of light, their meaning varied with the position of the observer.

The crisis in science and philosophy was matched by a crisis of faith. Darwin's biology and Nietzsche's philosophy picked up where the earlier biblical criticism of the Left Hegelians had left off, attacking the claims of Christianity to truths relevant to the modern world. Many found religion no more satisfying than science in offering a meaningful explanation of the world. Other doctrines such as Christian Science and theosophy became enormously popular as replacements for the church. If mind took on new meaning to scientists and philosophers, then the irrational became equally important to the bewildered. The most popular philosopher in prewar France, Henri Bergson, had himself undergone a rather typical conversion from the scientific positivism of Herbert Spencer to a discovery that time was lived duration, a stream of experience, rather than a mere dimension described in geometric and spatial metaphors. Truth was not revealed by intellect, but by intuition; the driving force behind all human endeavor was not mind but the more visceral *élan vital*. In his poetic summation of his views, *Creative Evolution* (1907), Bergson reached an almost feverish optimism regarding the power of man:

> The whole of humanity, in space and time, is one immense army galloping beside and before and behind each of us in an overwhelm-

ing charge able to beat down every resistance and clear the most formidable obstacles, perhaps even death.[5]

Although he did not employ the term "unconscious" used by Eduard Hartmann and Sigmund Freud, Bergson was equally concerned with the deeper and more irrational level of the human psyche. But unlike Freud the scientist, he transformed it into a weapon against the mind of man.

Bergson revitalized belief and made it intellectually legitimate. In the social sciences too there was a new perception of the importance of mind, religion, and myth in motivating people; truth was what people believed in and acted upon. Max Weber and Emile Durkheim as sociologists discovered that religious beliefs could be more significant than rational economic interests in determining the growth of capitalism or the prevention of suicide. Marxism too underwent a process of "revision" in the 1890s, not only in terms of an accommodation with capitalist society through reform rather than revolution, but also in its philosophical structure. Men like Weber and Benedetto Croce no longer considered Marxism a scientific formulation of laws regarding economic and political society, but a useful hypothesis to be tested against the data of social science. For Georges Sorel in his *Reflections on Violence* (1906), Marxism and the myth of the "general strike" were simply surrogate religious doctrines appealing intuitively to the unconscious of the proletariat. If they believed, they might well act in such a manner as to confirm that belief by making the myth a reality.

Art, too, reflected the crises of science and of faith. In painting and music after 1905 form and color no longer imitated reality, and notes no longer obeyed the rules of harmony. Rather, they became the essential elements to be manipulated and reassembled in an "abstract" or "atonal" manner by the mind of the painter or composer. The visual world dematerialized on canvas as surely as ether and matter in the face of the Bohr atom and the x-ray. The purpose of art was no longer to represent any supposed absolute reality, but to communicate the vision of the artist to the viewer or listener through a new language. The essence of art was expression, not imitation. For the artist, too, truth was relative to his own position and view of the world.

The intellectual revolution, then, was perhaps less of a shift from positivism to idealism, from science to religion, than a creative tension between them. Philosophies such as Bergson's vitalism and William James's pragmatism, with their "will to believe," expressed a continuing struggle between religious questions and scientific answers. Few could still believe in the absolute truth of either science or religion. But it was equally difficult to do without them. The beliefs might not be true, but the will to believe was unmistakable. And that will to believe could

certainly be studied and even manipulated by others. In pre-1914 Europe both positivism and symbolism reflected this will to believe.

Positivism as a nineteenth-century philosophical system had flourished as a religion of science since its creation by Auguste Comte in the 1830s. Like other systems, it was greatly changed by the intellectual revolution at the turn of the century. Comte's positivism, or positive philosophy, argued that things exist only in our experience and that there are no universals behind them. The world is simply a collection of observable facts ordered by science, and science provides our only means of knowing reality. All value judgments—such as the naming of things "good" or "evil"—are beyond our experience, and therefore not scientifically knowable. On these assumptions Comte fused the experimental method of Francis Bacon, the search for simplicity and economy of William of Ockham, and the skepticism of David Hume into a single philosophy which proclaimed science the only basis for a good society. Men, individually and in society, had outgrown their earlier adherence to theology and metaphysics; now they would turn to science, the "religion of humanity."[6]

At the turn of the century positivism existed primarily as the philosophy of "empiriocriticism." Empiriocriticism defined the world as pure experience but went even further than positivism by eliminating the self from any role in the perception of that experience. One of the leading exponents of empiriocriticism was Richard Avenarius (1843–1896), who taught at the University of Zurich in the 1880s and 1890s. In his *Critique of Pure Experience* (1888–1890), Avenarius taught that all knowledge is a product of the central nervous system; it is a biological fact. There is no dualism between mind and matter; experience is all-encompassing, and no distinction may be made between self and environment, subject and object. From "Ockham's razor"—the admonition that "entities are not to be multiplied unnecessarily"—Avenarius proceeded to define a "principle of economy" whereby the mind tends to economize and simplify in order to remember and transmit experience; science is therefore a kind of mental shorthand for describing experience. Like Husserl's phenomenology, empiriocriticism sought to eliminate or "bracket" the subject or self in order to arrive at knowledge of a more essential and primitive world of concrete experiential data. For Avenarius, therefore, truth was not a set of laws revealed by science but merely a form of biological cognition of pure experience.

The second major exponent of empiriocriticism at the turn of the century was the Austrian physicist and philosopher Ernst Mach (1838–1916). Initially, in the 1860s, Mach came under the influence of Gustav Theodor Fechner and his book *The Elements of Psychophysics* (1860). Fechner's new science purported to measure precisely the relations between physical and mental phenomena, for example, $S = K \log R$, or

"the magnitude of a sensation is proportional to the logarithm of its stimulus."[7] Later, Mach rejected Fechner in favor of a doctrine that the world consists only of our sensations and criticized the Newtonian space-time universe in terms not unlike those used by George Berkeley. Like Avenarius, Mach also adopted the notion of "economy," that science consists of the simplest possible descriptions of our experience. But we know that experience only through our sensations, bundles of which constitute what we call our "self." For Mach there was in fact no "I" or soul; yet in the pantheistic world of experience, one's ideas, at least, can live on in the consciousness of others, providing a certain kind of immortality. Mach himself remained an atheist and after 1905 flirted with socialism, which undoubtedly made him attractive to some Bolshevik intellectuals. But he retained a sense of immortality in the persistence of experience of which we are all a part.

The most succinct statement of Mach's views was probably his *Contributions to the Analysis of Sensations* (1886). In this work he argued that the self is simply a "complex of memories, moods, and feelings, joined to a particular body," and is no more permanent than that body. In fact, he declared, "the world consists only of our sensations." We must give up the notion of immortality in any religious sense; yet what we call our self "remains preserved in others even after the death of the individual" through their memory of us. In life we are constantly changing. Therefore "that which we so much dread in death, the annihilation of our permanency, actually occurs in life in abundant measure."[8] Though opposed to organized religion, Mach was often concerned with religious questions. He had rejected Fechner's pantheistic universe of interconnected forms where plants and planets had souls in a common universal consciousness reminiscent of the Swedish engineer-mystic Emanuel Swedenborg. But he had been influenced by Fechner's belief that "death is only a second birth into a freer existence," and that the dead live on in our memory.[9] Mach's scientific positivism was tinged with both the relativism of modern science and a strong undercurrent of religious seeking.

The same fusion of science and religion existed among Mach's many followers at the turn of the century. He was most popular on the continent, especially in Zurich because of the teachings of Avenarius. But his views were also popularized in England by the mathematician Karl Pearson (1857–1936) in his *Grammar of Science* (1892). Pearson agreed with Mach that "space and time are not realities of the phenomenal world, but the modes under which we perceive things apart."[10] But Pearson the scientist was also fascinated by the question of death, which he pursued using probability theory to show that it was not a random occurrence but struck with varying frequency during different phases of a person's life. In America, too, Mach's views were popular at the

turn of the century through the work of William James and the support
of Paul Carus (1852–1919), editor of the journal *Monist*. In Russia his
influence dated from 1875 when a Russian student, G. V. Osnobchin,
had worked in Mach's Prague laboratory. By the 1890s Mach's writings
were widely used in Russian schools, and he had at least one regular
correspondent and translator in P. K. Engelmeyer, a Moscow factory
owner and automobile inventor. In 1906 Engelmeyer wrote Mach that
"the intellectual situation in Russia is very favorable for the acceptance
of your views," and in 1910 he helped found the Moscow Society for
Positivism.[11] Thus by the time Lenin launched his own attack against
Mach and his Russian followers in 1909, Mach had been well known in
Russia for more than a decade.

The positivism or empiriocriticism of Mach and Avenarius was
therefore quite different from the original vision of Comte. Science no
longer dealt in absolutes but in relative definitions and hypotheses;
"space" and "time" were shorthand economical conventions to describe
our experience. The crisis in physics helped give Mach a sense of truth
as contingent hypothesis, rather than absolute natural law. The crisis
of faith had given him a thrust toward secular immortality, a view that
the self lives on in the consciousness of others even as death ends the life
of the body. And it was through Mach that the European intellectual
revolution involving both science and the irrational reached Russia
and entered Russian Marxism. Here his effect was ambivalent. For
while Mach's views subverted any Marxist claims to the possession of
absolute truth, they also suggested the power of Marxism as a hypothet-
ical myth driving men to action. Lenin feared the first implication;
Lunacharsky welcomed the second.

Symbolism, like positivism, fused the religious and the scientific,
or at least the modern. Symbolist poetry and drama were intensely con-
cerned with the problem of death, and some of the symbolists also
welcomed the city and revolution as signs of modernity. Unlike posi-
tivism, symbolism perceived the world on two distinct levels: the surface,
material level apparent to most people and the deeper, more spiritual
level, accessible to the few and represented through the symbolic. In
symbolism the sense of the religious, the occult, and the spiritual was far
more powerful than in positivism, a dominant rather than a subdominant
theme. Both movements were highly influential in Russia before 1914,
sometimes with the very same individuals.

The most popular prewar symbolist dramatist, the Belgian Maurice
Maeterlinck (1862–1949), was fascinated throughout his life with the
problem of death. In his plays death assumes a role akin to fate in
general, a sensed presence which dominates man's life, as in his *Pelléas
et Mélisande* (1892). In Maeterlinck's later plays, however, love begins
to triumph over death and despair, and the tone becomes more opti-

mistic. In *The Death of Tintagiles* (1894), Tintagiles's sister Ygraine actually defies death, and the other characters become active personages rather than passive toys of fate. In 1905 Maeterlinck reached the peak of his new optimism with *The Blue Bird,* a tale not unlike James Barrie's *Peter Pan,* where children are engaged in a dreamlike search for the bluebird of happiness. In *The Blue Bird* death is still the great riddle of the universe. But man has infinite power over nature: "Man is God!" the dog reminds the children Mytyl and Tytyl. Communication with the dead is possible. "How can they be dead," the fairy asks the children regarding their grandparents, "when they live in your memory? The dead who are remembered live as happily as though they were not dead." "We are always here," the dead grandmother reminds the children, "waiting for a visit from those who are alive. . . . They come so seldom." Lunacharsky later argued that the Moscow Art Theater had misinterpreted *The Blue Bird* by ignoring Maeterlinck's optimistic attitude toward death and fate. The expectation in the play is that the King of the Three Planets will soon arrive to bring happiness to Earth, Mars, and the Moon for thirty-five years. "Where are the dead?" asks Mytyl at the end of the play, and Tytyl answers: "There are no dead."[12]

Maeterlinck was drawn to both spiritualism and socialism before 1914. In Paris he read the works of Eduard Schuré, the occultist, and investigated sorcery, theosophy, and animal intelligence. In 1913 he wrote a book on death entitled *La Mort.* But he also considered himself a socialist, and his ultimate world of God in man was a kind of socialist utopia. In Russia his works were enormously popular. *The Blue Bird* premiered in Moscow in September 1908 and was translated into Russian; so were *The Death of Tintagiles, Monna Vanna,* and *Sister Beatrice,* all of which were performed on the Soviet stage in the 1920s. Maeterlinck was, in short, a modern mystic whose symbolism alluded to the world beyond, and who offered a sense of hope for both the religious and the secular worlds.

Another Belgian, the lyric poet Emile Verhaeren, was equally popular in Europe before 1914. Like Maeterlinck, he shared the symbolist sense of two levels of reality, but he also articulated a less typical enthusiasm for urban society, the machine, and an imminent revolution. His most influential work was probably his play *Les Aubes* (The Dawn, 1898). In this drama he intertwined Christian and revolutionary metaphors to provide an ecstatic anticipation of the future. "Of what use is ancient wisdom, prudent, systematic, buried in books?" asks the revolutionary, Hérénien; "It forms part of the humanity of yesterday; mine dates from today." The revolution itself occurs on Easter, but Hérénien is killed. "Is it true Hérénien is dead?" asks a beggar. "He!" replies a gypsy, "He is master and king now. People don't die when they are so great as that." For Hérénien has achieved his own kind of revolutionary

immortality. Because the revolution has succeeded, "the country will be reborn." In addition, he has achieved deathless fame. "Jacques Hérénien lives still," declares another character, LeBreux, "in his words, in his acts, in his thoughts, in his books; he is the force which now exalts us; he wills, thinks, hopes, acts in us. This is not his burial, it is his last victory."[13]

Symbolism began as a movement in French poetry during the 1870s and 1880s. At times it moved toward solipsism, mysticism, the cult of the Rosy Cross, and other mysteries which webbed the individual within the confines of fate. On the surface, therefore, it appears to be an unlikely doctrine for an activist to embrace. But in its later phase, on the eve of 1914, symbolism acquired a more revolutionary dimension, epitomized by the optimism of Maeterlinck and the revolutionary urbanism of Verhaeren. Symbolism could mean action in this life, as well as brooding over the infinite mystery of the next one. The elite of seers might some day not simply transcend bourgeois society but also transform it.

Both positivism and symbolism were greatly altered by the intellectual revolution in Europe after 1890. To a Marxist like Lunacharsky, they provided a certain intellectual sophistication and modernist appeal lacking in the writings of Marx and Engels. Mach, Maeterlinck, and Verhaeren all flirted with socialism after 1905, which made their philosophies that much more acceptable in Marxist circles. Together, they provided a new emphasis on the role of belief in motivating individuals to act. Each was crucial to Lunacharsky in building a religion of revolution which would transcend the death of the self by immortalizing the collective.

II

Visions of a new revolutionary culture distinct from that of bourgeois society had been common in Europe since the revolutions of 1848. Comte himself wrote that "when a stable and homogeneous, and at the same time progressive state of society shall have been established under the positive philosophy, the fine arts will flourish more than they ever did under polytheism, finding new scope and prerogatives under the new intellectual regime."[14] The idea that the artist belonged to his own revolutionary elite, the avant-garde, which was artistically ahead of and politically antagonistic to bourgeois society, was a commonplace in Paris by the 1830s. But the world of art, sex, morphine, and absinthe characterized on the Parisian stage as "bohemia" represented an escape from bourgeois society that was hardly suited to a socialist revolution.

Richard Wagner provided a more appropriate vision of cultural revolution in 1848. Wagner envisioned the artist not only transcending

society but transforming it. The art of the future would be a mass art, a popular culture reflecting social values and letting each citizen see himself or herself in the cathartic mirror of art, as in ancient Greek tragedy. Centering on music, it would also be a synthesis of all the arts. In his essay "Art and Revolution," written in 1849 and translated into Russian in 1906, Wagner criticized art whose aim was "the gaining of gold" at the box office; rather, he idealized the "free Greek" who could "procreate art from the very joy of manhood." Like Marx, Wagner praised the worker with his "mechanic's pride in the moral consciousness of his labor" and abhorred the "criminal passivity or immoral activity of the rich." The future culture that Wagner described in 1849 would be created by workers for workers; later Wagner's own festivals at Bayreuth would idealize ancient Germans, catering to the well-to-do. But in the wake of the upheavals of 1848 his vision of cultural revolution was apocalyptic:

> In godlike ecstasy they leap from the ground; the poor, the hungering, the bowed by misery, are they no longer; proudly they raise themselves erect, inspiration shines from their ennobled faces, a radiant light streams from their eyes, and with the heaven-shaking cry, *I am a Man!* the millions, the embodied Revolution, the God become Man, rush down to the valleys and plains, and proclaim to all the world the new gospel of happiness.[15]

By the end of the century Wagner's vision had been neither realized, nor entirely forgotten. The dominant cultural vision was the "imminent rebirth of Greek antiquity" predicted by Nietzsche in *The Birth of Tragedy* (1872) and the elitism of the superman-poet as acted out by the dandy and the aesthete and danced by Isadora Duncan. But the vision of a mass workers' culture persisted.

The term "proletarian culture" probably made its first appearance in 1909, when used by Bogdanov. But the idea had existed long before. In the 1870s the self-taught Rhenish tanner Joseph Dietzgen (1828–1898) had proposed a "religion of social democracy" and earned from Marx the label "our philosopher." Dietzgen predicted a "coming great revolution" of industrial socialism in the tradition of Greek civilization, Christianity, the Reformation, and the French Revolution:

> The new faith, the faith of the proletariat, revolutionizes everything, and transforms after the manner of science, the old faiths. In opposition to the olden times, we say, Sun, stand thou still, and Earth, move and transform! In the old religion man served the gospel, in the new religion the gospel is to serve man.

Dietzgen's cultural vision was heavy with religious overtones. Marxism itself would someday become a kind of popular religion. "Conscious,

systematic organization of social labor," he wrote, "is the redeemer of
modern times."[16] But Dietzgen's ideas remained little known until Ernst
Mach and others rediscovered them after 1905. While Dietzgen's sense
of Marxism as cultural myth now took on new meaning, it provided no
precise guidelines as to what a workers' culture would be.

Only after the turn of the century did the idea of a proletarian cul-
ture begin to catch on among European socialists. Karl Kautsky and
Emile Vandervelde both began to speak about the need for a new art
and culture in a new socialist society. Klara Zetkin, speaking on "Art and
the Proletariat" at a conference in Stuttgart in 1910, observed that "the
working class wants not only to enjoy art but to create it."[17] Socialist
schools for workers were established at Ruskin College at Oxford in
1899 and at the Rand School of Social Science in New York in 1906.
But Marxism as a doctrine had always placed art and culture in the
derivative "superstructure" of society, not in its economic "substructure."
While theoreticians such as George Plekhanov considered the arts a
class-bound product of bourgeois society, they provided no specific
guidelines as to what should constitute an art by and of the proletariat.

Some European artists were also interested in a workers' art. In
England, William Morris propounded a guild socialism which would
return the arts to their medieval status as handicrafts; for Morris, the
crucial arts were not decorative but functional: furniture design, book
printing, and tapestry, for example. The act of creation would become
an act of production, the artist a worker, and the worker an artist. On
the continent, *Art Nouveau* or *Jugendstil* produced a flourishing arts-
and-crafts movement, exemplified by the colony at Darmstadt where
artists worked on interior design, furniture, and other applied arts, which
were to be both ornamental and inexpensive. In 1907 a group of
artists organized the *Werkbund* in Germany, a forerunner of the
Bauhaus, which produced silverware, streetlamps, factories, sewing
machines, and book jackets; two members of the *Werkbund*, Peter
Behrens and Walter Gropius, also began to design factories, notably
the AEG Turbine Plant in Berlin (1908) and the Fagus Shoe Factory
in Alfeld (1911–1913).[18] The artists of this movement thought their
work should be functional rather than decorative, providing objects for
living and working.

In the years before World War I there was also a fascination with
the motion and rhythm of work, a theme that later found its way into
early Soviet culture. In part, this interest was manifest in the revival
of sports and dancing through the Olympic Games, in the free-flowing
movements of Isadora Duncan, and in the eurhythmics movement of
Emile Jaques-Dalcroze. But in the factory, too, workers' movements
were studied by the American efficiency expert Frederick Winslow
Taylor, whose time-and-motion analyses included the use of stop-

watches and film. In 1912 another American, F. B. Gilbreth, took movies of bricklayers with lightbulbs fastened to their arms and legs in order to record the geometry of their motions. Lenin and A. K. Gastev, one of Lunacharsky's proletarian-culture students in Paris, would become enamored of such methods in Soviet Russia in the 1920s, for labor itself was an integral part of a workers' culture.

These developments reflected a growing concern with the role of culture and art in a mass industrial society. But what exactly constituted a workers culture? Several definitions were offered. First, workers' culture might be the workers' immediate environment: the system of movement, organization, decoration, and sound enclosed in the walls of a factory. Second, it might be the entertainment provided to workers after working hours—a culture *for* workers but created very possibly by artists who were not workers themselves and embodying those elements in Western culture which would appeal to them. Third, it might be a culture actually created by workers through their poetry, songs, or paintings, a culture *by* the proletariat, rather than simply *for* the proletariat. None of these definitions were mutually exclusive; often they were all lumped together in the term "proletarian art" or "proletarian culture."

In Russia an interest in mass culture existed long before the 1917 Revolution. The Populists of the 1870s collected workers' poems and folksongs and taught in workers' Sunday schools. The writer Maxim Gorky sponsored a popular publishing program, Znanie, before World War I. Workers' clubs were founded, offering lectures, music lessons, plays, and choral groups. But these activities were overshadowed by the cultural brilliance of the Silver Age, an elitist and westernized movement that featured the music of Rachmaninoff and Scriabin, the singing of Chaliapin, and the ballets of Diaghilev. It is not surprising, therefore, that Lunacharsky drew his vision of proletarian culture from Western intellectual sources and not from the Russian proletariat.

III

Lunacharsky belonged to the generation of 1905, the aesthetes.[19] But unlike most artists of that generation, he was permanently converted to Marxism in the 1890s, as a student. If he moved from positivism to idealism, it was within the intellectual context of a doctrine he never relinquished. The center of the aesthetes was St. Petersburg, but Lunacharsky was born in the provincial town of Poltava in the Ukraine in 1875. Many factors impelled him toward a revolutionary career. His family was broken from his birth; his mother left his father and married A. I. Antonov, a state auditor who worked in Nizhnyi Novgorod and later Kursk. Although a government employee, Antonov held radical

views and often criticized the Imperial regime and the church, en-
couraging Lunacharsky in his atheism from an early age. His mother,
Aleksandra Yakovlevna, was a cultured and educated woman who, ac-
cording to Lunacharsky, found to her horror that her child had become
a "little Antichrist" in his religious outlook. When Lunacharsky was
nine years old, his stepfather died and his mother moved to Kiev. In
adolescence, therefore, Lunacharsky lacked both a religion and a
father. He found a home, instead, in the revolutionary movement.

Kiev had been a traditional point of entry for Western ideas, and in
the 1890s the dominant Western novelty was Marxism. In Kiev
Lunacharsky spent his adolescence in the harsh and arbitrary environ-
ment of the First Gymnasium, where he studied foreign languages,
literature, and music, while immersing himself outside of school in
Marxism. He later claimed that by the time he was fifteen he had read
Das Kapital, joined a socialist group from the university, and organized
his own circle of some two hundred gymnasium students. He also de-
bated Marxism with some exiled Polish students, held secret meetings
at night across the Dnieper River, and lived under the watchful eye
of the police. By age eighteen, Lunacharsky's revolutionary activity had
deepened to include propaganda work among railway workers and
artisans in the suburb of Solomenka and his first published articles on
Marxism for a local hectographed student journal.

In the mid-1890s Lunacharsky experienced his first direct contact
with Europe. In 1895, at the age of twenty, he left for Switzerland to
study at a university. His record at the gymnasium had not been im-
pressive; Lunacharsky later claimed that his poor grades in conduct,
inflicted because of his political activity, had kept him from entering a
Russian university. But there was a positive attraction to studying in
Europe as well. The center of Russian Marxism was then George
Plekhanov's Group for the Emancipation of Labor, and Plekhanov and
Paul Akselrod were generally considered to be Russia's leading Marxist
theoreticians. In addition, another Kiev student just back from Switzer-
land had told Lunacharsky about the modish philosophy of the day,
the empiriocriticism of Avenarius, then lecturing at the University of
Zurich. Both Marxism and positivist philosophy helped pull Lunacharsky
abroad. Promising his mother that he would return regularly, Luna-
charsky left for the West bearing a letter of recommendation to Akselrod.

Lunacharsky found his brief stay in Zurich (he was there only a
few months) enormously stimulating. Just being away from home made
him feel "completely independent."[20] At the university in Zurich he
found a rich library, interesting classes, and a welcome colony of other
young Russian radical students. From Paul Akselrod—"my real spiritual
father"—he received further lessons in the finer points of Marxist doc-
trine. When Plekhanov visited Akselrod for a few days, the brash

Lunacharsky took him on in a debate over the relative merits of Hegel and Avenarius; the next day he returned his volumes of Schopenhauer to the library and emerged with an armload of Feuerbach, Helvetius, Diderot, and Marx. In addition to the Marxist tradition, Lunacharsky had his first direct contact with one of the major figures of European positivism and empiriocriticism, Richard Avenarius. From his lectures and writings Lunacharsky quickly acquired a view of the world as pure experience, where the self existed only as a part of a larger unity of mind and matter, psychology was a branch of physiology, and only science provided an accurate description of reality. Plekhanov's views on art as a product of social class were important to Lunacharsky, but the legacy of positivism was to be deeper and more profound.

A series of personal tragedies soon forced Lunacharsky to leave Zurich. In 1895 his older brother, Platon Vasil'evich, had fallen seriously ill in Nice and was believed near death. For nearly a year Lunacharsky remained by his side at Nice and Rheims during his slow convalescence. At the end of 1896 he was able to resume a more normal existence, moving on to Paris. Here he attended the lectures of the eminent Russian legal historian M. M. Kovalevsky, lectured on Marxism to Russian student groups, read voraciously, and visited museums. By 1897 his brother had sufficiently recovered (although still partially paralyzed and walking with the aid of a cane) that Lunacharsky was able to move him back to Russia. Lunacharsky discovered that, despite his political interests, it was safe for him to remain there, because his near-sightedness made him draft exempt. But the whole affair was extremely trying and foreshadowed more personal tragedy to come—the deaths of Lunacharsky's own children.

At twenty-two Lunacharsky had returned from Europe with a wide reading knowledge of philosophy, art, and religion, and a continued commitment to Marxism as a revolutionary ideology. He now entered the risky world of clandestine revolutionary work in Moscow, joining the circle of A. I. Elizarova, Lenin's sister. The Russian Social Democratic Workers' Party had not yet been formed (its first congress was held in Minsk in 1898), and the very existence of Bolshevism lay five years in the future. But Lunacharsky was soon in contact with the future Bolshevik fraction in Moscow. After a year or two of revolutionary activity, the Moscow circle was exposed by one of its members, a police agent named A. E. Serebriakova, in April 1899. Lunacharsky was arrested for the first time and released to the care of his family by a lenient gendarme, initially to the home of his natural father near Poltava, then to join his mother again in Kiev.

But arrest and exile only intensified Lunacharsky's Marxist activities. In Kiev he contacted his old socialist friends and rejoined their circles. Although his main activity now was writing articles for legal Marxist

journals in Kiev, he was under constant police surveillance. Arrested for a second time, he spent most of the summer and early autumn of 1899 in a Kievan jail. Released in October, he received his first sentence to exile at the town of Kaluga on the Oka River. Exile, like study in Zurich, put him in contact with new revolutionary friends, among them a medical student and the future controversial philosopher of Bolshevism, A. A. Bogdanov, and an erudite economist, I. I. Skvortsev (Stepanov). The group was soon spreading Marxist propaganda among the Kaluga railway workers and school teachers, lecturing to employees of the self-styled Owenite factory owner, D. D. Goncharov, and making illegal trips to Moscow. But leniency had its limits, and the local governor-general soon disbanded the group, sending Lunacharsky to Viatka and Bogdanov to Vologda.

Exile also revived Lunacharsky's considerable interest in literature and philosophy. After spending most of 1901 at Viatka reading and translating the works of the German poet Richard Dehmel, Lunacharsky received a letter from Bogdanov suggesting that the group of exiles at Vologda was intellectually more stimulating. Lunacharsky requested and, remarkably, was granted a transfer there. In February 1902 he arrived at Vologda, a rail center north of Moscow and east of St. Petersburg. Here he found that the dominant figure was another Marxist from Kiev, Nikolai Berdyaev; Berdyaev was then undergoing his own conversion "from Marxism to idealism" and Lunacharsky soon entered into sharp conflict with him. Berdyaev's new philosophical idealism stressed the dualist separation of spirit and matter, religion and science, and sought a renewal of both ethical philosophy and Christianity. Such a philosophy was anathema to a positivist and a Marxist. In criticizing Berdyaev, Lunacharsky employed not only what he understood to be the positivist empiriocriticism of Mach and Avenarius, which he had absorbed in Switzerland, but also some ideas he had acquired from Bogdanov. An explication of these ideas is essential for an understanding of Lunacharsky's later career.[21]

IV

Berdyaev's philosophy of 1902 and his gradual conversion from Marxism to idealism were part of a general movement within the Russian intelligentsia that was called "god-seeking," or *bogoiskatel'stvo*, by critical outsiders. Under the repressive regime of Alexander III and his Procurator of the Holy Synod, Konstantin Pobedonostsev, many intellectuals considered religion in any orthodox sense as simply an arm of the hated Imperial government. At the same time, in the 1880s and 1890s, some Russan writers who rejected the earlier realism and materialism of the "men of the sixties" sought to reinterpret religion, philosophy,

and ethics and make them philosophically respectable once again. The prophets of this movement were Dostoevsky, whose Grand Inquisitor had turned Christianity into mockery and deception; Tolstoi, who separated the teachings of Christ and the spiritual light within all men from the practice of the Orthodox Church, which excommunicated him; and the philosopher Vladimir Soloviev, who predicted an imminent Third Kingdom of Christian redemption, which would come to earth only after the rule of Antichrist. At the turn of the century the leading exponents of the new religious sensibility were Berdyaev, another Kiev Marxist-turned-philosopher, Sergei Bulgakov, and the literary critic Dmitry Merezhkovsky. Tolstoi's acid criticism of organized Christianity as an arm of the state had recently appeared in his novel *Resurrection* (1899); a year later the philosopher Vladimir Soloviev died, leaving a number of disciples among the young symbolist poets. Religious seeking was in the air.

Bogdanov and Lunacharsky, by contrast, were atheists and Marxists who saw the turn to religion as a threat to the new Marxist labor movement emerging in Russia. Bogdanov was by far the more original thinker. Bogdanov, trained in medicine and psychology, but practiced in neither, combined a confusing mixture of European positivism and science into a philosophy in which man (through his power to organize his world) became God, and society moved toward a utopian collectivist future.[22] Bogdanov's scheme of things owed more to Darwin than to Marx. For the key to Bogdanov's historical process was not class struggle, but the evolution of man to a higher type of individual, defined variously as communist, socialist, or collectivist. From empiriocriticism Bogdanov derived the view that all life is pure experience, empirically and scientifically knowable; he called his own philosophy "empiriomonist," "empiriocritical," or "tectological" as his fancy allowed. His sources were primarily European: the positivism of Mach and Avenarius; the language theories of Max Müller; the fashionable "monism" of the German biologist Ernst Haeckel; and the materialism of the Mainz gymnasium teacher Ludwig Noire. Bogdanov's resultant philosophy was to play an important role in generating conflict among the Bolsheviks and in leading Lunacharsky to envisage a proletarian culture.

According to Bogdanov, all human society was evolving toward "collectivism," or the "collecting of man" (*sobiranie cheloveka*). Work was not simply labor for economic gain or subsistence, as Marx had written, but a physical human activity like speech or thought, both of which Bogdanov defined "empiriocritically" as biological and physiological functions. Work was therefore subject to both physiological and psychological variation; a man's body and mind affected the nature of his labor. Bogdanov felt that one could scientifically bring about a collective and cooperative society only by "organizing" a collective environ-

ment and a higher type of collective individual. One would not have to wait for changes in the mode of production in order to do this, however; one could consciously organize the entire process. The human body was an organism whose reflexes and movements could be altered "bio-mechanically" for greater productive efficiency or harmony, as Taylor's time-and-motion studies were to show. More than this, Bogdanov hoped for the organization of a new elite; the present types of men—"dream-ers," "utopians," and "activists"—would give way to a higher type of creative, active "realists" whose collective consciousness would enable them to build a new world. Like Goethe's Faust, Bogdanov's collective man would sell his (nonexistent) soul for earthly power.

Although Bogdanov considered himself a Marxist, he was, more accurately, a social and psychological engineer. From his medical read-ings he knew of the work of Pavlov and his teacher, I. M. Sechenov, on the theory of "conditioned reflexes." According to Bogdanov, the driving forces in life were biological and psychological, not economic, and ideology was not merely a class-bound reflection of economic interests but an independent entity capable of molding human beings and their work. In his emphasis on the organizing power of ideas and beliefs, Bogdanov was in tune with the work of James, Weber, and Sorel. But he also shared the positivist belief in a single all-encompassing physical and psychological reality of "pure experience," rather than the dualist distinction between the conscious and the unconscious characteristic of psychoanalysis.

Bogdanov seems to have been a monomanic about his theories, a man with an *idée fixe*, a "rigorist" in his own terms, who, like Rakhmetov in Chernyshevsky's *What Is to Be Done?* organized his entire life around a single idea. A lapsed Populist, Bogdanov had injected into his Marxism the medical and scientific terminology he had absorbed in a wide variety of books and schools. According to Berdyaev, Bogdanov was "a very fine person, extremely sincere and absolutely devoted to his idea, but rather narrow-minded and constantly engaged in hair splitting and sophistry."[23] On the other hand, Berdyaev found Lunacharsky, "despite his many talents, a relatively superior culture, and literary interests" to be "something of a provincial schoolmaster with a dash of a journalist in him."[24] In Vologda Lunacharsky married Bogdanov's nineteen-year-old sister and also came under the powerful influence of Bogdanov's philosophy.

Bogdanov's optimistic model of a new type of man, a "Russian Faust," as he called him, was especially important to Lunacharsky in anticipating a socialist world run by a scientific elite. In the spring of 1902 Lunacharsky wrote an essay entitled "A Russian Faust," in which he attacked Bulgakov for praising Dostoevsky, whom Lunacharsky considered a "decadent." Dostoevsky was "the Russian moralist" whose

nationalism, religiosity, and anti-Semitism were hardly acceptable; Nietzsche, in contrast, was "the German moralist" whose vision of man's Dionysian liberation from herd morality was far more appealing. Goethe's Faust was the true model for revolutionaries, since he exchanged life and youth for knowledge, and (in Part Two) was able to "begin a new life."[25]

In another article written in 1902 Lunacharsky argued that the idealism and "god-seeking" of Berdyaev and Bulgakov were essentially negative. This kind of thinking denied the sole reality of this world and hoped for happiness in the world beyond. On the contrary, argued Lunacharsky, man's power to organize nature is unlimited. For a true positivist, man's scientific control of his environment is (following Bogdanov) "an organizing principle in life's struggle." In fact, one day man might even be able to conquer death. Mach too, after all, had admitted that without believing in God, one could still believe in immortality as the collective memory of an individual who "continues to exist in other persons even after [his] death." "The fear of death," Lunacharsky declared, "does not exist for an active positivist."[26]

Personal unhappiness and political exile in 1902–1903 deepened Lunacharsky's revolutionary commitment. His first son died in infancy at Vologda. Then Russia's first Marxist party split into warring Bolshevik and Menshevik factions at the second party congress in London. He now chose to follow his mentor Bogdanov and join the faction of Lenin, whose recently published *What Is to Be Done?* stressed the role of will, belief, and activism through the revolutionary party. In the autumn of 1904 Bogdanov asked Lunacharsky to travel to Europe, make contact with Lenin, and help edit a new Bolshevik journal. Released from exile that spring, Lunacharsky now joined Lenin's circle in Paris.

V

Lunacharsky's degree of commitment to Bolshevism at this time is not clear. We know that in October 1904 he arrived in Paris with his wife at Bogdanov's request to help create a new Bolshevik newspaper to counter *Iskra* (The Spark), the newspaper founded by Lenin but now controlled by Martov and the Mensheviks. He probably knew little about émigré politics and the nature of the party fissures that had surfaced in London. In his 1907 autobiography Lunacharsky himself admitted that as recently as 1904 "I was not yet convinced of the correctness of the Bolshevik line."[27] Yet the personality of Lenin soon overcame most of his doubts. In December 1904 Lunacharsky met him in Paris and promptly agreed to move to Geneva to work on the new party journal *Vpered* (Forward). Until the autumn of 1905 Lunacharsky lent his writing skills to the enterprise, and also toured the Russian émigré

colonies speaking out against the Mensheviks. Lunacharsky may have had his doubts about the Bolsheviks when he left Russia, but by the end of 1905 he had become a leading journalist of the Bolshevik fraction in exile.

But what was Bolshevism in 1905? Hardly a real political party at the time, it was rather a group of conspiratorial socialists divided between Russia and European exile, a "fraction" by no means subservient even to Lenin. Its leaders were men and women of Lunacharsky's generation, born in the 1870s and involved in the student strikes and labor movement of the 1890s. After the third congress of the RSDLP, held in London in late April and early May 1905, an "Organizational Bureau of Majority Committees" was set up inside Russia, headed by Bogdanov; the bureau hoped to channel the revolutionary violence of Bloody Sunday, January 9, 1905, when Imperial troops fired on innocent petitioners to the Tsar, an event which had caught the Bolsheviks unprepared. In addition, there was the editorial board of *Vpered* in Geneva, dominated by Lenin, and another group of Bolsheviks inside Russia around the engineer Leonid Krasin. The latter group, known as the *praktiki*, were technical specialists concerned with smuggling, gunrunning, bombs, and bank robberies, activities of the revolutionary lower depths. As the events of early 1905 deepened into widespread urban and rural violence, Bolshevism as an organized movement emerged from these three groups headed by Bogdanov, Lenin, and Krasin.

By the summer of 1905 Lunacharsky had become exhausted by his lectures throughout Europe and his editing work. For a time he moved to Florence to rest and recuperate. From there he continued to help with the editing of the new Paris Bolshevik journal *Proletarii*. He also began to study Italian art and literature in his leisure time. His convalescence was cut short by events in Russia, where a national general strike was called in October 1905. On Lenin's instructions, Lunacharsky left for St. Petersburg immediately. Here in the winter of 1905–1906 he helped organize and edit two legal Bolshevik journals established under the lenient censorship which followed the October Manifesto: Maxim Gorky's *Novaia zhizn'* (New Life) and its successor in 1906–1907, *Vestnik zhizni* (Messenger of Life). *Novaia zhizn'* did not survive for long; it was closed by the censor in December 1905. Lunacharsky himself was arrested and spent the next two months in jail. Nevertheless, the journal provided Lunacharsky with his first real opportunity to bridge the gap between Bolsheviks and intellectuals, the politically revolutionary and the artistically creative.

Gorky also attempted to bridge that gap. In 1905 the great writer was an enormously popular figure whose moral stature as a critic of the autocracy was probably second only to that of Tolstoi.[28] Arrested in

connection with Bloody Sunday, Gorky inspired a storm of international protest that soon forced his release from jail. Since the spring of 1903 Gorky had actively contributed money to the Bolsheviks, often through his friend Krasin, and in 1904 he read Lunacharsky's essays on positivism and the "Russian Faust." By 1905 he had become a kind of Bolshevik "fellow traveler," an established writer who lent the party both money and prestige, but who was politically independent. His money was crucial. In December 1904 he sent Bogdanov a check for 700 rubles to help finance *Vpered* in Geneva; at Lenin's request, he also planned a popular series of books for workers to be put out by the Znanie publishing house. In October 1905 Gorky met with Bogdanov and Krasin in Moscow to discuss the undertaking, but instead agreed to publish (with Gorky's money) the journal *Novaia zhizn'*. Initially the editor was the symbolist poet N. M. Minsky, and the stories and articles were creatively satirical rather than ideologically consistent with Bolshevism, or even Marxism. Only when Lenin arrived in St. Petersburg from Geneva in late November 1905 did the journal launched by intellectuals become a journal firmly controlled by Bolsheviks.[29]

Plans for cultural propaganda among workers and intellectuals never really materialized in 1905. Lenin distrusted the autonomy of Lunacharsky's friends among writers and artists, and Gorky's idea of a "cheap library" for workers bore fruit only later, on Capri. The Bolsheviks were essentially unprepared for the events of 1905 and were able to take advantage of Gorky's largesse only subsequently. When Gorky returned from his trip to America in November 1906 and settled on the island of Capri, he quickly reestablished his contacts with Lunacharsky and Bogdanov, who followed him there. The idea of a "proletarian culture" was created in exile after 1905 by a tiny circle of Bolsheviks and intellectuals around Lunacharsky, Bogdanov, and Gorky. For them it was a utopian and even religious vision of a revoluntary future culture. But for Lenin it constituted a severe threat to his moral, political, and financial hegemony over the scattered groups and individuals that made up Bolshevism. Gorky in particular had exhibited some disturbing ideas in his novel *Ispoved* (Confession), which Lenin refused to publish in *Proletarii*. In the novel Gorky portrayed socialism as a surrogate religion. The hero, Matvei, realizes that God is dead when men disagree among one another; when they are united, they can resurrect God from among themselves, as Christ was once resurrected. Was Bolshevism, too, a new religion?

VI

When Lunacharsky rejoined his wife in Florence in February 1907 he had good reason to be despondent. The Revolution of 1905 had pro-

duced only a "bourgeois-liberal" regime of limited legal political activity. Parliamentary democracy in the new Duma, political campaigns, parties, and trade unions all existed but were severely circumscribed by emergency powers granted the Tsar and his appointed Prime Minister, P. A. Stolypin. The revolutionary tide had ebbed. After participating in the Duma elections of 1906 Lunacharsky, faced with the threat of a five- or six-year jail sentence, had emigrated once more. The Bolsheviks were now virtually bankrupt. In Vologda Lunacharsky had written essays and criticism for a variety of journals. Now his articles were published only in Bolshevik journals, and Gorky had rejected one of his plays for publication. At the age of thirty-two Lunacharsky was torn between art and politics and successful at neither. He was married but had no surviving children. Like many other intellectuals who had endured the turmoil of 1905, Lunacharsky now turned to religion.

In the 1920s the Bolsheviks provided key subsidies for writers and artists. But in 1905 and afterwards it was often the intelligentsia who supported the Bolsheviks, then badly in need of money. Gorky had gone to America in the spring and summer of 1906 on a trip arranged by Krasin to raise funds for the Bolsheviks. But the trip netted only $10,000 and Americans were scandalized that Gorky was living with the actress Maria Andreeva, who was not his wife. The fifth congress of the RSDLP in London in the spring of 1907 further revealed the party's financial crisis. Many of the three hundred voting delegates had no money to travel in England. When Gorky arrived at the congress, held at Ramsay MacDonald's church in Islington, in mid May, he found a scene of indigence and antagonism. The party leadership, represented by Lenin, Trotsky, Stalin, Plekhanov, and Martov, and Rosa Luxemburg from the SPD, was deeply divided over questions of revolutionary strategy in the wake of 1905. Did financial need justify a policy of bank robbery, extortion, and terrorism? Some thought so. Only a loan of 1700 pounds from Joseph Fels, the Philadelphia soap manufacturer and follower of Henry George, made it possible for the congress to continue at all. In the midst of this depressing scene the more solvent Gorky invited Lenin to his home on Capri for a rest.[30]

In the winter of 1907–1908 Lunacharsky and his wife joined Gorky and Andreeva on Capri, where they became good friends. Gorky provided the Lunacharskys with badly needed funds for medical expenses, since Lunacharskaia was ill in connection with a recent pregnancy. The writer was impressed with Lunacharsky's wide range of knowledge, praised him as a "very talented" man with a "brilliant future," and compared him to the great Populist theoretician N. K. Mikhailovsky. Lunacharsky, for his part, found Gorky congenial and persuaded Lenin to let him edit the literary section of *Proletarii* for a while. Together they once again discussed plans for a popular series of books for workers on

Russian history and literature, a project toward which Gorky gave Lunacharsky an advance of two thousand lire in the autumn of 1908. In public disputes, too, Lunacharsky defended Gorky's novel *Mother* and his other writings as "serious works of a socialist type."[31] The relations between Lunacharsky and Gorky were clearly symbiotic.

Gorky and Lunacharsky were not the only intellectuals close to the Bolsheviks who were interested in religious and philosophical questions after 1905. In 1906 Bogdanov, writing in jail, completed the third volume of his *Empiriomonism*, in which he argued that truth was relative, that the matter-spirit dualism did not exist in a world of pure experience, and that knowledge, religion, and ideology were all simply forms for organizing that experience. Even death was no absolute, since "future generations" might some day "find some other means to resolve life beside that which we now see in the crude [*grubyi*] crisis of death." New translations of Dietzgen's writings in 1906–1907 also touched off a lively debate in Russian Marxist circles. Even the twenty-nine-year-old Joseph Stalin, in jail in Baku in 1908, found "good sides" in the ideas of Mach and Bogdanov and proposed that Marxist philosophy should be developed "in the spirit of J. Dietzgen, recognizing the good sides of 'Machism.'" To counter such trends, Lenin immersed himself in Dietzgen's writings in the spring and summer of 1908; in his *Materialism and Empiriocriticism* (1909), he argued that Dietzgen was not a monist but a "dialectical materialist," even if he was often "not free from confusion." Lenin thus faced a major threat within his own faction from those who hoped a religion of the proletariat might help keep alive the radicalism of 1905.[32]

In 1907–1909 Lunacharsky developed his theory of a "proletarian culture" which would someday transform socialism into a religion for the Russian proletariat. These were years he would later come to regret. In his autobiography of 1932 he recalled them with a tone of recantation and repentance. "In the period after the defeat of the 1905 revolutionary movement, I, like many others, was subject to religious moods and seeking"; it was at this time, he remembered, that he had engaged in the heresy, in Lenin's mind, of "god-construction," or *bogostroitel'stvo*, whereby he regarded Marxism not as scientific truth but as the "highest form of religion," a theology without God.[33] In so doing, his moment of innovation—the articulation of "proletarian culture" in 1909—was well prepared by the ideas of Avenarius, Mach, Dietzgen, and Bogdanov.

VII

Lunacharsky's vision of a proletarian culture began to emerge in 1907. In an article that year he wrote that "social democracy is not simply

a party but a great cultural movement" out of which would come a "proletarian art." Such an art would be realistic in style and would be created by "proletarian artists." Bourgeois culture, he added, consists of ever novel forms and innovations and expresses its class decline in symbols of death and the fantastic. Proletarian art should be positive, optimistic, and comprehensible to the masses. Gorky epitomized the proletarian artist, a man born into the working class whose writings expressed the feelings of that class; artists like Gorky would soon produce a true "social democratic literature, and then painting and sculpture as well."[34] European socialists like Kautsky and Vandervelde were writing in *Vorwärts* that the proletariat should help create a new culture, and Lunacharsky was undoubtedly familiar with their ideas. But he felt that in cultural matters Russia, not Germany, would lead the way. "The social-democratic intelligentsia of Russia should develop the thesis indicated by *Vorwärts* on its own."[35]

Such a culture would be religious in nature, or at least it would help replace organized religion in the new society. Like Nietzsche, Lunacharsky felt that art in general expressed the tragic in life. Echoing Comte, he also wrote that "socialism, as a doctrine, is the true religion of humanity." "Socialism needs art. Any kind of agitation is a form of art. Any kind of art is agitation." The future socialist society would need a religious cult, a public theater of tragedy, outdoor festivals, dramas, processions, and ceremonies. With the help of modern technology, Lunacharsky felt, the individual citizen could see such public festivals even while sitting at home watching his movie-phonograph (*kinemo-fonograf*). The symbolist theater of the young director Meyerhold appealed to Lunacharsky in this respect. Through a drama which reflected human psychological needs, the culture of the future socialist society would achieve nothing less than "a new victory over death."[36]

In 1908 Lunacharsky contributed to a remarkable collection of essays whose revision of Marxism in Russia anticipated the work of Lukacs and Gramsci by a decade or more. Like them, the essayists of 1908 stressed the role of consciousness, and hence of intellectuals, in the historical process, including revolution. They accused Plekhanov of being a neo-Kantian, or a mystic, or both. V. A. Bazarov noted that Engels, like Mach and Avenarius, began with the reality of directly perceived experience. "The materialism of Marx and Engels," he concluded, "is a living method of scientific investigation—the materialism of Plekhanov is dead scholasticism." The essayists were all enthusiasts of Mach's empiriocriticism in varying degrees and agreed that Mach and Avenarius were better Marxists than Plekhanov.[37]

In his own essay, entitled "Atheists," Lunacharsky argued the merits of a positivist philosophy without God. Atheism need not imply pes-

simism. The American poet Walt Whitman was a good example of "optimistic atheism." Lunacharsky called for a "proletarian monism," an optimistic view of life that would destroy the "artificial boundary between spirit and matter" created by Kantian dualism and idealism. Monism—the belief that there is only one fundamental reality in the universe—was enormously popular in Germany at the time through the writings of Mach, Dietzgen, and the biologist Ernst Haeckel. For Lunacharsky, monism, like positivism, was not just a cult of science but a religion of the future suitable for the proletariat. "The proletariat thinks realistically and monistically," he wrote; "it naturally reveals the unity of spirit and matter, the laboring and struggling character of history, life, and nature, and feels its growing spontaneity (*stikhiia*); despite the hardships of life, it says its joyful 'Yes.'" Lunacharsky did not yet use the term "proletarian culture"; rather, he referred to "religious atheism" as a future myth for the proletariat. But he placed a clear emphasis on "religious atheism" as the "felt essence of socialism," as opposed to the class struggle. Citing Sorel's *Reflections on Violence*, recently translated into Russian, Lunacharsky concluded that any future revolution would need not be simply a proletarian victory in political or economic terms, but a "new religious consciousness." In terms that sharply antagonized Lenin, Lunacharsky had defined Marxism as a form of religion, or at least of religious myth.[38]

The recent (1906–1907) translations of Dietzgen and Sorel no doubt facilitated the view of Russian followers of Mach that Marxism, like relativity theory, was simply a useful hypothesis about reality, a social *Gedanken-experiment*. Plekhanov's materialism was inadequate because it accepted the neo-Kantian and idealist division of the world into the real and the ideal, even while arguing the primacy of the material world. Positivism, as articulated by Bogdanov and Lunacharsky in 1908, was much more than this; it was a radical union of the world into a single universe of pure experience that included both subject and object, self and society. Much of this anticipated Gyorgy Lukacs's *Geschichte und Klassenbewusstsein* (1923). For subject and object were now one, consciousness was as real a force for revolution and class struggle as the means of production and material possessions, and intellectuals were therefore a preeminent elite in the creation of a revolutionary society. Bogdanov, Lunacharsky, and other Russian Machists had pushed to its logical conclusion the triumph of consciousness over spontaneity, and of elite over the proletariat, that had been spelled out in Lenin's *What Is to Be Done?* Mind could triumph over matter.

Lunacharsky's theories at this time were best summarized in his two-volume work *Religion and Socialism*, which appeared in St. Petersburg in 1908 and 1911. Here he argued that the future dictatorship of

the proletariat envisaged by Marx would be prepared by its ideological hegemony over the bourgeoisie. Art and propaganda would precede control over the economy and would win over allies from among the bourgeois intelligentsia. For Lunacharsky, world religions were all basically myths bound to the cultures of particular societies at particular times. Thus Christianity itself was a kind of proletarian culture, an "ideology of the tormented poor of Jerusalem and the Jews in general." Christianity was therefore revolutionary, and even communist, a revolt of the propertyless. Like other ideologies, Christianity moved masses of people by its emotional appeal to their beliefs. Socialism should do the same. "The dissemination and clarification of the ideal-realist, religious principles of proletarian socialism should facilitate the development of powerful seeds of psychological collectivism in the proletariat."[39]

None of this was entirely original. Lunacharsky had borrowed liberally from Bogdanov's scientistic elitism and a wide variety of European sources: Comte's vision of a "religion of humanity"; Karl Kautsky's writings on Christianity as a form of early communism; Ernst Renan's histories of various religions; Dietzgen's articles on the "Religion of Social Democracy," republished in 1906; Sorel's *Reflections*; and of course the empiriocriticism of Mach and Avenarius. Lunacharsky credited Bogdanov with being "the only Marxist philosopher continuing the pure philosophical tradition of Marx"; the ideas of Dietzgen on socialism as a form of religion, he admitted, "coincide completely with our own." *Religion and Socialism* was thus a work of synthesis more than of true originality.

Lunacharsky's moment of innovation was certainly well prepared. Since the 1890s he had gradually worked out a reconciliation between science and faith, Marxism and religion, through the positivism of Avenarius and Mach. Central to his theory was the vision of a future socialist culture that would memorialize the heroics of the revolution and therefore provide a kind of victory over death, an eternalizing of the transient. But in 1908 in *Religion and Socialism* he brought his ideas together in a single work for the first time. He was also able with Gorky's help to launch the first attempt at proletarian culture, a workers' school on Capri. Finally, death was personally on his mind, since in June 1908 another baby had died in infancy. In his play *Faust and the City*, written that year, Faust appears as the popular leader of a Free City who treats his citizens as his children; when told that Faust has died, Gabriel replies that this cannot be true: "Faust is alive in all things! He lives in us! He lives forever!"[40] The proletarian revolution, too, would provide for the resurrection of the laboring classes of society, "the people reborn (*novorozhdennyi*) in the factory."[41] At a moment of personal tragedy and political exile and inactivity, Lunacharsky proclaimed that the socialist revolution would be nothing less than a victory over death.

VIII

The "god-construction" of Lunacharsky and Gorky threw Lenin into a rage and nearly destroyed the Bolshevik fraction of the RSDLP. In the spring of 1908 Lenin arrived on Capri at Gorky's invitation and argued with them endlessly. A year later he persuaded the editorial board of *Proletarii* in Paris to read them out of the party. It was this philosophical and political crisis which helped Lunacharsky formulate a role he was to play for several decades, that of conciliator between two seemingly irreconcilable forces: Bolshevik revolutionaries and free-thinking intellectuals.

Lenin had been pleased with Lunacharsky's work in St. Petersburg in 1905–1906 and again at the Stuttgart Congress of the Second International in 1907. He was one of the party's leading journalists, with considerable experience in illegal operations, and an important link with the intelligentsia. The first sign of conflict came in a letter from Lenin to Lunacharsky in January 1908, after Lunacharsky had moved to Capri, in which Lenin criticized the "empiriomonists" and "empirio-critics" within the party.[42] Lenin was obviously worried about the Bolshevik circle forming around Bogdanov, who also arrived on Capri in April 1908. That circle now included not only Gorky, Lunacharsky and Bogdanov, but also two more Vologda exiles: I. I. Skvortsev (Stepanov) and V. A. Bazarov (Rudnev), who, respectively, would later become the editor of *Izvestiia* and a leading economist in Gosplan. The group represented both an ideological and economic threat to Lenin's control over the fraction.

In April 1908 Lenin came to Capri and confronted his rivals. Precisely what happened is difficult to determine, but there was a week of constant argument and debate over the future of Bolshevism and the merits of empiriocriticism, punctuated by long games of chess, to which both Bogdanov and Lenin were addicted. At the end of the week Lenin returned to Paris and began to prepare his own theoretical work attacking the followers of Mach and Avenarius within the party—*Materialism and Empiriocriticism*. Lenin's treatise stressed the epistemological weaknesses of a doctrine he claimed, not completely wrongly, went back to the skepticism of Bishop Berkeley. But it was the political threat that most concerned him.

Lunacharsky had his initial opportunity to practice his theory on the island of Capri in 1908. There Lunacharsky, Bogdanov, and Gorky began their first experiments in proletarian culture by organizing a school to educate and train workers for propaganda inside Russia. The "First Higher Social Democratic Propagandist and Agitator School," as it was finally called, actually began operating in the summer of 1909.

Its financial angel was Gorky, who obtained considerable funds from his own royalties, as well as from Krasin, Andreeva, the singer Feodor Chaliapin, and a Nizhnyi Novgorod steamship owner named Kamensky. Lenin obviously had in mind better uses for the two hundred thousand rubles raised by Krasin than the five-hundred-ruble stipends provided for workers who left Russia to study on Capri. In Gorky's eyes, the purpose of the school was to "strengthen the intellectual energy of the party" and to "create abroad courses for training organizers and propagandists." This suggested not only the great importance of ideology in the revolution, but also a broad-based concept of party membership with an unhealthy resemblance to the Mensheviks. By April 1909 even the Paris branch of the Russian political police, the Okhrana, was well informed about the school through its agent on Capri, Andrei Romanov.[43]

The leading organizer of the Capri school was N. E. Vilonov, a worker from the Urals who came to Capri on party funds originally to cure his tuberculosis. Gorky, Bogdanov, and Lunacharsky were delighted to find a real worker among the ranks of the émigré intelligentsia. With Vilonov, they worked out a plan to bring workers to Capri, establish a party school or "university," and institute a four-month series of lectures. By the summer of 1909 Vilonov had returned to Russia and recruited twenty workers for the school. Once on Capri they encountered an impressive faculty—Bogdanov, Gorky, Lunacharsky, the Moscow historian M. N. Pokrovsky, the lone Bolshevik Duma delegate G. A. Aleksinsky, among others—and courses ranging from the history of Russian literature and European socialism to political theory and the practice of agitation. Vilonov, however, found the religious and philosophical dimension of the "god-builders" distasteful. In the end he supported Lenin, was expelled from the school in November 1909, and left for Paris.[44]

Lenin was furious at the Capri school. In December 1908 he wrote his sister Elizarova, charging Lunacharsky and Bogdanov with "creating a new religion." "But there is no 'socialist' religion," Lenin railed. "It is just an attempt to 'unite' what cannot be united—religion and socialism."[45] In June 1909 he called a meeting of the *Proletarii* editorial board in Paris and passed a sharp resolution condemning "god-construction" within the Bolshevik Party. But by December 1909 the Capri circle had established its own rival journal *Vpered* in Geneva.

Lunacharsky was an unhappy man. His second son died, and his wife had quarreled increasingly with Andreeva. In the autumn of 1909 the Lunacharskys left Capri and settled for a time in Naples. Keeping apart the *Proletarii* and *Vpered* groups, Lunacharsky, with Aleksinsky, established his own party school at Bologna in 1910. The twenty students at Bologna were again recruited mainly from among young workers from the Urals area. The Bologna school opened in November

Anatoly Lunacharsky and his son in Paris, 1911. From *Literaturnoe nasledstvo* (Moscow, 1971).

1910 with seventeen students and a small faculty headed by Luna-charsky, Bogdanov, and Gorky. Since only Lunacharsky could speak Italian fluently, he served as director. Nominally, the *Vpered* circle still controlled the school and was to provide funds for it from party coffers. But that circle, too, was disintegrating. Krasin had withdrawn his support and was working as an engineer for Siemens and Schukert in Berlin. In February 1911, Bogdanov announced that he was leaving the Bolshevik Party. Trotsky, Martov, and Kollontai refused to lecture at Bologna, and Lunacharsky and Aleksinsky disagreed over policy and curriculum.[46] At this low point, Lunacharsky decided to move to Paris.

Lunacharsky's move to Paris in November 1911 marked a new beginning. As the second volume of *Religion and Socialism* appeared in St. Petersburg, Lunacharsky initiated a slow process of recantation and reconciliation with Lenin. He moved away from "god-construction" to a more modest but crucial role as intermediary between Bolsheviks and artists. Both Capri and Bologna had failed as experiments in proletarian culture; Paris offered new opportunities. Finally, Lunacharsky

had at last become the proud father of a healthy baby boy. At thirty-six he had generated his major theoretical work on Marxism as a form of religion as well as a more personal contribution to his own immortality through the next generation.

IX

In the autumn of 1911 Paris was in ferment. For two years there had been mounting labor unrest, first among striking postal and railway workers and then among the vineyard laborers of Champagne. Nervous diplomats confronted another war scare in the second Moroccan crisis. An itinerant Belgian, Gery Pieret, had stolen the *Mona Lisa* from the Louvre in August, and Guillaume Apollinaire—the art critic for *Le Mercure de France*, whose labels turned artists into movements—had been arrested for suspected complicity. The Belgian writers Maeterlinck and Verhaeren were living in Paris, and Maeterlinck had just been awarded the Nobel Prize for literature. The Russian ballet master Sergei Diaghilev was in his third season at the Théâtre Châtelet, where he was staging the ballet *Petroushka* by the young Petersburg composer Igor Stravinsky. Cubists and futurists vied for the public eye. For many, Paris in 1911 meant art, and art conjured visions of revolution.

Russian art in Paris generally meant Diaghilev, whose Ballet Russe with its lavish sets, the dancing of Nijinsky, and the music of Stravinsky seemed revolutionary to Parisian audiences. Initially successful as editor of *Mir iskusstva* (The World of Art), Diaghilev was frustrated in his attempt to become director of the Imperial Theaters in Russia in 1904. In 1906 he brought Russian culture to Paris instead. Diaghilev was concerned with politics as well as with entertainment; in 1905 he collaborated with Gorky and Meyerhold in plans for a new theater of satire, and he expressed the hope of becoming the artistic dictator of any new Russia that might emerge. "We are doomed to die," Diaghilev said at a banquet in Petersburg that year, "to pave the way for the resurrection of a new culture, which will take from us what remains of our weary wisdom."[47] In art, as Lunacharsky's wife once remarked, Diaghilev was more revolutionary than Lunacharsky. Paris between 1911 and 1914 provided Lunacharsky with ample opportunity to observe a revolution in art, and to envision a new dimension for proletarian culture.

Although Lenin was then in Paris, living on the Rue Marie-Rose, Lunacharsky avoided politics, devoting his attention to art. As a critic for the Kiev journal *Kievskaia mysl'* (Kievan Thought), he visited art museums, galleries, and exhibitions, and wrote reviews. "Beside my literary work," he later recalled, "I founded a circle for proletarian culture."[48] The circle consisted mainly of a few Russian workers Lunacharsky found living in Paris: P. K. Bessalko, a railway worker and

former Menshevik from Ekaterinoslav; A. K. Gastev, a metalworker and trade union leader who later established a Central Institute for Labor in Soviet Russia; M. P. Gerasimov, a teacher; and F. I. Kalinin, who had helped organize both the Capri and Bologna schools. They organized a new journal named *Vpered*, which Lunacharsky billed as a "popular workers' journal." Lunacharsky contributed notes on party and international developments and on the "deep crisis" within the RSDLP. He also wrote rather vaguely about his vision of a future proletarian culture, a "culture of social revolution, but not of socialism," which would produce a "proletarian art, proletarian science, proletarian philosophy."[49]

In Paris Lunacharsky came into contact with artists and writers whose work might well be described as "proletarian." The writings of Maeterlinck and Verhaeren combined mysticism and socialism in a manner that appealed to Lunacharsky. In addition, Lunacharsky discovered the Estonian musician, Eduard Syrmus, a Bolshevik who had led street demonstrations in 1905 with his violin, had met Gorky on Capri and Lenin in Paris, and now played for émigré socialist fundraising concerts. He pronounced Syrmus a "proletarian violinist," apparently more for his Bolshevik enthusiasm than his class origin.[50] He had high praise in his journalism for the French worker-poet Jehan Richtus (Gabrielle Randon), who edited ballads, songs, chants, and poems of the poor. In addition, Lunacharsky attended trade union festivals and concerts, such as the syndicalist festival in Wagram Hall on May 3, 1913, which, he found, exemplified "what great progress Parisian proletarian culture has made in recent years."[51] May Day parades, Isadora Duncan's dancing, and workers' choral concerts at the Trocadero Museum all seemed to Lunacharsky to embody the kind of proletarian culture by and for workers that would someday emerge in Russia.

In Paris Lunacharsky also discovered bohemia, although his tastes in art were far from avant-garde. He preferred the wall murals and frescoes of Puvis de Chavannes with their groups of happy youth to the newer abstract and geometrically deformed work of cubists, orphists, and futurists. In the painting of the young Russian Jewish artist Marc Chagall, he found only "pretentious posing and a kind of sick taste." The Italian futurist exhibit of February 1912 in Paris was "purely subjective chaos," and Boccioni's painting and sculpture was "nine-tenths artistic hooliganism."[52] Insofar as Lunacharsky's own tastes were to be embodied in proletarian culture, it would be realistic and not abstract, appealing less to critics than to workers. In Paris, Lunacharsky made it clear that the mystic realism of Walt Whitman's *Leaves of Grass* or the urbanism and socialism of Verhaeren were much preferable to the antics of Marinetti or the collages of Braque. For Lunacharsky in 1912, proletarian culture would not be avant-garde, by any definition.

Despite his antipathy to artistic modernism, Lunacharsky spent considerable time among the art colony of La Ruche (The Beehive) on the Rue Danzig. La Ruche, an area near Montparnasse developed by the architect Alfred Boucher for the Universal Exposition of 1900, consisted of a series of barracks around a central octagonal structure known as La Rotonde, where dozens of artists had studios. By 1913 it was known as "Babylon Number Two" because of the massive influx of foreign artists: the Italian painter Modigliani, the Mexican Diego Rivera, and an entire ghetto of Russian Jews from the Pale of Settlement—Marc Chagall, Chaim Soutine, Pinchus Kremegne, Osip Zadkin, Moise Kisling, and Mikhail Koukine, among others. Most of these artists came from artisan families in Lithuania, Belorussia, and Poland and sought in Paris an art education they could not obtain in Russia. In 1914 they were generally in their early twenties. When not painting, or drinking at the café "La Rotonde," they were at another Russian émigré center, the Russian Academy of Painting and Sculpture on the Impasse Avenue de Maine. Here the painter Maria Vasileva, a dwarfish version of Gertrude Stein, gave art classes, ran a canteen, and arranged Saturday night concerts and charity balls for needy émigrés.[53] In his "proletarian culture" circle Lunacharsky had surrounded himself with young workers; in La Ruche he enjoyed the company of young artists.

La Ruche introduced a colorful side of life to Lunacharsky, accustomed to more serious matters of revolutionary politics. Zadkin wore proletarian-style overalls and went about accompanied by an enormous Great Dane. Kisling fought a duel. Modigliani drank and smoked hashish. "The whole world seemed to be intoxicated with art," recalled one La Ruche visitor. To the Paris police, La Ruche was a "menace to public order"; to the young Russian writer Ilya Ehrenburg, it was "not a place of debauchery, but a seismographic station where men recorded impulses not perceptible to others."[54] In describing the young painters of La Ruche to his Kiev audience, Lunacharsky referred to the colony as "young Russia in Paris."[55] Artistically, Lunacharsky was most impressed with David Shterenberg, a young Jewish painter whose realistic style contrasted sharply with the cubist and futurist deformation around him. In later years Shterenberg would head the painting section of Narkompros (Commissariat for Public Enlightenment) and would help Lunacharsky protect and subsidize the artistic revolutionaries he had first encountered in the back streets of Paris before World War I.

By 1914 Lunacharsky, at age thirty-nine, had worked out a theory of proletarian culture. His vision was not simply a reworking of the positivist philosophies of Bogdanov, Avenarius, or Mach, or even a transformation of Marxism into a religious myth along the lines suggested by Dietzgen or Sorel. In Paris he had found workers and artists who provided him with a model for that culture, which would join

educated workers from the bench with those artists of the avant-garde who were more radical in their politics than in their art.

The central sources of Lunacharsky's vision of proletarian culture, as we have seen, were not Russian. His geographic origin was Ukrainian, and his Marxism originated in the classrooms and railway yards of Kiev. As a student in Zurich he had discovered the European positivist tradition later reinforced by the powerful philosophy of his brother-in-law Bogdanov. On Capri after 1905 he found Gorky receptive to the fusion of religion and socialism that Lunacharsky sought in the writings of Dietzgen, Kautsky, and other Marxists. Later in Bologna and Paris he discovered circles of like-minded workers and intellectuals who shared his interest in a revolution that would be as much cultural and ideological as economic and political. But that vision would only be realized in Russia after the Bolshevik Revolution of 1917. For the moment it was confined to Lunacharsky's writings and a few younger followers in Europe. Yet one can say that by around 1909 Lunacharsky's moment of innovation—his articulation of a theory which combined religion and Marxism to anticipate a cultural revolution in the way workers would perceive and organize their experience—was at hand. At a time of political defeat and artistic failure, Lunacharsky proclaimed a future proletarian culture in which artists and workers would transform the experience of bourgeois society. In age and in his personal artistic taste Lunacharsky belonged to the generation of the aesthetes; but ultimately he became well known as the older leader of the constructivist generation of the 1920s, for whom pre-1914 European ideas had a renewed appeal.

X

Lunacharsky's European vision of proletarian culture, in its rough outline, thus preceded the Russian reality by nearly a decade. Such a culture would be proletarian and collectivist, urban and socialist, atheist but appealing to religious needs and beliefs, joining workers and artists in a common revolutionary cause whose ultimate goal was nothing less than a victory over death. Proletarian man would ultimately survive the death of any individual. Yet all of this seemed unreachable in the summer of 1914. When war broke out, Lunacharsky left Paris for Brittany with his wife and son, and then moved on to Switzerland in 1915. Here he published attacks on the patriotic "defensists" among the Russian socialists and lived comfortably on his mother's inheritance. In May 1917 after a decade of European exile, he returned to Russia to help edit Gorky's new journal *Novaia zhizn'* (New Life). When the Bolsheviks seized power five months later, Lunacharsky was named head of the Commissariat of Public Enlightenment.

During the Russian Civil War (1918–1921) the theory of proletarian culture was put into practice not so much by Lunacharsky as by Bogdanov. His mass cultural organization Proletkult held its first national conference on the eve of the Bolshevik seizure of power; its leadership consisted mainly of veterans of Capri, Bologna, and Paris. Lunacharsky and Bogdanov were the original organizers, but they were soon joined by Kalinin, Gastev, Bessalko, and other exiles who streamed back to Russia after the February Revolution. By the spring of 1919 Proletkult claimed a membership in the tens of thousands, possibly even greater than the ranks of the Bolsheviks. Most members were not artists but ordinary workers. They edited a dozen separate journals, performed plays, wrote poetry, gave concerts, and organized revolutionary festivals.

Bogdanov considered Proletkult a harbinger of "collectivist" culture. For him the worker was most important, and the artist simply the "organizer of the great collective's living forces."[56] But the leadership of the movement was still dominated by prerevolutionary exiles and intellectuals. Lenin was as suspicious of the practices of Proletkult in 1919 as he had been of its theory in 1909. He publicly criticized the "abundance of escapees from the bourgeois intelligentsia, who often looked on the newly-created workers' and peasants' organizations as the most convenient field for their own personal fantasies in the sphere of philosophy or culture . . . and smuggled in something supernatural and foolish in the guise of pure proletarian culture."[57] Such criticism boded no good. By 1921 Proletkult was subordinated to Lunacharsky's Narkompros. In 1928 Bogdanov died performing medical experiments on himself, probably a suicide.

Once in power Lunacharsky supported even those avant-garde artists whose work he disliked. Many quickly sought protection, commissions, jobs, and subsidies from Narkompros, especially the Visual Arts Section headed by David Shterenberg. Other former inhabitants of La Ruche were also active, among them the painter Nathan Altman, who taught at the Petrograd Free Art Studios (SVOMAS) and directed the Petrograd section of Narkompros concerned with monuments and festivals.[58] In September 1918 Lunacharsky named Marc Chagall Commissar of Art in his home town of Vitebsk and permitted him to open an art school there. As a result, the first anniversary of the revolution in October 1918 featured streetcars, walls, lamp posts, and buildings covered with cubist shapes and green cows and flying horses à la Chagall. A month or two later the graphic artist M. V. Dobuzhinsky arrived to help Chagall establish his Vitebsk Academy, where Chagall dreamed of "making ordinary houses into museums and the average citizen into a creator."[59] In the summer of 1919, however, the suprematist followers of Kazimir Malevich ousted Chagall from his school, and three years later he was back in Paris.

The Bolshevik Revolution thus provided Lunacharsky with his long awaited opportunity to build a revolutionary culture that would join workers and artists in a common effort. In the 1920s he became the dominant figure in education and the arts in Russia, the head of a sprawling bureaucracy and one of the few men capable of bridging the gap between workers and artists, the proletariat and the avant-garde. He became the architect of proletarian culture, utilizing the schoolroom, the city square, the outdoor stage, and the monument to inculcate new values and to legitimize the revolution.[60] At forty-two he had found success through revolutionary commitment.

Lunacharsky's vision of proletarian culture was more than the reconciliation of workers and artists. In his earlier play *Faust and the City*, Faust had become immortal in the good works he had provided for his people. When Verhaeren, whom Lunacharsky praised as a "true futurist" whose urbanist poetry reflected "contemporary metallic and electrical culture," died beneath the wheels of a train in November 1916, Lunacharsky wrote that "Verhaeren's spirit is immortal (*bessmerten*)." He found Maeterlinck's best work to be his essay *La Mort* (1913) where Maeterlinck argued, in Lunacharsky's words, that "the dead continue to live in us" through the "heroism of that death." In February 1918 he traced the dream of an immortal communist society back to Walt Whitman: "Communism places man in his proper place. Man awakens and happily realizes his own destiny as the conscious and immortal fulfillment of the universe. Man as collectivist is immortal. Only the individual is mortal."[61] For Lunacharsky proletarian culture meant revolutionary immortality.

Lunacharsky did not arrive at his vision of proletarian culture overnight. Rather, it resulted from a gradual accumulation of intellectual influnces: European positivism, Russian "god-seeking," Marxism, the experience of 1905, the workers' schools of Capri and Bologna, and contact with the artists of La Ruche. His sense that a revolutionary culture would bring a victory over death with its own forms of immortality for the collective proletariat was most clearly articulated around 1909, and worked out in practice over the next several years in Europe. In 1925 he referred to a story told by Mach in *Analysis of Sensations* about the Eskimo who refused the gift of immortality because he would not be allowed to bring his seals and walruses with him to eternal life:[62]

Personal immortality is something which a man wears like a set of blinders, and with which he can never really get anywhere; it defines a limit to his horizons. But when man frees himself of all private property, he then ceases to feel only himself as "I." The center of his world view becomes the great, dazzling "we" with its real and painful past and its evolutionary climb from animal to ruler in the kingdom of justice we are now experiencing. Then he feels that his existence continues through his environment, his children, and his grand-

children, then he becomes a historical person, a human being, not just Paul Ivanovich or Maria Ivanovna. Then when he is asked about immortality, he inquires not about his own seals and walruses, that is, his own possessions, his so-called personality; instead he asks if that idea which he has served, that beauty which he has seen, and that justice which he has created will develop further to its outer limits, achieving new victories and establishing new harmonies. And in a deep sense, that he is eternal only in those contributions of his personality which he has made to the stream of human existence, that he fears neither sacrifice, nor suffering, nor death. For he knows that the spirit, if we may use that old word for a minute to describe the collective impulse of humanity, that spirit which he serves is truly eternal.

Thus would proletarian culture immortalize the individual worker.

Although more of a critic than an artist, Lunacharsky embodied the tension between innovation and revolution, artistic creativity and political participation, characteristic of the avant-garde. He was also a professional revolutionary, and his commitment to Bolshevism was lifelong. So was his fascination with the view of secular immortality by reputation, a view he articulated in his mid-thirties. In 1929 Lunacharsky left his post at Narkompros and retired to the south of France. In 1933, on the eve of his death, he wrote: "If I die, I shall die well, quietly, as I have lived. As a philosopher, as a materialist, as a Bolshevik."[63] By then Stalin's party controls over Soviet culture had swept away the remnants of Proletkult. Only a post-Stalinist generation would resurrect the long buried example of revolutionary art and artistic revolution that Lunacharsky's experiments of the 1920s had tried to fuse.

3

Antagonism and Political Satire: The Cartoon and the Poster

Innovation enters art by revolution.
—Viktor Shklovsky

The elements of artistic juxtaposition and political antagonism persisted throughout the art of the revolutionary period in Russia. Nowhere was this more apparent than in the black-white contrasts (artistic and political) of graphic art. As early as 1905 graphic artists and cartoonists had engaged in sharp attacks on the Imperial Russian government and Russian society, a negative antagonism which was easily converted to more positive political propaganda after the 1917 Bolshevik Revolution. Graphic artists were especially important in turning art to political use, since their art form reached a mass audience through lithography and printing; their medium was the newspaper, the magazine, and the poster. In a society where literacy was not yet widespread outside the cities, the visual messages of graphic artists reached a broader audience than the written word. The element of antagonism characteristic of Soviet propaganda art, with its we-they philosophy, originated not in 1917 but in 1905. New journals modeled on the Munich magazine *Simplicissimus* sprang up in Russia. The Russian revolutionary poster and cartoon of the Civil War days were born in Munich at the turn of the century.

I

By 1905 Sergei Diaghilev's World of Art movement seemed to have achieved its goal of bringing European modernism to Russia. Launched in 1898 by some St. Petersburg schoolboy friends, then in their late twenties and early thirties and dissatisfied with the work of the Imperial Academy of Arts, the World of Art group organized exhibits of Western painting, published a lavishly illustrated journal, and generally aimed

at acquainting Russians with the latest trends of *Art Nouveau*: the graphic work of Aubrey Beardsley; the paintings of Gustav Klimt and Claude Monet; the poetry of the French symbolists. The westernism of the World of Art clashed sharply with the Academy, dominated by the Moscow rebels of two decades earlier, the Wanderers, whose realistic canvases evoked a nationalist enthusiasm for pre-Petrine Moscow. Instead, the World of Art looked to eighteenth-century Petersburg and Versailles for a mannered style appropriate to a new national art of quality equal to that of the West. In their quest for closer bonds between Russian and Western art, the World of Art aesthetes were a great success in St. Petersburg. But in 1904 the journal ceased publication for lack of patronage, and a year later the group suffered the secession of younger, more provincial, and more Europeanized elements.[1]

The secession of these younger artists reflected broader trends in Russian society, especially a population explosion which led to massive urbanization. Moscow and the southern and western provincial towns grew most rapidly. As the population of the Empire more than doubled between 1861 and 1914 (from 73 million to 170 million), its urban population tripled, and the population of Moscow and Petersburg quadrupled. The figures were even more striking in the provinces. The population of Kiev increased during the same period by a factor of seven, that of Tbilisi, Kharkov, and Odessa by a factor of five. These increases represented not simply inmigration from the countryside with its surplus and landless peasantry, but also an increase in the national birth rate and therefore of the proportion of young people crowding into the schools and universities. For every thousand Russian citizens, there were thirteen students in 1895 and seventy-five in 1914. The university population increased from 4,000 in 1865 to 22,000 in 1905, and 40,000 in 1912. Between 1905 and 1914 a flood of young people inundated the provincial towns and capitals in search of school and work.[2]

The Academy of Arts was not immune to this process of urbanization and provincialization. By 1904 more than half its Higher Art School students came from the Academy's provincial art schools, established during the reform of 1894. But despite Ilya Repin's introduction of private faculty studios as part of the curriculum, the Academy remained a place where very few young artists could develop their talent. Senile rectors, pseudo-classical exercises, long lectures, drawing from models, and the confusing rotation of faculty in and out of the studio each month combined to produce a training system that was neither efficient nor innovative. As early as 1896 Repin himself quietly began encouraging his students to seek a better education abroad in the art schools and studios of Paris and Munich.[3]

If young Russian art students had felt somewhat provincial at the Academy in St. Petersburg, they found in Europe an artistic modernism

that made even the Academy seem provincial. In the 1890s they visited Paris, prowled the corridors of the Louvre, took courses at the Académie Julienne, toured Brittany in the summers, and discovered the world of French painting: the pastel murals of Puvis de Chavannes, the Tahitian scenes of Paul Gauguin, the speckled and light canvases of the Barbizon painters and the Impressionists. When they returned to Russia, often to provincial towns like Saratov, they brought with them the latest in French styles.

In 1898 one young Russian art student in Paris discovered that to come from Russia often meant to be a non-Russian from the provinces:

> When we came to the Eiffel Tower, pointed at it, and began talking, the two men asked Zarubin what nationality we were. When he answered that we were Russians, they were incredulous. The Frenchmen found our language like Spanish. In fact, what kind of Russians were we? Kuindzhi—stocky and broad-shouldered with a great head of hair, an aquiline nose, and a face with a magnificent moustache and beard. The handsome Greek, Khimon, or Chumakov, sunburned as an Arab. Kalmykov, something between a Greek and a Crimean Tatar; Stolitsa, a Zaporozhian Cossack with a moustache, who looked like Taras Shevchenko. The tall, handsome blond Poles Rudisz and Wroblewski. The tall, heavyset Kurbatov, always aiming at things with his walking stick. I suppose I was the only real Russian type, a little Russian dandy with a little blond beard, a derby hat, a new ready-made suit the color of quail.[4]

Thus the experience of study abroad could accentuate a young artist's sense of provincialism and non-Russianness.

Munich in the late 1890s could make a Russian artist feel as provincial as Paris. "Munich at the time," recalled the painter K. S. Petrov-Vodkin, "was a nursery of the arts which influenced Moscow, and thus there were many Russians among the artistic youth, and the Russian colony on the whole was very extensive." As to the non-Russians, "their fear of their native provincialism pushed them into another kind of provincialism, a faith in fashionable German modernism."[5] By imitating the latest in European art, it seemed, the provincial Russian artist could at one bound overcome his own sense of backwardness within the Russian Empire and achieve a feeling of "advanced" stature.

In fact Munich, not Paris, was the major center of Russian art students before 1905. The arrival there in 1896–1897 of Vasily Kandinsky, Aleksei Yavlensky, and Marianne Verefkina is well known to art historians because of their subsequent involvement in the Blue Rider circle within German expressionism. But there were many more Russians in Munich at the time. As early as 1894, Police Chief Göhler had expressed his concern over the growing number of East European "nihilists" who

were settling in Munich to study or to engage in revolutionary activity
free from the observation of the Russian Okhrana.[6] Even at that time
Russian students and émigrés had established an Academic Slavic
Embassy Club, a Polish Reading Circle, a Russian Student Fund, and a
Russian Reading Society in a building on the Görrerstrasse. The local
police suspected that these might well be more than friendly cultural
organizations, a not unreasonable assumption when one recalls that by
1905 the Munich colony of Russian revolutionaries had included Lenin,
Rosa Luxemburg, Trotsky, and Parvus (Alexander Helphand). Between
1894 and 1905 the number of Russian students at the Munich Technical
High School jumped from 76 to 243; by 1912 there were 552 Russians
enrolled at the university as well, making up 39 percent of all foreign
students there. In 1909 the Paris office of the Okhrana reported that
Munich had become "within the last two years the most active center of
the Russian colony's student and political life in Germany," estimating
that some 800 Russians were living or studying in Munich at the time.[7]

Russian art students in Munich at the turn of the century headed
for Schwabing, the bohemian student quarter near the university. They
generally gravitated around two well known art schools run by Anton
Ažbe (1862–1905) and Šimon Holločy (1858–1918).[8] Ažbe, a Slovak
painter, was a friend of the Russian portrait painter V. A. Serov, a former
Munich student now teaching at the Petersburg Academy. Holločy, a
Hungarian, studied at the Munich Academy of Arts from 1878 to 1892
and then opened his own school there in 1896; he gave lessons in Munich
in the winter and then took his students to his home town of Nagy
Banya for landscape work during the summer. Most Russian art students
worked with Ažbe, and after his death in 1905, with Holločy. When these
students returned to Russia, they naturally brought with them many of
the techniques and lessons learned in Munich. Ažbe, in particular, offered
precisely what the Academy lacked: more unified training by a sympa-
thetic teacher who worked closely with his students. For the first year
every student spent most of his working day in drawing lessons using
models, and in the evenings attended anatomy lectures at the university.
Only during the second year did the student go on to painting. Ažbe
emphasized the simplification of form. Students worked mainly with
charcoal instead of the finer and harder "Italian pencil" familiar to most
Russians; they mastered outline first and details later. In addition,
students were taught to reduce human anatomy to geometry—the head
to a sphere, for example—in order to understand the basic shapes in-
herent in nature. Even if Ažbe did not directly encourage abstraction,
the use of charcoal—soft, malleable, providing better shading—tended
to steer the student away from attention to detail.

The World of Art artists studying in Munich around 1900, who
included M. V. Dobuzhinsky, Dmitry Kardovsky, Ivan Bilibin, and Igor

Grabar, found Holločy rather different from Ažbe. Holločy emphasized feeling and emotion rather than technique, and encouraged his students to paint in the manner of the French impressionists, then in vogue in Munich. His students, too, were less technically oriented: mainly non-Germans who reveled in the artistic life of the "Athens on the Isar" with trips to the Alte Pinakothek Museum, beer and arguments at the Café Stephanie, the *Jugendstil* revolt against parental and artistic authority, and the general bohemian atmosphere of Schwabing, "kein Ort, sondern ein Zustand," not a place but a state of mind. The atmosphere of Munich was often more important than the art schools themselves for the Russians who lived there. Munich both trained and politicized the artists and provided them with a model of avant-garde opposition to bourgeois society, which they employed in their own country during the 1905 Revolution.

II

To the thirty-year-old graphic artist Mstislav Valerianovich Dobuzhinsky, the Revolution of 1905 brought both artistic innovation and political radicalism. As a graphic artist recently returned from Munich, he found new opportunities created by the revolution. With the lifting of the more onerous censorship restrictions after the October Manifesto in the autumn of 1905, some four hundred short-lived journals of political and social satire sprang up across Russia, utilizing new techniques of lithography and linotype to ridicule the government and bourgeois society through savage cartoons and caricature. In December 1905 Dobuzhinsky contributed two striking drawings to one of these, the journal *Zhupel* (Bugaboo). Both drawings evoked images of death imposed on innocent victims by an unjust and evil government. In "October Idyll" a doll lies flung across a blood-stained sidewalk, with only the glasses of the victim left lying in the street nearby. In "Pacification" the Kremlin sits in front of a glorious rainbow awash in a sea of blood. In the midst of revolution, Dobuzhinsky turned his art to political use and gave new meaning to his own life.

In the 1920s satirical graphics became a familiar and important element in early Soviet culture, focusing antagonism on enemies of the revolution. Capitalists, priests, generals, and European politicians all fell victim to the acid pens of Soviet cartoonists in *Krokodil, Bezbozhnik,* and *Pravda.* Bourgeois society, which had not died overnight with the revolution, was now destroyed on paper by graphic propaganda. The origins of Soviet satirical graphics can be traced to 1905, when the latest developments in European graphics returned to Russia from Munich along with the artists who had studied there.

The satirical graphics of 1905 were certainly innovative in the Rus-

"October Idyll"

Two drawings by Mstislav Dobuzhinsky, 1905. From E. P. Gomberg-Verzhbinskaia, *Russkoe iskusstvo i revoliutsiia 1905 goda* (Leningrad, 1960).

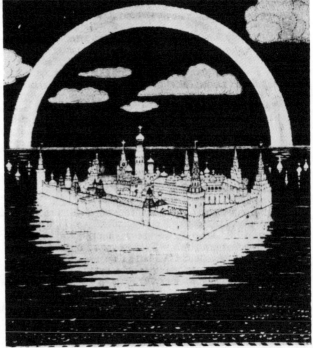

"Pacification"

sian context. The very term *grafika* first appeared in transliteration from the German in the 1890s, at a time when linotype printing and color lithography in Europe were creating a whole new art of the poster, the book, and the newspaper cartoon. The models for Russians before 1905 were mainly western: the *Yellow Book* of Beardsley, the theater bills of Toulouse-Lautrec, and the works on graphic art by Walter Crane and Max Klinger. Most Russian books of quality were printed abroad; the type for a 1901 monograph on Van Dyck, for example, was set in Amsterdam and the illustrations were printed in Berlin, while a new edition of Gogol's *Dead Souls* was printed later that year in Stuttgart with the plates engraved in Vienna. The heliogravures and phototypes for Diaghilev's *Mir iskusstva* were done in Germany and the autotype set in Finland. In addition, the layout for *Mir iskusstva* was modeled after the lavish Berlin journal *Pan*, and the journal reproduced the drawings of European artists like Beardsley and the German cartoonist T. T. Heine.[9]

Despite the intelligentsia's long tradition of social and political criticism of the autocracy, satire as a visual art was also relatively undeveloped in Russia before 1905. The European political cartoon began in eighteenth-century England, victimized by Hogarth and Rowlandson, and it was epitomized by the work of Honoré Daumier in nineteenth-century France. By the turn of the century Germany had achieved a leading position in the application of graphic art to political satire. The popular German humor magazines of the mid-century, *Kladderadatsch* and *Fliegende Blätter*, now competed with more lavishly illustrated periodicals such as *Pan* in Berlin and *Simplicissimus* in Munich. Yet in Russia satirical graphics was represented only by the older tradition of the eighteenth-century woodcut (*lubok*), itself not unlike the contemporary Dutch or English broadside cartoon, and by some more recent popular journals like *Shut* and *Niva*.[10]

Dobuzhinsky was one of the younger members of the World of Art, who constituted a "left wing" in 1905 by virtue of their support of the revolution. Like other members of that group—Ivan Bilibin, Igor Grabar, O. E. Braz, D. N. Kardovsky, and the editor Zinovii Grzhebin —Dobuzhinsky had studied in Munich at the turn of the century and had brought the spirit of Schwabing home with him. Like many of the other Russian artists abroad, Dobuzhinsky had a provincial background.[11] Again, like Diaghilev, he came from an army family; as a child he had traveled frequently with his father, an artillery officer. This geographic rootlessness was complicated by family problems; when Dobuzhinsky was four years old, his mother left his father to pursue her own career as a singer and actress, and the child shuttled back and forth between his father in St. Petersburg and his grandparents in Vilna. His father's side of the family was Lithuanian, and Dobuzhinsky attended

the gymnasium in Vilna, a cosmopolitan city of Poles, Lithuanians, and Jews. The baroque architecture of the Orthodox, Catholic, and Lutheran churches in Vilna later reminded Dobuzhinsky of Munich. As a Lithuanian and an educated child of middle-class intelligentsia parents, Dobuzhinsky felt that he "saw Russian cities and nature almost with a foreigner's eyes."[12] Even before he went to Munich, Dobuzhinsky did not really feel that he was a Russian.

Nor was Dobuzhinsky a revolutionary when he arrived in Munich in October 1899.[13] His father had supported his academic pursuits, which included study at the Law Faculty of the University of St. Petersburg and at the Society of Fine Arts in the 1890s, and was now sending him abroad to study art as a luxury to be enjoyed, newly married, at age twenty-four, before deciding upon a career. Initially Dobuzhinsky sought to enter the Academy in Munich. To his chagrin he was rejected by an Academician who looked at one of his landscapes and asked: "Are those trees?" As a result, he joined the growing colony of young Russians studying in Munich's private art schools. He began work at first with Anton Ažbe, in whose studio he discovered two friends who would later become fellow members of the World of Art, Igor Grabar and Dmitry Kardovsky. Later, studying with Holločy in the summer of 1900, Dobuzhinsky met Grzhebin, a drop-out from the St. Petersburg Academy of Arts who hailed originally from Odessa.

Technically, Dobuzhinsky learned a good deal from both Ažbe and Holločy. "Our 'neo-academism,'" he later recalled, "had its beginnings in a German school with the principles of Ažbe, on which a whole generation of Russian artists was raised." Ažbe's emphasis on the reduction of objects to geometric forms was especially important. "I recall the works of some students in the school who drew only with straight lines —like future cubist drawings," Dobuzhinsky added. "But they did not see this as an end in itself, only as an exercise or experiment." Work with Ažbe also encouraged Dobuzhinsky to move toward the technique of the cartoon and the poster; "his principle of the 'large line' and 'large form' logically led to simplification, to 'poster art,' to the decorative, and in the end to the deformation of nature and a departure from reality."[14]

What radicalized Dobuzhinsky politically in Munich was the satirical magazine *Simplicissimus*, which presented an example of how graphic technique could become a weapon of social criticism.[15] Albert Langen had founded *Simpl* in 1896 on the model of the magazine *Gil Blas* in Paris, where Langen had lived in the early 1890s. The symbol of *Simplicissimus* was a bulldog and its anti-establishment bite was sharp. Some of the most talented graphic artists in Europe—T. T. Heine, Bruno Paul, Wilhelm Schulz, and the Norwegian Olaf Gulbransson—joined in creating savage drawings and cartoons that ridiculed Prussian generals,

Bavarian clergy, self-satisfied businessmen, and other targets of the Second Empire. In 1898 these victims of ridicule were joined by the Emperor William II, with the result that Langen, Heine, and the future *Simpl* editor Ludwig Thoma found themselves in jail. In 1900 Munich artists were being politicized by *Simpl*, and were being prosecuted for it. Dobuzhinsky, too, was an avid reader of *Simpl*, which he found to be "the sharpest and most progressive journal of its time; [he] awaited impatiently the appearance of every issue."[16]

Dobuzhinsky's Munich stay was cut short in the summer of 1901 by a family tragedy, the death of his younger brother in Vilna. He returned to Russia in 1901 with new techniques, new friends, and an acquaintance with the latest in European satirical graphics. In the winter of 1901–1902 Dobuzhinsky was a married man of twenty-six in need of a career of his own to replace his father's subsidies. He had not been very successful as an artist. In Munich the Academy had rejected him, and the journal *Jugend* had turned down a watercolor he had submitted for publication. He thought of giving painting lessons, but studios were far more expensive in Petersburg than in Munich, and he had no real teaching experience. There was an opening at the Hermitage as an art curator, but he knew no art history in any formal sense. To paint portraits for the wealthy he would have had to compete with Serov, Repin, or Levitan. In the end Dobuzhinsky was unable, as he put it, to turn creativity into money. He could find no market for his skills.[17]

Dobuzhinsky now went to work for the government, which he would later attack in his drawings. He took a job as a clerk in the Waterways and Ports section of the Ministry of Communications. He had found the position through the aid of a benevolent uncle and was unhappy with it from the start. It consisted of routine desk work with colleagues he considered "hemorrhoidal" bureaucrats, and he would not receive a full salary for two years. Still, he did not have to be at the office until noon, which gave him considerable free time for art. Ironically, Dobuzhinsky found a market for his art through his job; a fellow employee turned out to be an artist for the magazine *Shut*, and through him Dobuzhinsky arranged to do a weekly cartoon-page for thirty rubles a month. He signed the drawings "M. D." While the money was not much more than a student stipend of the time, it was Dobuzhinsky's first real income as an artist.[18]

By the winter of 1902–1903 Dobuzhinsky's prospects were improving. Although he still drew only a partial salary and was dependent on his father, the Ministry had shifted him to its main office, which was closer to home and provided more interesting work under the direction of Lunacharsky's older brother Mikhail. In addition, his friend Igor Grabar

had now returned from Munich and introduced Dobuzhinsky to the World of Art circle. Here he met those members of the group who would produce the best satirical art of 1905.

III

The stormy events of the 1905 Revolution politicized many Russian artists. Bloody Sunday, the first event to galvanize them into action, was commemorated by the painter V. E. Makovsky in his work "January 9, 1905." Many artists and writers were outraged by the shooting down of innocent workers in Petersburg. Gorky spoke out publicly against the atrocity and was promptly arrested. Well-known painters like Repin, V. A. Serov, and V. D. Polenov joined students in protest at the Academy of Arts; Serov resigned his position when the Academy took no stand on the matter. The St. Petersburg Conservatory expelled music students who demonstrated against Bloody Sunday and even ousted the composer Rimsky-Korsakov when he demanded that the director of the Conservatory resign. Autumn brought further upheaval. Russia suffered a final defeat in the war with Japan, a national railroad strike turned into a general strike, and the October Manifesto with its promise of civil liberties and a parliament failed to prevent armed violence in the streets of Moscow in December. Throughout this period artists signed petitions, attended public demonstrations, went on strike, and wrote letters of protest. Some resolved to commit their art to the revolution.[19]

The hundreds of satirical journals which sprang up in 1905–1906 in Russia were one obvious manifestation of artists' involvement in revolution. Many were little more than crude leaflets of a few pages brought out in a single issue; others were well funded and artistically sophisticated in their format. All of them went beyond the letter of protest, the petition, or even the political painting, for they were intended not merely to express the artist's antagonism to the government but to reach and persuade a mass audience. One of the earliest such journals, Zritel' (Spectator), featured a cover showing a woman, blindfolded and in tears, holding the scales of justice. Another showed a crowd with red flags massed in a demonstration. Still others portrayed government leaders and right-wing politicians as marionettes; plans for a Russian constitution were drawn as a house of cards. In the journal Signal a group of ministers were shown playing leapfrog; in Maski a firing squad was shooting its already sheeted victims.[20] Death and violence were everywhere in 1905, and graphic satire sought to fight back against their perpetrators.

The best satirical graphics of 1905 were produced by the young Russian artists who had studied in Munich and admired the art and wit of Simplicissimus. There were many other satirical journals produced

by less well known and less "bourgeois" artists, as Soviet historians point out, but the tone was set by the younger World of Art satirists, and their model was *Simplicissimus. Simpl* itself mocked Russian defeats at the hands of Japan and the attempts of Nicholas II to preserve autocracy in the face of revolution.[21] Inside Russia it had immediate imitators. Within a week of Bloody Sunday, Grzhebin conceived the idea of publishing a Russian version of *Simpl* under the title *Zhupel* (Bugaboo). He quickly enlisted the support of his friends in the World of Art, including Dobuzhinsky, Bilibin, Lanseray, and Boris Kustodiev. In April this group held a series of strategy sessions in Dobuzhinsky's apartment in St. Petersburg, but both the tight censorship and lack of money prevented the immediate realization of their scheme.

In June 1905 Dobuzhinsky and his friends managed to persuade Gorky to support their satirical journal. At the time, Gorky was also planning to launch the first Bolshevik legal journal, *Novaia zhizn'*, and to produce a "cheap library" of books for workers. On July 10, 1905, some forty artists and writers, including Dobuzhinsky and Grabar, met at Gorky's summer home in Kuokalla, Finland, just north of Petersburg, to plan the new journal. (The police were satisfied that the meeting concerned only "literary and artistic matters.") At the meeting Gorky agreed to help finance the new journal *Zhupel* in the autumn under the editorship of Grzhebin.[22] Gorky's money made Grzhebin's Russian *Simplicissimus* a reality.

With the lifting of the censorship after the October Manifesto, the publication of more liberal journals became possible. But it was not long before they exceeded their limits. On December 2 *Novaia zhizn'* was closed by the censor. The first issue of *Zhupel* was distributed on the same day; all remaining copies were immediately confiscated by the police. The journal included poems ridiculing Nicholas II, a caricature of a double-headed eagle drawn by Grzhebin, a painting by Serov of Cossacks charging a crowd of demonstrators, and Dobuzhinsky's "October Idyll"—his drawing of the doll in the street. If this were not enough, a note observed mockingly that "the contributors of *Zhupel* send greetings via the chiefs of the Russian police to their talented comrades of *Simplicissimus,* which is still not permitted in Russia by the censorship."[23]

Despite police surveillance and the fate of the first issue, the censorship permitted a second issue of *Zhupel* to appear on December 24. Its most controversial item was the Dobuzhinsky drawing "Pacification," showing the Kremlin awash in a sea of blood; the drawing was later reprinted in *Simplicissimus.* The second issue, like the first, was quickly confiscated; so was the third and final issue, which came out in January 1906 and included Bilibin's drawing of a donkey surrounded by a royal border, entitled "Equus Asinus 1/20 Scale." Grzhebin and Bilibin were arrested. A few months later the same group of artists organized another

journal, subsidized by Gorky's money, called *Adskaia pochta* (Mail from Hell). To gain the censor's approval Lanseray was listed as editor, but Grzhebin was the real manager. This time they succeeded in putting out four issues before the journal was closed down.

The satirical journals receded along with the revolutionary wave in 1906. By that summer most of them had disappeared, leaving instructive examples of the possibilities for political satire. Gorky had departed for his fund-raising trip to America, and the symbolist publishing house Fackel had taken over what was left of *Adskaia pochta*. But an important precedent had been set. In the spring of 1908 another Russian satirical journal, *Satirikon*, appeared and lasted until the 1917 revolution. Like its short-lived predecessors of 1905, it declared war on "all illegality, falsehood, and banality" and modeled itself after *Simpl; Satirikon* soon became known as "the Russian *Simplicissimus*." Later, another satirical journal, *Budil'nik* (The Alarm Clock), also followed *Simpl;* its leading cartoonist, D. Moor (D. S. Orlov), came to be known as "the Russian Gulbransson." Both journals helped strengthen the influence of Munich's satirical graphics on Russian artists.[24]

Dobuzhinsky achieved considerable success after his notorious political drawings of 1905. He became well known not only as a graphic artist and political cartoonist, but as a painter and book illustrator as well. In later years he turned from political satire to urban themes, as in his famous painting "The Man with Glasses" (1905–1906; Tretiakov Gallery) and in his series of drawings entitled "The City," which appeared in *Satirikon*. In addition he did book illustrations for the works of Dostoevsky, Leskov, and Pushkin, taught art in Petrograd during and after the 1917 revolution, and finally emigrated to America in 1924. Yet in his graphic art and political satire he remained a product of the the years of study in Munich and of the revolutionary year 1905 in Russia.

Death was a central theme of Dobuzhinsky's graphic art from 1905 through World War I. His innovative political works were more of a protest against the inhumanity of death than a call for revolution. "October Idyll" and "Pacification" contain no human figures; the dropped doll and the sea of blood surrounding the Kremlin remind the viewer of the cost of 1905 in human life. In his later works Dobuzhinsky concerned himself with the fate of the individual caught up in an emerging mass society haunted by the impersonal forces of revolution and urbanization. His weakest paintings and cartoons were his portraits; he continually avoided the human face by drawing masses of identical figures, or individuals with their backs toward the viewer. His cityscapes lacked the urbanist enthusiasm common to the futurists; they portrayed only the alienated individual at the window, or the street crowd beneath the skyscrapers.

In 1905 Dobuzhinsky's artistic stance was perhaps more humani-
tarian than political in any direct sense. His works evoked a rage against
impersonal forces and inhuman individuals who destroy the innocent, a
statement about life that anticipated subsequent expressionist outrage.
As Lunacharsky wrote in a review of Dobuzhinsky's works in 1907:
" 'Man has been forgotten!' cries Dobuzhinsky to us, and his cry brings
with it real terror."[25] It seems fair to say that Dobuzhinsky was contin-
ually fascinated with death, the senseless death of the victims of 1905,
or the psychological and spiritual death of man alone in the modern
urban anthill. His art was a protest against evil, the kind of sharp com-
ment on society characteristic of *Simplicissimus*, but not an answer to
its problems.

Like Lunacharsky, Dobuzhinsky belonged to the generation of the
aesthetes; like that generation, his ties were closer to St. Petersburg and
the World of Art than to the provinces. But as a Lithuanian artist influ-
enced by European modernism, his involvement in artistic protest in
1905 through satirical graphics anticipated a later antagonism to bour-
geois society common to many other artists in Russia. If Dobuzhinsky
shared the symbolist brooding over the inexorable forces of fate and
death, it was not without a cry of opposition more characteristic of the
emerging Russian avant-garde.

IV

In the application of graphic arts to political satire, 1905 was a pre-
lude to 1917. In 1905 the enemy was the Imperial regime and bourgeois
society; during the Russian Civil War of 1918–1921 it was the White
armies and their Allied supporters. Faced with an exhausted population
and limited military resources, the Bolsheviks, after they had seized
power in 1917, utilized all available forms of mass persuasion in their
effort to survive. In 1905 the satirical journals had served as a medium
of mass persuasion. But at a time of paper shortage and desperate
necessity, the Bolsheviks relied increasingly on the wall poster as a
weapon of agitation. Cheaper than a newspaper or a journal, it required
only a single sheet of scarce paper. Its abrupt and telegraphic captions
literally screamed at the literate viewer, while its visual content left
even the illiterate with little doubt concerning how they might help
good triumph over evil. Revolutionary artists now found a new market
for their art through the designing of such posters.

The color lithograph poster had come of age in Europe long before
1917 in the Paris of Henri Toulouse-Lautrec during the 1890s. As an art
form it was greatly influenced by the flat, outlined designs of the
Japanese woodblock print, especially the work of Utamaro, then very
popular in Europe. Although color lithography had been used in wall-

paper during much of the nineteenth century, it became inexpensive only in the 1880s when posters could be manufactured using four or five blocks with separate colors on each block. From its inception the purpose of the wall poster was persuasion; it invited the viewer to attend a play at the Moulin Rouge, or to buy a Waverley bicycle, or to eat Coleman's mustard. By 1900 the poster was as much a collector's item as a form of street art, and its masters, men like Aubrey Beardsley and Alphonse Mucha, were developing it into a significant and original art form throughout Europe.

During World War I the poster became a major propaganda weapon. Many artists used their talents to exhort citizens to sacrifice their lives in the interests of king and country. In each belligerent nation St. George appeared slaying the enemy dragon, the enemy was accused of unspeakable atrocities, and men were asked to volunteer. In an era of total war, the poster became a crucial device in mobilizing public opinion, and artists found new employment manufacturing social hatred and guilt. These two functions—the advertising of goods and services and political propaganda—were the main legacy of Western poster art to Russia in 1917.

In Russia the poster, like satirical graphics, did not develop as an art form until after 1905. The eighteenth-century woodcut known as the *lubok* is often cited as a predecessor of the Russian Civil War poster or the poster "windows" produced by the Russian Telegraph Agency, ROSTA.[26] Yet the *lubok* was a hand-colored satirical broadside in which the text knit together the strands of one or more pictures; the poster emphasized a single figure and a single, short message. Until the 1890s posters were almost unknown in Russia. In 1905 the satirical journal, not the poster, became the agitational weapon of radical artists. In fact, before 1914 the best Russian posters were often produced abroad, for example, V. A. Serov's lovely portrait of the dancer Anna Pavlova done in Paris for the Diaghilev production of *Les Sylphides* in 1909. Russian World War I posters were still generally of inferior quality by lesser known artists. Occasionally Malevich would produce an anti-German poster in *lubok* style, or Leonid Pasternak a humanitarian poster (such as the one concerning aid for the wounded reissued by the Bolsheviks under a different caption in 1918). But these were exceptions. In 1917 Russia had no indigenous tradition of the color lithograph poster.

V

The outstanding poster artist of the Russian Revolution and Civil War was Dmitry Stakhevich Orlov, better known by his poster signature, "D. Moor." Although dozens of artists produced several thousand posters between 1918 and 1921, the most famous poster was created by Moor

in a single evening in late June 1920. In this poster a Red Army soldier stands holding his rifle against a background of factories, points directly at the viewer, and asks: "Have YOU volunteered?" The poster suggests a nation in danger, portrays a heroic soldier in its service, and exhorts the viewer to ask himself whether he should not do likewise and volunteer for the revolutionary cause. Moor's poster appeared in the intense atmosphere of civil war Russia. But its origins as a work of political art, like Dobuzhinsky's satirical graphics, lay in prewar Munich and, subsequently, wartime British lithography. Like Dobuzhinsky, Moor found artistic fame through political revolution in his thirties.

Dobuzhinsky belonged to what we are calling the aesthete generation and absorbed the influences of Munich graphics first hand as a student there at the turn of the century. Moor, born in 1883, belonged to the futurist generation of the avant-garde and followed the work of the *Simplicissimus* artists second hand, from Russia. Dmitry Orlov was a Cossack from Novocherkassk on the Don River. During World War I Moor's editors had to assure their readers that "D. Moor" was not German but Russian; Orlov apparently took his pseudonym from the name of the hero of Schiller's *The Robbers*. Moor came from an old Don Cossack family; his father, a rising mining engineer and administrator, was a member of the newly emerging professional classes associated with Russia's industrialization. Moor himself came from a generation whose student years coincided with the 1905 Revolution, and from a social class sufficiently well off to tolerate the Imperial regime but sufficiently educated to criticize it.[27]

Like many artists of his generation, Moor migrated from a provincial town in south Russia to Moscow. Novocherkassk, with a population of 67,000 in 1914, prized its local statue of the the sixteenth-century Cossack explorer Yermak and its Don Museum with rooms of old Cossack banners and trophies. The town was also a winemaking center, in addition to being part of the industrialized Don Basin. Moor attended school in Novocherkassk through the gymnasium years, and in later life he referred to himself as a Cossack. Virtually nothing else is known about Moor's early life, except that his father's career took the family to Kiev, Kharkov, and, in 1898, to Moscow. In 1902 the nineteen-year-old Moor finished his gymnasium education and entered the Physical-Mathematical Faculty of Moscow University to study science.

Like many other artists drawn to the revolution, Moor was not very successful in his early adult life. Prior to 1905 he seems to have been a rather unmotivated young man interested in no particular career. He had once been expelled from Moscow University for nonpayment of tuition (he was subsequently readmitted). Money itself was not a problem, since Moor's father had become the head of the Moscow Experimental Station, which conducted research on mining for the

entire empire. As a student Moor spent his university years reading
Marxist literature and working on a student newspaper named *Parus*
(The Sail). He showed no interest in art.

In 1905 Moor was caught up in the revolution. He attended mass
workers' meetings, watched the barricades go up in Moscow in Decem-
ber, and saw his best friend, Sergei Dneprov, arrested. Moor took no
more active part in revolutionary events in 1905 and joined no political
group. But in early 1906 he became involved in the printing and dis-
tribution of illegal political leaflets. He also shifted from the mathe-
matics faculty at the university into law. He married Dneprov's sister
and took a job with the publishing house of the wealthy Moscow mer-
chant and art patron, Savva Mamontov. Like Dobuzhinsky, he lived on
the boundary between society and its revolutionary opponents.

The Revolution of 1905 may have affected Moor politically, but it
did not make him an artist. It was his job with Mamontov that provided
a stimulus for his previously unknown artistic talent. A newspaper editor
who saw some of Moor's sketches suggested that he do something for
the paper. Moor promptly produced a drawing, for which he was paid
three rubles. In 1907, at age twenty-four, Moor decided to become a
professional artist. He undertook no formal training at first, but began
to do more drawings and cartoons for Moscow journals. In 1908 he
produced his first cartoon for *Budil'nik*, the journal of humor and liter-
ature, to which Moor now added a new note of political satire. He left
the university and soon acquired a reputation doing satirical drawings
directed against both the government and the liberals; he portrayed
Duma candidates as priests, ridiculed ministers, and engaged in a con-
stant game with the censor to find permissible limits for his art work.
But when he and a friend, Ivan Maliutin, tried to edit a more radical
political journal, *Volynka* (Bagpipe), on their own, the censor refused to
permit any of the four issues. Except for a few months at the private
studio of the portraitist P. I. Kelin, Moor remained an untrained but
quite successful amateur.

One reason for Moor's success was his emulation of Munich graphic
artists. *Budil'nik*, as we have seen, was one of the many Russian satirical
journals that modeled themselves after *Simplicissimus*. In the pages of
Simpl Moor saw the clean lines and biting portraits of the Norwegian
cartoonist Olaf Gulbransson, and soon began imitating him. Gulbransson
provided an excellent model, both in his graphic economy of line and in
his political acuity. Moor's imitation was so evident that he became
known as "the Russian Gulbransson." This is acknowledged even by
Moor's Soviet biographer: "The study of Gulbransson for Moor was a
substitute for the professional schooling he never had."[28] In the Russian
context, imitation meant innovation.

During World War I *Budil'nik*, like many other Russian journals,

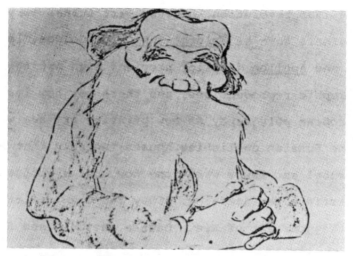

Portrait of Lev Tolstoi by Olaf Gulbransson, 1903.
From D. Gulbransson-Bjornson, *Olaf Gulbrannson: Sein Leben*
(Pfullingen, 1967).

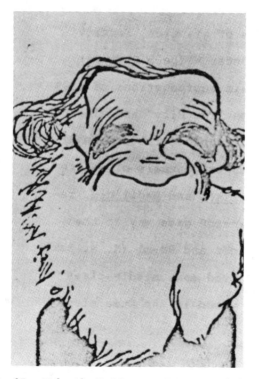

Portrait of Lev Tolstoi by D. Moor, 1918. From I. Khalaminsky,
D. Moor (Moscow, 1961).

became more patriotic and lost its sharply antagonistic stance toward the government. Satire previously directed against Nicholas II and his ministers now turned its guns on the Emperor William II and the Germans in general. Moor changed with the times and produced a number of chauvinistic drawings for Moscow journals in order to support himself. In 1916 he moved leftward once again, reviving his old drawings of Nicholas and joining the newly constituted, and more radical, *Budil'nik* editorial board. One of his more novel inventions to evade the censor was a black square which, held to the light, revealed a savage cartoon otherwise unacceptable.

The February 1917 revolution gave Moor, now thirty-four, new opportunities in art. *Budil'nik*'s attacks on the Provisional Government, the liberals, and General Kornilov were, as a result of the revolution, virtually free of any censorship. Moor felt revitalized. "I always preserved my youthful dreams of 1905," he recalled, "which determined forever my role as a political cartoonist." He also remembered the "special influence on me" of the work of Gulbransson and other *Simpl* artists.[29] With the October Revolution, antagonism to the Provisional Government gave way to propaganda for the Bolsheviks, and the satirical journal cartoon to the wall poster. For Moor, a friend of his later wrote, "the transition from antigovernment caricature under tsarism to revolutionary caricature and the poster was an organic one."[30] The 1905 Revolution had been the crucial experience of Moor's youth; the revolutions of 1917 caught him entering middle age and gave him a new role to which he responded with new enthusiasm.

VI

In 1918 the enthusiasm of many artists for the new Soviet Russia could not overcome the deplorable conditions for art. Many of the established art institutions had neither money nor personnel, journals were shutting down for lack of paper, and studios went unheated and unused. Yet for less well-known artists like Moor, the Bolsheviks provided new opportunities, new patronage, and a sense of participation in the defense of the revolution. During the May Day festivities in 1918, the first post-October revolutionary festival, Moor was given the job of decorating the façade of the Historical Museum on Red Square in Moscow. This marked the beginning of his artistic involvement with the Bolshevik Revolution.

Moor's commitment to the revolution deepened during the Civil War. In the summer of 1918, as the uprising of Czech troops along the Trans-Siberian Railroad initiated the more serious phase of the war, Moor was hired to paint the first agit-trains. The agit-trains were a form of propaganda on wheels directed toward the military front by the All-

Russian Central Executive Committee (VTsIK) under the supervision of Ya. I. Burov. Bearing names like "Red Cossack," "October Revolution," and "Red Star," the trains, seven or eight railway cars long, had facilities for distributing literature, showing movies, reproducing Lenin's speeches on gramophones, and providing the latest news from the front and the capitals. Under the direction of I. I. Nivinsky, a Polish graduate of the Stroganov School of Applied Arts in Moscow, Moor and a number of other artists found employment painting frescoes, or *rospisi*, along the wooden sides of the cars, for which they were paid in bread, tea, and sugar.[31]

For Moor, painting the agit-trains was a means of making ends meet in desperate times. He was much more interested in the art of the revolutionary poster. Moor conceived of the poster as a graphic equivalent of the revolutionary orator, who accompanied the trains and gave fiery lectures at towns and villages along the way. In 1918 he did his first poster for VTsIK, entitled "Before and Now," in which he established the principle of stark and simple contrast between opposites: we and they, good and evil, Red and White, the past and the future. In the summer of 1919, after producing more such posters, Moor went to work for the Red Army, or, more specifically, for the Political Administration of the Revolutionary Military Committee (PUR-Milrevkom) under the direction of Viacheslav Polonsky. In this capacity Moor soon became famous as the most talented poster artist of the Civil War.

By 1919 posters had become an important substitute for newspapers throughout war-torn Soviet Russia. Artists turned them out at a feverish pace in order to keep up with the battles and events of the day. In the autumn of 1919 General Denikin's armies were near Orel, and Moscow was in danger; by the time Moor finished his poster, "Everyone to Moscow's Defense!" the Whites had been driven back and the poster was never used. Between June 1919 and June 1920, Moor completed about twenty more posters of a symbolic and allegorical nature, utilizing models from tsarist movie posters, wartime posters, and *lubok*. He now went to work for the Russian Telegraph Agency, where he encountered a new form of agitational art.

In the autumn of 1919 ROSTA's director, P. M. Kerzhentsev (Lebedev), commissioned Mikhail Cheremnykh to produce a wall newspaper (*stennaia gazeta*) for distribution throughout the country. Instead, Cheremnykh devised a new form of agitational art, which would become known as the ROSTA "window." It consisted of a series of cartoons and captions that would fit into the ordinary store or house window and make up a kind of magnified comic strip. Wall newspapers were usually posted in the corridors of institutional buildings and were thus not accessible to the mass population; a series of drawings put up inside shop windows would be seen from the street by the ordinary

passerby. Moor, along with his friend Ivan Maliutin, the poet Vladimir Mayakovsky, and other Moscow artists, was soon involved with Cheremnykh in producing the windows.[32] Most of the collaborators were young ex-cartoonists from *Satirikon* or *Budil'nik* with little formal art training. Within several months there were groups of artists throughout the country designing and drawing windows to be distributed in hundreds and thousands of copies.

While working on the ROSTA windows, Moor continued his poster work for Polonsky and the army. Between June 1919 and December 1920 Moor drew thirty-three posters, which were distributed across Russia in production runs of more than one million copies each.[33] Like his earlier posters, these were agitational, sharp, demanding action from the viewer, caricaturing the enemies of Russia and her revolution. But Moor's style was now less symbolic and more heroic. It also appears that Moor, through Polonsky, discovered another European tradition from which to borrow: the wartime British poster.

VII

One of Moor's students, A. A. Deineka, once wrote that "with his first poster he became the commissar of propagandistic revolutionary art."[34] Actually, Moor's real fame came only in the summer of 1920 when he produced his best posters, which circulated throughout Russia and earned him national acclaim.

In 1920 the poster was at the height of its popularity in Russia; 1,719 posters were produced that year, five times as many as during 1919.[35] Under the direction of the Red Army, posters had become a major propaganda weapon. Moor's poster "Wrangel Still Lives!" drawn in June, had a circulation of 65,000 copies, for example. The major producer of posters in the summer of 1920 was the literary editing section (*litizdatotdel*) of the Revolutionary Military Council, for which Moor now worked. Under its auspices, Moor produced the most famous poster of the Russian Civil War.

Moor completed the poster "Have YOU volunteered?" in a single night in late June 1920. A Red Army soldier stands against a white background with a row of red factories, pointing directly at the viewer with his right hand and holding his rifle in his left. The question, with its YOU in capital letters at the top of the poster, leaps at the viewer. The red-on-white provides a striking color contrast as simple and direct as the outlines of the figure and the buildings. Like his earlier posters "The Third International" and "Everyone to the Front!" this poster contains a single dominant human figure. The Red Army soldier is stylized, generalized to all soldiers and none in particular; he is a collective type. Initially, Moor asked the viewer "*Will* YOU volunteer?" but then de-

cided to change the tense, thus implying that others, like the soldier in the poster, had in fact already volunteered. What led Moor to draw this impressive poster?

Moor's poster probably owes more to the British recruiting poster of World War I than to any native source. Polonsky may have overstated the case when he wrote later that in early Soviet Russia "the idea of the poster is borrowed from wartime English lithography," inasmuch as posters were rather universal by that time.[36] Moor's poster bore a strong resemblance to two particular British posters. The first, an anonymous poster of 1914, shows John Bull pointing at the viewer with a row of unequally spaced soldiers in the background, and asking: "Who's absent? Is it You?" The pointing finger and the size of the human figure are much smaller than in the second, more famous poster, by Alfred Leete (1915), entitled "Your Country Needs YOU!" Here, Lord Kitchener points directly at the viewer with a gloved hand almost identical to the one in Moor's poster, and the YOU is emphasized by huge capital letters. Whereas Leete commands, Moor inquires, but the visual similarity is striking.

There were a number of ways Moor might have seen British posters in Russia during or after the war, and a number of reasons why he would not wish to stress the fact. In 1916 the Academy of Arts in Petrograd held an exhibit of 217 British lithographs from the collection of a Russian businessman, S. V. Krasitsky. Although there is no evidence that Moor attended the exhibit, he probably heard about it from Polonsky and may have seen photographs or reproductions. At a time when the British were giving military aid to the White armies, it was certainly prudent to avoid comparison of Moor with Leete's Kitchener poster. Yet Leete's poster was well known and widely imitated throughout Europe by this time, with identical pointing fingers directed at the viewer. In America, for instance, the Uncle Sam of James Flagg told the observer "I want YOU for U.S. Army!" Leete's poster, one scholar concluded, "is the archetype of all wartime father figures, crib-source for a host of mimics."[37] Among them, it would seem, was Moor.

Whatever its specific origins, Moor's poster had an enormous impact in Soviet Russia in 1920 and afterwards. Some 47,455 copies were run off, and the poster quickly became the visual symbol of the Red Army in its final days of victory. Moor himself realized this only later. "In this poster," he recalled, "the Red Army soldier, pointing with his finger, fastened his eyes directly on the viewer and turned in his direction. I had many conversations about the poster. Some even told me they were ashamed by it, that it inspired shame if one did not volunteer."[38] It certainly established Moor's fame.

Moor's contribution to Soviet art did not end with his Civil War posters. After 1921 he returned to his original art form, the caricature.

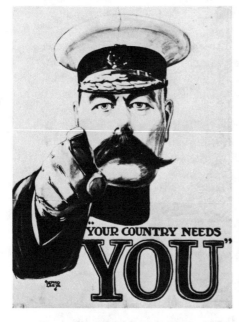

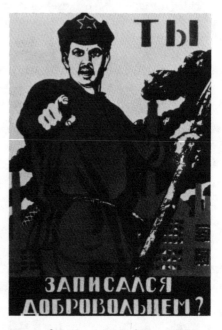

Poster by Alfred Leete, "Your Coun-
try Needs YOU," 1914. From M.
Rickards, *Posters of the First World
War* (London, 1968).

Poster by D. Moor, "Have YOU
Volunteered?" 1920. From B. S. But-
nik-Siversky, *Sovetskii plakat epokhi
grazhdanskoi voiny 1918–1921* (Mos-
cow, 1960).

During the war he had continued to draw for *Krasnoarmeets* and other
Red Army journals. Now, as a civilian living under the relative leniency
of the New Economic Policy, he helped organize the humor magazine
Krokodil in 1922 and the antireligious journal *Bezbozhnik* (Atheist)
a year later. In these journals, as well as in *Pravda* and *Izvestiia*, Moor
continued to establish himself as perhaps the foremost Soviet cartoonist
of the day. Completely self-taught, he ended by teaching others poster
and graphic art at the Higher Art Workshops and the Moscow Poly-
graphic Institute until his death in 1946. Like Dobuzhinsky, he had trans-
formed the satirical graphics of Munich into a revolutionary weapon.

Satirical graphics by its very nature contains an element of simplifica-
tion and antagonism. It draws out the weaknesses of its victims and
makes them humorous. There is no way to measure its ultimate effect
in shaping opinion, revolutionary or otherwise. In both 1905 and 1917
it became an important weapon of revolutionary propaganda. Both
Dobuzhinsky and Moor found that it provided them with a new audi-
ence, a new market for their art, and fame in their thirties. Revolutionary
involvement coincided with personal success.

4

From Naturalism to Symbolism:
Meyerhold's Theater of the Future

A perfectly new life dawned that night for Nekhlyudov; not because he had entered into new conditions of life, but because everything he did after that night had a new and quite different meaning for him.

—L. N. Tolstoi, *Resurrection*

Theater played a crucial role in Soviet cultural life in the 1920s, and Vsevolod Meyerhold was the most exciting experimental director of the age. He embraced the revolution almost immediately, joining the Communist Party in 1918, and established his reputation as a revolutionary director with the production of Vladimir Mayakovsky's *Mystery-Bouffe*. In 1920 Lunacharsky named him to head the Theater Section of Narkompros. In his productions of the 1920s Meyerhold introduced a number of innovations on stage, including audience participation, the sending of actors into the audience, the use of abstract wooden sets and of machines on stage: cars, machine guns, cameras, movie projectors, wheels, and movable screens. For Fernand Crommelynck's *The Magnanimous Cuckold* (1922), Meyerhold employed sparse backdrops and ramps on which his actors moved in accordance with his "biomechanics" gymnastic exercises. For Ilya Ehrenburg's *Trust D. E.* (1924), he placed an entire jazz band on stage. Even when performing the Russian classics, such as Ostrovsky's *The Forest* (1924), Gogol's *Inspector General* (1926), or Griboedov's *Woe from Wit* (1928), Meyerhold experimented with movable sets, workers' coveralls for eighteenth-century characters, flashing neon lights, and other novelties. The circus, the music hall, and vaudeville all provided Meyerhold with new methods to show his audience that what they were watching was not reality but artifice.[1]

Meyerhold's work in the 1920s was part of the larger "constructivist" element in early Soviet culture. The deliberately artificial conventions of his stage were no mere escape from the real world, but an example of

man's power to dominate it. His workers' choruses were suggestive of early Soviet "collectivism," his biomechanics of the techniques of agitation. Yet in the 1920s Meyerhold only brought to fruition a revolution in theater that he had effected long before 1917. "By 1905," one scholar has written, "Meyerhold had actually done very little that could be considered revolutionary"; yet by the end of 1906, in his staging of the poet Alexander Blok's *Balaganchik* at the theater of Vera Komissarzhevskaya, Meyerhold had arrived at the "quintessential production of his pre-Bolshevik years," which "permanently influenced his ideas about theater."[2] *Balaganchik* was a symbolist drama with *commedia dell'arte* characters; the audience was deliberately made aware of the artificiality and theatricality of the production by the use of a stage-within-a-stage, masks, a chorus, and cardboard figures through which the actors placed their heads. Later Meyerhold would turn quite naturally to revolutionary and constructivist themes and methods, but would retain the principle of theater as convention which he established in 1906. Meyerhold's conversion from naturalism to symbolism around 1905 anticipated his revolutionary theater of the 1920s.

One can therefore talk fairly precisely about a moment of innovation in the case of Meyerhold. *Balaganchik,* or *The Fairground Booth,* is generally considered to be the first Russian "symbolist" play, and Meyerhold's breakthrough to convention from the naturalism of the Moscow Art Theater. Like Dobuzhinsky, Meyerhold belonged to the generation of the aesthetes, but in 1905 he was seeking a more innovative art by means of simplification and abstraction, in theater rather than in graphic art. Lunacharsky, Dobuzhinsky, and Meyerhold had all just turned thirty in 1905, and undoubtedly all knew each other from the famous Wednesday soirées held at the apartment of the poet Viacheslav Ivanov on the seventh floor of Dobuzhinsky's apartment building. Both Dobuzhinsky and Meyerhold found the inspiration for innovation in Munich, in Meyerhold's case, in the theories of a "theater of the future" propounded by the director Georg Fuchs in his book *Die Schaubühne der Zukunft,* or *The Theater of the Future.* Inspired by Fuchs's ideas and supported by the patronage of the radical actress Vera Komissarzhevskaya, Meyerhold was able to bring European symbolism into the Russian theater and thereby to establish his reputation as an innovative director.

I

At the turn of the century the European stage was dominated by naturalism.[3] Writer and director commented on real life in a believable manner by the use of accurate and detailed sets and realistically costumed actors and actresses. Theater purported to imitate reality, not

to transcend it. Like many other intellectual and artistic trends of the time, naturalism originated in the Paris of Emile Zola and moved eastward into Russia in the 1890s. The Théâtre Libre, founded in Paris in 1887, became the model for the Berliner Frei Bühne (1889), the Independent Theater Society in London (1891), and the Moscow Art Theater (1898). The latter also copied the methods of the traveling Meiningen Court Theater, which toured Russia in the 1880s. All of these theaters produced meticulously realistic plays in which the characters were not ideals or types, but unique and believable individuals drawn from everyday life. The most popular plays of the day were all social commentaries: Ibsen's *Ghosts, A Doll's House,* and *The Wild Duck;* Strindberg's *Miss Julie;* Hauptmann's *The Weavers;* Chekhov's *The Sea Gull, The Three Sisters,* and *The Cherry Orchard.* For most theatergoers around 1900 the stage was a reflection of their real lives, not an evocation of their dreams, fears, and fantasies.

Symbolist theater was beginning to emerge at the turn of the century, as we have seen in the work of Maeterlinck and Verhaeren. Instead of detailed sets, symbolist drama depended on the creation of a mood through poetry, vision, silences, and gestures, which tapped the emotions of the audience. Instead of imitating real life, symbolist drama sought to conjure a more mysterious world beyond, behind, or beneath apparent reality. Its progenitors were poets and musicians—Baudelaire, Wagner, and Mallarmé, most notably—and its leading proponent in Europe by 1900 was Maeterlinck. From *Pelléas et Mélisande* (1892) through *The Blue Bird* (1908), we have seen how Maeterlinck became increasingly concerned with the theme of death, and with evoking a world that lay beyond, but which was still in communication with the living. He conveyed this world on stage through background music, silences, mime, and heavily draped backdrops, creating an atmosphere in which dark forces appeared to manipulate the actors and transform them into puppets. The audience, too, experienced the feeling of spiritual forces beyond its control. Symbolist theater was religious in nature, and it shared religion's concern with human emotions about love and death.

From a technical point of view, symbolist theater reflected a decline in the quality of acting and the appearance of new forms of staging and lighting. Two Swiss admirers of Richard Wagner made important contributions in the latter respect: Adolphe Appia, who sought to achieve stage unity and mood through music integrated closely with sets, plot, and acting; and Emile Jaques-Dalcroze, who created a philosophy and method of body motion known as "eurhythmics." Both Appia and Dalcroze made use of the new incandescent spotlight, introduced around 1900, to provide a magical combination of color in background and costumes and to free the actor from the tyranny of footlights. In England the flamboyant director Gordon Craig attempted to do away with the

actor entirely, transforming him at the director's will into a Nietzschean "Super-Marionette." He also utilized doors, steps, and ramps to open up movement for the actors on the stage. All of these experiments led to a new theater of suggestion rather than explication, mood rather than message, gesture and movement rather than speech.

Like naturalism, symbolism originated in Paris and moved eastward across Germany into Russia. In France it dominated the Théâtre d'Art; in Berlin, the Kleines Theater of Max Reinhardt; and in Munich, the Munich Art Theater of Georg Fuchs. Fuchs was especially important as a transmitter of European symbolism to Russia, both because many Russians in Munich saw his productions and because he published several books about his theatrical technique. As a director Fuchs sought to create a mystical experience for his audiences by the use of sight and sound rather than by the spoken word. He had the Munich architect Max Littmann build a small theater auditorium with steeply pitched seats to create greater intimacy and involvement. In addition, he divided the stage into two planes: a proscenium, or forestage, in front of the footlights; and an inner stage, which could be raised or lowered mechanically.

Around 1900 Munich had had two main legitimate theaters: the *Residenztheater*, which featured a revolving stage and a conventional repertoire of Ibsen, Strindberg, and Shaw, and the *Schauspielhaus*, which changed its bill almost nightly and produced a more controversial repertoire, including Gorky's *Lower Depths*, Ibsen's *Ghosts*, and Maeterlinck's *Monna Vanna*. To an English visitor from Vienna, both of Munich's theaters seemed provincial.[4] But within a few years Munich became more advanced. In 1908 another visitor from Vienna, Georg Fuchs, succeeded in establishing an experimental Munich Art Theater to fulfill his dream of a "stage of the future," which would transform theater into festival.

Fuchs began recording his ideas on theater in the *Wiener Rundschau* in 1900 when he was thirty-two.[5] In 1906 he gathered his essays in *Die Schaubühne der Zukunft*. According to Fuchs, modern machine civilization was destroying traditional culture and a new generation was emerging that would have to master those machines. A new culture was in the making. Traditional middle-class theater would give way to a new theater of festival, which would draw on medieval mystery plays, primitive rituals, and the classical theater of Dionysus to create a new relationship between theater and audience. The purpose of the "theater of the future," wrote Fuchs, would be to "stimulate and then discharge an exuberant tension" in the audience through "the suggestion of rhythmic power." This would create a purifying catharsis in the audience, a sense of psychological release. "Dramatic art," Fuchs suggested, "is primarily the rhythmic movement of the human body in space"; it

should utilize the techniques of carnivals, acrobats, circuses, and the Japanese Kabuki and No theaters to emphasize the non-spoken means of communication: foot stamping, gestures, hand-clapping, finger snapping, and so on.[6] Mood and movement were the essence of theater.

Fuchs stressed the importance of unity between actor and audience and among the various arts. The stage should become the "festival center of the entire culture," with outdoor productions. It should combine art, architecture, music, and poetry into a single whole. The stage should be broken down into three separate planes as "relief stages," actors should use their bodies as much as their voices, and electric spotlights should be used to replace footlights and to bring the action on the proscenium right down to the audience. Side walls should be eliminated to reveal the actual machinery of the theater. These innovations would create a theater whose purpose was not to imitate reality, but to provide "rhythmic play" and the "movement of groups and crowds in front of a stable background."[7] Theater would not imitate life, but select certain elements from it and rearrange them to create a mood.

Fuchs was enthusiastic about the great outdoor festivals he observed in Bavaria. These included the Wagner productions at Bayreuth, the passion plays of Oberammergau and Dachau, street Punch-and-Judy shows, church festivals, and the revelry of Oktoberfest and Fasching. As on the indoor stage, festival acting should be a matter of gymnastics, acrobatics, and mime, rather than of words. The sense of a crowd and of audience participation was vital. All of this would create "an enchanted world of make-believe, of joyous vitality, of dreamlike fantasy, and of a drama that has its roots in the body, in the animal instincts, and in the senses."[8]

Symbolist drama was still a novelty around 1905, but an increasingly popular one. It stressed the unreal over the real, the group over the individual, movement and rhythm over speech, and psychological appeal to the emotions over conformity of mind to reality. It appealed to the dreams and nightmares of a believing audience, thus containing a religious element. These qualities combined to give symbolist drama powerful potential as a psychological weapon for manipulating an audience with a will to believe.

II

Meyerhold belonged to the generation of the aesthetes, although he ultimately achieved fame as the leader of constructivism in the early Soviet theater. In addition, he was a non-Russian raised in the provinces. Penza, where Meyerhold was born in 1874, was a Siberian trading center for grain, timber, and spirits along the route between Moscow and Samara; in 1914 it had a population of 80,000. The Meyerhold family

was relatively well-to-do. Meyerhold's father owned a vodka distillery, an estate with a winery in a nearby village, and four houses in the area. A German citizen, the elder Meyerhold insisted that the family speak German in the home and kept a portrait of Bismarck prominently displayed. Meyerhold's mother came from a Baltic German family, originally descended from French immigrants. Vsevolod, their eighth child, was baptized a Lutheran as Karl Theodor Kazimir and was raised as a German.

Meyerhold's provincial origins did not imply an absence of culture. While his father was a businessman, Meyerhold's mother was both artistic and musical. With her encouragement he attended plays in Penza from an early age and took both violin and piano lessons. Guests in the Meyerhold home often included actors, musicians, and schoolteachers. Meyerhold's father failed to persuade his children to enter the world of business; two of them left home for the stage, and the eldest married an actress, for which he was banished from the family. Although relations between Meyerhold's parents appear to have been amicable, their divergent interests expressed a division between art and life that was to haunt Meyerhold throughout his creative work.

A further sense of separation between art and life stemmed from Meyerhold's cultural ambivalence. At home he spoke German; in the streets and at school he spoke Russian. His piano teacher was a German, his violin instructor a Pole. As a child, his readings included not only the classics of Russian literature but the popular German magazines of the day: the comic *Fliegende Blätter*, the acerbic *Kladderadatsch*, and the popular *Über Land und Meer*. The tales of Baron Munchhausen mixed with the sights and sounds of Russian traveling circuses with their puppet shows and carousels. The ambivalence of being a German in Russia was heightened by the division between the stern expectations of his father and the cultural world of his mother. By the time he reached adolescence, Meyerhold recorded in his diary, he felt he was living "two lives—one real, the other a dream," and he much preferred the world of the dream and the stage.[9]

Failure at school heightened Meyerhold's identity problem. At the second Penza gymnasium, which he entered in 1884, Meyerhold was kept back three times and completed the curriculum only at age twenty-one. The russification policies of Alexander III further complicated life for a young German student. A slow learner, Meyerhold was bored with all but his history and mathematics teachers. But there were many intriguing alternatives to school: a young socialist tutor hired by his father who introduced Meyerhold to the writings of Chernyshevsky, Pisarev, and Lavrov; a colony of Polish revolutionary exiles who had settled in Penza by order of the Imperial government; and the world of the local stage. By 1892 Meyerhold, at eighteen, was involved with

acting and had appeared in a local production of Griboedov's *Woe from Wit.* Yet in the eyes of the authorities the theater was no less suspicious than political activity, and Meyerhold often acted under a pseudonym in order to avoid censure at school.

It does not appear extreme to employ the term "identity crisis" to describe Meyerhold's late adolescence. In 1892–1893 he was uncertain of his own nationality and came to grips with the reality of death. Meyerhold's father died in February 1892. The son's reaction was apparently not only personal and psychological, but cultural: actually, his father's death emancipated him from his German youth and freed him for a Russian adulthood. One day he read a blustery speech by William II and realized that he was a German citizen subject to conscription into the German army. "How can I call Germany my country?" Meyerhold wrote in his diary in the autumn of 1893. "How can I, who was born in a purely Russian city, grew up and was educated among Russians, among people from whose lips I heard nothing about Germany and its state or national interests, how can I not be offended at what someone completely foreign to me has to say?"[10]

> I am nineteen and for nineteen years I have lived among Russians, become accustomed to the ways of the Russian people. I love them. I was raised on Gogol, Pushkin, Lermontov, Turgenev, Tolstoi, Dostoevsky, etc., etc.—great Russian poets, writers. I even pray in Russian and suddenly I am supposed to call Germany 'my country'?

In 1895 Meyerhold finally graduated from the gymnasium. On June 25, 1895, he acquired Russian citizenship and assumed a Russian name, Vsevolod Emelianovich.

The gymnasium degree opened the way to a university education, and his father's estate provided the financial means. In the autumn of 1895 Meyerhold left Penza to enroll in the Law Faculty of Moscow University. In Moscow he was one of many young students from the southern provinces who streamed into the city in search of schooling, adventure, and work. Again Meyerhold soon became bored with his studies and began attending plays rather than lectures and visiting the Tretiakov Gallery; he was refused admission to the university orchestra as a violinist because he simply stopped practicing. Everything seemed to push him away from school and toward the stage. In January 1896 he dropped out of the university; in April he married Olga Munt, an actress he had known in Penza. He tried once more to enroll in the university, this time in the Medical Faculty, but was rejected. By the spring of 1896 Meyerhold had resolved to make the stage a career.

Meyerhold at twenty-one was thus a talented provincial actor in search of work. He had failed to achieve success within the higher edu-

cational system of the country he had recently adopted as his own. He had lost his father and taken on the responsibilities of marriage. And he now sought on stage what had eluded him in life: success in a world he could control.

III

Meyerhold displayed his first interest in radical activity in 1896, while organizing a summer stock company in Penza; here he met the young poet Aleksei Remizov, then an exiled Marxist, who introduced him to the writings of Plekhanov. Meyerhold's reading of Marx and Plekhanov did not become the catalyst it had been for Lunacharsky, although in later years he found it convenient to emphasize this youthful contact. Instead, he returned to Moscow that autumn to enter the Musical Dramatic School of the Moscow Philharmonic Society, the more avant-garde alternative to the Imperial Dramatic School. Through its director, V. N. Nemirovich-Danchenko, Meyerhold found himself involved in a revolt against traditional theater which would lead to the founding of the Moscow Art Theater. He also became familiar with European modernism through the plays of Ibsen, Hauptmann, and Maeterlinck.

Meyerhold entered the theater at a moment when Russian theatrical tradition was under fire. In March 1897 more than a thousand actors, actresses, and directors from across Russia met in Moscow in a national congress to deplore publicly the state of the art. Theater in general, it was said, was in a sad condition in Russia because of the lack of funds; actors and actresses were woefully underpaid; the taste and the repertoire of Russian theaters, both in the capitals and in the provinces, were atrocious. Meyerhold was getting good reviews in the Moscow papers for his performances at the Philharmonic, but few other actors had Meyerhold's talent, or the income that his father's estate provided. Many young theater people were unhappy with their art, and they made it clear at the congress that a new kind of theater was needed. In June 1897 Nemirovich-Danchenko and the director Konstantin Stanislavsky met for eighteen hours at a restaurant in the Slaviansky Bazaar Hotel in Moscow and decided to launch a new theatrical enterprise: the Moscow Art Theater.

The artistic reforms of the Moscow Art Theater (MAT) are now established tradition. But in 1898 they were considered radical innovations: the director would dictate to the actor, not vice versa; favoritism on the part of the front office would be eliminated; the public would not be allowed to enter or leave the auditorium during a play, a common practice at the time; sets would be designed by top artists for each individual play, not by decorators as a stock item; actors would contribute

from their salaries to a joint fund for shareholders and would undergo rigorous training to submerge themselves psychologically in their roles. None of this was easy to achieve in the face of financial need and church censorship. In fact, the first MAT season (1898–1899) produced a deficit of 45,000 rubles; only a contribution of 200,000 rubles by the rich merchant and sympathizer with radical causes, Savva Morozov, saved the undertaking.[11]

The Moscow Art Theater provided Meyerhold with his first professional training as an actor and a director. He worked for the MAT off and on until the end of 1905. Even his own troupe, which he formed to tour the provinces, was primarily inspired by the MAT's repertoire and naturalist methods. Within the MAT Meyerhold was an immediate success. "As an actor," Nemirovich-Danchenko recalled, "Meyerhold gave no indication of being a pupil. He showed a measure of experience and mastered his roles with unusual quickness."[12] He was soon one of the best MAT actors, drawing a salary of more than one hundred rubles a month at a time when his own financial situation became desperate; his father's business had collapsed in the winter of 1897–1898, eliminating a major source of income for Meyerhold. In the MAT Meyerhold played a variety of traditional roles in plays like *The Merchant of Venice* and *Tsar Fedor*; he also acted in newer productions by Chekhov and Gorky. By 1900 Meyerhold, at twenty-six, had tasted success as an actor.

Meyerhold soon felt confined by the MAT. His favorite role as Treplev in Chekhov's *The Sea Gull* may have represented an omen of impending crisis. Chekhov greatly admired the role when he first saw Meyerhold perform it in 1899 in Yalta. Treplev is a would-be playwright of twenty-five, which was Meyerhold's age in 1899. "We must have new forms," cries out Treplev, "New forms we must have, and if we can't get them we'd better have nothing at all."[13] Treplev sees all art as "stale routine" and perceives himself as a great unrecognized talent whose youth is fast disappearing. Ridiculed by friends and family, he also confronts the established talent of an older and highly respected writer, Trigorin, who is the object of affection of the girl Treplev loves. The play ends with Treplev's suicide. "The tragedy is self-evident," Stanislavsky observed; "Can the provincial mother understand the complex longings of her talented son?"[14]

At the turn of the century Meyerhold, too, appears to have gone through a period of torment and apparent failure. During the 1900–1901 season Stanislavsky gave him fewer good roles to play; Meyerhold became increasingly outspoken about what he considered the repetitious quality of the MAT repertoire. "The most dangerous thing for the theater," Meyerhold wrote in his notebook in 1901, "is to serve the bourgeois tastes of the crowd." By the spring of 1901 he had become

frustrated and depressed, particularly after witnessing the bloody repres-
sion of a mass student demonstration at the Kazan Cathedral in St.
Petersburg while on tour with the MAT. "I am distraught," he wrote to
Chekhov, "and am thinking about suicide." "My life," he continued,
"seems to me a long, painful crisis, like some terrible protracted disease.
I can only wait and wait until this crisis resolves itself one way or an-
other. What lies ahead for me is not terrible, if there were only an end,
any kind of end." And again:

> I suffer often because I have a sharply developed self-conscious-
> ness. I suffer often because I know that I am not what I should be.
> I am often distraught with myself, with what is around me. I have
> constant doubts, I love life, but I run from it. I despise my weak will
> and I want strength, I need work. I am unhappy more than I am
> happy.

Such gloomy self-analysis was tempered by optimism. "Ahead lies new
creativity," Meyerhold felt, "because it is a new life. The new wave
has already caught hold of me." Russian theater, he concluded, now had
before it a "great mission" to fulfill in an evil and immoral society, the
"reconstruction of everything which exists around us."[15]

Meyerhold's remarks may remind us of the "superfluous man" of
nineteenth-century Russian literature, or of the agony of the Russian
intelligentsia in general. But there were more specific reasons for his
crisis. At twenty-seven, he had achieved some success within the MAT,
but had also found limits; in the 1901–1902 season there were more
disputes, more unhappiness, and still fewer roles. In addition, the old
division in his mind between the "real" world around him and the more
controllable world of the stage persisted. Sensing the urgent need for
social and political change in Russia, he began to think of the theater as
a vehicle for such change, although precisely how an innovative theater
might help transform society was as yet unclear. In 1902 he left the
MAT with several other actors and actresses and organized his own
theater, the Society for New Drama (*Tovarishchestvo novoi dramy*) in
the provincial town of Kherson. He was exchanging the role of Hamlet
for that of Don Quixote.

IV

The town of Kherson, Chekhov once wrote to Meyerhold, "is not
Russia and it is not Europe";[16] there would be a public only for the
fairground booth (*balagan*), not for the legitimate stage. But Meyerhold
hoped to establish a revolutionary theater in Kherson that would have
been impossible in Moscow. Here in the provinces he could be inde-

pendent, the director of a theater of social action and artistic innovation. In the spring of 1902 Meyerhold traveled to Italy and in the factories of Milan discovered signs of the same ills of industrial society now appearing in Russia. He felt that the theater should somehow cure those ills.

Meyerhold's first season proved more imitative than innovative. The Society for New Drama was both an artistic and a financial success in Kherson and in other towns where it played. In Tbilisi, where the troupe spent the 1904–1905 season, young people found it far superior to the local productions. But the theater repertoire, according to one of Meyerhold's actors, was "copying exactly the Art Theater," emphasizing conventional plays acceptable both to the public and to the Kherson city duma, which provided an auditorium and a subsidy.[17] The dominant tone was naturalism as represented in the works of Ibsen, Chekhov, Hauptmann, and Gorky; a symbolist work such as Maeterlinck's *Monna Vanna* or Przybyszewski's *Snow* was definitely an exception. Meyerhold was independent of the MAT, but was not yet an innovator.

For Meyerhold, as for Lunacharsky and Dobuzhinsky, the Revolution of 1905 presented new opportunities following initial disruption. In January there were strikes and food riots in Tbilisi and theaters closed down for an entire week. After its final production of *Woe from Wit* in February, the Society faced an uncertain future. Actors were drafted into the army to fight in the Russo-Japanese War. Chekhov had died the summer before and could no longer lend his moral support to the enterprise. Meyerhold, just turned thirty, now had a wife and a daughter to support. He was thus at another turning point in his life, facing unemployment and failure in the midst of social and political upheaval. At this moment of desperation he received a telegram from Stanislavsky in Moscow inviting him to open an experimental studio theater under the auspices of the MAT.

Stanislavsky's experimental Studio Theater on Povarskaia Street was intended to help Stanislavsky and Nemirovich-Danchenko out of financial disaster with the MAT. The theater had had a bad season in 1904–1905, but art patron Savva Mamontov was willing to invest 15,000 rubles in an experimental studio composed of Stanislavsky's "young enthusiasts" from the MAT along with Meyerhold's troupe from the provinces.[18] Stanislavsky rented a new building in Moscow, assembled the troupe in May, and gave them the summer to rehearse at his Pushkino estate outside Moscow. Unfortunately, the entire project never got beyond the rehearsal stage. During the turmoil of late 1905, martial law, curfews, street fighting, and a threatened actors' strike combined to close the MAT and its Studio Theater. That winter Stanislavsky loaded his company into a railroad train and set out on a European tour, following Diaghilev in search of a new public outside Russia.

The Studio Theater did not fail because of political circumstances alone. Meyerhold's first attempt at a symbolist theater was plagued by artistic problems as well. In Stanislavsky's words, the Studio Theater was an attempt to produce "the unreal on the stage"; "it was necessary to picture not life itself as it takes place in reality, but as we vaguely feel it in our dreams, our visions, our moments of spiritual uplift."[19] To evoke such a mood, Meyerhold commissioned the composer Ilya Sats to create the musical effects of wind and waves and hired several excellent young painters to design the sets, among them N. N. Sapunov and S. Yu. Sudeikin, subsequent contributors to the symbolist Blue Rose exhibit. Yet the painters were amateurs at building sets and mock-ups, which had to be constructed to scale for a smaller stage and often came unglued; by autumn they were rebelling against such work with the slogan "Down with the Mock-up!" and would paint only backdrops and two-dimensional sketches, rather than the required wooden models.[20] The actors were equally unhappy at having their roles restricted to poses, gestures, and body movements, for which they had no training. In addition, salaries were low and the revolutionary mood caught on through whispered intrigue and secret meetings of the dissenters. Thus Meyerhold faced insurgency in his own theater in 1905. Although the Studio mounted an impressive dress rehearsal of Maeterlinck's *Death of Tintagiles*, its actors and actresses were unprepared for the new demands of a symbolist theater.

The MAT Studio Theater of 1905 thus failed to bring European symbolism onto the Moscow stage. Meyerhold's ideas were largely improvisations, and they did not inspire the necessary skills in either actors or set painters. In the winter of 1905–1906 Meyerhold, at thirty-one, once again found himself unemployed and left for St. Petersburg with some of his troupe.

Stanislavsky was probably right in observing that Meyerhold had tried to create a theater without actors, a theater of mood, in which the all-powerful director attempted to reach his audience through sight and sound rather than words. "The talented stage director tried to hide the actors with his work, for in his hands they were only clay for the moulding of his interesting groups and mise-en-scène, with the help of which he was realizing his ideas."[21] In Moscow in 1905 Meyerhold had learned the difficulty of reducing conventional actors to puppets and creative painters to carpenters. In Petersburg he hoped to create a symbolist theater independent of both.

V

When Meyerhold arrived in St. Petersburg in early 1906 he found to his surprise that he was not unknown. His poet friend from Penza days,

Aleksei Remizov, wrote for the symbolist journal *Vesy* (Scales) and had followed Meyerhold's work in both the Society for New Drama and the Moscow Studio. Remizov also belonged to a circle of symbolist poets in St. Petersburg who were interested in theater. *Vesy* complained that at the time there was "neither a repertoire, nor actors, nor a public" there, except for the theater of Vera Komissarzhevskaya.[22] Komissarzhevskaya was an actress, a political radical and friend of the Bolshevik leader Leonid Krasin, and an innovator who had been looking for a new director for her own theater, opened in Petersburg in 1904. Since the autumn of 1903 she had been interested in Meyerhold for the post.

Unlike Moscow, Petersburg had already discovered European symbolism. The symbolists were mainly poets and artists who gathered at the apartment of Viacheslav Ivanov on Wednesdays to discuss their work. In January 1906 Meyerhold reported to them about his own experiments; the group included the poets Alexander Blok and Georgy Chulkov, Gorky; the *Zhupel* artists Dobuzhinsky, Lanseray, and Bilibin; and a number of other intellectuals. For several months Dobuzhinsky and the *Zhupel* circle had talked of extending their political satire from journalism into theater; the symbolists, too, were interested in a "theater of Dionysus" to be called *Fakely* (Torches). Both graphic artists and symbolist poets welcomed Meyerhold to their group. In fact, by the end of the evening Chulkov had persuaded Blok to turn his poem "Balaganchik" into a play which could be the basis for a symbolist theater.[23]

Meyerhold was enthusiastic about his new opportunities in Petersburg. It was just as well, he wrote his wife, that the Studio had failed; "It was my salvation because it was neither fish nor fowl." Even his imminent departure for the provinces for another season with the Society for New Drama did not seem to depress him. The sun and frost of wintry Petersburg, he noted, brought back memories of his youth in Penza. In addition, he was relieved to have survived the terrible events in revolutionary Moscow in late 1905, where he had fearfully walked the streets at night with a revolver in his pocket. More than once he had brushed close to death. "Having lived through so much," he wrote, "I feel young, still young."[24] At thirty-one, Meyerhold was ready to begin again. Although *Fakely* fell through for lack of money, in February Meyerhold received a telegram from Komissarzhevskaya offering him the directorship of her theater for 1906–1907.[25] In May they met to sign a contract for 4,500 rubles. Having found a theater, a patron, and a play, Meyerhold was about to produce his first truly innovative, symbolist work.

Symbolism at the time was a movement in poetry that sought to transcend the apparent world through the magic power of words, rather than to change it through action. Many of the metaphors and themes

of Russian symbolism derived from the peculiarities of the Russian language and the theosophical doctrines of the philosopher Vladimir Soloviev. But its roots as an intellectual movement lay as much in Europe as in Russia. The myth-making power of words integrated with color and sound was embedded in the writings of Goethe and Mallarmé, and of Nietzsche and Wagner. Baudelaire's notion that there exist "correspondences" between colors and sounds was enormously important to the symbolists. Andrei Belyi observed that "colors are the substance of a poet's soul";[26] Chulkov, who was now calling himself a "mystical anarchist," expressed the synaesthetic power of the moment of symbolic perception of the true reality behind the veil:

> There are instants when the human soul, having rejected the bonds of logical consciousness, enters into a direct communication with the beyond. Then all these earthly sounds, colors, and scents assume another significance; objects are lit from within; their radiance reflects in our soul like a multicolored rainbow . . . another world opens before us; we hear the sound of color, we see the sounds.[27]

The symbol was the key to the true reality, a reality beyond language, a reality of the soul, a spiritual reality. It suggested mysticism, an escape into the world of personal experience, emotion, and fantasy popular in Russia after the shock of 1905. In works such as *Prometheus*, *Poem of Ecstasy*, and *Poem of Fire*, the Russian composer Alexander Scriabin sought to create a mood and to unify the senses through a color organ whose visual projections would correspond to the music. Symbolism in Russia was a kind of esoteric religion which sought to synthesize and unify all the senses and the arts into a single whole capable of providing an elite of seers with visions of the true world behind the apparent material one. The artist thus became a kind of priest; in Blok's words, he was "the sole possessor of a hidden treasure; but there are others around him who know about the treasure. . . . Consequently, *we*, the few who know, are the Symbolists."[28] The symbol revealed one world in the apparent terms of another, but only the few would recognize that revelation.

The central figure among the Petersburg symbolists in 1906 was the poet Viacheslav Ivanov. At forty, Ivanov had just returned from thirteen years in Berlin, Rome, Athens, and Paris, where he had studied the classics. His European model was Nietzsche, who greatly influenced his views on what ancient Greek culture was like. Ivanov established a cult of the Greek god of wine, Dionysus, whom Nietzsche, in *The Birth of Tragedy* (1872), had seen as the central figure in the creative drive of all art, especially theater, and through whose festivals the audience could find personal ecstasy and social catharsis. Ivanov had studied Dionysian cults and mystery religions in Greece and in 1905

was writing a book on *The Hellenic Religion of the Suffering God*. In Ivanov's view, Dionysus became a symbol of "self-forgetting" and "ecstasy" by which one could return to the unconscious, the original unity of one's childhood, and the life-giving force of *eros*, the suggestive title of a cycle of poems he wrote in 1907.[29] For Ivanov poetry thus came close to being a form of therapy, as did theater. He disseminated his ideas at his "Wednesdays," which were as important for Petersburg intellectual life in 1906 as Mallarmé's "Tuesdays" had been in Paris a few decades earlier.

By the spring of 1906 Meyerhold had found an environment favorable to innovation in the theater in Russia. The final stimulus for that innovation came not from Russia, but from Europe.

VI

Georg Fuchs's *Theater of the Future* was a revelation for Meyerhold when he first read his little book in the spring of 1906. What Meyerhold discovered in Fuchs was a sense that movement and body motion were more important than words on the stage, and that music and color could be employed to create mood and suggestion for the psyche of the audience. Fuchs helped Meyerhold by giving him a theoretical justification for what he was already attempting to do. Fuchs's book encouraged him in considering the stage a world apart from the real world, a world of game and artifice which should not imitate reality but which could tap the emotional recesses of the audience in far more powerful ways.[30]

Throughout 1906 Meyerhold experimented with Fuchs's ideas. In Poltava that summer he had his actors treat their movements as dance steps in a Japanese manner and on several occasions utilized violet lighting for mood. In his first productions for Komissarzhevskaya he continued these experiments. In *Hedda Gabler* (November 10) he arranged costumed actors as color masses, utilized a relief stage only twelve feet deep, with overhead lighting to bring the actors onto the proscenium, and introduced long silences. In Maeterlinck's *Sister Beatrice* he had the Sisters speak in unison, move as a group, and act as a chorus, again bringing the backdrops forward and utilizing extended pauses and gestures. But all of these experiments were preliminary attempts to employ new techniques. Meyerhold's first completely innovative work along the lines of Fuchs's theories was Alexander Blok's *Balaganchik*, first performed in St. Petersburg on December 30, 1906.

Blok himself had been moving toward symbolism in the theater, as well as in his own poetry. As a former actor, he was increasingly critical of the MAT for its attempt to imitate reality rather than to transcend it. Theater, like poetry and the spoken word, he felt, should provide a

reflection of deep-rooted popular myths and collective desires in the manner of the theater of Dionysus. It should employ all means necessary to create a proper mood in the audience and a sense that what it was seeing was game and artifice, not reality. Thus when the "*Fakels* and *Zhupels*," as Blok called them, asked him to transform a poem into a play for a new Russian symbolist theater, he agreed.[31]

Blok's play *Balaganchik* confuses the real and the unreal, and is especially concerned with death. It is more of a playlet than a play, a short farce based on the stock *commedia dell'arte* characters that had populated Blok's poetry since about 1902: Pierrot, Harlequin, and Columbine. It consists of a single rather short act and was written in about three weeks. By using the theatrical setting of a fairground booth, puppet-show characters, and masks for the actors, Blok made explicit the artificiality of the play. The audience was familiar with the theme, since the Petroushka puppet shows were a traditional part of the St. Petersburg Lenten carnival season. But Blok exaggerated his game elements further by having the booth become a stage upon a stage and by employing an "Author" to provide constant explanations to the audience. In addition to the old triangle of Pierrot, Harlequin, and Columbine, he placed a Maeterlinck-like chorus of "Mystics" at a table parallel to the front of the stage.

Balaganchik opens with the Mystics seated at the table awaiting the coming of "Death," a character in whom Pierrot believes he sees his loved one, Columbine. But Pierrot's rival Harlequin arrives to take her away to a carnival at the fairground, from which she returns in the person of "Death." Now Pierrot does not know what is real and what is not, nor does the audience. In the end reality dissolves completely when Harlequin leaps through a window on stage, which he discovers is made of paper, and then tears it to pieces in anger. Other characters "die" bleeding cranberry juice. The entire play interlaces the real and the imaginary in a game that the audience must observe but cannot resolve. Death is real. But who is Death and when will he choose to come?

Balaganchik epitomized the symbolist perception of the world on two levels: the importance of nonverbal communication and the mystery of death, so important to Maeterlinck. Blok's play, received with a mixture of "Bravo!" and boos on opening night, fit perfectly with Meyerhold's experiments and the theories of Georg Fuchs. This is not surprising, since Blok was immersed in Nietzsche's *Birth of Tragedy*, attending Ivanov's "Wednesdays," and copying aphorisms by Nietzsche into his notebooks at the time he wrote *Balaganchik*.[32] Meyerhold's innovations concerned the staging itself. He hung blue drapes at the rear and the side of the stage but eliminated the conventional border so that the audience could see clearly the exposed ropes, flies, and wires of the stage machinery. He announced the action by the rhythmic

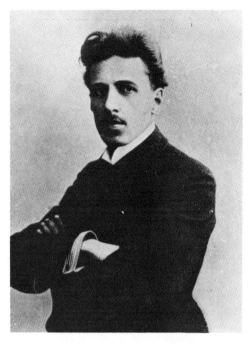

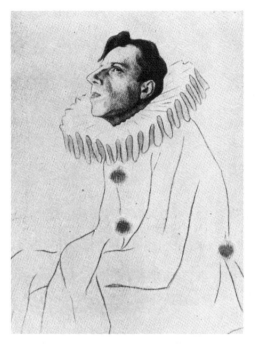

Vsevolod Meyerhold, 1905. From N. Volkhov, *Meierkhol'd* (Moscow-Leningrad, 1929).

Meyerhold dressed as Pierrot for production of *Balaganchik*, 1906. Portrait by N. N. Ulianov. From N. Volkhov, *Meierkhol'd* (Moscow-Leningrad, 1929).

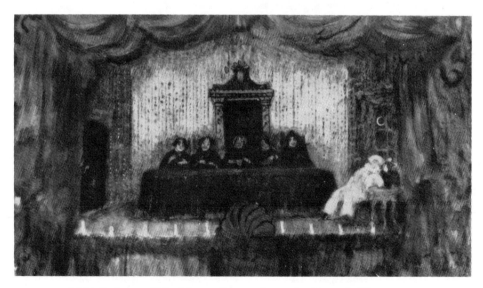

N. N. Sapunov, "The Mystics," stage design for Meyerhold's production of *Balaganchik*, 1906. From M. N. Pozharskaia, *Russkoe teatral'no-dekoratsionnoe iskusstvo kontsa XIX nachala XX veka* (Moscow, 1970).

beating of a drum. He also employed the relief stage principle of Fuchs, with both the drapes and the table of the Mystics on one plane in mid-stage and the Author speaking at another forward plane from the proscenium. The set was strikingly sparse: a window, the booth, a round table with a pot of geraniums, and a chair for Pierrot. Finally, to over-come the poor acting that had plagued the Studio, Meyerhold himself took the role of Pierrot and the gifted future director Alexander Tairov played the "Blue Mask." Few of the other characters had individual speaking parts. The actors who played the Mystics spoke in chorus, their bodies hidden by cardboard costumes.

Balaganchik was not immediately a widely recognized success, nor was it a significant departure from the European symbolist theater of the day. But as the first attempt at symbolist drama on the Russian stage, it was extremely innovative, standing in sharp contrast to the naturalism of the MAT. Most important, *Balaganchik* anticipated Meyerhold's future development as a director by establishing the principle of the theater as artifice. The actor was now superseded in importance by the director, the writer, the painter, and the stage itself. The audience would participate emotionally and intellectually in the experience of pure theater. *Balaganchik* constituted a "moment of innovation" for Meyerhold. With the help of Georg Fuchs he had found his way to a theater of the game, the mask, and the grotesque.

Balaganchik also marks the beginning of Meyerhold's rise to suc-cess, which had so long eluded him. Although many Petersburg actors and actresses left Komissarzhevskaya after the 1906–1907 season in protest against the new drama, Meyerhold was able to replace them with a number of loyal young followers from the Society for New Drama and the Moscow Studio.[33] When Komissarzhevskaya finally rebelled against Meyerhold's deemphasis on acting and fired him, he went on to further successes with the Imperial theaters. Employing the best actors, actresses, and set designers of Russia, he staged lavish productions of Molière's *Don Juan* (1910), Richard Strauss's *Elektra* (1913), and Lermontov's *Masquerade* (1917). Long before the Revolution of 1917, Meyerhold had established himself as one of Russia's foremost directors.

A European source of inspiration certainly facilitated Meyerhold's moment of innovation. Fuchs's book set down theoretically what Meyer-hold had been striving for in practice; it opened the way to success in the capital by justifying and clarifying Meyerhold's ideas. In later years Meyerhold constantly cited *Die Schaubühne der Zukunft* and other books by Fuchs in his own writings on theater. He also employed Fuchs's terminology concerning a "revolution in the theater," "theater as festival," and a "theater of the future." In his productions, too, Meyerhold con-tinued to employ mime, gesture, and motion, the relief stage and the proscenium, and the symbolist emphasis on mood, music, and lighting.

He contrasted the excellent work of the Munich Art Theater under Fuchs after 1908 with the limited theatrical resources of Russia, the absence of a Russian "national repertoire," the "apathy of the actor," and the great need for "national myth-making."[34] Fuchs and symbolism helped make Meyerhold an innovator. But only after 1917 would he find the opportunity to bring his ideas to ultimate fruition through street theater, festivals, revolutionary plays, constructivist sets, and the gymnastic motions of biomechanics. "If one wishes to understand the history of the Russian theater over the last twenty-five years," Meyerhold's biographer and close friend N. N. Volkhov later wrote, "one might say that we returned to the first decade of our century and again encountered for the first time the book of Georg Fuchs on the theater of the future."[35]

VII

Meyerhold's moment of innovation occurred in 1906 with the production of *Balaganchik* under the strong influence of Georg Fuchs. Revolution, patronage, and a Western source of inspiration combined to make him a successful director at age thirty-one. There is also evidence that Meyerhold needed that success in a psychological sense, that he had reached a point of despair in his own life from which he now emerged with a sense of renewal. When he dropped out of the university in 1896, he later wrote, "I left to find my salvation in art."[36] But art had not been any easier than life. His early success with the MAT had led to frustration and to his departure to form his own theater. That theater had proved imitative rather than innovative. Ultimately, the 1905 Revolution opened the way for him, first at the Studio and later with Komissarzhevskaya.

Many Russian intellectuals reacted to the 1905 Revolution in apocalyptic terms, anticipating either the end of the world or the dawn of a new age, or both. Many flirted with mysticism and found in the Bible omens of that end, or of a new beginning. "We saw the glow of a new dawn," wrote the philosopher Nikolai Berdyaev, "and the end of an old age seemed to coincide with a new era which would bring about a complete transfiguration of life."[37] There was often a strong sense of having survived a cataclysm, of having been reborn, with a chance to start anew. Meyerhold wrote: "I am happy about the revolution. It overthrew the theater from above in a day. And only now can one begin to work on the creation of a new altar."[38]

Meyerhold played no political role in the Revolution of 1905. For him, revolution would come through art rather than politics. His lifelong sense of a duality between the world around him and the dream world of the stage was resolved, through symbolism, in favor of the stage. Like Treplev in *The Sea Gull*, Meyerhold thought of suicide

in his late twenties out of a sense of personal failure and lost youth. But in *Balaganchik* neither Pierrot nor the audience can accept the reality of Death, which comes disguised in life and turns out to be a joke. On the stage one can die and live again.

Lunacharsky contributed to early Soviet culture a powerful vision of revolutionary immortality whereby the individual survived death through the memory of the proletarian collective. Dobuzhinsky and Moor contributed a sense of antagonism through simplification, dividing the world into we and they. Meyerhold, also of the generation of the aesthetes and a thoroughly westernized non-Russian, shared the avant-garde sense of tension between art and politics. His vision of a revolution was at first artistic, rather than political, a vision of Nietzschean transcendence in keeping with symbolism. In the 1920s his theater work became more political with its revolutionary slogans, anticapitalist plays, and workers' choruses. But although the symbols were by then revolutionary rather than religious, the division between the unreal and the real remained. The utopian goals of the revolution could be idealized and symbolized on the stage even though they could not immediately be realized in the towns and villages decimated by years of war, revolution, and civil war. In *Balaganchik* death was an unreal visitor who appeared in many guises; in revolutionary Russia he was a familiar figure. Only on the stage could he be made to vanish, along with remnants of the capitalist world, in celebration of a new society that was being born.

5

Theosophy and the Fourth Dimension: Malevich's Suprematism

Death is for us the end of this journey. Do we, at death, enter the eyrie of the fourth dimension, from which life is now perceived in its entirety and its meaning is made plain? Such surely is the hope of all, the belief of many, and if we may credit the testimony of the illumined, the certainty of the few. The higher-space hypothesis gives to the idea of immortality a curious validity and coherence, opening up to the imagination new vistas of progress, new possibilities of power.

—Claude Bragdon, 1914

Among all my patients in the second half of life— that is to say over thirty five—there has been not one whose problem in the last resort was not that of finding a religious outlook on life.

—C. G. Jung

The abstract painter Kazimir Malevich epitomized the mystical element in the Russian avant-garde. His fascination with geometric shapes became nothing less than a religious cult. In 1920, El Lissitzky, then a Malevich follower, wrote that the square was "the source of all creative expression," and that Malevich's movement, "suprematism," was "a clear sign and plan for a definite new world never before experienced" and a new "cosmic creation."[1] During the early 1920s Malevich collected his followers into an Institute for Artistic Culture, which was at once an art school, a movement, and a religion that promised a revolution more sweeping than the Bolshevik Revolution. Proclaimed Lissitzky:

Suprematism—which embraces the totality of life's phenomena—will attract everyone away from the domination of work and from the domination of the intoxicated senses. It will liberate all those engaged in creative activity and make the world into a true model of perfection. This is the model we await from Kazimir Malevich.

101

AFTER THE OLD TESTAMENT THERE CAME THE NEW—
AFTER THE NEW THE COMMUNIST—AND AFTER
THE COMMUNIST THERE FOLLOWS FINALLY THE
TESTAMENT OF SUPREMATISM.[2]

In 1924 Malevich proposed the cube as the proper form for the mauso-
leum in Red Square that would immortalize Lenin after death. For the
cube symbolized the "fourth dimension" of life, which, in the eyes of
theosophists, survives our bodily demise. Like other artistic utopias,
Malevich's fell victim to the authority of the Communist Party in the
late 1920s. But for a time his suprematism contributed an important
mystical dimension to Russian avant-garde art.

Malevich's moment of innovation antedated the 1917 Revolution.
By 1915 the European avant-garde was proclaiming that art was dead.
The feverish journey of European art through cubism, expressionism,
futurism, and vorticism led finally to the dead end of anti-art and Dada.
The swirling canvases of Vasily Kandinsky, the geometric shapes of Piet
Mondrian, the ready-mades of Marcel Duchamp, and the corner reliefs
of Vladimir Tatlin all proclaimed the divorce between art and reality,
between the abstract and the representational. It appeared that every
innovation had been tried; there was nothing left for an artist to do.
"Merely breaking up some object or placing a red or yellow square in
the middle of his canvases will not make him original," wrote the French
painter Fernand Léger, a leader of the La Ruche painters, in 1914.
"He will be original by virtue of having caught the creative spirit of an
external manifestation."[3] Yet this was precisely the road taken in 1915
by Malevich. At the so-called "last futurist exhibit," entitled "0.10" and
held at the Dobychina Gallery in Petrograd from December 17, 1915,
through January 19, 1916, Malevich hung a series of canvases consisting
of brightly painted squares and rectangles. As Léger had predicted,
Malevich's creative spirit was external to his art. Western theosophy
helped inspire his moment of innovation.

If the birth of suprematism, as Malevich called his art, marked the
death of all art in the eyes of some viewers, it also signified the rebirth
of Malevich himself. At thirty-seven, he was a middle-aged painter
who had moved through Russian neo-primitivism and futurism without
the fame of Larionov or Mayakovsky. Soon afterward, almost overnight,
he became the high priest of a new religion. His powerful canvases were
covered with bright geometric shapes that seemed to float in space;
they bore mysterious titles: "Square," "Red Masses in the Fourth
Dimension," "Self-Portrait in Two Dimensions." Malevich had absorbed
second hand the ideas and writings of European and American theos-
ophy, which enabled him to visualize on canvas the "fourth dimension"
of life beyond death.

I

Many intellectual historians consider theosophy a fad, a minor eddy in the philosophical currents of late nineteenth- and early twentieth-century thought. Yet theosophy had phenomenal popularity in the decades before World War I in both the United States and Europe. The psychologist Carl Jung has noted the "unbelievable rise of oc-cultism in every form in all cultured parts of the western world since the late nineteenth century," and has argued that people have flocked to such movements because these "modern gnostic systems meet the need for expressing and formulating wordless occurrences going on within ourselves better than any of the existing forms of Christianity, not ex-cepting Catholicism."[4] The new faiths, including Christian Science and theosophy, all revolved around the premise that this world is not the only one, that there is a spiritual reality beyond the visible material one, and that it is possible for the living to communicate with the dead. Many believed quite literally in the existence of ghosts, the possibility of photographing spirits of the dead, and their ability to communicate with those on "the other side" via table-rapping and seances. Theosophy in particular offered an escape from death through a belief in a scien-tifically knowable life after death.

In 1900, theosophy was appealing but not new. After the American Civil War, the Russian mystic Elena Blavatsky, together with Colonel Henry Steele Olcott, had founded a Theosophical Society in the United States. The Society's teachings quickly spread to England. The TS, as its members referred to the Society, and Blavatsky's own voluminous writ-ings—*Isis Unveiled* (1877) and *The Secret Doctrine* (1888)—claimed to hold the key to the world's secret and primal wisdom, bequeathed by ancient Tibetan *mahatmas* to the esoteric elite of the TS. In England the Society passed into the hands of Mrs. Annie Besant, a Fabian socialist and biologist turned mystic, and the Reverend C. W. Leadbeater, a hanger-on of dubious religious and intellectual credentials. Through spiritual-ism, table-tipping, seances with the dead, and the esoteric secret doctrine understandable only to the initiates, the TS offered solace to the bereaved and confused in an increasingly secular society. According to theosophy, we live not only on a material plane but also on a spiritual plane; there are several such planes, the most important of them being the "ethereal" and the "astral." The astral body survives the death of our worldly body. Theosophy also saw society as a whole evolving toward a higher type of race. Around 1900 believers in theosophy pre-dicted that a new cycle of world history would soon usher in a new type of human being, the sixth sub-race of the fifth root-race.[5] Secrecy and complexity of doctrine served to make theosophy seem important to insiders and confusing to outsiders.

By 1914 theosophy was an important worldwide religious movement. In 1879 the TS had established its headquarters at Adyar, India. By the outbreak of the First World War it claimed thirty thousand members. Among them were a number of first-rate artistic and scientific minds who cannot be dismissed as mere crackpots; they included the inventor Thomas Alva Edison, the poet William Butler Yeats, the composer Cyril Scott, and the Dutch abstract painter Piet Mondrian. Many others who did not actually join the movement attended its lectures, read its books, and gave it more credence than they would publicly admit. Among these theosophical fellow-travelers was the Russian painter Vasily Kandinsky, whose breakthrough to abstract painting around 1912 occurred under the strong influence of Munich theosophy. Indeed, members of the Munich Russian colony associated with the Blue Rider exhibits played an important role in bringing theosophy to Russia.

The central figure in Munich theosophy before 1914 was the Austrian mystic Rudolf Steiner.[6] Steiner was a specialist in the writings of Goethe and Nietzsche, and the author of many books. He claimed to have had spiritual visions since childhood, although he began attending theosophical lectures in Berlin in 1900 at age thirty-nine. Steiner was deeply critical of organized Christianity. Yet he accepted the mystery of Christ's resurrection as the pivotal fact in human history and found distasteful the English emphasis on eastern Buddhist and Hindu wisdom. He hoped to reconcile science and religion through a "spiritual science" of his own. In 1902 Steiner founded a German branch of the TS in Berlin together with his future wife, Marie von Sievers, a Baltic German. At the International Theosophical Congress in Munich in 1907, however, a rift appeared between the Christ-centered mysticism of Steiner and the eastern mysticism of the TS president, Mrs. Besant. When in 1910 she presented an Indian boy, Krishnamurti, as Christ reincarnate, Steiner's patience came to an end. In the winter of 1912–1913 he seceded from the TS and established his own movement known as anthroposophy; its headquarters was the idyllic village of Dornach near Basle. By 1914 theosophy was thus deeply divided into warring Anglo-American and German factions.

Steiner's views were especially important for Kandinsky and the Munich Russians, but they also reached into Russia where people like Malevich absorbed them second hand. According to Steiner, during the Age of Atlantis man had lived a spiritual life guided by a group of Initiates who expressed their truths through various mystery centers and oracles. After a great flood, the Initiates who survived moved to Central Asia, where they maintained their methods for training successively higher levels of consciousness in those desiring to know true reality on the spiritual, astral, or ethero-physical planes. These ancient truths had eventually been lost; only now could they be rediscovered, articulated

by Steiner in his lecture cycles delivered throughout Europe before 1914.

Steiner was significant to artists because he saw art as a means to the spiritual. In a lecture given in Vienna in March 1910, he said that "there are definite methods which a man may apply to his life of soul and which enable him to awaken certain inner faculties slumbering in normal daily life, so that he is finally able to experience the moment of Initiation." Physical reality is merely a veil "drawn over everything that man would behold were he able spiritually to see through the spectacle presented to him in space." The "vibrations" which produce colors in a painting, for example, make us "experience and feel inwardly as a result of the impressions made upon us by the red, violet, or yellow color." This deeper "soul-and-spiritual reality" is accessible only to the "seer," a man of vision who "directs his gaze into the Imaginative world; there he has the impression, let us say, of something blue or violet, or he hears a sound or has a feeling of warmth or cold. He knows through the thinking of the heart that the impression was not a mere vision, a figment of the mind, but that the fleeting blue or violet was the expression of a soul-spiritual-reality, just as the red of the rose is the expression of a material reality."[7] The artist, too, was a seer who could paint spiritual reality.

Steiner also claimed to have a scientific knowledge of life after death. In a lecture series in 1912–1913 he described to his audiences "life between death and rebirth." Life after death, he claimed, was real. Our consciousness after death can be maintained if, and only if, we remember the mystery of Christ's resurrection. Those who have reached the age of thirty-five are more likely to have consciousness after death, to be deeply involved in the cosmos. Death is in fact a rejuvenation, a becoming young again at spiritual birth, as suggested by Goethe in Part Two of *Faust*, the section that so fascinated Lunacharsky. Our astral body survives the death of our physical body and draws new strength from the stars and the planets. As man ascends into higher spiritual worlds after death, he expands into the planetary system itself. The "supreme" principle is the Christ Principle—that we are all gods. The experience of death itself is akin to being expanded and spread out into space. Those with clairvoyant powers can in fact visualize what happens between death and rebirth in the world of cosmic space. Our normal waking ego-consciousness cannot perceive this spiritual world; only our subconscious astral consciousness can give us glimpses of it. In short, said Steiner, "death does not exist in the world beyond," a world which can be visualized by a few capable of astral perception.[8]

Theosophy and anthroposophy began to penetrate Russia on the eve of World War I, although symbolism and the philosophy of Soloviev and "god-seeking" had prepared the way. In 1908 a Russian section of

the TS was founded in St. Petersburg by Anna Kamenskaia, who had met
Mrs. Besant in London in 1902. The easing of censorship restrictions
that followed the 1905 Revolution made this possible for the first time,
since theosophy was anathema in the eyes of the Russian Orthodox
Church. In 1906 the theosophists set up the Lotus Press in Kaluga and
published a journal, *Vestnik teosofii*. Two years later they were allowed
to incorporate as a public organization. Still, the movement remained
small and isolated, attacked by radical intellectuals as obscurantist and
by the church and government as blasphemous. In 1911 the censor
suspended the journal and charged Kamenskaia with blasphemy; she
was acquitted after an unpleasant courtroom trial in 1912.[9] Yet as in
Europe and the United States, the importance of the TS lay not in its
formal membership but in its remarkable appeal to many intellectuals,
readers, and sympathizers.

In the wake of the 1905 Revolution a number of Russian intellectuals
and artists became fascinated with theosophy and anthroposophy. The
composer Scriabin had read Blavatsky's *Key to Theosophy* in 1905 and
found it very close to his own thinking. He predicted a coming spiritual
revolution directed by the "consciousness of geniuses," which would
render the masses "more perceptive of finer vibrations than usual" and
would "shake the souls of peoples and force them to perceive the idea
hidden behind the outer event."[10] After 1909 theosophy became popular
at Ivanov's "Wednesdays" with the encouragement of Steiner's main
Russian follower, Anna Mintslova. Poets began to see themselves as
keepers of the word, *Logos*, the "microcosm" that reflected the universal
truth of the "macrocosm." The poet Andrei Belyi followed Steiner to
Munich and then to Dornach as a convert. "In 1912–1913," his wife later
recalled, "our entire life was under the sign of Rudolf Steiner's lectures."[11]
The painter Margarita Voloshina was another Russian Steinerite who
moved from Paris to Munich in early 1909 in the hope of discovering
a "new landscape painting" that would express "cosmic reality."[12] In
September 1912 she helped form a branch of the new Anthroposophical
Society in Moscow.

The Russian painter Kandinsky was among those who came under
Steiner's spell. Art historians now generally accept that his earliest
abstract works were done around 1912 under the direct influence of
theosophy and anthroposophy.[13] Since his 1906 visit to Paris, Kandinsky
had painted primarily in a fauvist manner, utilizing bright colors, de-
forming his landscapes, but maintaining identifiable objects in his works.
In 1908 Kandinsky attended some of Steiner's lectures in Munich. He
also read and annotated Steiner's 1909 book on Goethe's aesthetics, which
argued that the artist knows the "secret laws" of the cosmos and is
therefore destined to raise the world to a new spiritual level through
an "aesthetics of the future." Kandinsky also read the 1908 German

translation of Besant and Leadbeater's book on art entitled *Thought-Forms*; here they argued that people's thoughts and feelings give off an aura of free-floating lines and colors through vibrations that reveal their deepest inner emotions. Finally, in his own work *Concerning the Spiritual in Art* (1912), Kandinsky also called for a "spiritual revolution" in art, where the artist would seek to establish "vibrations" in the soul of the observer or listener, express his own "inner necessity" through his work, and synthesize sight, sound, and even temperature into a unified "nonrepresentational, abstract" work of art. Kandinsky also specifically praised theosophy as "one of the most important spiritual movements" which seeks to "approach the problem of the spirit by way of inner knowledge."[14]

Kandinsky was the most important example of the influence of theosophy on the Russian avant-garde before World War I. His abstract paintings of 1912–1914 revealed his conversion, not only in their physical resemblances to some of the auras in *Thought-Forms*, but also in their religious motifs and titles: "The Deluge," "The Last Judgment," and so on. He probably never actually joined the TS or Steiner's movement, but he found in both groups a religious dimension for his art and a justification for removing the visual object from his painting. Kandinsky's views were as well known in Russia as in Munich. Even before its publication in Germany, *Concerning the Spiritual in Art* was read by Nikolai Kulbin to an all-Russian Congress of Artists in St. Petersburg in December 1911.[15] Other members of the Blue Rider circle in Munich also exhibited with the Jack of Diamonds painters in Russia in the winter of 1910–1911. The influence of Munich theosophy on Russian artists was thus probably well established before 1914.

An acquaintance with theosophy and anthroposophy is essential for an understanding of the origins of Malevich's suprematism. Malevich himself read no German, did not visit Europe before 1914, and therefore had no direct contact with Steiner's ideas. But through intermediaries such as Kandinsky and Kulbin, he could easily have absorbed the rudiments of the doctrine. When Malevich himself became interested in theosophy, it was not so much in its German as in its Anglo-American form. Here he found not simply a push toward abstraction or a surrogate religion, but a model for painting the "fourth dimension" of life after death.

II

Anglo-American theosophy before World War I was distinguished in part by its mathematical and geometrical dimensions. The mystical connotations of number and form, of course, were well known to the ancient Greeks and were never really lost to the Western tradition. The

Cabala, the astronomer Kepler, the Rosicrucians, and the Free Masons all exhibited a certain fascination with number lore and with squares, circles, and triangles as evocative of universal and divine significance. We have seen how the intellectual revolution of 1890–1914 led to a crisis of faith and of science over disbelief in absolutes. Time, for example, now appeared to be either intuitive experience or the "fourth dimension" of four-dimensional space, and many writers who were not theosophists used the term and the concept. But for theosophists the fourth dimension carried more mystical connotations.

What would a space of more than three dimensions look like? In the 1880s an English writer and Shakespearean scholar, Edwin A. Abbott, tried to answer this question in a book entitled *Flatland*. Writing under the pseudonym "A. Square," he described a two-dimensional, planar world, whose inhabitants could imagine three-dimensional bodies only as the traces they left behind when passing through a plane; for example, a sphere appeared as a circle and a cube as a square:

> Imagine a vast sheet of paper on which straight lines, Triangles, Squares, Pentagons, Hexagons, and other figures, instead of remaining fixed in their places, move freely about, on or in the surface, but without the power of rising above or sinking below it, very much like shadows—only hard and with luminous edges—and you will then have a pretty correct notion of my country and countrymen.[16]

The narrator, A. Square, visits three-dimensional space, learns the nature of a cube, and then concludes by analogy that four-dimensional space must also exist. He returns home, tries to explain the world he has visited, and is thrown in jail for insanity. The story concludes with the hope that ultimately three-dimensional beings "may aspire yet higher and higher to the secrets of four, five, or even six dimensions."[17]

At the turn of the century America produced several little-known thinkers who concerned themselves with the fourth dimension. The most prolific was Charles Howard Hinton (1853–1907) an untenured mathematics instructor at Princeton University in the 1890s (and the inventor of a gun to pitch baseballs), whose main intellectual sympathizer appears to have been the philosopher William James. As early as 1892 Hinton complained to James that "nobody here will print anything which I have written," namely, his work on the development of a "higher space sense" for visualizing the fourth dimension. Hinton's main interest was non-Euclidean geometry. In 1895 he wrote James that he was working on a "flat four-dimensional space"; this was many years before Minkowski's definition of time as the fourth dimension became known to either Einstein or the general public. Hinton himself was not uninfluenced by Bergson and believed that "matter has another dimension which is experienced by us as duration." His geometry in fact had a

mystical dimension. He sought in higher dimensional space a means to "apprehend the higher reality, the higher personality, the actual being." "We must train ourselves to apprehend a series of changing forms as a single thing," Hinton wrote to James; for example, three-dimensional pyramids or cubes passing through planes change form by leaving two-dimensional traces. To imagine one form from another would require mental exercises with the help of colored cubes, which for Hinton would produce "the sensation of the higher world."[18]

Hinton's published works reiterated these privately expressed views. He gave the term "fourth dimension" a mystical connotation as a higher consciousness accessible only to those who could "cast out the self" by ridding themselves of the "apparent facts of the objects." In *A New Era of Thought* (London, 1885), Hinton provided a series of mental exercises with colored cubes for developing the "higher space sense." Gauss and Lobachevsky, he announced, had inagurated the era of the fourth dimension. "I shall bring forward," he proclaimed, "a complete system of four-dimensional thought—mechanics, science, and art. The necessary condition is that the mind acquire the power of using four-dimensional space as it now does three-dimensional." In 1904 he provided another handbook of higher space in *The Fourth Dimension*, where he observed: "As our world of three dimensions is to a shadow or plane world, so is the higher world to our three-dimensional world."[19] Hinton died in 1907 after a career at the U.S. Patent Office.

Hinton's work was well known, particularly among artists, in both Europe and Russia before 1914. Although Hinton's illustrations bore little outward resemblance to the work of Mondrian, Kandinsky, the cubist painters, or Malevich, many artists of the period were attracted to his writings. The "fourth dimension" became a kind of cliché, a term used loosely to describe time, or a higher, spiritual dimension of life. Steiner lectured on the theme in 1904–1905 but never made it central to his doctrine. Some cubist painters in Paris imagined that intersecting planar surfaces portrayed time by showing an object simultaneously from several points. The French poet Guillaume Apollinaire used the term in a lecture in the autumn of 1911, Léger employed it in his lectures in 1913 and 1914, and the painters Albert Gleizes and Jean Metzinger also wrote about it in their book *Du Cubisme*, which appeared in Paris in 1912 and was translated into Russian the following year.[20] But much of this was largely rhetorical, a way of describing what painters were already doing. Hinton's writings provided no visual glimpse into the fourth dimension.

Another American writer, Claude Bragdon, did translate Hinton's ideas on the fourth dimension into visual form. Bragdon, who was born in Rochester, New York, was both an architect and a theosophist. Because his father had been a theosophist, he was exposed to *Isis Unveiled*

and other theosophical literature at an early age. Around 1900 he met Leadbeater's Indian protégé, C. Jinarajadasa, with whom he founded the Genesee Lodge of the TS. In addition, Bragdon applied theosophy to his architecture with a theory of "projective ornament," which used mathematical "magic squares" to generate decorative shapes and designs for his buildings and to illustrate his many books. Bragdon called for a "rhythmic subdivision of space" through basic geometric forms such as squares, triangles, and "root rectangles"; well versed in both mathematics and architecture, he argued that "geometry and number are at the root of every kind of formal beauty."[21]

Bragdon soon began to visualize the fourth dimension theosophically. Around 1910 he helped Jinarajadasa by doing some drawings for the latter's lantern slide lectures on theosophy. Jinarajadasa elaborated Blavatsky's theories and the esoteric doctrine for the uninitiated.[22] But he also felt that art could make divine archetypes visible to human beings through symbol, intuition, and a portrayal of the "supreme moment." Visually, Jinarajadasa provided only some photographs and charts of evolution and cosmic planes. Consequently, in 1912 Bragdon decided to write a book in which he would make visible the geometric world of higher dimensions. Published in 1913, it was entitled *A Primer of Higher Space: The Fourth Dimension* and contained an essay on "Man the Square," illustrated by Bragdon with the aid of an American mathematician, Philip Henry Wynne.

It was Bragdon, rather than Hinton, who fused geometry and theosophy into a new mysticism of the fourth dimension. In his essays, Bragdon argued that one could in fact visualize four-dimensional space by analogy. Consider the relationship between three and two dimensions in terms of a cube passing through a plane at various angles so that it produces traces as lines, squares, rectangles, triangles, and polygons: "If the cubes be taken to represent the higher selves of individuals in a higher-space world, the plane our phenomenal world, the cross-sections would then represent the lower space aspects of these higher selves—personalities." The square in particular, wrote Bragdon, is the most perfect plane figure. In the Revelation of St. John, he reminded the reader, the city of the New Jerusalem "lies foursquare, its length is the same as its breadth"; he also quoted Blavatsky's comment in *The Secret Doctrine* that man is the "mystic square—in his metaphysical aspect—the Tetraktys; and becomes the cube on the creative plane." The square, as we perceive it, simply represents the archetypal cube projected in a perfect way on a plane. The cube symbolizes our higher and immortal self existing in four dimensions; the square is its visible three-dimensional earthly projection on the physical plane.[23] The fourth dimension for Bragdon thus, by analogy, symbolizes a world beyond death.

Bragdon elaborated on the fourth dimension in a subsequent volume,

Four-Dimensional Vistas (1916). Only the mystic, he wrote, could see into the world of four dimensions. Only he "represents super-humanity in the domain of consciousness" and therefore is aware of "dimensionally higher worlds."[24] Both Bragdon's language and Wynne's drawings bear a striking resemblance to Malevich's writing and painting after 1915. We shall see how Malevich, who had no command of English, was able to acquire knowledge of that work. For the moment it is sufficient to note that by 1913 Claude Bragdon had fused the Anglo-American theosophical tradition with the more general mathematical tradition of Hinton and others to produce a visual expression of life after death as the fourth dimension. In order to understand how this doctrine came to influence Malevich, we must first consider his own career within the context of the Russian avant-garde prior to 1915.

III

In recent years art historians have written about Malevich's painting without generally recognizing the influence of theosophy on his work.[25] In terms of his innovations in painting, Malevich had encouraged the view that suprematism originated as early as 1913 in Moscow. This view was accepted by the art historian Camilla Gray in her pioneering study of Russian painting in 1962. It suggests the work of a solitary genius in a uniquely Russian environment, an interpretation which Malevich's oracular and often obscure pronouncements did nothing to dispel. More recently, the Danish art historian Troels Andersen has concluded that "the first suprematist paintings were executed in 1915, no matter when the concept arose."[26] There is in fact no photographic or other evidence of a Malevich suprematist painting before December 1915. Malevich himself probably did not visit Europe before World War I. But he was familiar with the latest in European easel painting, borrowed liberally from it, and was only able to break free to his own innovative style with the aid of theosophy.

The center of the revolution in painting before 1914 was Paris. In 1905 at the Salon d'Automne, Henri Matisse showed his first canvases in which strokes of pure bright color gave tones to objects quite unlike their accepted counterparts in the visible world. In 1908 Georges Braque exceeded the deformation of shapes and space begun by Paul Cézanne and produced works in which objects were cut by planar sections and lost their accepted shape when viewed from several angles simultaneously. The French art critic Louis Vauxcelles quickly coined the term "fauves," the wild beasts, for Matisse and his friends and the term "cubistes" for Braque and his young friend Pablo Picasso. Within several years Europe was experiencing a visual revolution in form and color that broke down standards accepted since the Renaissance.

Russian easel painters responded quickly to Parisian trends. The generation of the aesthetes had been influenced particularly by Munich, as we have seen; the younger futurist generation of the avant-garde was under the spell of Paris between 1905 and 1914. Hundreds of young Russians in their late teens and twenties lived and studied in Paris in those years. The Blue Rose painter P. V. Kuznetsov greatly admired the Gauguin retrospective during his 1906 visit, Kandinsky returned to Munich from Paris the same year inspired by the fauves, and the Kiev painter Alexandra Exter returned to Russia from her annual trips to Paris laden with photographs of the latest works. Russians unable to travel abroad heard about the new painting from friends and often saw photographic reproductions; they could also visit the private Moscow collections of the wealthy art patrons Sergei Shchukin and Ivan Morozov, the exhibits organized by Alexander Mercereau of the journal *Zolotoe runo* (The Golden Fleece), or the traveling International Art Exhibitions established by the Odessa art patron Vladimir Izdebsky. Without leaving Moscow, a young Russian painter could see first hand, or in magic lantern slides and photographs, the latest canvases by Picasso, Braque, Delaunay, or Matisse.

Exposure bred imitation. No matter how talented a painter might be, nor how many Byzantine or Russian icons he might have seen in churches or at the Tretiakov Gallery, there was a frantic desire to keep up with the latest European fad. Some painters produced Russian scenes in a European manner, as in the series of paintings of the Kirghiz Steppe by Kuznetsov with its debt to Gauguin. When Braque and Picasso began doing collages, pasting newspaper clippings and other objects on wood, so did their Russian followers. When Vladimir Tatlin saw reliefs and constructions in Picasso's studio in Paris in 1913, he immediately returned to Russia to produce his own. The 1910 Jack of Diamonds art exhibit probably took its name from a Paris street exhibit; the Donkey's Tail exhibit of 1912 was inspired by the work of Lolo, a Montmartre cabaret mascot. It was not surprising that some critics called the Jack of Diamonds painters *pikassiti* and *matissiati* and charged that the Russian painters "only copy their teachers, the French, simplifying and carrying to absurdity their theses and methods."[27]

In their attempt to be innovative in Russia, many artists thus found themselves imitative of Paris. No matter how nationalist or primitive the motif, the technique often appeared to be Parisian. The Jack of Diamonds painter P. P. Konchalovsky admitted in his memoirs that "Cezanne's methods gave me the possibility to see nature in a new way"; but while Russian viewers considered him a French painter, visiting Frenchmen commented on the purely Slavic character of his work.[28] The Russian futurist poets proclaimed the national character of their *zaumnyi yazyk* or trans-sense language, but found that Marinetti

considered them a branch of the Italian movement when he visited Russia in 1914. Like the European avant-garde, the Russians declared themselves creative geniuses, broke the rules of form and color, and established their own "isms" and movements.

The influence of Paris on the Russian avant-garde from 1905 to 1914 did not mean that Russian painters were not often extremely talented, or that none worked virtually apart from that influence. Russian easel painting in these years was rich, original, and often national. The Wanderers and the World of Art painters persisted in their own styles and trends. The portraits of Serov, the landscapes of Levitan, the realism of Repin, and the grotesque line drawings of Filonov all suggest both artistic talent and artistic diversity. But it was precisely this established artistic world embodied in the Academy, the World of Art, and the Union of Russian Artists against which the avant-garde set itself. For the young provincial art students of the avant-garde who streamed into the capitals after the turn of the century, European modernism provided the weapon with which to attack the middle-class artistic establishment and its patrons. To the philistines, their painting was not imitation at all, but shocking novelty, and novelty could well lead to public recognition. Perhaps this desire for recognition in an increasingly sophisticated and competitive art market in Russia was what produced, in the words of one critic, "rayonnism, suprematism, and other provincial ism-creations" in these years.[29]

IV

Malevich deliberately veiled his early life in mystery. Both of his parents were Poles who had fled to the Ukraine in the wake of the Polish uprising of 1863. His brief autobiography states only that his father worked in a sugar refinery near Kiev, that there was "no mention of art" in the house, and that neither of his parents was especially religious.[30] His father apparently opposed his artistic desires to the point of hiding his letters of application to the Moscow School of Painting, Sculpture, and Architecture. His mother was obviously the dominant figure in his life, from the time she bought him his first paints when he was fifteen until her death in 1935. For most of Malevich's later life, his mother lived with him and encouraged his work. Other than this, we know little about his family and his early years.

Malevich was a somewhat older member of the futurist generation of the avant-garde. Born in 1878 near Kiev, he belonged to the age cohort of the Blue Rose painters, but he became artistically active only after 1905 and especially just before World War I. By nationality he was Polish and Ukrainian (some friends called him "Pan Kazimir"). He was therefore more typical of the provincial southerners who in-

vaded Moscow after 1900 and took up positions in the front line of the avant-garde: the Burliuk brothers, David and Vladimir, from the Ukraine; Mikhail Larionov from Tiraspol; and Alexandra Exter from Kiev. In the mid-1890s the Malevich family moved to Konotop, a district town of about 28,000 located on the railway line between Kiev and Kursk. By 1898 Malevich left home for Kursk, where he lived for three years and began painting his first landscapes. In 1902, when Malevich was twenty-four, his father died. Malevich then moved to Moscow, where he successfully passed the entrance examinations to the Moscow School of Painting, Sculpture, and Architecture.

The Moscow School, founded in the mid-nineteenth century, was the center of the Russian easel painting avant-garde between 1905 and 1912. Its history was bound up with the Wanderers, the young painters who had seceded from the Academy in 1863 to paint national themes in a realistic manner, and who now dominated the Academy itself. At the turn of the century the Moscow School had a distinguished faculty, which included the well-known landscape painter I. I. Levitan, the portraitist V. A. Serov, and the graphic artist L. O. Pasternak, the father of Boris. All were familiar with impressionism and *Art Nouveau,* and many had studied or traveled in Europe. Despite the long course of study (eight years in painting and in sculpture, and ten years in architecture), the Moscow School provided a more open and democratic alternative to the rigorous and less experimental Academy. Here a creative mixture of prosperous young Muscovites and more indigent provincials like Malevich—"the same *raznochintsy* whose circumstances were such that they often had no money for supper"—provided fertile ground for planting the seeds of an avant-garde after 1905.[31]

The first sign of Moscow's artistic rebellion against the St. Petersburg Academy and the World of Art came in 1903 with the founding of the Union of Russian Artists in Moscow. In 1905 the Union itself was attacked by a group of younger painters from the Moscow School, who organized an independent painting exhibit under the name Blue Rose in the spring of 1907. The Blue Rose painters were mainly students from the Volga town of Saratov who had come to Moscow in the late 1890s. Their light and speckled canvases reflected the work of their Saratov teacher Viktor Borisov-Musatov, the French Nabis (the Hebrew word for prophet) painters Paul Sérusier and Maurice Denis, the pastel murals of Puvis de Chavannes, and the Tahitian and Breton scenes of Gauguin. Many of their works were highly symbolic. Malevich's canvases of this period, the lovely "Flower Girl" of 1903 and the summer landscapes done around Kursk before 1908, also reflected the established vogue of French impressionism and the Nabis. The Blue Rose painters may be said to mark the transition from the generation of the aesthetes to that of the futurists. Malevich's early work lacked their direct contact with Paris but was not dissimilar.[32]

Malevich himself did not exhibit with the Blue Rose painters in 1907 but with another organization, the Moscow Association of Artists. At this exhibit his paintings hung alongside the canvases of two other Moscow School students about to become leaders of the avant-garde, Mikhail Larionov and Natalia Goncharova, together with works by Kandinsky and Vladimir Burliuk. All of these artists were from the south (Kandinsky grew up in Odessa), and Burliuk came from a remarkable family that had both money and artistic interests. During the following years, Russian art exhibits were favored with the patronage of Burliuk's father, the bailiff on an estate north of the Crimea belonging to Count Mordvinov, and with the catalytic enthusiasm of Vladimir's brother David. The Garland (*Venok*) exhibit in Moscow in the winter of 1907–1908, the Link (*Zveno*) exhibit in Kiev later that year, and the Jack of Diamonds (*Bubnyi valet*) exhibit in Moscow in December 1910 all brought Burliuk money together with the emerging avant-garde. Most of the participants had come from the provinces, had studied at the Moscow School, in Munich, or in Paris, and were in their twenties or thirties. Although Malevich did not exhibit widely until the Jack of Diamonds, he absorbed the trends around him, especially the neo-primitivism of Larionov and Goncharova. Like them, he explored in his paintings popular themes suggested by the icon and the *lubok* woodcut, emulated the forms of Gauguin and the colors of Matisse, which he saw in Shchukin's collection, and gave his Russian or Ukrainian peasants the heavy eyes and elongated noses characteristic of Picasso's enthusiasm for African and Oceanic masks.[33]

The Jack of Diamonds exhibit, held in Moscow during the winter of 1910–1911, united for the first time the diverse elements of the Russian avant-garde. The neo-primitivists of the Moscow School, led by Larionov and Goncharova, joined with the newer followers of Cezanne (Robert Falk, P. P. Konchalovsky, and Ilya Mashkov) and the Munich Russians of the *Neue Künstlervereinigung* (New Artists' League), led by Kandinsky, Alexei Yavlensky, and Marianne Verefkina.[34] But their unity soon dissolved into rival factions. In the spring of 1912 Larionov seceded from the Jack of Diamonds group and, with Goncharova, exhibited independently under the name of the Donkey's Tail, proclaiming his own art movement, rayonnism (*luchizm*). While Malevich also hung some of his paintings at the Donkey's Tail, he never succumbed to Larionov and Goncharova's use of light rays, suggested by the "force lines" of Boccioni and the Italian futurists. Instead he found a source of inspiration in the work of Fernand Léger, the La Ruche painter whose canvases were first shown in Russia at the second Jack of Diamonds exhibit in February 1912.[35]

Malevich's French source was not really French. Léger provided an important contact with Italian futurism. In his own painting Léger combined the Italians' enthusiasm for machines with the reduction of

visual objects to tubes, cones, and cylinders. Under Léger's influence Malevich now began to paint in this manner; canvases such as "Taking in the Rye," "The Woodcutter," and "Morning in the Village after Snowfall" all indicate Léger's influence on Malevich in 1912–1913, although Malevich's figures are heavier and more compact. Malevich also explored the possibilities of collage à la Braque and Picasso in 1913 in "Desk and Room," with its pasted objects, newspaper clippings, and lettering. Finally, he followed the futurist technique of painting "cinematic" motion in his "Knife Grinder," as Goncharova had in "The Bicyclist."

Around 1912 the center of the Russian avant-garde shifted from Moscow to St. Petersburg and from painting to poetry. Malevich moved to the capital, where he joined the Union of Youth, a group of painters, musicians, and poets.[36] Under the influence of the Russian futurist poets, Malevich began to employ the terms *zaumnyi* (trans-sense) and *sdvig* (displacement) to describe his painting. In December 1913 he designed the costumes and backdrops for the futurist opera *Victory over the Sun*, with music by the Union of Youth leader, the violinist Mikhail Matiushin, and lyrics by the poet Alexei Kruchenykh.

Malevich's painting prior to 1914 revealed a continuing involvement with the Russian avant-garde and its European sources. But it did not mark him as an innovator. By about 1912 Russian painting appears to have suffered a crisis of imitation brought on by widespread enthusiasm for artistic trends emanating from Munich and Paris. The Russian futurists attempted to disavow their Italian origins by naming their original circle Hylea, after the ancient Greek colonies in the Crimea, and by shifting their emphasis from easel painting to poetry, where the Russian language would by definition stamp their work as national. Larionov and Goncharova soon gave up rayonnism and joined Diaghilev in exile in Paris. There was also a crisis of aging. By 1912 the art students of a few years back were no longer young. The leaders of the Union of Youth—the doctor Nikolai Kulbin, Matiushin, and his wife, the poet Elena Guro—were forty-five, fifty-one, and thirty-five respectively. In Munich the Russians of the Blue Rider movement, who proclaimed themselves "healthy youth" uniting the "young forces" of international art, were headed by Kandinsky, forty-six; Verefkina, fifty-two; and Yavlensky, forty-eight.[37] With the exception of Falk, twenty-six, and Exter, twenty-eight, the Jack of Diamonds painters were now all over thirty.

By 1914 Kazimir Malevich, at thirty-six, had achieved little artistic success. He was a not very original Polish-Ukrainian painter with little formal artistic training who joined the futurists in wearing wooden spoons in their lapels on street corners. Although he had never been to Europe, his entire career reflected European trends in painting, in-

cluding impressionism, cubism, and futurism. He had created no style and founded no movement. He had not even graduated from a higher art school. To be sure, Malevich had been doing some interesting and even innovative painting before World War I, but he had failed to achieve much of a reputation. It was only in 1915 that theosophy helped him become a recognized innovator at age thirty-seven.

V

In 1914, the Russian avant-garde was divided into a number of warring factions, including the Jack of Diamonds group, the futurists, cubo-futurists, and ego-futurists, the Blue Rider circle, and the Donkey's Tail. Each sought to outdo the others in creating a new style, a new rhetoric, and a new artistic public. In January 1914 there was a secession from the Union of Youth in Petersburg. Its leader was the twenty-two-year-old painter Ivan Pougny, a wealthy Petersburg art student who in 1912 had worked in Paris with Vasileva. There he had fallen in with the La Ruche painters, including Léger and the Russians, and had married another wealthy young Russian art student, Xenia Bogoslavskaya. Upon their return to St. Petersburg, their apartment became a gathering place for the Russian futurists and the Union of Youth. Pougny left the Union in 1914, and Malevich soon became the beneficiary of his patronage.[38]

During the winter of 1914–1915 Pougny, Vladimir Tatlin, and Malevich organized an exhibit of their own, independently of the futurists and the Union of Youth. Pougny provided the money. The result was Tramway V, held in Petrograd in March 1915 and named after a Moscow streetcar line. The exhibit attracted nearly two thousand visitors, but it also drew considerable criticism: while Russian soldiers were dying by the thousands in the trenches of Galicia during the first winter of World War I, a handful of frivolous bohemians was exhibiting pseudo-Parisian canvases. In the eyes of the critics, Exter's paintings of Florence, Tatlin's reliefs, and Pougny's collages all bore the unmistakable stamp of Gris, Léger, and Picasso. Malevich's painting "An Englishman in Moscow" contained, as one reviewer wrote, "neither an Englishman nor Moscow."[39]

Mysticism also flourished in Petrograd during the dark winter of 1914–1915. Scriabin returned from England and planned his ultimate musical performance. Entitled *Mysterium,* it was to be performed in the open air near Darjeeling, India, at the foot of the Himalayan Mountains, creating a divine experience of ecstasy through the use of incense, smoke, dancing, and bells hung somehow from the clouds. Scriabin was not the only intellectual intrigued by the mystery of the East. The director Alexander Tairov, back from Paris, performed the Indian reli-

gious play *Sakuntala.* The painter Nikolai Roerich, a member of the
Russian Section of the Theosophical Society and the librettist of Stravin-
sky's *Rite of Spring,* planned to import a Buddhist shrine from India.
Most important, the Russian mystic philosopher P. D. Uspensky re-
turned from India via London in November 1914, and in February and
March 1915, during the Tramway V exhibit, delivered lectures to large
audiences in Petrograd on Indian philosophy, theosophy, and the "fourth
dimension" under the titles "In Search of the Miraculous" and "The
Problem of Death."[40] Uspensky appears to have provided Malevich
with his first exposure to the ideas of Hinton and Bragdon and to theo-
sophical conceptions of the "fourth dimension."

Peter Demianovich Uspensky (1878–1947) had been a member of
the Russian Section of the Theosophical Society since 1911. In 1913–
1914 he spent several months at the TS headquarters at Adyar. But his
horizons were not limited to theosophy, and as a mathematician he
had for many years been interested in the general topic of the "fourth
dimension." He was familiar, if not entirely in accord, with the writings
of both Hinton and Bragdon. He later recalled that around 1913 "Mr.
Bragdon's *Man the Square* reached me in Petrograd" and "carried the
message of a common thought, a common understanding."[41] In 1915 he
also translated Hinton's book *The Fourth Dimension* into Russian. His
early works, *The Fourth Dimension* (1909) and *Tertium Organum*
(1911), revealed a thorough familiarity with the writings of Hinton,
which he summarized for Russian readers. In his later works in emi-
gration—*A New Model of the Universe* (1931) and *In Search of the
Miraculous* (1949)—Uspensky continued to refer to the books on theos-
ophy and the "fourth dimension" that had inspired him in Russia before
World War I. Many English intellectuals considered Uspensky and an-
other mystic Russian philosopher, George Gurdjeff, to be Eastern seers
offering solace and religious truth in a troubled postwar world. But in
Russia Uspensky was more important as a popular philosopher who
transmitted to many Russians unable to read English a tradition of both
theosophy and the "fourth dimension" as a way out of the confines
of death.

Uspensky was no mere borrower. As a mathematician and a theoso-
phist, he was able to fuse both a scientific and a mystical tradition into
his own unique philosophy, familiar to many artists among the Russian
avant-garde. To Bragdon's work, he added an important new emphasis
on immortality. For Uspensky, the "fourth dimension" provided an es-
cape from death into the real world of the spirit. Our entire life, he
wrote, is merely a shadow of reality, a reality accessible only to a "new
category of men, for whom there exist different values than for other
people." The mass of humanity consists of four-dimensional beings who
are normally conscious only of three dimensions. Carrying Bragdon's

spatial analogy one dimension higher, Uspensky argued that "a cube, a sphere, a pyramid, a cone, a cylinder, may be projections or cross-sections of four-dimensional bodies unknown to us." There is not only a fourth dimension but a fifth. If the fourth dimension represents time, then the fifth dimension represents the "line of eternity," the eternal present of Hindu philosophy, the "perpetual now for some moment," time stopped, as in death. But the fourth and fifth dimensions are known only to a few capable of seeing beyond the apparent world of this life, dimensions in which we are all continually dying and being reborn.[42]

For Uspensky, the fourth dimension was a world beyond death. We know that the world is three-dimensional, he wrote, but in fact we "see and touch only surfaces." Our three-dimensional world is actually a projection from a four-dimensional one; to visualize this, we should imagine a plane surface on which solids are projected when passing through the plane:

> We know that it is possible to represent a three-dimensional body upon a plane, that it is possible to draw a cube, a polyhedron, or a sphere. This will not be a real cube or a real sphere, but the projection of a cube or of a sphere on a plane. We may conceive of the three-dimensional bodies of our space somewhat in the nature of images in our space of, to us, incomprehensible four-dimensional bodies.[43]

This passage from *Tertium Organum* conjures up strong visual images, such as the ones that appear in Bragdon's book. But Uspensky gave the fourth dimension even more of a religious and mystical significance. All life is a circle that moves from birth to death and then to rebirth, a "circle of the fourth dimension," which is "inevitably escaping from our space."[44] For the elite, life in the fourth and fifth dimension promises nothing less than immortality, a world beyond the limits of death.

Uspensky concluded *Tertium Organum* with a chapter on the "supra-conceptual" mind. In it he provided forebodings typical of the years after 1905, an apocalyptic sense of a coming new age, a new consciousness, a new humanity, and a new master. He also cited at length the work of R. M. Bucke, a Canadian psychiatrist and mystic friend of Walt Whitman. In his book *Cosmic Consciousness* (New York, 1901), Bucke argued that the human race was moving from simple consciousness through self-consciousness to cosmic consciousness, that is, a "sense of immortality, a consciousness of eternal life, not a conviction that he shall have this, but that he has it already." Three imminent revolutions would "literally create a new heaven and a new earth": first, a material revolution based on the attaining of "aerial navigation"; second, an economic revolution, which would eliminate both riches and poverty; third, a psychic revolution in which all men's spiritual eyes would be opened to the truth at approximately the age of thirty-five—Bucke's

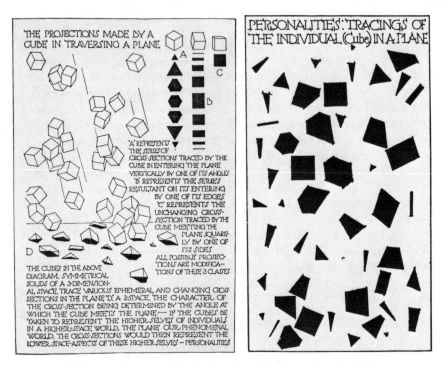

Two illustrations by Claude Bragdon and Philip Wynne for *Man the Square*, 1913. From Claude Bragdon, *A Primer of Higher Space: The Fourth Dimension, to which is added Man the Square, A Higher Space Parable* (New York: Alfred A. Knopf, 1923).

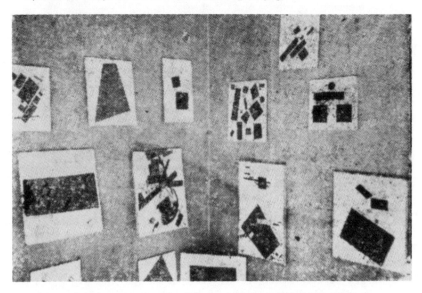

Suprematist paintings by Kazimir Malevich at futurist exhibition "0.10," Petrograd, 1915. Courtesy of the Stedelijk Museum, Amsterdam.

age when he discovered truth. Cosmic consciousness would come to the middle-aged at a moment of "supreme occurrence." Bucke himself claimed to have had a "supreme moment" of illumination in 1872 at thirty-five, so that he too "passed through a new birth" and attained a "higher spiritual plane."[45]

There is considerable evidence that Malevich was greatly influenced by Uspensky's ideas in 1915. We know that Malevich was in Petrograd in the spring of 1915 in connection with Tramway V and that Uspensky was lecturing there on death and the fourth dimension. We also know that Uspensky was the Russian most familiar with the ideas of Hinton and Bragdon, and that he was disseminating those ideas through his books and lectures. We cannot say definitely that Malevich attended Uspensky's lectures. But in the months following them there was a dramatic change, a "moment of innovation," in Malevich's painting. His new style of geometric abstraction involving colored plane figures bears a close resemblance visually to Wynne's drawings in Bragdon's *Man the Square,* and his new language to describe his painting abounds with talk about the fourth dimension and theosophic terminology. It is perhaps inappropriate to interpret the effect of Uspensky on Malevich as a sophisticated kind of intellectual influence. Uspensky's ideas were popular in Petrograd, and they may well have suggested a new kind of abstract painting to Malevich.

Malevich's first suprematist paintings along the lines suggested by Uspensky and Bragdon were hung at the "last futurist exhibit," entitled "0.10," in December 1915. In the summer and autumn of 1915, members of Pougny's circle gathered at his family estate at Kuokalla to plan the exhibit. They obtained permission to use the private art gallery of Nina Dobychina near the Hermitage. Apparently, they wished to outdo Vladimir Tatlin, who had emerged more successfully from Tramway V than Malevich; Malevich's work had not received equal critical recognition, and the patron Shchukin had even purchased one of Tatlin's reliefs for 3,000 rubles. The rivalry between Tatlin and Malevich emerged openly at 0.10. Here Malevich exhibited his first suprematist paintings—canvases covered with bright colored squares, triangles, and rectangles. He hung a sign outside his exhibition room proclaiming "suprematist painters." Tatlin responded with a sign at the door of his room that read "professional painters." At one point a fist fight erupted between the two artists; it was stopped by Pougny, who explained to a policeman present that Tatlin simply had stomach cramps. In the end the exhibit achieved public notoriety but little financial success. Six thousand visitors viewed its work, but only one painting was sold. The art critic Lopatin found "no painting and no individuality," while the newspaper *Petrogradskie vedomosti* called the painters "savages" playing at "anarchism in art."[46]

Nevertheless 0.10 gave Malevich a new reputation. He proclaimed

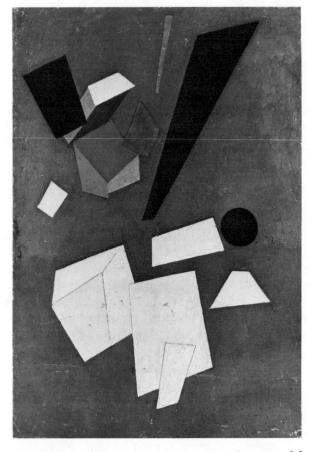

Ivan Pougny, Suprematist composition, 1915. Courtesy of the
Stedelijk Museum, Amsterdam.

himself head of a post-futurist art movement, suprematism. His ab-
stract, geometric canvases were highly innovative. In a pamphlet en-
titled *From Cubism and Futurism to Suprematism,* which Malevich
handed out at the exhibit, he declared that "the forms of suprematism,
the new realism in painting, are already proof of the construction of
forms from nothing, discovered by Intuitive Reason." Painters should
now abandon completely the physical object and create an entirely new
painting of pure geometry based on the square. "The square is not a
subconscious form," he announced; "it is the creation of intuitive reason.
It is the face of the new art. The square is a living, royal infant."[47]
Surrounded by his coterie of younger followers, notably the Pougnys
and Olga Rozanova, Malevich became the high priest of a new artistic

Olga Rozanova, Xenia Bogoslavskaia, and Kazimir Malevich at the
futurist exhibition "0.10," Petrograd, 1915. Courtesy of the Stedelijk
Museum, Amsterdam.

religion. "I am the royal infant," he declared at a public lecture toward
the end of the 0.10 exhibit in January 1916; "before me there have
been only stillborn children. Tens of thousands of years have prepared
my birth."[48] As a thirty-seven-year-old Polish-Ukrainian painter was
proclaiming himself man the square and Christ resurrected, many mem-
bers of his audience got up and left the hall.

VI

Malevich's moment of innovation in 1915 did not bring immediate
fame and success. But he had found in the Anglo-American tradition
of theosophy and the "fourth dimension" imported by Uspensky the
key to a new art and a new beginning for himself as an artist. Uspensky's
Petrograd lectures undoubtedly contributed to the popularity of theos-
ophy and Indian philosophy. In 1915 Scriabin, for example, proclaimed
his interest in the "crisis of Euclidean geometry" and the idea of
a "many-measured space" beyond three dimensions; he referred fre-
quently to the *sphota* of the Rig Veda: the Supreme Being, Supreme
Reality, or Supreme Truth.[49] Malevich described Uspensky at the time
of the 0.10 exhibit (in a letter of May 1916) as a philosopher "seeking
for a new man, for new paths," although he did not entirely agree with
him. "Reason," Malevich wrote, "has now imprisoned art in a box of

square dimensions. Foreseeing the danger of a fifth and sixth dimension, I fled, since the fifth and sixth dimensions form a cube in which art will stifle."[50]

Theosophy and the "fourth dimension" continued to influence Malevich in later years, although he avoided explicit reference to them in public. He soon ceased to employ the term "fourth dimension" in the titles of his paintings, as he had in 1915. But theosophical terminology continued to appear in his writings. After the 1917 Revolution, he wrote that Russia would some day be the "rotating creative axis and race" for a new kind of culture. Uspensky had described the fourth dimension as a way out of death. Malevich would employ the fifth dimension as the basis for his new art:

1. A fifth dimension is set up.

2. All creative discoveries, their buildings, construction, and system should be developed on the basis of the fifth dimension.

3. All discoveries developing the movements of elements in painting, color, music, poetry, and constructions (sculpture) are evaluated from the viewpoint of the fifth dimension.

Theosophical centers, poles, rays, and dimensions continued to pervade Malevich's writings long after his initial encounter with the doctrine in 1914–1915.[51]

Malevich's real fame in Russia came only after the 1917 Revolution. In 1918 the forty-year-old painter went to work for the painting section of Lunacharsky's Narkompros, designed the costumes and scenery for the first production of Mayakovsky's *Mystery-Bouffe*, and brought the Pougnys to join him in Vitebsk in 1919, when he displaced Marc Chagall as head of the art school there. In Vitebsk Malevich, together with El Lissitzky, proclaimed another new art movement, Unovis, toward a new art. In the 1920s he headed the theoretical section of Inkhuk, the Institute for Artistic Culture, in Petrograd; he also moved away from painting to the design of architectural forms, which he called "planits." His work became well known in Europe through the Van Diemen Gallery exhibit of 1922 in Berlin and his 1927 visit to the Bauhaus. He died of cancer in 1935 in Leningrad.

Malevich's philosophy, with its emphasis on the fourth dimension as an escape from death, symbolized the mystical element in the Russian avant-garde. In 1924 the painter made a specific proposal to institutionalize that mysticism and theosophy by immortalizing the dead Lenin. Writing in January 1924, immediately after Lenin's death, Malevich compared Lenin to Christ.[52] Lenin, too, had been resurrected after death from "he" to "He," from time-bound matter into immortal spirit. He had now departed this world for the world of true art and religion,

the "supra-material kingdom of the ideal spirit." Lenin's body, wrote Malevich, should not be placed in any ordinary mausoleum, but "in a cube, as if in eternity. The cube of eternity should be constructed as a sign of its unity with the dead." In death, Lenin should become the object of a new cult. "Every working Leninist should have a cube at home, as a reminder of the eternal, constant lesson of Leninism, which will establish a symbolic, material basis for a cult." Music, poetry, and workers' clubs with their Lenin corners (*ugolki Lenina*) should celebrate the dead revolutionary leader, especially through the symbolic cube, the Soviet version of an Egyptian pyramid.

Malevich considered the cube a proper symbol for the Lenin cult because it symbolized the eternal fourth dimension. "The cube, as the symbol of eternity; the chair, as an object to sit on; the icon, as a religious object—all can pass from one state to another. Material things depend on ideas and spirit." The cube for Malevich meant metamorphosis, not death; a new beginning rather than an end. "The view that Lenin's death is not death, that he is alive and eternal, is symbolized in a new object, taking as its form the cube. The cube is no longer a geometric body. It is a new object with which we try to portray eternity, to create a new set of circumstances to maintain Lenin's eternal life, defeating death." The cube would symbolize Lenin's immortality. More than that, it would symbolize an entire new culture:

> In the cube is the entire culture of human development; the cube symbolizes the first epoch or first cycle of the objective basis of ideas, and a new epoch which will move toward a new creation of form, conceived as the cube of its knowledge moves into a higher space (*prostranstvo-dal'she*); or as the cube, as a moving space, creates a new body, a new space.

In painting, the cube moving through two-dimensional space at an angle had created the patterns of suprematism; in life, it would now help to build a new Soviet culture.

When one is aware of Malevich's earlier journey through the fourth dimension of Hinton and the square of Bragdon, his arcane theosophical plans for a Lenin cult cease to confound. "Lenin has died," wrote Malevich, "but his life remains for five minutes, like the eclipse of the sun (*zatmenie sol'ntsa*) during the death of Christ as life ceased." Around 1913 Malevich had produced the painting "An Englishman in Moscow," a symbol-laden combination of a fish, a man in a top hat, and the words "partial eclipse of the sun." This painting can stand as a symbol of Malevich's own metamorphosis and partial eclipse. For it was precisely at that time that Anglo-American theosophy and the interest in the "fourth dimension" began to transform Malevich into a new kind of painter.

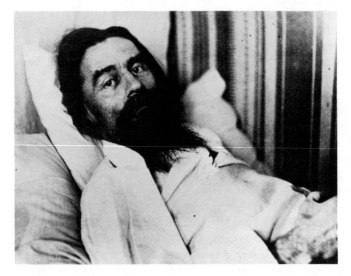

Malevich on his deathbed, 1935. Courtesy of the Stedelijk Museum, Amsterdam.

In an unpublished manuscript Malevich had expressed his own per-sonal belief in immortality. "No phenomenon is mortal," he wrote, "and this means not only the body but the idea as well, a symbol that one is eternally reincarnated in another form which actually exists in the conscious and unconscious of a person." The artist also seeks fame at a "moment," wrote Malevich, when he transforms himself from "nothing" into "something." Eternal life is therefore possible "not only in my exis-tence after death but in my every new step, as soon as I am transformed from one situation to another; it is then all the same whether I go to a graveyard or to the city of the future, where they expect my reincarna-tion."[53] Much of this bears echoes of Ernst Mach, whom Malevich mentions in passing, as well as of theosophy. But Malevich's notion of immortality was far more mystical than that of Mach or Lunacharsky, which amounted to little more than a permanent reputation in the memories of others. His was a quite literal escape from the confines of this three-dimensional world into the eternity of four dimensions.

Malevich's doctrine of revolutionary immortality thus appears to have emerged from the prerevolutionary world of art and ideas. The Russian avant-garde was familiar with various theosophical notions, emanating from Munich and London, before the war. In early 1912 the theater director Sergei Volkhonsky told the Congress of Artists in Petersburg that "a theosophical principle has penetrated something close to me, i.e. art"; the members of the Union of Youth also em-ployed theosophic terminology often to describe their art. In addi-

tion, Matiushin was familiar by early 1913 with Hinton's work on the broader topic of the fourth dimension, but through Uspensky's *Tertium Organum,* rather than directly.[54] It is probably most accurate to view Malevich as a relatively uneducated painter who absorbed ideas from Russians around him, rather than from Western books or thinkers. His passing references to the "intuitive" of Bergson, the "I" of Mach, and the "fourth dimension" of Bragdon and Hinton were all part of the philosophical language of the time used by Russian artists. At any rate, in 1915 Malevich, at the age of thirty-seven, had found his own cosmic consciousness of the eternal square in his suprematist moment of innovation.

6

Immortalizing the Revolution:
The Poetry of Mayakovsky

Youth, large, lusty, loving—Youth, full of grace,
force, fascination.
Do you know that Old Age may come after you, with
equal grace, force, fascination?
 —Walt Whitman, *Leaves of Grass*

Throughout his life the poet Vladimir Mayakovsky was deeply con-
cerned with the problem of death and immortality. He seriously con-
templated suicide on a number of occasions, the last in 1930 when he
ended his life with a revolver. His poetry was filled with images of
death and hopes of resurrection derived from sources as diverse as
traditional Christianity and the poetry of Walt Whitman. In his politics
he converted to the Bolshevik cause in 1917 with the fervor of a mis-
sionary, and he sought to memorialize the revolution through his art.
As an innovator he made a major contribution to Russian poetry and
language by his novel use of colloquialisms, slang, and archaic words
and syntax. His principal contribution to revolutionary art, however,
lay in his raising of politics to the level of religious ecstasy in poems
such as "V. I. Lenin" and "150,000,000." For Mayakovsky the Russian
Revolution provided an opportunity to immortalize himself through its
poetic celebration.

Mayakovsky attained artistic and political immortality only after
his own death, when Stalin chose to deify him as a poet laureate of the
revolution. During his lifetime he suffered continual frustration and ob-
scurity, both as a self-proclaimed "futurist" and as a Bolshevik fellow-
traveler. Only in 1923, at the age of thirty, did he finally achieve wide-
spread recognition by intertwining his personal and political concerns
with death and resurrection in what is generally recognized to be his
greatest lyric poem, "About That." The circumstances of this moment
of innovation are particularly important; it occurred in the wake of
Mayakovsky's first trip abroad and during a personal crisis in his rela-

tions with Lily Brik. This suggests once more the importance of Western ideas and personal concerns in the life of the Russian avant-garde, even after 1917.

<div align="center">I</div>

Christian imagery and the person of Christ form perpetual themes in the poems of Mayakovsky. But it is rarely the Christianity of Russian Orthodoxy; it is, rather, a Christianity of Mayakovsky's own making, containing elements of mockery and satire along with a sensitivity to the relevance of Christian imagery to the revolution. The promise of resurrection pervades much of his poetry. Christ is sometimes identified with the revolution itself, sometimes with Mayakovsky personally. Both the city and the revolution in Mayakovsky's poems promise immortality and threaten martyrdom, more than they define any futurist or Bolshevik social or political utopia. Christ stands before Mayakovsky as a man returned from the dead, "escaped from his icon," as he wrote, reappearing on earth in a manner suggested by Dostoevsky's Grand Inquisitor, James Ensor's painting of "Christ's Entry into Brussels," or Alexander Blok's poem "The Twelve." He is, in a sense, Mayakovsky himself in a new incarnation.

In Russian poetry before 1914 the theme of immortality was often connected with the stormy revolutionary events of the time. During the summer of 1905 the Ukrainian poet Ivan Franko composed a workers' song proclaiming "The eternal revolutionary/Spirit calling the body to battle/For progress, for good, for freedom/He is the example of immortality."[1] The writings of Maeterlinck and Verhaeren, as we have seen, were also full of the symbols of revolutionary immortality, suggesting a connection between the revolution and Easter, the revolutionary leader and Christ. The symbolist poetry of Alexander Blok, set in the context of the city, suggested the alienation of modern man by blurring the distinction between the living and the dead. "The living sleep/The dead man rises from the grave/And goes to his bank, and goes to Court, then to the Senate . . . /The whiter the night is, the blacker the malice of the day/And the triumphant pens keep squeaking."[2]

The theme of immortality also predominates in the writings of a little-known Russian philosopher of the time: Nikolai Fedorovich Fedorov (1828–1903), the librarian of the Rumiantsev Museum in Moscow at the end of the century, who was regarded as a propertyless saint by many intellectuals who knew him. In Fedorov's view, all men form a community of brothers in time and space, sons of their fathers, and of the Father of all fathers. Man must not await God's grace, but should act upon the world to improve it through science. Fedorov believed

quite literally in a "resurrection of the flesh," whereby the fathers could be brought back to life by the sons:

> The mass of mankind will be transformed from a crowd, a jostling and struggling throng, into a harmonious power when the rural mass or common people (*narod*) become a union of sons for the resurrection of their fathers, when they become a relatedness, a 'psychocracy.'[3]

There was as much scientism as mysticism in Fedorov's views, a kind of extreme version of the positivist religion that we discussed in the case of Lunacharsky. Ultimately, science would control even the weather and would conquer death itself. The positivists, wrote Fedorov, did not go far enough; they did not believe literally that the dead could be raised. Secular progress was a form of hell, a belief that the living were superior to the dead, the future to the present, the present to the past. Fedorov's vision was even more utopian. "The doctrine of raising the dead may be called positivism," he wrote, "but it is a positivism of action."[4] Fedorov never concerned himself with the social and political results of this action, considering doctrines such as socialism mere lies. His revolution was more far-reaching in that it promised through science the ultimate sign of man's dominion over the earth: victory over death.

Walt Whitman was another important influence, reinforcing Mayakovsky's concern with the theme of immortality. Here again, the young Mayakovsky, unable to read English, derived his Western source through an intermediary, Kornei Chukovsky, the translator of *Leaves of Grass* (1907). Whitman identified the celebration of himself with the composite American, who appears in his poems as Modern Man, or Everyman, or the hero of the New World; he was enthusiastic about the modern city, science, and industrial democracy—gaining the approval of the futurists—and critical of the "depravity of the business classes"—gaining the approval of socialists. Although Mayakovsky lacked Whitman's sensual, mystical, and pantheistic side, he embraced his solipsism, his urbanism, and his intimations of resurrection and immortality, as in the verse from *Leaves of Grass*, "I know that I am deathless." In the summer of 1913, when Chukovsky was interviewing Mayakovsky in Moscow, the poet accused him of prettifying his Whitman translations, and he recited whole passages aloud from memory. "During one of our later meetings," Chukovsky recalled, "Mayakovsky asked me about Whitman's life as if he were measuring it against his own."[5]

Finally, Russian futurism provided Mayakovsky with another important dimension of immortality. The futurists' central concern was language, a "revolution of the word," which they hoped to introduce into Russian society by the use of nonsense, neologism, and argot. They

shared with their Italian prototype an enthusiasm for the novel and the young, a rejection of the past, and a heroic disdain for death. The cult of the machine and the city carried with it a sense of the importance of the secular and the present, the here and now, the eternal values of dynamic youth and the uselessness of the aged and the ancient. As a poet, Mayakovsky was tremendously influenced by (and involved in) futurist trans-sense language (*zaumnyi yazyk*) and the theories of words as independent sound units laid down in Velemir Khlebnikov's *The Word as Such* (1913) and Viktor Shklovsky's *Resurrection of the Word* (1914). But the desire to make new extended from poetry into life itself; death was to be risked rather than feared.

We shall soon consider all of these remarks in the context of Mayakovsky's own life. For the moment it is worth noting that while Mayakovsky did not travel abroad before World War I, and while the medium of his art was the Russian language, a number of Western individuals and influences significantly affected his life and his work. Like Tolstoi, he took his Christianity in a far more direct and free-thinking way than allowed by the Russian Orthodox Church and employed its metaphors even as he mocked many of its beliefs. The revolutionary symbolism of Verhaeren and Maeterlinck reached him, albeit second hand, through Blok and the symbolists. Fedorov transmuted the religion of science developed by Comte, Avenarius, and Mach into his own science of regeneration. Chukovsky's translations gave him access to Whitman, and David Burliuk introduced him to the European sources of what would come to be called Russian futurism. All of these ideas formed the matrix of Mayakovsky's world in his youth, and all displayed a concern with death and immortality. They provided him with poetic images to express his continual concern with the theme of death in his own life and with the hope of resurrection through revolution.

II

Mayakovsky belonged to the futurist generation of the avant-garde that launched its cultural offensive against bourgeois society in the years before World War I. Like many other artists of that generation, he came from the southern non-Russian frontiers of the Russian Empire. Mayakovsky was of Russian and Cossack descent on his father's side and Ukrainian on his mother's. He spent the first thirteen years of his life in Georgia, where his father was a forest ranger assigned to the tiny settlement of Bagdadi near the town of Kutais. Mayakovsky was born here in 1893, on his father's birthday. Growing up, he encountered a complex national and linguistic environment. Most of the Mayakovskys' friends were not Russian but Georgian or Polish. "In Bagdadi,"

his mother later recalled, "all the inhabitants were Georgian and our family was the only Russian one. Our children played with the neighbors and learned Georgian from them."[6] Thus Mayakovsky and his two older sisters Olga and Ludmilla grew up with the language duality of Russian provincial life, speaking Russian at home and in school and Georgian at play and in the streets. Unlike many artists of his generation, Mayakovsky was ethnically part Russian, but he shared the larger experience of a non-Russian childhood.

Similarly, Mayakovsky migrated from the village and small town to the city. In the fall of 1902 he entered the gymnasium in Kutais, and by 1905 he was an unusually tall twelve-year-old, joining with other students in singing Georgian revolutionary songs during demonstrations. In 1904 his sister Ludmilla went to Moscow to attend the Stroganov School for the applied arts; two years later Mayakovsky's father died, leaving the family virtually penniless. Mayakovsky and his mother moved to Moscow, where in the summer of 1906 she obtained a government pension of fifty rubles a month and rented an apartment on Malaia Bronnaia Street. As a result Mayakovsky found himself at age thirteen in the big city, virtually on his own, poor and fatherless.

Mayakovsky's adolescence in Moscow coincided with the emergence of the easel painting avant-garde associated with the Moscow School and the Jack of Diamonds exhibit of 1910–1911. At first he attended a *Realschule*, rather than the classical gymnasium; in September 1908 he began to audit some evening classes at the Stroganov School, where his sister was enrolled. But he soon became more involved in revolutionary politics than most avant-garde artists of the time. Toward the beginning of 1908 he joined the Bolsheviks and began studying Marxist literature under the tutelage of an older law student, Ivan Karakhan. In March of that year, Mayakovsky, fifteen years old, was arrested during a police raid on a Bolshevik printing press, imprisoned for a brief period, and then put under police surveillance. In January 1909 he was arrested again. Released a month later, he was arrested a third time in July. This time he was put in solitary confinement for several weeks, placed on trial for distributing revolutionary leaflets, and released only in January 1910 to his mother's custody. This apparently harrowing prison experience was crucial to Mayakovsky, and the metaphor of the iron cage persisted in his later poems. He used his time in prison for self-education, reading symbolist poetry, keeping a notebook of sketches and jottings, and writing his first poems. Faced with the choice between deeper revolutionary commitment and a career as an artist, he now chose art.

Mayakovsky was not much more successful at art than at politics. After several months of studying painting with P. I. Kelin, who prepared art students for the Moscow School, Mayakovsky was advised not to take the entrance examinations. In the summer of 1910 he ignored this

advice, took the examinations, failed them, and returned to Kelin for further study. In the autumn of 1911 he managed to pass the entrance requirements and entered a world of drawing lessons, anatomy lectures, and painting exercises, which soon bored him. A fellow student described his paintings as gaudy oils which produced a "rather cheap, superficial effect."[7] At eighteen Mayakovsky was one of hundreds of poverty-stricken provincial art students walking the streets of Moscow. At this point he encountered his first patron, David Burliuk.

Burliuk was a central figure in the development of the Russian avant-garde because of his travels in Europe, where he had studied with Ažbe in Munich and Cormon in Paris, and because of his father's money. In 1911 he was a thirty-year-old Ukrainian painter at the Moscow School, who had studied in art schools off and on for at least eight years. Burliuk's father, the bailiff for the estate of Count Mordvinov in the Crimea, provided the mony to educate David and his brothers and sister and to support their art exhibits, among them the Link and the Jack of Diamonds. The Burliuk home became a kind of family art colony, to which David often brought his friends and fellow-students to paint, argue the merits of art, and see photographs of the latest Paris works. Two of the visitors, Velemir Khlebnikov and Benedikt Lifshits, jokingly proposed in the winter of 1911–1912 that David and his friends should constitute a new "ism" in art. Rejecting geotropism, heliotropism, and the more Russian sounding *chukuriuk*, they hit upon the name Hylea, after the ancient Greek colony on the Dnieper River not far from the estate.[8] It was Hylea that gave birth to Russian futurism.

Mayakovsky thus by chance entered the world of art and patronage represented by the Europeanized Russian avant-garde. In January 1912 he became friendly with Burliuk, then involved in organizing the second Jack of Diamonds exhibit in Moscow. They agreed that life and art were generally boring. Upon hearing Mayakovsky read one of his poems, Burliuk promptly declared him a genius and offered him fifty kopeks a day so that, in Mayakovsky's words, "I could write without starving."[9] In this manner, the would-be painter became a poet. To an art teacher like Kelin, Burliuk, who carried a lorgnette and sported a red velvet vest, tails, and top hat, was a conceited and untalented dandy. But for Mayakovsky, he was a patron who could turn failure into success, poverty into riches, and poetry into a radical movement: futurism.

III

Some members of the Russian avant-garde invoked another European art movement in 1912 when the Hyleans began to call themselves "futurists." The St. Petersburg poet Igor Severianin had already proclaimed something called "ego-futurism" in the autumn of 1911, and the

Moscow painters Goncharova and Larionov were developing the "force lines" of Boccioni and other Italian futurist painters into a movement of their own, which they called "rayonnism" (*luchizm*). Now Burliuk, too, wanted an up-to-date movement and asked his friend Benedikt Lifshits to "be our Marinetti."[10] Burliuk left Russia that spring for a tour of Paris, Milan, Rome, Venice, and Munich, from which he returned laden with futurist manifestoes and photographs of paintings and sculpture. In the autumn of 1912 he and Mayakovsky moved from Moscow to St. Petersburg. In December they printed their own manifesto, *A Slap in the Face of Public Taste*, which called for an end to traditional art, throwing Pushkin, Dostoevsky, and Tolstoi overboard from the steamship of modernity. They were joined shortly by two more friends, the linguist Khlebnikov and another art student from Kherson and Odessa, Alexei Kruchenykh. Without leaving Russia, Mayakovsky now found himself surrounded by the influences of Italian futurism, from which Russian futurists drew their initial inspiration.

Mayakovsky's move to Petersburg in 1912 was part of a general shift of the center of gravity of the Russian avant-garde. Poetry and drama replaced painting as the radical artistic medium, and Petersburg replaced Moscow as the geographic center of the movement. In 1913 Burliuk and his friends joined forces with members of the St. Petersburg Union of Youth against their Moscow rivals, and with some students of the linguist Baudouin de Courtenay. The result was "Russian futurism" in which the dominant art form was poetry; words were declared to be independent of their meaning, new rhythms and rhymes were created on the basis of sight and sound, and a trans-sense language emerged subject to the poet's own will and often designed to shock middle-class audiences. The futurists took to the streets wearing outlandish dress: Mayakovsky's yellow tunic, Burliuk's top hat, and spoons or radishes in buttonholes. They issued manifestoes and painted their faces, employing all means to antagonize the philistines. They threw tea at their audiences, read poetry on street corners, glorified the modern city, and made their life into public theater.

For Mayakovsky, futurism was an ideal movement, fusing his inclination toward rebellion with his enthusiasm for art. Both elements were present in his first play, a tragedy about himself entitled *Vladimir Mayakovsky*, which was performed under the auspices of the Union of Youth in December 1913 on alternate nights with the futurist production *Victory over the Sun*. At one level Mayakovsky's play was a futurist parody of Meyerhold's symbolist production of Blok's *Balaganchik* with its cardboard figures. But even more important was the fact that it made Mayakovsky himself the hero of his own art. The play consisted mainly of Mayakovsky playing himself in various identities: the Man with One Arm, the Old Man with Scrawny Black Cats, and so on. The intent of

the play was to scandalize; in this it succeeded admirably, attracting more whistles, jeers, and catcalls than applause. The critic Kornei Chukovsky dismissed it, in *Russkoe slovo*, as "naive, provincial impressionism."[11] The play did not bring Mayakovsky widespread recognition beyond the coterie of futurists.

At about the same time Mayakovsky also became intrigued with death. Through Chukovsky's new translations, he found in Whitman a sense of deification of self and a yearning for immortality. In addition, a friend at the Moscow School, Vasily Chekrygin, introduced Mayakovsky to Fedorov's ideas concerning man's scientific ability to conquer death and resurrect his dead ancestors. Finally, in 1913 a student in Mayakovsky's apartment building committed suicide by throwing himself under a train, an incident that deeply depressed Mayakovsky. These developments provided Mayakovsky with a heightened sense of self-importance and with intimations of death.[12]

The tragedy *Vladimir Mayakovsky* is full of references to death and immortality. "I/may well be/the last poet there is," Mayakovsky announces to his audience. Revelation and salvation will come not in the pantheistic sensuality of Whitman's "body electric" but in a similar fusion of the spiritual with the modern and the urban, "our new souls —humming/like the arcs of street lights." The poet is despondent; in the end he will simply lie down on a railroad track and "the wheel of a locomotive will embrace my neck." Yet death is treated with irony, and even mockery, despite its apparent finality. "My son is dying," says the Woman with a Tear in an unconcerned manner; "No trouble/Here's another tear./ You could put it on your shoe/it would make a fine buckle." References to death and suicide abound, as, for example, the Man with Two Kisses, who tells the story of "A man who was big and all dirty," who goes home and hangs himself. But death may not be all that final, for Mayakovsky also suggests that one's soul lives on indefinitely beyond the death of the body, although in new forms, in a manner reminiscent of Whitman's "No doubt I have died ten thousand times before." "I'm old," says the Old Man with Scrawny Black Cats, "a thousand-year-old gaffer." And Mayakovsky proclaims his own immortality: "I undaunted/have born my hatred for sunlight through centuries/my soul stretched taut as the nerves of a wire."[13] Throughout the poem there lurk, beneath the mechanized trappings of modernity, the spiritual needs of men in a secular age.

The suggestions of suicide, death, and resurrection that appear in *Vladimir Mayakovsky* were not a passing adolescent mood. Rather, they presaged a theme that Mayakovsky would continually return to and embellish. Many of his themes are common to Whitman and the futurists—the importance of the poet as a symbol of everyman, the enthusiasm for modernity through the machine and the city, and the

general sense of man's power to determine his own future. By 1914 such
motifs had been widely publicized by the futurists' poetry-reading tours
of the provincial towns, and the expulsion of Mayakovsky and Burliuk
from the Moscow School in February 1914 only added to their
notoriety.[14] But it is important to keep in mind that Mayakovsky had
hardly achieved success or maturity by 1914, whatever his futurist stand-
ing within the avant-garde.

IV

World War I brought death and violence to Europe with unprece-
dented horror. For Mayakovsky, however, the reality of the trenches
was far away. As an only son, he was exempt from the draft, but he
volunteered anyway; the Moscow police promptly rejected him because
of his political activity and arrest record. On the home front he turned
patriotic, publishing anti-German poems and articles for the St. Peters-
burg journals *Nov* and *Novyi satirikon*. He hung out with other bohe-
mians at the Stray Dog cabaret of Boris Pronin, since 1912 a central
gathering place for Petersburg artists and intellectuals—Lifshits,
Chukovsky, the poets Osip Mandelshtam and Anna Akhmatova, and
Meyerhold. Hundreds of customers often crowded into its two small
rooms, decorated with wall paintings by the former Blue Rose artists
Sudeikin and Sapunov. Pronin, a former actor, divided the world into
two groups: his avant-garde friends and the "pharmacists," or middle-
class and aristocratic patrons who paid outrageous cover charges to
mingle with bohemia. But World War I made the Stray Dog seem super-
fluous, if not immoral and frivolous, and most of its clientele drifted
away. "In Russia," one regular patron noted, "there was hardly enough
culture to create something like Montmartre."[15]

In 1915 Mayakovsky adopted a home and a family. For a time he
continued to frequent the Stray Dog, where he read poems such as
"Mother and the Evening the Germans Killed" and the anti-war "To
You!" Here he met Maxim Gorky, who arranged for him to be assigned
to the Petrograd Military Automobile School as a draftsman when he
was finally conscripted in 1915. Gorky praised his poetic talents as
revealed in "The Backbone Flute" and introduced him to the family
of the poet Osip Brik. Mayakovsky became a regular visitor at the
Briks and soon fell in love with Osip Brik's wife Lily. In Brik he found
a new patron to replace David Burliuk, and within a few months he
moved into the Briks' apartment on Zhukovsky Street. In the words of
the poet Nikolai Aseev, Mayakovsky "chose a family for himself, into
which he flew like a cuckoo, without displacing and making its members
unhappy, however."[16] Mayakovsky's relationship with Lily Brik brought
him depression and thoughts of suicide, which he fought off with cigar-

ettes, alcohol, and poetry. "I do not need you!/I do not want you!," Mayakovsky wrote in "The Backbone Flute," "It's all the same/I know/ soon I'll die."[17]

Death and resurrection persisted as themes in Mayakovsky's wartime poetry. The senseless death of war pervades "War and the Universe" and other poems of the period. In the Whitmanesque poem "Man" of mid-1917 Mayakovsky evokes a strong sense of resurrection. In "Man" a poet dies, ascends to heaven, and returns to earth to discover that he is famous and that Zhukovsky Street has been renamed Mayakovsky Street. Yet the world is still dominated by money and the omnipotent Ruler of All. Although the world has given immortality and fame to the poet who shot himself (Mayakovsky may have considered such an act in 1915), little has changed. Such themes suggest a continuing concern with death and a personal despondency.

The March Revolution of 1917 gave Mayakovsky new life. The poet who had considered suicide was ecstatic at the historic events surrounding him. He immediately became involved in the first attempts to organize artists on behalf of the revolution. "Our cause—art," he told a crowd at the Mikhail Theater, "must mean in the future state the right of free determination for all creative artists."[18] Like other futurists, Mayakovsky feared that members of the World of Art, who dominated the new Provisional Government's Commission on the Arts, would seize artistic control. Moscow seemed more receptive to the futurists than Petrograd, and it was there that Mayakovsky and Burliuk organized the "first republican evening of art" in late March 1917. Yet Mayakovsky's life went on in rather ordinary fashion; he kept his job at the Automobile School until August. In addition, he began turning his art to political use in the manner of Moor, executing a series of colored *lubki*, which satirized the Old Regime, for one of Gorky's publishing operations.[19]

On the eve of the Bolshevik Revolution, Mayakovsky was a twenty-four-year-old poet, enjoying his new freedom under the Provisional Government. He had patrons in Gorky and Brik and a market for his art in the journals of the time. The Briks provided him with a surrogate family. But it was the October Revolution that gave the relatively little-known poet his greatest opportunities for fame and success.

V

"Mayakovsky was saved by the October Revolution," wrote his friend, the literary critic Viktor Shklovsky. "He enjoyed the Revolution physically. He needed it very badly."[20] Mayakovsky provides the same impression in his carefully constructed autobiography. "To accept it or not? Such a question for me (and for the other Moscow futurists) did not exist. My Revolution."[21] Mayakovsky was, in fact, one of the first

artists to answer Lunacharsky's call for support of the Bolsheviks, and he immediately threw himself into artistic proselytizing. Like Whitman, he identified himself with his nation and the turmoil of the time. In 1918 he began to mythologize the revolution, with his play *Mystery-Bouffe*. He adopted the revolution and made it out to be something quite his own.

Mystery-Bouffe illustrates the technique of myth-making in early Soviet culture. The idea of a revolutionary variety show and poetry reading had been suggested by Gorky in July 1917. But what Mayakovsky produced was quite unique: a religious mystery play about the international proletarian revolution which mocked religion. In *Mystery-Bouffe* the earth has been destroyed by a flood, and seven pairs of "clean" and "unclean" seek refuge at the North Pole. The unclean proletarians throw the clean bourgeoisie overboard from an ark, take them to hell, become disenchanted with heaven, and return to a communist paradise on earth. As in the tragedy *Vladimir Mayakovsky*, the poet emerges once again as the "ordinary young man" of "no class/no tribe/no clan" who arrives on the ark to deliver a "new Sermon on the Mount"; he denounces the Christian heaven and predicts an earthly paradise where "you will live in warmth/and light, having made electricity/move in waves." Despite its antireligious satire, the play abounds in Christian imagery and suggests that the revolution amounts to a kind of rebirth. In the electrified scientific utopia of communism, Mayakovsky announced, the whole world would become "one great commune" where all mankind would find a "new spring" of rebirth.[22] In *Mystery-Bouffe* Mayakovsky greeted the Bolshevik Revolution in terms reminiscent of the very Christianity he mocked.

Mayakovsky first read *Mystery-Bouffe* aloud, to an audience that included Meyerhold and Lunacharsky, as a play designed to celebrate the first anniversary of the Bolshevik Revolution. Lunacharsky's chauffeur liked the play, and so it was assumed to have mass appeal. Yet initially it was a failure. Production was difficult, and many actors refused to perform in it. Meyerhold, the producer, and Malevich, the set-designer, did not get along well with Mayakovsky, the writer. Despite Lunacharsky's cheerful predictions that *Mystery* would be a "communist spectacle" that would be "understandable to anyone," the actors garbled their rhythmically complex verses, Meyerhold complained of a "complete lack of communication," and only a few futurists reacted favorably to the production. When Mayakovsky later tried to produce the play in Moscow and to make a film of it, the project was rejected by the Moscow Soviet because of what it called the play's "foggy ideas" and "incomprehensible language for the broad masses."[23] Intended as mass spectacle, *Mystery-Bouffe* turned out to be a play by and for a small segment of the Russian avant-garde.

The gap between the futurists and the average Soviet citizen was wide. The futurist journal *Iskusstvo kommuny* (Art of the Commune), financed by the Painting Section of Lunacharsky's Narkompros in 1918–1919, functioned more as a haven for the avant-garde than as a service to the revolution. When Mayakovsky proclaimed in an article that "the streets are our brushes, the squares our palettes," the "our" obviously referred to the futurists rather than to the worker-artists of Proletkult. "Proletarian art," Brik noted rather cleverly, "is neither 'art for the proletarians' nor 'art of the proletarians,' but art of the artist-proletarians." Another contributor, Nikolai Punin, admitted, "We want to build a minority dictatorship, since only a creative minority has sufficiently strong muscles to keep pace with the working class." This was too much even for Lunacharsky, who warned that the futurists should stop thinking of themselves as "persons of authority" in artistic matters, adding that "not all art is bourgeois and not all bourgeois art is bad."[24] Mayakovsky may have wholeheartedly accepted the Revolution, but the Revolution did not wholeheartedly accept Mayakovsky.

Brik and Punin nonetheless continued to proclaim themselves "builders of proletarian culture" endowed with "revolutionary wisdom," and to attack both Narkompros and Proletkult. Narkompros artists, they wrote, had a "complete misunderstanding of the revolutionary problems assigned to them," and Proletkult had no monopoly on true proletarian culture. Accused of imitating Marinetti and the Italian futurists, they retorted that any pre-1914 ties with Europe had been severed, and that Russian futurism was now "isolated along with communism."[25] By the spring of 1919 the futurists had thoroughly alienated Narkompros, and there were no further subsidies. Mayakovsky now left Petrograd for Moscow and committed himself further to the Bolshevik cause.

In the spring of 1919 Mayakovsky turned his art to the service of the Soviet government and thereby found new sources of patronage. At first he participated in Cheremnykh's workshop along with D. Moor and other artists and began to paint ROSTA windows. In addition, he wrote his first poem glorifying the Bolshevik Revolution, "150,000,000." Here again, Mayakovsky identified strongly with the anonymous masses of his country; he exhibited his devotion to the collective by not signing his name. His new role as propagandist alienated a number of his avant-garde friends. While Chukovsky saw him as "Isaiah in the guise of an Apache" and an orator who "needs not paper but larynx," others were less sympathetic. Former allies accused him of selling his soul for 150,000,000 rubles. Lenin attacked what he called "hooligan communism," and wrote that Lunacharsky should be "whipped for futurism" because he let Narkompros print five thousand copies of Mayakovsky's poem.[26] Intended to illustrate the avant-garde's support of the Bolsheviks, the poem served only to estrange Mayakovsky from both.

In the case of other artists, we have seen how revolution often provided new opportunities for political conversion and patronage, as well as fame. Mayakovsky's conversion had yielded money, but not success, and had alienated him from other artists. Critics charged that he had received "fantastic fees" for doing ROSTA windows. Poems published in *Izvestiia* could not overcome the deep unhappiness and isolation that Mayakovsky expressed in 1921 in his letters to Lily Brik. Many of his friends had emigrated, or assumed the silence of inner exile. Burliuk had left for America, Pasternak and Gorky no longer befriended him, and Blok and Khlebnikov were dead. The utopian phase of War Communism was giving way to the normalcy and profiteering of the New Economic Policy. Futurism as a movement was dead.

It is easy to read back Mayakovsky's subsequent fame into his early years. Yet from the perspective of the man of twenty-eight who had survived eight years of war, revolution, and civil war, the picture was quite different. Although Mayakovsky had written some of his best poems ("The Backbone Flute," "War and the Universe," and "Man"), he was not famous or even widely recognized beyond intellectual circles. Neither the Bolsheviks nor the avant-garde had accepted his personal identification of self and revolution. Mayakovsky's love for Lily Brik remained a source of personal torment. As of 1921 Mayakovsky had not found the fame he desired.

Yet Mayakovsky's optimism that the revolution, or at least his revolution, might some day bring about a victory over death remained unbroken. *Vladimir Mayakovsky* and *Mystery-Bouffe* had revealed his deep concern with the shape of death, with suicide, and with resurrection and the transmutation of self through art and life. The revolution appears to have heightened that concern. In the spring of 1920 the linguist Roman Jakobson observed this mood after returning from a trip to Europe. In the middle of Jakobson's attempt to explain the recent work of Einstein on general relativity, Mayakovsky suddenly interrupted him: "Don't you think that in this way we will achieve immortality?" Taken aback, Jakobson let him continue. "I am quite convinced," said Mayakovsky, "that there will be no death. The dead will be resurrected." In part, Mayakovsky's comment reflected his old fascination with the ideas of Fedorov and Walt Whitman. But Jakobson himself was struck by the remark. "At this moment," he later wrote, "I discovered a quite new Mayakovsky, one who was dominated by the desire for victory over death."[27]

VI

Mayakovsky's moment of innovation, like those of other artists discussed in this book, came about in part because of the influence of

Western ideas, novel inside Russia, at a particularly crucial period in his life. To understand the creation of the poem "About That," it is therefore helpful to sketch briefly the situation in Russian avant-garde art and its relation to Berlin Dada in 1922.

By 1922 the Bolsheviks had become increasingly intolerant of the rebellious activities of the Russian avant-garde. The normalization of economic life under the NEP was accompanied by increasing harassment of both political opponents and intellectuals. Proletkult had long since become a subsection of Narkompros. A number of intellectuals were forced to flee abroad. Tatlin's art studio was closed down on party orders. Kandinsky and Chagall both returned to Europe, which had nurtured their art before World War I. Thus, at the very time that Soviet Russia was reentering the European community through participation in the Genoa conference on economic reconstruction in the spring of 1922, the last wave of Russian émigrés was moving on Europe.

Political pressure led to new internal rivalries within the avant-garde. The younger generation of artists, whom we have labeled "constructivists," sought various means to make their art useful to the new society. The actual movement known as "constructivism" emerged in August 1920 in Moscow when two brothers, Naum Gabo and Antoine Pevsner, posted their "Realist Manifesto" in the streets and called for a socially useful art of real materials in space, akin to the work of the engineer. Alexander Rodchenko and his wife, Varvara Stepanova, specialists in metalwork and textiles in the Industrial Arts Section of IZO-Narkompros, immediately issued their own "productivist" manifesto. In it they demanded that art serve the needs of the new society by the design of workers' housing, clothing, stoves, factories, furniture, and eating utensils. In September 1921 they exhibited such objects, together with Alexandra Exter, the architect Alexander Vesnin, and Stepanova's friend Liubov Popova, in a show of twenty-five works entitled "5×5=25." As the utilitarianism of the productivists flourished, the earlier aesthetic orientation of constructivism became superfluous.

Another division within the avant-garde was occasioned by the split between Vkhutemas (the Higher Art Studios) and a new art organization known as AKhRR, or the Association of Artists of Revolutionary Russia. Vkhutemas was the central gathering place of the avant-garde during the Civil War, an open and experimental art school created from the faculties of the Moscow School and the Stroganov School in 1918. Vkhutemas was also a hotbed of European modernism, where instructors and students vied in imitating and outdoing the work of Cezanne, Matisse, Picasso, Van Gogh, and the German expressionists. But during the spring of 1922 a number of students left Vkhutemas at the time of an exhibit of Wanderers' paintings in Moscow and declared themselves in favor of a new "heroic realism" in art. On May 1, 1922, AKhRR held

its first exhibit of paintings done inside Moscow factories in order to raise money for relief of the famine then raging in the provinces. Forerunners of the socialist realists of the 1930s, the AKhRR artists reverted to the style of the Wanderers—realistic, national, and popular—and attacked the westernism of Vkhutemas and Narkompros.[28]

Both productivists and AKhRR artists illustrated the tenuous position of avant-garde artists such as Mayakovsky in 1922. The Soviet government was now choosing to support those artists who represented a new style and a new conformity to desirable canons of realism, mass art, Russian themes, and utilitarian art. The novelty and experimentalism of the Europeanized avant-garde was dated as a product of prewar "bourgeois" society, and criticized as an unnecessary and even dangerous luxury in a socialist society. A number of artists therefore sought refuge in Europe, on either a temporary or a permanent basis. Through them, the old prewar ties between Moscow, Petersburg, Berlin, and Paris were reestablished.

In prewar Germany the center of the German avant-garde had been Munich; in 1922 it was Berlin. Because of political pressure at home, the head of IZO-Narkompros, Lunacharsky's painter-friend David Shterenberg, now decided to bring Russian avant-garde art to Europe with an exhibit at the Van Diemen Gallery in Berlin. The German capital in those days was not only the center of "Weimar culture," but also the home of numerous Russian émigrés and Russian-language publishing houses. In 1922 it was also a place to "change directions," a place where Russian émigrés who had fled their homeland mingled with Russian intellectuals living abroad on Soviet passports, and with still other émigrés who, like the writer Aleksei Tolstoi, had decided to return home. Malevich's friend Ivan Pougny arrived in Berlin in 1920, opened an art studio, and exhibited his works a year later at the Der Sturm gallery. In early 1922 Shterenberg sent El Lissitzky and Naum Gabo to Berlin to join Pougny and to help organize the Van Diemen Gallery exhibit.[29]

This conjunction of circumstances made Berlin a center of the Russian avant-garde in 1922. Pougny's studio and the cafés along the Nollendorfplatz became the gathering places of a number of Soviet artists and writers living and traveling abroad. El Lissitzky and the writer Ilya Ehrenburg, in their Berlin journal *Veshch* (Object), proclaimed that spring that "the blockade of Russia has ended," and that the "young masters of Russia and the West" would now inaugurate a "new epoch of creativity."[30] Mayakovsky's friend Viktor Shklovsky arrived in Berlin and began writing his book *Zoo*. The director Alexander Tairov brought his Chamber Theater to give performances and to arrange for the publication of his book *Das Entfesselte Theater*. Boris Pasternak and Sergei Esenin were in Berlin, primarily to publish their

poetry. In the autumn of 1922 Shterenberg and Nathan Altman came to Berlin to supervise the Van Diemen exhibit.

The Berlin migration of 1922 provided many Russian artists with their first direct contact with German expressionism and the anti-art movement known as Dada. Berlin Dada was an offshoot of the wartime movement, centered in Zurich, which emerged after the abortive German revolution of 1918–1919. Led by the cartoonist Georg Grosz, it was more political than its Swiss prototype; the Berlin Dada artists pasted "Hurra Dada!" posters on police station and cell walls, read poetry at night in the middle of traffic, and publicly attacked every facet of Weimar Germany's "ruling class." Like prewar futurism, Dada represented a fusion of artistic and political rebellion against all conventional order and meaning, in both art and life, but with a less optimistic sense of despair and absurdity. Although Berlin Dada was actually in a state of decline by 1922, it was novel to the Russians who encountered it there. Since Lissitzky arranged for the *Novembergruppe* painters to exhibit in Moscow, and Grosz was a frequent visitor at Pougny's studio, Berlin Dada was well known among Russian artists by the end of the year.[31]

Berlin Dada provided some unusual examples of artistic innovation, along with its political rebellion. These were generally in the area of book publishing and poster art and involved layout, typography, and "photomontage." The Berlin Dada artists mixed large and small letters at random on the page, made faces out of typed words, spouted nonsense language in public, and juxtaposed pasted objects on paper for shock effect. The founder of the Berlin journal *Der Dada* was the Vienna-born Raoul Hausmann. Beginning in 1918 Hausmann had worked on what he called "photomontage," the combining of cut-out photographs into a kind of collage:

> This process was called photomontage because it embodied our refusal to play the role of the artist. We regarded ourselves as engineers, and our work as that of construction: we assembled (in French: *monter*) our work, like a fitter.[32]

Such a view of art as construction and rearrangement of constituent elements into a new whole fit well with what we have called the "constructivist" element in Russian avant-garde art. As early as 1920 Hausmann had done a photomontage of Tatlin and his monument to the Third International, and the Berlin Dada artists greatly admired the constructivist elements in Tatlin's "machine art" without knowing much about it. Berlin Dada journals were full of photomontages and visual collages by 1922, and provided a novel influence on a number of Russian artists, among them the painter Rodchenko, El Lissitzky, and the film director Sergei Eisenstein. Montage was a staple of Berlin Dada long

before Eisenstein theorized about it in Mayakovsky's journal *LEF* in 1923.

We are now in a position to understand the significance of Mayakovsky's trip to the West in 1922. To be sure, exile and travel abroad often breed patriotism even when times are difficult in one's own country. "Only abroad," wrote the poet Sergei Esenin of his trip to Europe in 1922, "did I understand how great are the merits of the Russian Revolution which has saved the world from a horrible spirit of philistinism." Mayakovsky's experience was likewise reinforcing of his Russian loyalties. "I went to Paris trembling," he later wrote of his first visit in October 1922 at the age of twenty-nine; "I saw everything with a schoolboy's diligence. What if we turn out to be provincial again?" His whirlwind week in Paris with Elsa Triolet, Lily Brik's sister, included visits to nightclubs, the Louvre, the studios of Léger and Picasso, the Eiffel Tower, the metro, restaurants and clothing stores; all seemed to indicate the decadence of capitalist society and the fresh possibilities of the Soviet experiment. "Before the war," Mayakovsky remembered, "schools and art trends came into being, lived, and died to the orders from artistic Paris."[33] The futurist generation of the avant-garde had found its artistic innovations in Paris; the generation of the constructivists would seek its own revolutionary paths.

Like Paris, Berlin in 1922 also provided Mayakovsky with a good deal of material for his art, despite his pejorative comments about the West. The city itself, with its factories, its bustle, its great zoo, and its elevated railways, provided a background which would emerge in his poetry. At the Café Leon in the Nollendorfplatz he found receptive audiences of both Russians and Germans, equally impressed by his poems and his news of revolutionary Russia. The typographical experiments and photomontage of Berlin Dada were also of great interest to him, and within a few months he incorporated them into the pages of his own new journal *Left Front*, or *LEF*. Most important, he had a chance to meet in person the kindred spirits of the Berlin avant-garde (John Heartfield, Hausmann, and Grosz) and to return to Russia with their journals and drawings, including a copy of Grosz's bitter and satirical *Ecce Homo*.[34] All of this helped give Mayakovsky a sense that the Russian avant-garde was part of a larger revolt against the wealth and banality of bourgeois society. It also helped provide the immediate setting for and the most recent experience prior to the composition of his greatest lyric poem.

Mayakovsky's "moment of innovation" followed almost immediately upon his return from Western Europe. While his contacts with Berlin Dada and his European trip formed an important background, the timing appears to have been largely the result of personal considerations. In December 1922 Mayakovsky had a major quarrel with Lily Brik, and they agreed to part company for two months, from December 28,

1922, to February 28, 1923. During this period Mayakovsky worked for some five hundred hours over a thirty-five-day span to produce what most critics consider his greatest lyric poem, entitled "About That" (*Pro Eto*). It was a time of agonizing self-imprisonment; he drank continuously, saw almost nobody, and left his room only when absolutely necessary. For weeks Mayakovsky worked out his emotions on paper in three separate versions of the poem which moved progressively away from thoughts of death and suicide to hopes for resurrection. In "the most important letter of my life," written to Lily Brik in early January 1923, Mayakovsky told her, "You will get to know a completely new person, as far as you are concerned. Everything that will happen between you and him will now be based not on past theories, but on deeds from February 28 on, your 'deeds' and his."[35]

The poem "About That" reveals Mayakovsky's concern with death and immortality in even greater intensity than the earlier poems we have discussed. A major theme of the poem is the tension between the individual and society, between personal love and the revolution. As usual, it is autobiographical. Reminiscent of the frustrated lover who nearly jumped into the Neva River seven years earlier, the poem's main character is a man who reappears in various metamorphoses, as a polar bear on an ice floe, as a poet-revolutionary who resembles Jesus Christ, and as a young man who has left his family but is returning to his mother's home for Christmas. It recalls the transmigration of souls in Whitman and the lines from "The Ballad of Reading Gaol," probably obtained from Chukovsky's recent translation of Oscar Wilde: "For he who lives more lives than one/more deaths than one must die." The poem is a summation of Mayakovsky's past life, and of his hope for a new one. He appears to be at a point of self-transformation. Images of crucifixion and resurrection appear throughout the poem, and Christ appears as a Komsomol member in an apparent parody of Alexander Blok. The significance of his recent travels with the Briks to Paris and Berlin emerges in his images of the Seine, the Oder, the Café Rotonde, and the Berlin Zoo. The poet will be resurrected four times before he actually dies, Mayakovsky tells the reader in reference to possible suicide attempts; his personal love has been unfulfilled, and now he must find a new role and a new life in the new society, even if as a porter or zoo-keeper. The poem ends with the desperate cry: "Resurrect me!"[36]

The poem "About That" thus reflects a turning point in Mayakovsky's life, a break with his past, a rejection of suicide, and a hope for a new start. Probably suicide was on his mind not only because of his despair over Lily Brik, but because his old friend from the Moscow School, Chekrygin, had been run over by a train in 1922, a probable suicide.[37] In Mayakovsky's mind Chekrygin, the student who had introduced him

Montage by Alexander Rodchenko, for the first edition of Vladimir
Mayakovsky's poem, *About That (Pro Eto)*, Petrograd, 1923.

to the ideas of Fedorov and the painter of Christ's resurrection, had
now chosen the same way out as the student in Mayakovsky's apartment
in 1913, when he was writing *Vladimir Mayakovsky*. Yet the poem
clearly moves away from despair to optimism. In part this may have
been caused by the good news in January 1923 that Mayakovsky had
been granted permission to edit his new journal, *LEF*. After publishing
frustrations and public attacks on his poems, this must have come to
Mayakovsky as a great relief and a sign of hope. One can only specu-
late. When the first issue of *LEF* appeared in March 1923, its contents
included the poem "About That."

"About That" was innovative in its poetic qualities and in its explicit
articulation of the theme of immortality of self hinted at in earlier
works. The journal *LEF* also marked a new beginning in Mayakovsky's
art, a rallying point for the Russian avant-garde, based in part on the
model of Berlin Dada. Its reference to "art objects" reminded the reader
of Lissitzky's Berlin journal *Veshch*. The leading contributors—Maya-
kovsky, Pasternak, Brik, and Nikolai Aseev—had been in Berlin in the

autumn of 1922 and were familiar with Dada journals and techniques. The artist Rodchenko specifically imitated the layout and illustrations of Hausmann and *Der Dada*; he also employed the technique of photomontage in the pictures accompanying "About That," which showed, among other things, Lily Brik amid the polar bears of the Berlin Zoo. And like Mayakovsky himself, the journal's first editorial vowed, "We will purge ourselves (*ochistim*) of the old 'we.'"[38] Both the poem "About That" and the journal *LEF* marked a new beginning in Mayakovsky's life and art after another apparent brush with suicide.

Only in 1923 did Mayakovsky work out a satisfactory relationship to the Bolshevik Revolution. Neither his futurist antics nor his Civil War propaganda had produced such a relationship, the first because they antagonized political authority and the second because it served that authority all too well for the integrity of the artist. Now in *LEF* he had found an independent journal acceptable to both the regime and his friends among the avant-garde, and he could try once again to achieve the balance between individual need and social demands articulated in "About That." In Berlin in 1922 he had seen an example of independent artists creating a radical art in bourgeois society; *LEF* now followed that example in Soviet Russia. In Moscow he had gone through two months of isolation and agony, which had ended with his greatest work of art, a work pervaded with themes of revolutionary immortality.

VII

At the age of thirty Mayakovsky finally achieved the fame he had so long desired. With the launching of *LEF*, the death of Lenin in January 1924, and Mayakovsky's eulogy of him in the poem "Vladimir Il'ich Lenin," the poet's name became a household word in Soviet Russia. He signed autographs, was recognized by people on the street in Moscow, and read his poems throughout the country to large audiences. When Mayakovsky visited New York in August 1925, it seemed to his old friend David Burliuk that he was "just as young, throws the bricks of his jokes around just as before. There is nothing strange in this. After all, he is only thirty. And who will be weighed down by fame, even if world fame, at the happy age of thirty?"[39]

Fame did not end Mayakovsky's thoughts of suicide or his poetic quest for some kind of immortality. His poetry came under increased criticism in the late 1920s as the work of "an extreme individualist and an egocentric," a man who wrote less about the revolution and more about his own love affairs, a throwback to the prewar futurists. By 1927 the *LEF* was losing both money and contributors; Gorky called it a "nihilistic requiem." "Your poems are too topical," shouted a hostile

Vladimir Mayakovsky in Berlin, 1923. From L. Maiakovskaia, *O
Vladimire Maiakovskom: Iz vospominanii sestry* (Moscow, 1968).

listener at one of Mayakovsky's poetry readings; "tomorrow they will be
dead. You will be forgotten. You will not be immortal." To which
Mayakovsky replied: "Please drop in a thousand years from now, we'll
talk then!" The critic Viacheslav Polonsky saw in Mayakovsky "the re-
volt of a bohemian who was himself a refined, subtle, sharpened
bourgeois." The futurists, he wrote in *Izvestiia*, have simply outlived
themselves; "we will not let them be resurrected."[40] Yet resurrection,
as we have seen, was precisely what Mayakovsky articulated in his
poetry.

Mayakovsky's new career was also marked by more frequent trips
to the West, including not only Berlin and Paris but also Mexico and
the United States (1925). Returning from these travels, he would often
import the latest innovations in Western art. Rodchenko recalled the
results of these trips:

Mayakovsky often travelled abroad, on the average of four times a
year. After each journey he would bring back suitcases filled with
books, periodicals, advertising materials, posters, photographs, post-
cards and reproductions of art works. After making use of them in
the press, he would distribute all the materials to his friends accord-

ing to their particular interests. This distribution took place in the room of Osya [Osip Brik] which took on the appearance of a store. Zhemchuzhny took materials relating to theatre and the cinema, Lavinsky—those dealing with architecture and sculpture, and I took art and photography. He gave me many monographs on Grosz, Larionov, Goncharova, Delaunay, Rousseau's 'Negroes,' Picabia, A. Lothe, V. Grigoriev, Picasso. Once he brought from Paris photographic paper, a gift to me from the famous Man Ray. That was an innovation at the time—paper on a transparent base. Man Ray made photograms. On another occasion he gave me two Picasso lithographs which he had received from the artist personally. In this way, thanks to Mayakovsky, we had a steady flow of information on the culture and art of the West. And he brought with him not only the West's art, but its life, atmosphere and daily affairs with all its rays and shadows.[41]

Mayakovsky's 1922 exposure to Berlin Dada was thus only the beginning of his enthusiasm for European artistic modernism. In this way the *LEF* circle served much the same function as the prewar Hyleans in adopting the poses of the European avant-garde. Generally in their late twenties or early thirties, members of the *LEF* circle served as a crucial link between the Westernism of the Silver Age and the revolutionary constructivism of the 1920s.[42] This is not to say that Mayakovsky should be considered a "westernizer"; but neither should he be thought of as simply a revolutionizer of the Russian literary language uninfluenced by foreign developments.

In 1927 Mayakovsky once more began to approach the sense of imprisonment and desperation that had gripped him in 1922. At the tenth anniversary of the Bolshevik Revolution, the poet represented a kind of embarrassment to the regime. Like Trotsky, who was about to be hounded into exile by Stalin, Mayakovsky was a reminder of revolutionary idealism and freedom at a time of approaching dictatorship and uniformity. As such, he was increasingly attacked in the press by official writers' organizations. Under pressure to conform, he returned to the theme of death and immortality, which had pervaded his earlier works. In 1928 he wrote *The Bedbug*, a play in which the frozen body of the hero, Prisypkin, is resurrected decades after his death, in 1979, in a manner reminiscent of Fedorov and modern cryogenics; Prisypkin discovers that he is caged in a zoo as a freak example of immortality. In 1929 Mayakovsky confided to a friend at a poetry-reading in Dynamo Stadium: "To write an excellent poem and read it here—then one can die."[43]

On January 30, 1930, Mayakovsky's new play *The Bathhouse* had its premier in Leningrad. In it the inventor of a time machine, Chudakov, is continually frustrated by a party hack, Pobedonosikov, whose name

recalled the hated Procurator of the Holy Synod under Alexander III. The reviews were sharply critical, and Mayakovsky was told to revise the script. Even as a twenty-year exhibit of his work was being shown in Moscow, he felt compelled to join the Russian Association of Proletarian Writers (RAPP) in order to go on writing. "I'm fed up," he told a friend at the time; "fame, like the beard of a dead man, will grow on me after death. While I am alive I shave it."[44] On April 14, 1930, Mayakovsky shot himself in his room, leaving behind a note:

> Mother, sisters, friends, forgive me—this is not the way (I do not recommend it to others), but there is no other way out for me.
> Lily—love me.

Stalin provided the public eulogy, but Boris Pasternak best expressed the private remembrance of the poet who had finally chosen death: "His face restored the time when he called himself the beautiful twenty-two year old, because death had stiffened the facial expression, which hardly ever gets into its clutches. It was the expression with which one begins life, not the one to end it."[45]

Mayakovsky's concern with death and immortality was lifelong, although it apparently achieved a personal and political intensity for him in 1922–1923. The historian can only speculate about how his unhappy personal life, from the death of his father through his frustrating love for Lily Brik, contributed to his continuing thoughts of suicide and his receptivity to the theme of immortality in Whitman and Federov. He never married or sired children, so that concern for immortality ultimately centered on himself and his poetry. A member of the prerevolutionary avant-garde, he was a highly original poet of the Russian language, who was continually receptive to influences from abroad. Christianity, the pantheism of Whitman, and Fedorov's positivist hope of literal resurrection all provided him with death-defying motifs for his poems. In them he could create a self that was beyond time, eternal, continually reborn in new forms. In "About That" he fused his personal quest for transcendence with the revolutionary quest for transformation, his private and public search for immortality. His identification of himself with Russia, the revolution, and the masses in "150,000,000" recalls the immortalization of the self through the collective preached by Lunacharsky more than the mystical leap into the "fourth dimension" of Malevich. Perhaps this enabled him to embrace death as intensely as he had long embraced life.

7

Constructivism: Tatlin's Monument and Eisenstein's Montage

There is a wonderful moment in the life of every artist, the moment when you realize that you have become an artist, that you have been recognized as an artist.

—Sergei Eisenstein

As a well-spent day brings happy sleep, so life well used brings happy death.

—Leonardo da Vinci, *Notebooks*

The generation of the constructivists added the cult of the collective and the mass to the urbanism of the futurists. In the 1920s the umbrella term "constructivism" implied that the revolutionary artist should be a builder whose use of modern technology was both socially useful and aesthetically inspirational for the new mass audience. In technique, the constructivists retained the futurist juxtaposition of the unfamiliar, its antagonism, but added the vision of a mass culture. Two artists were particularly significant as examples of the constructivist outlook. The painter and sculptor Vladimir Tatlin, in age a member of the futurist generation, created the most famous machine structure of the period, a monument to the Third International, the utopian aspirations of which were realized only in a scale model of 1920. The film director Sergei Eisenstein, a member of the constructivist generation, recreated the Revolution of 1905 in his film *Potemkin* in 1925; the film's revolutionary heroes were a battleship and the anonymous masses. Both men pursued a revolutionary art of juxtaposition and construction.

I

Vladimir Tatlin was a lapsed architect who envisaged himself a Renaissance man and who turned his art to the support of the revolution after 1917. An avant-garde visionary, Tatlin sought to transform

151

his private vision into useful public objects. Like Leonardo da Vinci, he hoped to realize Icarus's dream of setting man free of the earth with wings of his own. To this end he designed and built a glider, which he named *Letatlin,* a combination of his surname with the Russian verb "to fly." But he was best known for his monument of 1920, a massive double spiral of steel and glass which, if it had been built, would have exceeded the Eiffel Tower in height. Despite Tatlin's fascination with the functional possibilities of art, as in his "productivist" designs for workers' clothing and stoves, he remained a frustrated visionary. His glider never actually flew; it remained suspended from the ceiling of a bell tower at the Novodevichy Monastery in Moscow; his monument to the Third International never developed beyond a twenty-foot model to be paraded through the streets of Moscow in a horse-drawn cart—and even the model burned in a fire. Like the ideals of the Russian Revolution, Tatlin's vision faded in the face of material limitations and political exigency.

The Western tradition that influenced Tatlin was a fusion of art and life, form and function, architecture and engineering. A central theme of all his work was the articulation of the perfect geometric forms found in nature. In part, this was a legacy of the Greeks: the perfect numbers of the Pythagoreans and the perfect geometric solids of Plato or Archimedes. Renaissance painters like Da Vinci and Albrecht Dürer also were fascinated with divine proportions, such as the Golden Section, a ratio of 1:1.618, which appears in numerous mathematical forms. In the nineteenth century Gustav Fechner claimed to find ideal ratios and forms in everything from the Parthenon and Greek music to the organic plant life of nature; Fechner's ideas and his scientistic "psychophysics" later had considerable influence, via Ernst Mach and Lunacharsky, on Soviet artists in the 1920s, among them both Tatlin and Eisenstein. The form of the spiral was of particular interest to some European writers before World War I. Theodore Cook's *The Curves of Life* (1914) and D'Arcy Thompson's *Growth and Form* (1917) traced the appearance of the spiral in conch shells, staircases, towers, screws, plants, and other objects. Often this geometric tradition, in its search for perfect forms in nature, mixed the practical and the mystical, seeing a close relationship between man the builder and God the architect of the natural world.[1] The spiral of Tatlin's tower and the rectangle of Eisenstein's movie screen both reflected this general search for perfect form, as did Malevich's square.

The idea that art should serve society was popular in the West before World War I, particularly among architects, who had long been interested in combining aesthetic beauty with the new materials and needs of industrial society. One of the great admirers of Joseph Paxton's

Crystal Palace of 1851 was Gottfried Semper (1803–1879), a German architect, who envisaged new areas of textile design, ceramics, metal-work, iron architecture, and industrial design schools. By 1914 his ideas were realized across the continent, especially by the Darmstadt archi-tect Joseph Olbricht and the Berlin architect Peter Behrens. In addition to buildings (such as the German embassy in St. Petersburg, 1911–1912), Behrens designed a variety of useful objects: industrial brochures, fans, teakettles, stoves, and a turbine factory for his employer, the Allgemeine Elektrische Gesellschaft. Behrens's offices in Berlin soon became a train-ing ground for an entire generation of young architects, among them Walter Gropius, Mies van der Rohe, and Le Corbusier.[2] In their careers, all went on to preach the virtues of an architecture of function as well as form.

There also existed a visionary and even mystical tradition in Euro-pean architecture, especially in German expressionism. "Art is revolu-tionary," wrote the Austrian architect Adolf Loos; it "shows mankind new roads and looks to the future." Bruno Taut, another German archi-tect, writing in 1914, urged the use of "constructive (*aufhebenden*) sculptures" in building design; he also admired attempts by Kandinsky and the Blue Rider painters to give art religious or spiritual meaning. The architect should build the "cathedral of the future" as a new form. In Holland, too, sources as diverse as Frank Lloyd Wright's houses and cubist painting inspired the geometric building and furniture design of the De Stijl movement during World War I. "The machine," wrote the twenty-eight-year-old German architect Eric Mendelsohn in 1915, "is already a law unto itself as the starting point of a new culture."[3]

Theosophy provided one such vision. We have seen how the ab-stract painters Kandinsky, Mondrian, and Malevich were, in different ways, impelled via theosophy to construct nonobjective works of art and to describe them in theosophical terminology. There were similar theosophical influences in architecture. Adolf Loos was a good friend of Rudolf Steiner, for whom he designed a house in Vienna. Erich Men-delsohn absorbed the doctrine through his painter friends Franz Marc and Kandinsky in Munich after 1910. Another friend of Steiner was Paul Scheebart, a utopian architect-writer who advocated the extensive use of glass as the building material of the future. In his book *Glasarchi-tektur* (Berlin, 1914), he urged the construction of glass and steel build-ings for a "new glass culture" that would "completely transform man-kind." He also proposed that "towns and other places should always be distinguished by towers. Every effort must be made to lend enchant-ment to towers by night. Under the rule of glass architecture, there-fore, all towers must become towers of light."[4] Theosophy naturally did not give precise guidelines concerning architecture (although Steiner

later did just that in connection with the Anthroposophical Temple at Dornach), but it helped give architects a visionary rhetoric to inspire and describe their work.

Monuments were an integral part of these traditions in Western architecture. Their function was usually to memorialize the dead or to eternalize the transient. Monuments, whether actually built or not, were a familiar feature of the French Revolution. Art historians have devoted considerable effort to seeking prototypes for Tatlin's own monument in everything from Athanasius Kircher's painting of the Tower of Babel, through Etienne Boullée's eighteenth-century tower designs, to Auguste Rodin's 1897 monument to labor. All of these shared the common denominator of a helical or spiral form, but there is no real resemblance to Tatlin's tower beyond this form, and no evidence that Tatlin ever saw, or imitated, such prototypes. More plausible sources of inspiration are the Eiffel Tower, which Tatlin saw in Paris in 1913, and the spiral monument designs of the Munich expressionist painter, Hermann Obrist, much admired by Erich Mendelsohn; in 1919 Mendelsohn designed and built a tower of his own in Potsdam as a monument to Albert Einstein. But again the Eiffel Tower provides a quite different type of iron revolutionary monument, and the abstract sculptures of Obrist provide only the spiral motif.

In sketching the background for the Tatlin tower, then, the intellectual historian must beware. Tatlin wrote little or nothing about which monuments he had seen or admired. One can say that in Europe before 1914 many young architects shared a common interest in geometric forms found in nature, including the spiral; wished to apply their art to practical and industrial use; hoped to employ steel and glass in constructions free of ornamentation; and described their work in visionary or mystical, sometimes theosophical, terms. All of this would have facilitated, but does not totally explain, Tatlin's monument of 1920 in Soviet Russia. It is easier to see the source of Tatlin's later "reliefs" and "counter-reliefs" in Marcel Duchamp's "ready-mades" and Picasso's collages of 1913, or the inspiration for the *Letatlin* machine in the bird-like gliders of Otto Lilienthal. The point is that precedents for all of Tatlin's subsequent creative experiments can be found in Europe on the eve of World War I.

II

Born in Kharkov in 1885, Vladimir Evgrafevich Tatlin grew up in a sprawling Ukrainian industrial town.[5] His father was an engineer; his mother, a housewife who enjoyed writing poetry. But Tatlin barely knew his mother, who died when he was two years old, and he later grew to dislike both his father and stepmother. We know almost noth-

ing else of Tatlin's early life. In 1902, at seventeen, he escaped from home by enlisting in the navy. His career as a sailor took him to exotic ports of call, especially in Turkey, Morocco, and the south of France. When Tatlin returned home in 1904, he discovered that his father had died. He now decided to embark on a career in art, and entered the N. D. Seliverstov Drawing Academy in Meyerhold's home town of Penza.

A member of the southern provincial avant-garde, at the time of the 1905 Revolution, Tatlin, at twenty, was in appearance a tall, thin, sad-looking and shy young man, "rather like a fish," as Natalia Goncharova later remembered him.[6] Tatlin met Goncharova and Larionov shortly after 1905, and spent the summers of 1907 and 1908 at Larionov's grandparents' estate near Tiraspol on the Rumanian border. Larionov had been to Paris in connection with Diaghilev's 1906 painting exhibit; under his influence Tatlin was soon experimenting with the bright colors of Van Gogh and the tilted shapes of Cezanne. Larionov's own painting of Tatlin in a sailor's uniform at this time captures this unlikely and idyllic conjunction of Parisian modernism and a Bessarabian estate. Shortly afterward Tatlin was persuaded to join the stream of provincial artists heading toward the Moscow School of Painting, Sculpture, and Architecture.

Around 1910 Tatlin entered the Moscow School, where he made friends with the sculptress Sara Lebedeva and the architect Alexander Vesnin. Leaving the Moscow School a year later, Tatlin, by 1911, was showing his works with the Union of Russian Artists in Moscow and the Union of Youth in Petersburg. Along with Larionov, he was one of a number of Russian art students painting in a Parisian manner. After exhibiting with Larionov at the Donkey's Tail show of early 1912, he broke off relations with Larionov and joined the rival Jack of Diamonds group. In January 1913 Tatlin became a full member of the Union of Youth, and he continued to share a studio with Alexander Vesnin. Now an indigent provincial painter with few prospects, whatever his talent, Tatlin was nearly thirty.

Tatlin had his only direct contact with Western art in 1913, when he managed to leave Russia by signing on as a dancer and accordionist with a Ukrainian folk ensemble. At a reception in Berlin, according to one story, Tatlin imitated a blind musician so effectively that William II presented him with a gold watch; by selling it he obtained the money to go on to Paris. Here Tatlin visited Picasso in his studio, where he watched the artist make his collages—paper and wooden objects pasted on a board. He also asked Picasso for a job, but was refused. While in Paris, Tatlin visited the Eiffel Tower, that monument to the French Revolution constructed for the exposition of 1889. We know little about the trip, except that Tatlin returned to Russia in the autumn of 1913.

The Paris contact with Picasso apparently inspired Tatlin to move

away from painting and toward a kind of sculpture during the winter of 1913–1914. Along with Kazimir Malevich, Tatlin left the Union of Youth and set up his own studio in Moscow. Here he joined forces with two painter friends of Malevich (A. V. Grishchenko and Aleksei Morgunov) and two women artists just back from their studies in Paris, Nadezhda Udaltsova and Liubov Popova. In May 1914 Tatlin opened his first one-man show in Moscow, consisting of what he called "synthetic static compositions." Not surprisingly, these turned out to be constructions of wood and metal not unlike the collages and "ready-mades" he had seen in Paris. These "reliefs," as Tatlin began to call the compositions, marked a definite move away from the flat surface of the canvas to the creation of objects in space, an approach that would ultimately lead him to the monument and the glider.

During World War I Tatlin moved into the field of architecture. Exempt from the draft, he continued to paint and to construct reliefs in his own studio. In need of money, he also worked as a decorator and an assistant to Vesnin, now an established architect. This relationship did not last long, for Tatlin proved too independent and unreliable. In January 1915 Vesnin wrote his brother that Tatlin would no longer be doing ceiling decorations for him; "As you warned me," he wrote, "working with him would be impossible—and that is what happened. He was not very interested in this work, and although he always said that it was interesting and useful, he himself did none of it. He is now working on a screen for a plaster composition, which he will show at a futurist exhibit in Petrograd."[7]

At the Tramway V exhibit of 1915 Tatlin's reliefs created a certain sensation, and he even sold one to Shchukin. A few months later, however, the famous fist fight with Malevich ended their artistic and personal relationship; when Malevich published his little booklet on suprematism, Tatlin followed with a booklet on the art of "counter-reliefs." He also organized an exhibit of his own, *Magazin* (The Shop), in Moscow in March 1916. But by the time of the March 1917 Revolution, his collaboration with both Vesnin and Malevich at an end, he was artistically isolated and had achieved little success.

III

Tatlin welcomed the revolution, although he played no active role. Within days of the abdication of Nicholas II, artists began to organize into various groups. On March 12 an umbrella organization known as the Union of Art Leaders (*Soiuz deiatelei iskusstv*) appeared, dominated by Alexander Benois and the artists of the World of Art. Tatlin joined a more radical group known as Freedom for Art (*Svoboda iskusstvu*), whose members included Meyerhold, Nathan Altman, and

Alexander Rodchenko. To these artists, even the "left bloc" of the Union of Art Leaders seemed too conservative. The radicalism of the Freedom for Art group had more to do with artistic independence than with social transformation; unlike Mayakovsky, Tatlin did not immediately support the Bolsheviks.[8] He was an observer, not a revolutionary participant.

In early 1918 Tatlin accepted the Bolshevik Revolution and began to lend his art to its cause. By January he had joined the Fine Arts Section of Narkompros, headed by Shterenberg. In 1917 he had spent some time decorating the avant-garde Café Pittoresque in Moscow and trying unsuccessfully to revive the Union of Youth; in 1918 he became head of the Moscow section of IZO-Narkompros. A number of artists were now flocking to Narkompros, not only because of ideological conversion but also out of personal need for food rations and supplies paid as salaries. In the summer of 1918 Tatlin headed a group of Moscow artists including Kandinsky, Malevich, and other avant-garde painters, whose task was to decorate Moscow for the revolutionary anniversary festivities of November 7. The celebration was to feature a parade in Red Square, fireworks, banners, posters, wall murals, and outdoor concerts. Here the diversity of the avant-garde was permitted full expression; the *Internationale* was sung along with Beethoven's *Ode to Joy*, portraits of Marx hung alongside those of Stenka Razin, a cubist monument of Bakunin was unveiled in the presence of a Petroushka puppet show on an automobile.[9] Not himself a Bolshevik, Tatlin led artists in commemorating their revolutionary victory.

The revolution rewarded Tatlin with success. In 1919 he was given new opportunities as an art teacher in Moscow and in Petrograd. In Moscow he headed the painting section of the new Higher Art Studios (*Vkhutemas*); in Petrograd he became an instructor at the Free Studios (*Svomas*), where he organized his own workshop on "volume, materials, and construction." Some artists engaged in easel painting turned their new freedom into frivolity; at the Tenth State Exhibit that year Malevich showed his "White on White" painting, and Rodchenko promptly replied with his own "Black on Black." Tatlin was more interested in turning his art to practical use. At the Svomas studios he received a state salary to teach twenty or thirty art students according to his own system. For the first time Tatlin had the money and the opportunity to realize his vision of an art of material construction in space. The most striking result of that vision was his model for a monument to the Third International.

It is not known how or when Tatlin decided to construct the model. The Communist (Third) International, or Comintern, held its first congress in the spring of 1919, but Tatlin did not receive a commission to design a monument until September 1920. The movement known as

"constructivism" came into being in August 1920 when Gabo and Pevsner posted their "Realist Manifesto." Gabo had studied engineering before World War I in Munich, where he had also audited the lectures of the art historian Heinrich Wölfflin. From his engineering training Gabo had created a new kind of sculpture, an art in space using real objects and new materials, a kind of abstract sculpture for which he became best known abroad after his emigration from Russia. From Wölfflin he absorbed the idea that artistic styles and movements obeyed certain laws of form, developing over historical time as a "spiral movement." In revolutionary Russia Gabo continued to shift his art from the easel and the drafting board into space, from painting to sculpture and volume. "Reality is the highest beauty," he proclaimed, "we shape our work as the world its creation, the engineer his bridge, the mathematician his formulas of a planetary orbit."[10]

Gabo's constructivism immediately preceded Tatlin's monument. Still, Gabo's Munich engineering training and art theory had led not to functional buildings or revolutionary monuments but to new art forms. Tatlin moved toward a more socially useful art which, as we have seen, became known as "productivism" to distinguish it from constructivism. His art did not merely assemble real objects in space, as did sculpture; it turned materials into useful creations. His first such project was the monument to the Third International, designed to be exhibited at the third anniversary of the October Revolution in 1920. Within a month of Gabo's manifesto, on September 7, 1920, Tatlin received a government commission of 700,000 rubles for the project. Under the inflationary conditions of the Civil War, however, this amount was barely sufficient to support Tatlin and his two assistants—T. A. Shapiro and I. A. Meierzon—for a single month. Together they came up with a design for the monument, described by Tatlin's friend, the painter Nikolai Punin:

> The main idea of the monument is based on an organic synthesis of the principles of architecture, sculpture and painting. It was to comprise a new type of monumental construction, combining a purely creative form with a utilitarian form. In agreement with this principle, the monument consists of three great rooms in glass, erected with the help of a complicated system of vertical pillars and spirals. These rooms are placed on top of each other, and have different, harmonically corresponding forms. They are to be able to move at different speeds by means of a special mechanism. The lower story, which is cubic in form, rotates around its own axis at a rate of one revolution per year. This is intended for legislative assemblies. The next story, which is pyramidal, rotates around its axis at a rate of one revolution per month. Here the executive bodies are to meet (the International's executive committee, the secretariat, and other administrative executive bodies). Finally, the uppermost cylinder, which rotates one revolu-

tion per day, is reserved for centers of an informative character: an information office, a newspaper, the issuing of proclamations, pamphlets and manifestoes—in short, all means for informing the international proletariat; it will also have a telegraphic office and an apparatus that can project onto large screens. These can be fitted around the axes of the hemisphere. Radio masts will rise up over the monument. It should be emphasized that Tatlin's proposal provides for walls with a vacuum in between (thermos), which will make it easy to keep the temperature in the various rooms constant.[11]

A model for Tatlin's monument was constructed in Petrograd at the Svomas studio in the autumn of 1920. Although the monument itself was to be built of steel and glass, the basic material used for the model was wood. The model consisted of a series of wooden laths nailed together as struts, with the spiral pieces constructed out of intersecting narrow pieces of veneer. The internal cube, pyramid, and cylinder were also made of wood, connected by ropes and pulleys, and rotated not by a machine but by a hand crank operated by a small boy. It was unveiled to the public in Tatlin's studio on November 8, 1920, the day after the Bolshevik storming of the Winter Palace was reenacted with 8,000 actors to celebrate the revolution. Since the model was only twenty feet high, it was easily moved. In December 1920 it was shipped to Moscow for the Eighth Congress of Soviets, where Lenin was among its viewers. It was also paraded through Moscow on a horse-drawn cart under a banner which read: "Engineers Create New Forms." Tatlin and his assistants wrote an accompanying artistic manifesto, which declared that glass and steel were the building materials of the future and that the task of artists was to unite "purely artistic forms with utilitarian intentions."[12]

Tatlin's moment of innovation was at best a limited success. The model attracted considerable attention, especially in European art circles, where Tatlin was seen as the creator of a new "machine art." But under the more pressing conditions of the Civil War, critics reacted less favorably to his utopian dream. "Where are we to find the iron and other material (for its realization), so that the model can be a monument?" asked the writer Ilya Ehrenburg. Even Lunacharsky, who had subsidized the project, wrote two years later, "In my view the Eiffel Tower is a thing of real beauty in comparison with the twisted structure of Comrade Tatlin."[13] In the end the model burned in a fire; the monument itself was never constructed.

IV

Tatlin's utopian dream was a characteristic component of early Soviet art. Intended to mythologize the revolution, the project could not be realized, given the economic difficulties and tightening political controls

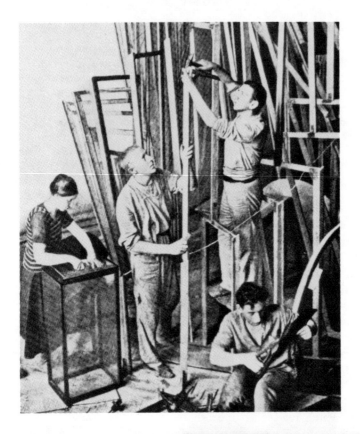

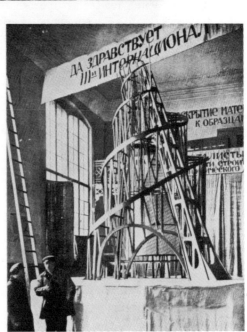

Above: Left to right. S. Dymshits-Tolstaia, Tatlin, T. A. Shapiro, and I. A. Meierzon (seated), at work on Vladimir Tatlin's model for a monument to the Third International, Petrograd, 1920. Below: Tatlin (with pipe) next to completed model. Photos courtesy of Troels Andersen.

of the period. For its spiral form, its materials of glass and iron, and its utilitarianism, the plan for the monument drew heavily on European modernism in architecture, which was then hardly known in Russia. In addition to the Eiffel Tower, it appears to have drawn upon many sources common to German expressionist architecture. Both Obrist and Scheebart would have appreciated its spiral form and its intensive use of glass. Wölfflin would have found it typical of the "style" of the period. But it must ultimately stand quite alone as Tatlin's peculiar vision of the revolutionary monument, an innovation which made him well known among both Russian and European artists at the age of thirty-five.

In later years Tatlin suffered a gradual fall into oblivion. In the summer of 1921 critics demanded that his Svomas studio be closed down, which it was in 1922. For a while he joined Malevich and Punin in organizing a museum under the auspices of the Institute for Artistic Culture in Petrograd. He later produced a play by the futurist poet Khlebnikov entitled *Zangezi*, did textile designs for the Shveiprom factory, and taught art at the Institute. In 1924 he began designing a stove and clothing for practical use; the next year he rebuilt his model for display at the great exposition of decorative arts in Paris. That summer he became director of Teakino, a theater and film institute in Kiev. In 1927 he returned to Moscow to teach metalworking at Vkhutemas. In 1931 he received permission to use the bell tower of the Novodevichy Monastery in Moscow to design and build a glider, *Letatlin*. Although Tatlin claimed only Icarus, Da Vinci, and the flight of cranes as his inspiration, the design closely resembled those of Otto Lilienthal in the 1890s, rather than the more sophisticated and streamlined gliders then in use in Germany and the Soviet Union. Actually, *Letatlin* was not avant-garde at all, but rather atavistic.

During the Stalin era, Tatlin virtually disappeared. Attacked for "formalism," he turned to the creation of stage sets for the theater, still lifes, and work for the Soviet gliding club, DOSAAF. At his death in 1953 he was virtually forgotten.

There is little evidence that Tatlin ever shared the larger concern with death and immortality that we have traced in the life and work of other artists. His tower was one of many attempts to eternalize the revolution in art, and to use real materials to create useful objects for the proletariat. His artistic innovations—the reliefs, the monument, and *Letatlin*—belonged more to the European world of 1913 than to the world of early Soviet art. But their vision and individualism were typical of that culture. Tatlin's constructivism was a remarkable example of the fusion of art and life through the combination of materials and of the desire to utilize the geometric forms of nature in engineering to facilitate man's dominance over the natural world.

V

Like Tatlin, Sergei Eisenstein was an admirer of Leonardo Da Vinci and sought to create a new world through the fusion of the aesthetic and the practical. For Eisenstein, the Bolshevik Revolution was a Renaissance, and he considered himself a Renaissance man. Engineer, mathematician, artist, linguist, bibliophile, actor, director, and writer—the list of Eisenstein's many interests and changing careers makes the comparison with Leonardo seem not so farfetched. Throughout his life Eisenstein was fascinated with Da Vinci, from the tormented oedipal figure invented in 1910 by Freud, through Leonardo's paintings in the Louvre, to the unpublished notebooks at Windsor Castle, which Eisenstein saw in 1929. One of his favorite examples of a literary description of a potential film sequence was Leonardo's terrifying word picture of the Deluge. Eisenstein's own Renaissance came not through the written word or the painting, but through the novel medium of film.

Eisenstein's moment of innovation occurred in the spring of 1924, when he first watched an editor at work in the cutting room, in this case on a German film, *Dr. Mabuse,* by Fritz Lang. Together with the films of Griffith and the Proletkult theater of Meyerhold, this experience started Eisenstein on the road to *montage,* a technique common to French cinema as well as to the photography of Hausmann, which Rodchenko and Mayakovsky had recently discovered in Berlin. For Eisenstein montage was not simply the combining of disparate shots into a new visual unity, but the collision of two objects in such a manner as to create or release tensions in the audience. Such a concept grew out of the fast-moving "attractions" or individual acts of the music hall and the circus, with their physical collisions of bodies, fists, and bicycles. What Eisenstein did was to translate theater into cinema, first in *Strike* and then in the film which made him famous, *Potemkin.*

Both the medium of film and the nature of Eisenstein's own personal life gave him a strong sense of death and immortality. The editing process of film, he once wrote, gives dead material new life and transforms individual pieces of film into something quite novel. In his own life Eisenstein became increasingly fascinated with death and resurrection, especially during the making of the film *Que Viva Mexico.* The revolution, too, created a new world from the old, where the masses as a collective whole survived the death of any individual, such as the sailor Vakulinchuk in *Potemkin.* All of this gave Eisenstein a sense that his own work resurrected the events of the revolution on film:

> Of all the living beings on earth we are alone privileged to experience and relive, one after the other, the moments of the substantiation

of the most important achievements in social development. More. We have the privilege of participating collectively in making a new human history.

Living through an historical moment is the culminating point of the pathos of feeling oneself part of the process, of feeling oneself part of the collective waging a fight for a bright future.[14]

Many of Eisenstein's comments suggest the influence of Mach and Lunacharsky, with their notion that the self lives on through the memory of others. But through the agitational medium of film he contributed a metaphor of resurrection to early Soviet art that was quite his own.

VI

At the time Eisenstein moved from theater to film, Russian cinema was still largely a product of European and American sources. By 1925 the cinema in the West was an established art form and industry nearly a quarter of a century old. Germany and the United States were the main centers, where directors like Lubitsch, Lang, and Griffith were all well established, and newcomers such as Cecil B. DeMille and Robert Flaherty were already at work. The year 1924 witnessed the production of DeMille's *Ten Commandments*, René Clair's *Entr'acte*, and Eric Von Stroheim's *Greed*, all now considered film classics of the silent era. In 1923 there were 467 films produced in the United States and 347 in Germany, a year when wartime recovery brought Soviet film output to 143 films.[15] Many prewar Russian film directors had emigrated, and large quantities of film supplies had been destroyed during the revolution and the Civil War. Soviet cinema was far behind the West.

The process of editing was a familiar cinema technique by this time. In 1903–1904 Edwin S. Porter had broken his scenes into individual shots and recombined them in new sequences, as in *The Great Train Robbery* and *The Life of an American Fireman*. D. W. Griffith went beyond this in his film classics *The Birth of a Nation* (1915) and *Intolerance* (1916). Griffith shifted the camera angle in the middle of a scene, developed the close-up, panning, and tilting, along with other novelties such as the dissolve, the fade, and the iris. He was also the first to control the duration of a shot for effect, utilizing ever shorter intervals to build toward a climax. In *Intolerance* Griffith cut from story to story and period to period in mid-film, used extreme close-ups, blocked out sections of the screen, and divided the screen down the middle. These techniques made a great impression on the young Russian film makers who saw *Intolerance* after the revolution.

From the start, the cinema played an important role in the Russian Revolution. By 1917 the Russian film industry was well established and

increasingly independent of the French companies that had dominated it prior to the war. During World War I a number of Russian cameramen and directors were employed by the government, filming scenes at the front under a wartime organization known as the Skobelev Committee. The Skobelev documentary (*khronika*) films provided some of the earliest shots of the revolutionary events of 1917, including Lenin at May Day festivities and the violence of the July Days. After the Bolshevik Revolution, Narkompros under Lunacharsky moved quickly to consolidate its control over film operations throughout Russia. It took over the Skobelev Committee, established new committees in Moscow and Petrograd, and in August 1919 nationalized the entire Russian film industry. During the Civil War, Russian directors worked under extremely difficult conditions. Many skilled operators had left the country, and the stock of negative film was low or nonexistent in most regions. Yet even in 1919 Lunacharsky anticipated the future significance that film would have as "revolutionary propaganda" for a mobile mythology appealing to the masses.[16]

In its early years, Soviet cinema was a rather crude art form, typified by the Civil War chronicles of Dziga Vertov (D. A. Kaufman) and others. Vertov made his first films on the original agit-train running from Moscow to Kazan in August 1918, serving as an assistant to Eduard Tisse, who later became Eisenstein's cameraman. Vertov soon began putting together newsreels from the fronts, letting the camera eye open up to life around it with a minimum of staging or editing. In Vertov's mind, art was a product of bourgeois society, and his own documentary realism, a revolutionary form of anti-art that reproduced life as it was. Tampering with the film through montage and editing was unthinkable. Yet Vertov soon developed his camera work into a skillful form that was crucial to the later films of the 1920s.[17] Its central message was that the director should record reality, not create it.

The philosophy of another Soviet cinema pioneer, Lev Kuleshov, was quite different. Kuleshov, a student at the Moscow School before World War I, had turned from painting to cinema, creating his first film in 1917 at the age of seventeen. Even in this first experimental film, entitled *The Project of Engineer Prite*, Kuleshov combined separate shots of people in different places in order to make them appear to be together. Like Vertov, he worked for the Moscow cinema committee in 1918, but as an editor rather than as a cameraman. This job, combined with the Civil War film shortage, led him to editing as the central feature of film making. In 1920 he shot an entire documentary film *On the Red Front* on positive, rather than negative, film stock, splicing in old newsreels and staged scenes as needed. A great enthusiast of Griffith and "American editing," Kuleshov taught Eisenstein and other students in Moscow in the early 1920s that the camera only recorded life, but

the editor was the true creator of the final film. "Our mistake in life," Kuleshov said bitterly toward the end of his life, "was that we were not the people who were to create the first revolutionary films, like Eisenstein. Rather, we were people who laid the groundwork for creating revolutionary films."[18] Kuleshov, in other words, developed montage as technique, but Eisenstein utilized it to create a myth of the Russian Revolution.

VII

Eisenstein belonged to the generation of "constructivists," which had barely come of age when the revolution broke out. Artistic innovation and revolutionary commitment were part of a process that had first swept over him as a young man. Born in 1898 in Riga, Eisenstein was the son of a German-Jewish municipal architect, Mikhail Osipovich Eisenstein, and his Russian wife.[19] Like Meyerhold, he experienced the crisis of a mixed national identity at an early age, and he received a well-to-do upbringing. Like Dobuzhinsky, Eisenstein suffered the consequences of a broken home; his parents were divorced when he was still a boy. In addition, Eisenstein's non-Russian origins were concealed by a Russian Orthodox baptism. All of this made for an unhappy and confused childhood.

Eisenstein came from Russia's new middle-class intelligentsia. His father was a highly successful architect, prosperous, educated, and a jovial punster. He emerges in Eisenstein's later recollections as a tyrant who directed the child toward an engineering career. His mother was refined, elegant, and well educated. The Eisenstein family was also cosmopolitan; German, French, and English were spoken in their home as often as Russian. The young Sergei Mikhailovich received more loving and constant care from his Russian nurse and housekeeper, a warm and superstitious peasant woman who wore amulets and charms and regaled the child with the lives of saints. Outwardly, Eisenstein's childhood was modern, materially comfortable, cultured, and apparently unhappy as a result of his parents' constant bickering. Inwardly, he experienced the more pleasant fantasy of the nursery, the imagined Russia behind the European exterior.

In 1905 his mother left her husband to live in St. Petersburg, taking with her the seven-year-old Sergei. Here, after furnishing an apartment, she sent the child back to Riga alone by train, locked in his own compartment. The following year father and son, on a vacation, visited Paris, where Eisenstein saw his first cinema. Upon his return to Riga, Sergei entered the local *Realschule*. Hypersensitive, isolated, lonely, he found new escapes through visits to the circus and the cinema with his governess, summer trips to the Baltic coast, and the world of books—Zola,

Dickens, Hugo, and Dumas. He made very few friends, with the notable exception of Maxim Shtraukh, a future actor who became a lifelong companion. After a last attempt at reconciliation in 1912, Eisenstein's mother left his father once again and emigrated to France. Sergei was fourteen.

Eisenstein's unhappy family life heightened the usual adolescent tension between the world within and the world outside. He continued to follow in his father's footsteps at the *Realschule* and, after 1914, at the Petrograd Institute for Civil Engineering. But he was unenthusiastic. In his spare time he sketched, painted, read books, and haunted the circus, where he identified most closely with awkward clowns, whose painted faces appeared to mask their inner selves. During World War I he lived with his father in Petrograd, pursued his engineering and architecture studies, and read voraciously on the *commedia dell'arte* theater of the Renaissance, art history, and Leonardo Da Vinci, including Freud's recent psychobiography.

Eisenstein engaged in no political activity and played no role in the Russian Revolution. A nineteen-year-old engineering student in Petrograd in 1917, he had little awareness of the events raging around him. When the rebellious Izmailovsky guards regiment took over the Engineering School during the March Revolution, his class voted *en bloc* to join the militia. Dropping his engineering studies, he began to sell cartoons to Petrograd journals, thus displaying the first real evidence of his artistic talent. He watched the street fighting of the July Days from a hotel doorway, and in November noticed only that there was more noise than usual on the night that the Bolsheviks seized the Winter Palace. His main concern was that he could not see Meyerhold's production of Lermontov's *Masquerade* at the Alexandrinsky Theater because it had closed its doors.

The Russian Civil War of 1918–1921 was the crucial political experience for Eisenstein, not the revolution. In 1918 his father emigrated from Russia, and Eisenstein enlisted in the Red Army as an engineer. In this capacity he helped to construct pontoon bridges across the Neva River in anticipation of a German breakthrough and to build fortifications near the town of Kholm. In late 1919 Eisenstein was assigned to the Fifteenth Army's Military Construction Unit Eighteen outside Velikie Luki. Here he found time to continue his reading—Ibsen, Maeterlinck, Hoffmann, and Schopenhauer—and to join a local army theater group. As far as we know, this was Eisenstein's first involvement in the theater. By January 1920 he had written down a number of ideas on how to organize a Proletkult theater studio in the army, and within a few weeks his troupe was staging its first productions.[20]

At twenty-two Eisenstein thus began to strike out on his own amid the turmoil of the Civil War. He had joined the Red Army to pursue

his father's initial career of engineering; in its ranks he embarked on his own career, in the theater. The revolution he had barely noticed thus began to change his life. In Eisenstein's words: "It took the shattering of the foundations of the country and two years of technical engineering work on the Red fronts in north and west to make the timid student break the chains of the career worked out for him by solicitous parents from early youth, abandon an almost completed education and assured future, and plunge into the unknown future of an artistic career."[21] Like that of other members of the "constructivist" generation, Eisenstein's formative experience was not the influx of ideas from prewar Paris and Munich, but the domestic crucible of revolution and civil war.

VIII

From the Red Army Eisenstein passed into the world of Proletkult, organized by Bogdanov and Lunacharsky to draw the average worker and soldier into mass art. The Red Army provided him with more opportunities to dream of theater than actually to create; he filled his notebooks with sketches and ideas, but lacked the facilities to realize them. When he was demobilized in the autumn of 1920, he went to Moscow with the intention of studying Japanese, a language that always had fascinated him because of its combination of the pictorial and the semantic. In Moscow he ran into his old Riga friend Maxim Shtraukh, now an actor, who suggested that they go to work for one of the many Proletkult theaters subsidized by Narkompros. Proletkult was then as much a haven for unemployed actors, writers, and artists, as for ordinary workers. Shtraukh found a job doing scenery and costumes for a play entitled *The Mexican,* taken from a Jack London story; he arranged with Eisenstein to work with him, and invited him to share an apartment with him and his wife.[22]

Eisenstein discovered that Proletkult theater lacked actors and money for sets and costumes, not to mention adequate salaries. Its repertoire was borrowed heavily from the circus, the carnival, and the music hall. Proletkult productions usually featured fast-moving episodes known as "attractions," a word taken from fairground and music hall terminology, and emphasized physical movement and slapstick: tightrope walking, juggling, fist fights, and somersaults. Eisenstein employed all of these techniques in his production of *The Mexican* in 1921, undoubtedly repeating his earlier enthusiasm for the circus. He placed wigs and plaster patches on his actors, staged a boxing match, and in other ways destroyed the accepted unity of action, having several on-stage performances in progress at once. Overnight Eisenstein became a young sensation of the Moscow theater world.

The real center of Moscow professional theater at that time was, not Proletkult, but the First RSFSR Theater of Meyerhold. In 1918 Luna-charsky had appointed Meyerhold head of the Theater Section of Narkompros, where he produced works under the slogan "October in the Theater." Among his early productions were Mayakovsky's *Mystery-Bouffe* and Verhaeren's *Les Aubes* (The Dawn), a favorite play of Luna-charsky, which set revolution within the Christian context of resur-rection.[23] Meyerhold had also become head of the new State School for Stage Direction; Eisenstein enrolled in the school in the autumn of 1921.

While Meyerhold's training introduced Eisenstein to the rich tradi-tion of Western theater, it also reinforced the Proletkult emphasis on body movement, rather than the spoken word, as the essence of the stage. In his lectures in 1921–1922 Meyerhold taught that the director should control and dictate every action of the actor (a main principle of Stanislavsky) and that what the actor said mattered less than how he moved and gesticulated. In part, these ideas reverted to the pre-1914 theories of Fuchs and Gordon Craig, which, as we have seen, enjoyed considerable popularity in Russia. But it also took on new connotations in the "biomechanics" gymnastic exercises designed to relate the actor's movements to the motions of the worker at the bench, in the manner of Taylor's time-and-motion studies, then popular in Moscow. Meyer-hold had all his students engage in some acrobatic exercises, a physical training program in which Eisenstein took great delight. By the end of 1921 Meyerhold had become deeply impressed by Eisenstein's bril-liance, and he became a kind of spiritual father to the young man. He greatly admired Eisenstein's production of *The Mexican*.

Meyerhold was not the only director to stress theater as artifice, rather than imitation of reality. Eisenstein worked for a time in the MASTFOR studio of Baron Foregger von Greiffenturm, a Kiev philolo-gist-turned-director and friend of Eisenstein's fellow theater student, Sergei Yutkevich. Foregger was an enthusiast of the *commedia dell'arte* theater of stock characters and masks, and probably encouraged Eisen-stein in his later use of "typage" in film, using an ordinary person who physically resembled the type of character he would play. In 1922 Eisenstein toured Leningrad with MASTFOR and encountered yet an-other theater group, the Factory of the Eccentric Actor (FEKS) of Grigorii Kozintsev and Leonid Trauberg. Kozintsev and Trauberg, teen-age actors from Kiev, reinforced Eisenstein's interest in physical move-ment with their interest in boxing, ju-jitsu, and gymnastics.[24] Involved in organizing a new film studio as well, they were fans of Charlie Chaplin and popular American actors such as Pearl White, Lon Chaney, and Billy West. For Kozintsev and Trauberg, the antidote to bourgeois culture was the circus, the Western, and the detective story. Their tech-

niques reached the screen in 1924 in the photographic tricks and acrobatics of *The Adventures of Oktiabrina*.

Thus when Eisenstein returned to Moscow in the autumn of 1922 he was familiar with the physical collisions of the "attractions" and the new possibilities of film. Still, he remained in the theater. With Sergei Yutkevich, he produced a *commedia dell'arte* parody of a play by Arthur Schnitzler, transformed from *Columbine's Scarf* to *Columbine's Garter*. In their version of the play, Pierrot became a bohemian, and Harlequin a capitalist banker. It was a far cry from Meyerhold's production of *Balaganchik* with the same characters. The "attractions" included a scene where Harlequin enters on a tightrope; prompted by Yutkevich returning from an afternoon at a carnival, Eisenstein decided to call his method "stage attractions."[25] Foregger ultimately would not produce the play, and Eisenstein took on a new job as Meyerhold's assistant in a production of G. B. Shaw's *Heartbreak House*. Here again, Eisenstein planned to use eccentric attractions, somersaults, and other acrobatics, but the play never opened, and Eisenstein broke away from Meyerhold, much as Meyerhold had broken with Stanislavsky fifteen years earlier. By 1923 Eisenstein was again on his own; he later remembered: "I was, beyond all argument, unlucky with my fathers," first the real one and now the adopted one, Meyerhold.[26] He was twenty-five and had not yet found a vehicle for his innovative creativity.

The catalyst for Eisenstein's moment of innovation turned out to be Proletkult, which encouraged his shift from theater to film. In fact, his theory of the "montage of attractions" grew out of theater in 1923, although it was effected in film only in the course of the next two years. In the autumn of 1922, fifteen members of the Central Proletkult Theater in Moscow seceded and formed their own theater known as *Peretru* (*Peredvizhnaia truppa*, or Wandering Troupe). At their request, Eisenstein agreed to direct them. He immediately launched classes in which he taught the techniques learned from Meyerhold: circus art, gymnastics, boxing, fencing, and voice training. Eisenstein's first Peretru production was Ostrovsky's *Enough Simplicity in Every Wise Man*, in which he worked out in practice some ideas described in his theoretical article on the "montage of attractions," published in *LEF* in January 1923.[27] According to Eisenstein, an attraction was simply an "aggressive moment" which shocks the audience, as for example, the Théâtre Guignole in Paris, which terrified audiences of the time by on-stage gouging, knifing, amputation, and other niceties. A montage of attractions was a combination, or "colliding," of such actions according to the whim of the director. In *Wise Man* Eisenstein created these effects by seating the audience around a stage resembling a circus arena, with attractions such as juggling, tightrope walking, singing, political satire,

water squirting, firecrackers, and acrobatics following one another in dizzying succession. He also showed a film in the middle of the play to illustrate Glumov's dream. The film was a comic parody of the early news films of Dziga Vertov. Indeed Vertov was initially engaged to supervise its production, but he walked out after one session with Eisenstein. The shooting of the film was rushed through in two days, just in time for the opening performance.

By 1923, then, Eisenstein had arrived at the montage of attractions through theater, not film. The theory had echoes of American films, the British music hall, French cinema and theater, and the circus. The basic principle of juxtaposing dissimilar objects for effect was also familiar to Russian futurist poets and linguists. One of Eisenstein's close friends, Viktor Shklovsky, a student of the linguist Baudouin de Courtenay and a literary critic, argued that words should be "made strange" by unusual combinations and juxtapositions that made the reader take notice.[28] Shklovsky was also a member of Peretru.

Eisenstein continued to pursue his theatrical innovations for another year or so before converting to film. In the autumn of 1923 he produced Sergei Tretiakov's agit-play *Listen, Moscow!;* in March 1924 he set the play *Gas Masks* in the middle of an actual gasworks in Moscow. Unlike *Wise Man, Gas Masks* was a failure; it closed after four performances. In the spring of 1924 Eisenstein was twenty-six—with a theater and a theory, but lacking fame or even a reputation outside of Moscow theatrical circles.

IX

In the spring of 1924 Eisenstein began to see the implications of montage for film rather than theater. The French word *monter* means, simply, to construct, and its cinematic derivative, montage, had been used for some time to describe the process of film editing. Lev Kuleshov had pioneered in the use of montage in Russia, but had developed it more as a cinematic trick than as a serious technique. Dziga Vertov had opposed its use as unwarranted interference in the recording process of the camera eye. In 1923 the term gained currency again in connection with the photomontage of Raoul Hausmann and the Berlin Dada artists, who were popular in the circle of intellectuals assembled around Mayakovsky and his journal *LEF;* among them was Eisenstein. In his *LEF* article of 1923 Eisenstein had developed the term into a theory of theater. But as of the spring of 1924 Eisenstein had never actually seen a film edited.

Eisenstein had, however, seen edited films. In 1921 he and Yutkevich attended a performance of Griffith's *Intolerance* in Moscow, and the American director's editing of the film to manipulate both space and

time left a strong impression; Yutkevich called it a "revelation."[29] Undoubtedly, Eisenstein had also seen the re-edited foreign films then popular in Russia. Alert cutting and splicing, along with suitable subtitles, easily turned the products of capitalist film industry into Soviet propaganda. Even Viktor Shklovsky found useful employment doing this for a time: "We re-montaged the American films which we received in minor ways, but skillfully and cheerfully," he later recalled.[30] In one famous experiment Kuleshov pirated shots from old films of a monument to Gogol, the White House, and figures climbing church steps in Moscow, to create a completely imaginary landscape in which some Russians are climbing the White House steps near a monument to Gogol.[31] The re-editing of old films was thus an answer to both the shortage of negative film in Russia and the need to propagandize the revolution. But it produced only crude anticipations of the great revolutionary films yet to come.

Eisenstein's teacher in the art of montage was Esfir Shub, a young stenographer for Lunacharsky and later Meyerhold's secretary in the Theater Section at Narkompros. When Eisenstein met her in 1922 she had just taken a job with Goskino, the State Cinema Committee, as a re-editor of both foreign and prerevolutionary Russian films. She soon answered Lunacharsky's call for an increase in the production of propaganda films. "From 1922 to 1925," she later recalled, "I had to re-edit and make subtitles for some two hundred foreign films which reflected their bourgeois ideology."[32] She introduced Eisenstein to re-editing in March 1924 when he observed her cutting-room work on *Dr. Mabuse*, a popular German film by Fritz Lang.

The German director Fritz Lang, like Eisenstein, had given up architecture and engineering to undertake a new career in film. Born in Vienna, he became a major director of German expressionist films in the 1920s. In 1919 he was to have directed *The Cabinet of Dr. Caligari*, but the job ultimately went to Robert Wiene. In 1921 Lang produced the pessimistic and shadowy *Der Müde Tod* (Tired Death), a dream sequence in which Death bargains with a young girl to save her lover. *Dr. Mabuse*, made in 1922, is typically expressionist in its evocation of a world dominated either by fate or by a sinister figure whose organization controls events. In this case Mabuse is an evil genius who heads a gang of thieves, counterfeiters, and murderers, who manipulate economic life in inflation-ridden Weimar Germany. Enormously popular in Germany, England, and France, the film was ideally suited for Soviet re-editing because of its stress on the evils of modern capitalism in the West.[33]

Dr. Mabuse became the object of Eisenstein's first experiment in montage. For a week he and Shub worked in the cutting room, shortening and editing the film for Soviet consumption by splicing and com-

bining the most unrelated sections of Lang's film with old films and newsreels. In this way the German expressionist film *Dr. Mabuse* emerged as the Soviet propaganda film *Gilded Putrefaction*, complete with new subtitles about the machinations of bourgeois society. Through this experience Eisenstein became aware of what Shub called "the magic power of scissors in the hands of an individual who understands montage."[34]

Within a few months Eisenstein and Shub went on to create a film of their own, *Strike*, for Proletkult. *Strike* was part of a larger Proletkult project, an eight-film series entitled *Towards the Dictatorship*, and Eisenstein immediately threw all his energies into it. He read books on the Russian labor movement, visited factories, and interviewed old party members and labor leaders. Boris Mukhin, the director of Goskino, assigned to him the skilled cameraman Eduard Tisse, also from Riga, who was to become his lifelong collaborator. Shub did most of the editing at her home during the autumn of 1924, while Eisenstein directed the shooting. Mukhin was not satisfied with the first two takes; he finally accepted the third. The resulting film was full of later Eisenstein techniques: elaborate attention to detail; massive crowd scenes using hundreds of extras; eccentric and acrobatic movements by Proletkult actors, as in the fight between striking workers and opposing boiler-plant mechanics; and montage effects, such as the comparison of the factory manager to a frog.

Strike, an experiment for Eisenstein, did not establish his reputation. Despite Shub's editing, Goskino's patronage and salaries, and Tisse's camera work, the film was a box-office failure. Although *Pravda* called *Strike* "the first revolutionary creation of our cinema," other reviewers criticized Eisenstein sharply for his heavy use of eccentric and grotesque elements.[35] Crowd scenes required too many takes, at a time when negative film footage was still scarce. Shub left Eisenstein, feeling that she had received insufficient credit for her role in the film. Eisenstein himself perceived *Strike* as a failure, and he bemoaned the backwardness of Soviet cinema with respect to the film industry in America. The only course now, he felt, was to abolish the story and the stars altogether and to "push into the dramatic center the mass as the basic *dramatis persona*, that same mass that heretofore had provided a background for the solo performance of the actors."[36] The failure of *Strike* thus caused Eisenstein to turn toward even more radical strategies of montage and collectivism—the use of the masses as hero.

X

Patronage opened the way for Eisenstein's moment of innovation. On March 17, 1925, the commission to celebrate the twentieth anniver-

sary of the 1905 Revolution, meeting in Moscow, agreed to fund a number of projects. The commission, which included Lunacharsky, Meyerhold, and Malevich, also decided that "the central spectacle devoted to the events of 1905 in two large theaters of Leningrad and Moscow should be a great film."[37] Nina Agadzhanova-Shutko, a thirty-six-year-old Armenian scriptwriter, whose husband happened to be on the commission, promptly began work on a scenario. The director was to be Sergei Eisenstein.

The initial plans were far more grandiose than the final result. On April 14, 1925, Eisenstein wrote his mother, "I will probably be filming a picture on *The Year 1905* for Goskino—most interesting material." The film was to encompass events of the revolution throughout the country, so that Eisenstein felt he would have to travel a good deal, "including the south where I will film an uprising in the fleet." By early June, Goskino had accepted Agadzhanova's scenario, Meyerhold had gone abroad to try to persuade Sergei Prokofiev to compose the score, and Malevich had been engaged to decorate the theater for opening night. Eisenstein's cameraman was to be the veteran A. A. Levitsky. In early July Eisenstein promised the press a "grandiose" film that would be "a very popular picture for the worker and peasant masses," in which the main hero would be "the single revolutionary mass of the proletariat."[38] By late July 1925 preliminary research, interviews with revolutionary veterans, and script revisions were virtually complete. Yet the entire ambitious plan soon collapsed. Only Eisenstein's power of improvisation saved the film and rendered it a classic.

The original script called for 250 shooting days and the use of 20,000 extras throughout the country. The project was to be completed by August 1926. A revolt on the battleship *Potemkin*, anchored off Odessa, was scripted merely as a prologue to the main film, which would be called *1905*. The filming began well enough, with Levitsky shooting a printers' strike in Moscow and a railway workers' strike in Leningrad in August. Then problems developed. Meyerhold could not find Prokofiev in Paris. Eisenstein did not like Levitsky's first shots. The naval fleet to be filmed in Leningrad had gone to sea on maneuvers. Finally, Leningrad's weather was typically dismal, producing rain and fog instead of the sunshine necessary for successful filming.

The change to a film about the battleship *Potemkin* and Odessa was thus an accident. Odessa had better weather for shooting, and a number of old ships, permanently anchored there, were always available. In addition, in the Lenin Library, Shtraukh had discovered a French journal, *L'Illustration*, which contained a picture of a crowd on the Odessa steps that appealed to Eisenstein. The crowd and the steps merged with his childhood memories of street fighting in Riga and news of Bloody Sunday in St. Petersburg; he began to imagine an event that had never

actually occurred: a massacre on the Odessa steps. By August 24 Eisenstein was in Odessa, where he engaged rooms for his crew at the Hotel London. Before breakfast the day after his arrival Eisenstein ran out to examine the setting for his film, a flight of 120 granite steps forty feet wide, descending in ten stages to the Black Sea harbor below. For a week Eisenstein sat on the Odessa steps making sketches, increasingly convinced that the *Potemkin* revolt, slated to be frames 170 through 213 of the original script for *1905*, would now become the entire film. Limited resources and unfavorable circumstances steered Eisenstein toward his greatest film.

Taking control of the film, Eisenstein replaced the cameraman Levitsky with Eduard Tisse, then in Moscow; Tisse arrived in Odessa in mid-September. To his staff, Eisenstein added a group of friends from Proletkult who were known as the "iron five" because of the prison-striped shirts they wore: Shtraukh, Alexandrov, Mikhail Gomorov, A. P. Antonov, and A. I. Levshin. Men in their twenties, they all had followed Eisenstein in his move from theater to film. The initial sequences shot in Odessa turned out to be excellent. When they reached Agadzhanova in Moscow, she exclaimed, "Tisse is not an operator but a god."[39]

The obstacles in Odessa were no fewer than in Leningrad. The real battleship *Potemkin* had been scuttled, so it was necessary to use her sister ship, *The Twelve Apostles*. This was not easy, since it was chained to a rocky shore in the middle of a mine field left over from Civil War days and was used as a storage ship for mines and ammunition below decks. It therefore took little persuasion to keep noise, running, and smoking at a minimum during the shooting. Moreover, the ship had to be turned ninety degrees so that the shoreline would not appear in scenes supposedly taking place at sea. Since *The Twelve Apostles* had been partly dismantled for mine storage, Eisenstein had to rebuild the quarterdeck out of plywood, according to plans for the *Potemkin* located at the Admirality. Finally, scenes of the Russian battle fleet could not be filmed live, so Eisenstein had to use old newsreel footage of foreign naval maneuvers, probably British. An unintended result of this substitution, when the film was shown in Berlin in 1926, was an interpellation in the Reichstag about the apparent inadequacy of current German intelligence estimates of the Soviet fleet.

To make *Potemkin* on schedule Eisenstein had to improvise. Shtraukh scoured Odessa for suitable faces to fit Eisenstein's "typage" conceptions of minor roles. The montage effect of a springing lion was achieved simply by separate shots of three stone lions, lying, sitting, and standing, at the Alupka Palace. Eisenstein and Tisse shot some of the best footage in the film in thick fog in the early morning, as an experiment. The terrifying scene of the tarpaulin thrown over the rebellious sailors about to be shot was invented by Eisenstein despite his naval adviser's denial

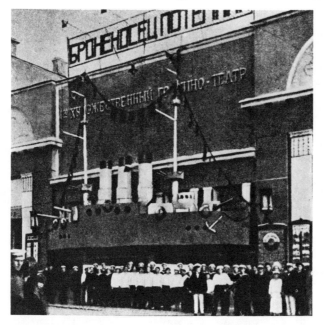

Arbat Square Movie Theater, Moscow, decorated for the opening night of Sergei Eisenstein's film *Potemkin,* 1926. Decorations designed by Kazimir Malevich. From V. Shklovsky, *Eizenshtein* (Moscow, 1973).

that the practice ever existed. The Odessa steps massacre itself was a brilliant fiction.

By November 23, 1925, Eisenstein was back in Moscow with 4,500 meters of film for editing, leaving Tisse to shoot the final scenes. On Christmas Day 1925 *Potemkin* premiered at the Bolshoi Theater in Moscow, which was decorated for the occasion by Malevich's mock-up of a battleship. As the first two reels were being shown, Eisenstein was busy cementing the montage sections of the third reel with acetone and his own saliva. After racing to the theater on his motorcycle and running out of gas in Red Square, he managed to deliver the reel in time. The reel held together, and Eisenstein became a cinematic hero. "I awoke one morning and found myself famous," he later recalled.[40]

For the realization of his art, Eisenstein depended heavily on the contributions of others—editors, cameramen, and actors. The credit for Eisenstein's innovation must certainly be shared with Kuleshov, Shub, and Tisse. Many aspects of *Potemkin* turned out to be accidentally successful, rather than the result of anything planned. In later years Eisenstein liked to write of *Potemkin* as an example of montage techniques, carefully planned, and to describe a five-act plot structure

modeled on the "golden section" of Fechner and the Greeks. But *Potemkin* was actually a marvel of improvisation, an act of genius, an overcoming of barriers, which achieved order and calculation only in later theory. French and American cinema, the British music hall, and German Dada with its photomontage all stimulated Eisenstein in his search for a cinema where the collisions of montage would articulate the revolutionary collision of the old and the new. *Potemkin* was the greatest example of that search.

<div align="center">XI</div>

Like other artists in this study, Eisenstein was preoccupied with death and immortality in his life and in his work. His films abound with violence, conflict, and threatened death, from the boxing match in *The Mexican*, through his fascination with the sadistic Théâtre Guignole, to the bloody slaughter of oxen in *Strike*. They are also very much concerned with immortality and rebirth. The very process of montage is a form of rebirth: old film is regenerated in the hands of the editor. The result of juxtaposing two shots, Eisenstein once wrote, is not "a simple sum of one shot plus another shot," but an entirely new "creation."[41] Christian metaphors are prominent in Eisenstein's films; he even expressed his own uneasiness at becoming an official film maker in Christian terms: "We aren't rebels anymore," he complained in a letter written in 1928, "we're becoming lazy priests. If you're lording it with Jesus on the cinematographic Golgotha, I feel myself hanging at your side."[42] Such droll humor is reflective of Eisenstein's more serious conviction that Christ's death and resurrection provided an appropriate film metaphor for the Russian Revolution. In Eisenstein's films, the death of an individual often heralds the birth of revolution, as, for example, the funeral of the sailor Vakulinchuk in *Potemkin*, which launches the revolution in Odessa. In *October*, made in 1927, Eisenstein again uses death to foreshadow revolution, with the dead horse on the drawbridge, the massacre on Nevsky Prospect, and the apparent explosion of the baroque statue of Christ.

As Eisenstein grew older, he expressed a growing sense of his own mortality and of the imminence of death. This sense became particularly acute after he was treated for a cardiac ailment in Berlin in 1929. During his trip to the United States in 1930 he sat in the electric chair at Sing Sing Prison in New York and said he experienced "the feeling of time turned off." "The only important time," he philosophized, "is the time you have to pass."[43] During the filming of *Que Viva Mexico* later that year he became fascinated with the Mexican attitude toward death, as expressed in the bullfight, religious flagellants, and the carnival atmosphere of Death Day, a kind of Mexican Halloween. The film itself, never com-

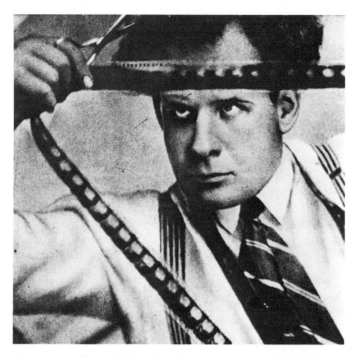

Eisenstein editing his film *October,* 1927. From V. Shklovsky, *Eizenshtein* (Moscow, 1973).

pleted, begins with scenes of Aztec and Mayan death cults; it includes shots of skulls, peons being trampled by horses in the sand, bullfights, and the Death Day festival. Eisenstein described the importance of death in his own scenario:

> Death, skulls of people. And skulls of stone. The horrible Aztec gods and the terrifying Yucatan deities. Huge ruins. Pyramids. And faces. Faces of stone. And faces of flesh. The man of Yucatan today. The same man who lived thousands of years ago. Unmovable. Unchanging. Eternal. And the great wisdom of Mexico about death. The unity of death and life. The passing of one and the birth of the next one. The eternal circle. And the still greater wisdom of Mexico; the *enjoying* of this eternal circle.[44]

The film itself was obviously important to Eisenstein. When it was not completed, he wrote that it marked "the death of my own child, on whom I lavished so much love, work and passionate inspiration."[45] Such a comment suggests Eisenstein's awareness that his generative power was embodied in his art.

Under Stalin, Eisenstein shared the guilt of the survivors. He had turned his art to the service of the revolution, even in its darkest hour, and had long ago sacrificed the antagonistic stance of the avant-garde. His teacher Meyerhold was shot, but his star pupil lived on, noting, not without truth, that "a dose of philistinism ensures peace and stability."[46] His marriage to Pera Atasheva ended in separation and produced no children. Much of his earlier work came under attack; only conformity to Stalin's wishes in *Alexander Nevsky* saved him from enforced silence or death.

Eisenstein's final film, *Ivan the Terrible*, summed up his own life in many respects. He had often identified with young outsiders alone in a brutal world, such as Charlie Chaplin and David Copperfield. In his last work of art he identified with the young Tsar Ivan against the conniving adult boyars. "Is not the coronation of the young Tsar," he wrote, "really the determination of the heir to free himself from the shadow of the prototype of the father?"[47] Eisenstein had escaped his own father by abandoning engineering for art, an experience paralleled by Ivan's creation of his private army, the *oprichnina*. "If a series of childhood traumas coincide, in emotional context, with the burdens facing the adult," Eisenstein once wrote, "well and good. Such was the case with Ivan. I consider that in this respect I, too, have been lucky with my life. In my own sphere I have proved essential to my times."[48] In this way Eisenstein made the Russian Revolution a metaphor for the passage to adulthood, the rejection of old authority in favor of new ways.

Eisenstein's metaphor of revolutionary immortality thus combined the sexual and social aspects of the family with the Christian metaphor of resurrection. Unlike Lunacharsky, he compared Soviet society not with the collective of humanity, but with related human beings, the family. "We can't reproduce the cultural nursery of an 'intellectual' or 'aristocratic' family. But there is another means. Our genuine family has become our Socialist society."[49] The broken home in Riga was thus replaced by Soviet Russia, not unlike the experience of Mayakovsky. Childhood remained an idyllic dream for Eisenstein, as it probably was for many who lived through the trauma and violence of the revolution. The film director could "make the children's paradise of the past accessible to every grown-up"; while film could not recreate the revolutions of 1905 or 1917 in reality, it could evoke, "psychologically, a wonderful resurrection."[50]

Eisenstein's death occurred, as he had predicted, at age fifty. On February 2, 1946, he suffered a heart attack, which he survived. For a time, he felt that he had gained a new chance at life. "I'm dead right now," he told a friend several weeks later; "the doctors say that according to all the rules, I cannot possibly be alive. So this is a postscript for me, and it's wonderful. Now I can do anything I like."[51] But this was

not to be. In September 1946, Part II of *Ivan the Terrible* was banned by Stalin. Eisenstein fell victim to the ideological offensive being mounted by Andrei Zhdanov against all traces of "bourgeois" and "foreign" elements in Soviet culture. As his fiftieth birthday approached, Eisenstein became obsessed with thoughts of death. Death came at last on February 11, 1948.

Both Tatlin and Eisenstein were concerned with immortality in the general sense of achieving artistic fame for themselves and eternalizing the revolution in monument or film. They also shared the "constructivist" interest in creating new art objects out of old forms through juxtaposition, and were greatly influenced by Western developments in their art. But Eisenstein's concern ran deeper; he continually sensed the presence of death in his own life, utilized it on the screen, and sought to overcome it in his art. He believed in resurrection, not of the body after death, but of the past through film. *Potemkin* not only brought him lasting fame, but immortalized the 1905 Revolution as myth.

8

The Russian Avant-garde
and the Victory over Death

*We are alive forever, young forever because we
ignore the opinions of the idle mob . . . ; we have
eternal life, eternal youth, and eternal self-perfection
—and in this lie our honor and reward.*
 —Alexander Shevchenko, 1913[1]

The Russian avant-garde demanded the eternal but was confined by the
transitional: such was its agony. As a segment of the Russian intelli-
gentsia, it shared the long-standing transition from a Russian childhood
to a Western education. Born and raised in the provinces, its members
migrated to the expanding cities of Russia during a period of rapid
industrial growth, which followed the emancipation of the serfs in 1861.
As children of a growing Russian middle-class intelligentsia, they were
drawn into artistic and political rebellion against the very society that
had nurtured them, especially by the events of 1905. Westernization,
urbanization, and revolution all helped form a Russian avant-garde;
aging intensified their sense of the moment and the transitional. Aspiring
in art to permanent youth and to the immortality of successful inno-
vation, the Russian avant-garde waged war against artistic failure,
poverty, aging, and death.

I

The Russian avant-garde was a movement of enormous diversity,
given unity only by subsequent critics. Here we have looked closely
at the lives, as well as the works, of eight Russian artists who shared in
different ways a desire for artistic innovation and political involvement.
In so doing, we have discovered rich diversity, for they were all very
different kinds of people. Only one was actually Russian by ethnic
background; the rest were Ukrainian, Lithuanian, Polish, German,
Jewish, and Cossack—a potpourri of nationalities, characteristic of the

180

Russian Empire. In age, they differed by nearly a quarter of a century. They received their education in private studios, at home, abroad, or at the Academy of Arts or the Moscow School. They worked in varied media: literature, graphics, theater, painting, poetry, and film. Some married, others did not. In their politics they ranged from a Bolshevik party leader to passive observers who hid in doorways or dodged gun-fire in 1905 and 1917. Although they generally shared the conjunction of artistic innovation and political commitment suggested by the term "avant-garde," they were otherwise quite distinct. Yet they did share many common experiences.

Westernization had traditionally facilitated innovation in Russia. Since the eighteenth century, the Russian intelligentsia was defined, both in its education and in its critical stance toward Russian society and reality, by a position on the margin of Russia and the West. Western tutors, books, travels, and study were the most common sources of Western ideas inside Russia, where they were a novelty. Such ideas did not necessarily create any enthusiasm for imitation of the West. In fact, European ideas often provided Russians with the very language (philosophical and political) with which to assert their superiority over the West, from the "Russian soul" of Gogol and Dostoevsky (drawn from German romanticism) to the transformed Marxism of Trotsky's "perma-nent revolution." Western ideas often helped define Russian advantages. When the Russian avant-garde emerged around 1905, in part as a reaction against the westernism of the World of Art movement, it sought an art of the abstract and the spiritual, whose value could not be clearly measured by the technical standards of the West and the Academy. Many Russian artists left for Europe (especially Munich and Paris) to study technique and method; they often returned home with the more radical ideas of their Western counterparts. In this way the Russian avant-garde was a European phenomenon which demanded and proclaimed a victory of Russian youth over Western senility. In so doing it articulated a traditional motif of the Russian intelligentsia.

Urbanization was equally important to the emergence of a Russian avant-garde. A vast migration from province to city characterized Im-perial Russia in the decades before World War I. For young artists who joined this migration, the city became a magnet for their skills and future careers, a market for their art, a school for their further develop-ment, and an opportunity to absorb contemporary artistic trends, many from the West. The artists of the Russian avant-garde grew up in the rapidly expanding provincial towns of the southern and western border-lands: Novgorod, Riga, Kharkov, Poltava, Kiev, and Novocherkassk, in the cases studied here. As adolescents they moved on to the capital cities, especially Moscow, for their education. They then had to prove their talent in the competitive arena of the metropolis. Failing in the

more accepted routes of artistic training, they found in Western sources an opportunity for innovation that turned failure into success.

An artistic relationship between province and city was not unique to Russia during this period. Kenneth Clark has observed that, in general, "the history of European art has been, to a large extent, the history of a series of centres, from each of which radiated a style. For a shorter or longer period that style dominated the art of the time, became in fact an international style, which was metropolitan at its center, and became more and more provincial as it reached the periphery."[2] We have seen how advanced artistic trends in Paris and Munich in fact achieved such an effect in Russia. Yet here artistic influences did not simply radiate outward from city to province, but also inward from province to city. The formation of the Blue Rose circle in Saratov, or of the Hylean poets and Russian futurism at the Burliuks' Crimean home, indicated that inside Russia, art was inspired not only at the center, but also on the periphery. Malevich observed that in an artist's own development, "the first stage is the village, and the last stages are the metropolises"; he went on to argue that as the artist "gradually gets nearer to the metropolis his coloring will change and eventually assume a dark shade," in contrast to the bright colors of his native village or town.[3] However fanciful this formulation, migration from province to city (Russian or European) and continual artistic traffic between them was a widespread phenomenon among the Russian avant-garde before World War I.

Urbanization helped define the avant-garde in Europe, as well as in Russia. The leaders of Italian futurism were generally born in the 1880s in provincial towns (Brescia, Piedmont, Turin, and Milan), and they created their movement in 1909 in Paris, when most of them were in their late twenties or thirties. The Dresden artists of Die Brücke came from the outlying towns of southern and northern Germany, and were in their twenties when the group organized around 1905. Within Russia, one might point to the Wanderers of the 1870s as a group of young artists from the provinces who migrated to Petersburg, and then often on to Rome, Paris, or Munich. As a youth movement of provincial artists in the big cities, the emerging Russian avant-garde thus had its predecessors and counterparts in both Europe and Russia. This may partly explain the appeal of urbanist themes in the art of the prewar period, where the city itself was the source of constant novelty.

Revolution, too, created a sense of transition that inspired innovation. The Revolution of 1905 was the formative political event of their youth for most members of the Russian avant-garde, although few actually joined political parties or participated in street demonstrations. Involved or not, most artists shared the sense of impending cataclysm, of a sharp transition from an old to a new society, however ill defined. Some, like Dobuzhinsky, found that they could introduce political

themes into art and thereby gain a measure of notoriety and fame. Others found that the revolution opened new doors for innovation, as in the case of Meyerhold and the Studio Theater of 1905. In general, 1905 was important to the Russian avant-garde because it provided them with a brief glimpse into a revolutionary future, of which they could claim to be a vanguard.

The 1905 Revolution also resulted in a lifting of the worst restrictions of church and state censorship. Thus, within months Russia was inundated by previously suppressed and subversive Western literature and art, now available in numerous translations and editions. Much of the new art and literature, as we have seen, was openly democratic, religious, or proletarian in content. The symbolist plays of Maeterlinck with their religious implications—*The Death of Tintagiles, Monna Vanna,* and *The Blue Bird*—all appeared in numerous Russian translations and performances between 1905 and 1925, along with Verhaeren's urbanist and revolutionary *The Dawn* and its Christian imagery. Joseph Dietzgen's essays on socialism as a form of religion also appeared in several Russian editions after 1905. Between 1907 and 1922 Walt Whitman's *Leaves of Grass* went through six editions of 67,000 copies. In addition, by 1915 a number of works of a theosophical and mystical nature—Steiner's lecture cycles, the writings of Blavatsky and Besant, Bucke's *Cosmic Consciousness,* and Hinton's *The Fourth Dimension*— were available in Russian translations.[4] Such literature was itself innovative in a society where for centuries the Russian Orthodox Church had been the keeper of religious truth and the censor of blasphemy.

Revolution thus facilitated westernization and innovation. More precisely, the new freedoms after 1905 made possible a literature of openly religious concern in Russia, devoted to the occult, the mystical, and even the atheistic, and persistently intrigued by the problem of death and the possibility of immortality. Lunacharsky discovered the theme of immortality through collective memory before 1905; other Russians had to wait until the writings of Dietzgen and Mach became available in translation. Similarly, only after 1905 could Meyerhold bring to the Russian stage the veiled religious moods of Maeterlinck or the Dionysian transcendence of Georg Fuchs without the burden of harsh church censorship. The theosophical literature that inspired Malevich was also unavailable in Russia until after 1905; even then, the blasphemy trial of Anna Kamenskaia witnessed the continual subversive effect of unorthodox religious speculation on the church. Whitman's writings encouraged a search for ultimate answers through pantheism or atheism, which were anathema in Russia. All these writings facilitated the innovative art of the Russian avant-garde. They also provided a language of the eternal with which to claim its transcendence of the difficult transitions of westernization, urbanization, and revolution.

Urbanization and revolution, in sum, accelerated a process of westernization and innovation that was traditional among the Russian intelligentsia. The transitions from province to city in adolescence, and from Russia to Munich or Paris in early adulthood, provided many artists with new sources of innovation outside the confining walls of the Academy. The drama of the 1905 Revolution, in turn, opened new routes of access to Western ideas and artistic trends for many young Russian artists. The city and the revolution provided the background for the Russian avant-garde in its search for success and fame. But they do not completely explain its persistent quest for the eternal and the immortal.

II

"We are witnesses of the greatest Moment of summing-up in history," wrote Sergei Diaghilev in 1905, "in the name of a new and unknown culture, which will be created by us, and which will also sweep us away."[5] This anticipation of impending cultural revolution, coupled with ultimate self-destruction, was central to the agony of the Russian avant-garde. Its goal was the eternal, even at the risk of its own demise. Suspended between past and future, youth and old age, the avant-garde sought the transcendent permanence of successful innovation, at the same time anticipating that in another generation such innovation would itself have become a tradition to be destroyed. As young artists, they risked all in a momentary gamble to anticipate the future.

The search for some kind of permanence and immortality characterizes much of the art and literature of the Russian avant-garde before and after 1917. On the political left, we have seen that it often took the form of a faith that the revolutionary collective would survive the death of the individual revolutionary hero. "The Russian Revolution," wrote Maxim Gorky in 1906 from America, "if you look at it even from a distance, is a splendid revolution. It has been going on for a long time. You and I shall die some time, but it will go on living. Fact. You'll see."[6] For some artists immortality meant reincarnation; beings do not end or die, but are continually reborn in new forms. The literary critic Viktor Shklovsky, describing Meyerhold's production of Blok's *Balaganchik* in 1906, noted that "the world is transparent, dematerialized, and that everything keeps repeating itself; the girl becomes death, the scythe of death changes into the girl's braid."[7] Mayakovsky also expressed the idea that immortality involves the continuous survival and reappearance of the self at other times and in other forms. Few artists would have agreed on any precise definition of immortality as eternal fame, collective remembrance, spiritual survival, or continual transmutation. Yet the metaphor of immortality constituted an important theme for the Russian avant-garde over its own lifetime.

Age was as much the enemy of the avant-garde as death. Age meant stagnation and tradition, while youth meant innovation. "The oldest among us are thirty," wrote Marinetti in the *Futurist Manifesto* of 1909; "we have, therefore, ten years at least to accomplish our task. When we are forty, let others, younger and more valiant, throw us into the waste-paper basket like useless manuscripts."[8] Youth was essential to the avant-garde. "I am almost thirty years old," wrote the Swiss painter Paul Klee in 1909; "this scares me a little."[9] From this perspective, the agony of the avant-garde is that it could not make permanent the con-dition it regarded as its main advantage over a philistine art public and the rest of society—its youth.

Aging was an important process for the Russian avant-garde. Its members having been born generally in the 1880s, it may be viewed as a youth movement that emerged around 1905 and reached its peak on the eve of World War I. Put in a different way, the Russian avant-garde consisted of artists who had finished their artistic schooling but had not yet achieved any real success or fame; their moments of innovation generally came when they were in their thirties. Many were well into middle life by 1914, however effusive they might have been about the youthful nature of their art. Lunacharsky, Dobuzhinsky, Meyerhold, and Malevich were relative elders of the movement, entering their thirties in 1905; Mayakovsky and Eisenstein represented a younger element. But the larger group of artists associated with the great exhibits of the prewar period (the Blue Rose, Garland, Link, Jack of Diamonds, and Tramway V) was made up of men and women in their late twenties or thirties by 1910; the émigré painters of La Ruche in Paris were about ten years younger, and became well known only after 1917. The Russian avant-garde was therefore more youthful in spirit than in age. While carrying on a rebellion against the artistic establishment, it yearned to remain young while achieving an artistic reputation that would endure.

On occasion the Russian avant-garde articulated a crisis common to middle life, a confrontation with the reality of one's own death to which creative innovation is one way out.[10] Such crises were not unknown in prewar Europe. Sigmund Freud created psychoanalysis with *The Inter-pretation of Dreams* (1899), written at the age of forty, within a year of his father's death. The German sociologist Max Weber emerged from despair and guilt over his father's death to write *The Protestant Ethic and the Spirit of Capitalism* in 1904, after several years in a mental institution. The Russian writer Leonid Andreev described his sense of crisis at age thirty-seven in 1908:

> For half a year now some sort of crisis has been growing more acute; it is becoming so obvious that I can write nothing serious. I have left the old, and do not know the way to the new. And what the new con-

sists of I don't know. Undoubtedly it is only that I have somehow suddenly turned from the rejection of life to the affirmation of it, and while I formerly thought that only death exists, now I am beginning to guess that there is only life.[11]

According to the then popular scientific popularizer, Elie Mechnikov, youth meant pessimism and age brought optimism. This transition often occurred, he argued, after a period of psychological crisis, as in the cases of Goethe and Tolstoi. "It is indubitable," he wrote in 1903 in *The Nature of Man*, "that among the instincts of man there is one which loves life and fears death. This instinct develops slowly and progressively with age."[12] The psychoanalyst Carl Jung, writing in 1913 about his own age of thirty-eight, observed that "the time is a critical one, for it marks the beginning of the second half of life, when a metanoia, a mental transformation not infrequently occurs."[13] This transformation often involves a new concern with immortality in some form.

Few of the artists studied here commented so explicitly on a personal crisis as did Andreev in 1908. But they were all men who, in their thirties, managed to turn past failure into successful artistic innovation, inspired by Western sources and the revolutionary events around them. Several of them also exhibited a concern with immortality often associated with the transition of middle life from 'youth' to 'age.' Around 1930 Otto Rank noted the "frequent occasions when a great work of art has been created in the reaction following upon the death of a close relation" and argued, in addition, that creative artists might well share a common urge toward personal immortality:

> There appears to be a common impulse in all creative types to replace collective immortality—as it is represented biologically in sexual propagation—by the individual immortality of deliberate self-perpetuation.[14]

Death was an all too common experience during World War I and the Russian Civil War. One can only guess what effect the death of Lunacharsky's baby son, or Dobuzhinsky's brother, or Mayakovsky's friend Chekrygin had on each of them. Likewise, the fact that many of them had lost their fathers through divorce or death by the time they were adolescents also constitutes an intriguing, but elusive, psychohistorical fact. One may suggest, if not prove conclusively, that a personal confrontation with death heightened a sense of limits already provided by artistic failure and aging, and encouraged a search for victory over death in some way. Intensely aware of death, the Russian avant-garde sought to eternalize its youth through innovation, and achieve a kind of immortality.

III

In the end the Russian avant-garde did achieve immortality through its art. In addition to their individual artistic reputations, they helped create a myth of the Russian Revolution. Their art fixed images of transitory historical events, from Bloody Sunday and the *Potemkin* mutiny of 1905, through the seizure of the Winter Palace in November 1917. In 1905 and after 1917, their art reached the masses, utilizing techniques often borrowed from the West to legitimize the revolution for an often illiterate public. Transformed by the revolution, such art subsequently achieved even greater success in the West, from which it had derived its initial inspiration. Throughout their art, avant-garde artists employed the metaphor of immortality to convey the intense transitions from the old to the new, the traditional to the revolutionary, and the religious to the secular. Such a metaphor fit both the traditionally religious society in which they had grown up, and the revolutionary and personal crises which they survived. It also helped provide a missing dimension to the official Marxist-Leninist ideology which promised a socialist utopia, not personal salvation.

This articulation of a basic human need common to most religions—the need to see death as something other than an end to existence—was a central function of the Russian avant-garde. The destruction of churches and the creation of a League of the Godless in the 1920s did not eliminate Russian religious traditions and needs. Nor could a secular doctrine of industrial growth and socialist distribution of property and wealth deal with the personal riddle of death. Marxism itself generally ignored philosophical and religious concerns as merely class-based delusions of society's "superstructure." Lunacharsky and the artists he supported helped articulate those concerns in a language intended to bridge the gap between traditional society and a revolutionary, westernized elite. While Lunacharsky and Bogdanov undoubtedly did not foresee the future Stalinist "cult of personality," they did properly anticipate the need to replace religious myths with secular counterparts in a revolutionary society. Members of the Russian avant-garde shared that need, for reasons of their own, and often articulated it through their art.

The Russian avant-garde consisted of three rather distinct generations of artists that we have called "aesthetes," "futurists," and "constructivists." The traumatic experiences of their early adulthood were, respectively, the 1905 Revolution, World War I, and the Russian Civil War. By the 1920s the Russian avant-garde thus ranged from the adolescent to the middle-aged, and was no longer the youth movement commonly associated with the period from around 1908 to 1914. Yet all

three generations were part of a society in which the agony of Christ and the belief in resurrection and immortality were transformed by the Russian Revolution into public celebrations of the embalmed Lenin, who lives eternally through his surrogate offspring, the Communist Party of the Soviet Union. In the 1920s the fascination with immortality persisted, as in Valerian Muraviev's book *The Mastery of Time* (1924); Muraviev shared Fedorov's belief that science could someday provide the survival of the body after death. The architect Konstantin Melnikov designed a sarcophagus for Lenin with the idea that he was, like the Sleeping Princess, only asleep, to be awakened one day at a signal from the Russian people.[15] For the Russian avant-garde, their cultural upbringing, their transitions from province to city, from Russia to Europe, from youth to middle age, and their survival of personal and revolutionary life-threatening situations all encouraged their search for immortality.

Ultimately, the Russian avant-garde grew old and died. In the early 1920s it was overtaken by a newer generation of constructivists, the youth movement of the October Revolution and Civil War. In film especially, as Sergei Yutkevich observed, "the Revolution made way for the young." One artist recalled that in the early 1920s "on the one side stood we youth at Vkhutemas, on the other Mayakovsky and his entourage, Inkhuk and *LEF*." Trotsky, too, recognized the emergence of a new postrevolutionary generation of artists whose youth coincided with the revolution and Civil War period.[16] The Russian avant-garde was born as a protest against bourgeois prerevolutionary Russian society; it died of old age in the new revolutionary Russia it helped invent.

The Russian avant-garde won its victory over death in art. Its members—if that is the appropriate word for a group that never formally existed—died their own natural and unnatural deaths. Its journals closed down, its art often ended up in museum basements. Mayakovsky, a suicide, and Malevich, who died of cancer, represented in age the outer limits of the avant-garde. In the end the older man outlived the younger, and prepared for death in his own way, decorating a coffin with suprematist symbols and keeping it close at hand as his end approached. As a significant social and artistic phenomenon, the Russian avant-garde had essentially ceased to exist by 1925, the year that Eisenstein accepted state patronage and created his first propaganda film. The thirty-year-old innovators of 1905 were now fifty. Revolution no longer encouraged innovation, but confined the innovator. The Russian avant-garde had experienced the agony of opposition, rebellion, and ultimate defeat; in death it achieved a victory over death in the innovative art it left behind.

APPENDIX

The following tables provide statistical data on the date and place of birth of various artists, their age at given times (such as in 1905 and 1917), and the year of their first trips abroad to study art. The reader will note that place of birth does not necessarily indicate non-Russian origin, or even a provincial upbringing; some artists of Russian ethnic background were born in the provinces and others moved to the capitals at an early age. The years in Munich and Paris indicate residence and art education, rather than travel. The designation "x" indicates association with a particular art exhibit, place of residence, or educational institution.

The sources for the statistical data in the tables are widely scattered. Some useful guides to biographical data on Russian artists during the revolutionary period are: *Avantgarde Osteuropa 1910–1930* (Berlin: Die Deutsche Gesellschaft für Bildende Kunst und die Akademie der Künste, 1967); Szyman Bojko, *New Graphic Design in Revolutionary Russia*, trans. Robert Strybel

TABLE I

Mean Age of Selected Art Groups: 1898–1925

Generation Group	Age: at Origin	1905	1907	1925
Aesthetes				
World of Art Founders (7)	29 (1898)	36	48	56
World of Art "Left" (6)	33 (1905)	33	45	53
NKVM* (7)	37 (1909)	33	45	53
Futurists				
Blue Rose** (8)	29 (1907)	27	39	47
Garland and Link (17)	25 (1907)	23	35	43
Hylea poets (6)	26 (1912)	19	31	39
Proletkult, Paris (13)	34 (1912)	27	39	47
La Ruche painters (11)	26 (1914)	17	29	37
Tramway V and 0.10 (11)	29 (1915)	19	31	39
Constructivists				
ROSTA workshop (12)	29 (1919)	15	27	35
Left Front (14)	30 (1923)	12	24	32
Eisenstein Proletkult (6)	26 (1925)	6	18	26
Kuleshov workshop (12)	27 (1924)	8	20	28
Vertov *Kino-eye* (11)	28 (1924)	9	21	29

*NKVM = Neue Künstler-Vereinigung München (New Artists' League of Munich)

**Blue Rose = painters of that exhibit who did *not* also show their works at the Garland or Link exhibits.

and Lech Zembrzoski (New York: Praeger, 1972); and Werner Schmidt, *Russische Graphik des XIX und XX Jahrhunderts* (Leipzig: VEB Seemann, 1967). For additional references, consult the Bibliography.

TABLE II

Birthplace of Selected Art Groups: 1898–1925

Generation	Group	St. Petersburg	Moscow	Provinces	Unknown
Aesthetes					
World of Art Founders (7)		6	0	1	0
World of Art "Left" (6)		2	0	4	0
NKVM (7)		0	3	4	4
	TOTAL:	8	3	9	4
Futurists					
Blue Rose (8)		0	0	4	4
Garland and Link (17)		1	2	9	5
Hylea poets (6)		0	0	6	0
La Ruche painters (11)		0	0	9	2
Tramway V and 0.10 (11)		2	1	4	4
	TOTAL:	3	3	32	15
Constructivists					
ROSTA workshop (12)		0	2	4	6
Eisenstein Proletkult (6)		0	0	4	2
Kuleshov workshop (12)		0	0	2	10
Vertov *Kino-eye* (11)		0	0	6	5
	TOTAL:	0	2	16	23

Note: The category "provinces" generally refers to the towns of southern and western Russia: Odessa, Kherson, Kharkov, Penza, Tiflis, Kiev, Riga, Belostok, Minsk, Vinnitsa, Vitebsk, and Vilna.

TABLE III

Birth Year of Selected Art Groups: 1860–1905

Years	Aesthetes	Futurists	Constructivists	Total
1860–1865	3			3
1866–1870	6	2		8
1871–1875	7	5		12
1876–1880	4	15	1	20
1881–1885	1	21	4	26
1886–1890		16	7	23
1891–1895		7	16	23
1896–1900			20	20
1901–1905			5	5
	21	66	53	140

TABLE IV
Leading "World of Art" Members: 1905

Name	Age 1905	Age 1917	Birthplace	In Munich	In Paris
Founders:					
L. N. Bakst	39	51	Petersburg		
A. N. Benois	35	47	Petersburg		
S. P. Diaghilev	33	45	Novgorod		
D. V. Filosofov	33	45	Petersburg		
V. F. Nuvel	34	46	Petersburg		
A. P. Nurok	42	54	Petersburg		
K. A. Somov	36	48	Petersburg		
MEAN AGE:	36	48			
"Left wing":					
I. Ya. Bilibin	29	41	Petersburg	1898	
O. E. Braz	33	45	Odessa	1891–94	
M. V. Dobuzhinsky	30	42	Novgorod	1899–1901	
I. E. Grabar	34	46	Budapest	1896–1901	
D. N. Kardovsky	39	51	Vladimir	1896–1901	
E. E. Lanseray	30	42	Petersburg		1896–99
MEAN AGE:	33	45			

TABLE V

Russian Art Students in Munich: 1890–1914

Arrival	Name	Age			Birthplace	School
		Arrival	1905	1917		
1891	O. Braz	18	32	44	Odessa	Holločy
1896	I. Grabar	25	34	46	Budapest	Ažbe
	A. Yavlensky	32	41	53	Tver	Ažbe
	D. Kardovsky	30	39	51	Vladimir	Ažbe
1897	V. Kandinsky	31	39	51	Moscow	Ažbe, Stuck
	M. Verefkina	37	45	57	Tula	Ažbe
1898	I. Bilibin	22	29	41	Tarkhovka	Ažbe
1899	M. Dobuzhinsky	24	30	42	Novgorod	Ažbe, Holločy
	K. Petrov-Vodkin	24	30	42	Saratov	Ažbe
1900	Z. Grzhebin	31	36	48	Odessa	Holločy
1902	V. Bekteev	26	29	41	Moscow	Knirr
	R. Genin	18	21	33	Smolensk	Ažbe
1903	D. Burliuk	20	22	34	Kharkov	Ažbe
	V. Burliuk	16	18	30	Kherson	Ažbe
	M. Kogan	24	26	38	Orgeev	Holločy
1904	A. Fonvizin	22	23	35	Riga	Indep.
1905	V. Favorsky	19	19	31	Moscow	Holločy
	MEAN AGE:	24	30	42		

TABLE V—*Continued*

Arrival	Name	Age Arrival	1905	1917	Birthplace	School
1906	K. Istomin	19	18	30	Kursk	Holločy
	A. Kravchenko	17	16	28	Pokrovsk	Holločy
	N. Rosenfeld	20	19	31		Holločy
	K. Zefirov	27	26	38		Holločy
1907	V. Falileev	28	26	38	Penza	Indep.
	A. Mogilevsky	19	17	29	Mauripol	Holločy
1908	P. Pavlinov	27	24	36	Petersburg	Indep.
	N. Shestapolov	33	30	42	Penza	Knirr
1910	N. Gabo	20	15	27	Briansk	U. Munich
1911	B. Ternovets	27	21	33		Holločy
	I. Varakin	22	16	28	Vologda	Tech H.S.
1912	A. Sidorov	21	14	26	Nikolaevka	U. Munich
	A. Tikhomirov	24	17	29		Holločy
	MEAN AGE:	23	20	32		

TABLE VI

Russian Art Students in Paris: 1890–1914

Arrival	Name	Age			Birthplace	School
		Arrival	1905	1917		
1895	V. Borisov-Musatov	25	35	47	Saratov	Cormon
1896	E. Lanseray	21	30	42	Petersburg	Julienne
1897	P. Konchalovsky	21	29	41		
1898	N. Milioti	24	31	43		
1904	D. Burliuk	22	23	35	Kherson	Cormon
	V. Burliuk	18	19	31	Kharkov	Cormon
1905	S. Delaunay-Terk	20	20	32	Ukraine	
	MEAN AGE:	22	27	39		
1906	A. Arapov	30	29	41	Petersburg	
	M. Larionov	25	24	36	Tiraspol	
	P. Kuznetsov	28	27	39	Saratov	
1907	D. Shterenberg	33	31	43		
	M. Vasileva					
1908	A. Archipenko	21	18	30	Kiev	La Ruche
	A. Exter	24	21	33	Kiev	Ac. Grande Chaumière
1909	L. Survage	29	26	38	Moscow	Matisse
	S. Bulakovsky	29	25	37	Odessa	
	J. Lipschitz	18	14	26	Lithuania	La Ruche
	O. Zadkin	19	15	27	Smolensk	La Ruche
1910	M. Chagall	23	18	30	Vitebsk	La Ruche

TABLE VI—Continued

Arrival	Name	Age			Birthplace	School
		Arrival	1905	1917		
	M. Kisling	23	18	30	Cracow	La Ruche
	N. Altman	22	17	29	Vinnitsa	La Ruche
1911	Yu. Annenkov	22	16	28	Kamchatka	
	I. Chaikov	23	17	29		Decorative Arts
	A. Lentulov	29	23	35	Penza	Fauconnier
1912	A. Pevsner	28	21	33	Orel	
	P. Filonov	29	22	34	Moscow	
	L. Popova	23	16	28	Moscow	Fauconnier
	I. Pougny	18	11	23	Kuokalla	Julienne
	K. Bogoslavskaya	18	11	23		
	S. Sharchun	23	16	28	Samara	
	N. Udaltsova	26	19	31		Fauconnier
	P. Kremegne	27	20	32	Vilna	
1913	G. Yakulov	29	21	33	Tiflis	
	N. Gabo	23	15	27	Briansk	
	V. Tatlin	28	20	32	Kharkov	
	M. Kikoine	23	15	27	Minsk	La Ruche
	C. Soutine	21	13	25	Minsk	La Ruche
	D. Baranov-Rossine	25	17	29	Kherson	
	MEAN AGE:	25	19	31		

TABLE VII
Blue Rose, Garland, and Link Exhibits: 1907–1908

Name	Age		Birthplace	MAS*	In Munich	In Paris
	1905	1917				
(Blue Rose)						
N. Feofilaktov	27	39				
P. V. Kuznetsov	27	39	Saratov	1897–1907		1906
A. T. Matveev	27	39	Saratov	1899–1902		1898
N. D. Milioti	31	43				
V. D. Milioti	30	42				
N. P. Riabushinsky	28	40				
M. S. Saryan	25	37	Armenia	1897–1903		
P. S. Utkin	28	40	Saratov	189?–190?		
MEAN AGE:	28	40				
(Blue Rose, Garland, and Link)						
A. A. Arapov	29	41	Petersburg	1897–1906		
P. Bromirsky	21	33				
V. Drittenpreis						
A. V. Fonvizin	23	35	Riga	1902–1904	1904–1906	
I. Knabe	29	41		1904–1911		
N. P. Krymov	21	33				

*MAS = Moscow School of Painting, Sculpture, and Architecture.

TABLE VII—Continued

Name	Age 1905	Age 1917	Birthplace	MAS*	In Munich	In Paris
N. N. Sapunov	25	37	Moscow	1896–1901		1906
S. Yu. Sudeikin	23	35		1897–1909		1906
MEAN AGE:	24	36				
(Garland, Link only)						
Z. A. Baikova						
D. V. Baranov-Rossine	17	29	Kherson		1903–1904	1904–1905
V. D. Burliuk	19	31	Kherson		1903–1904	1904–1905
D. D. Burliuk	23	35	Kharkov			
A. S. Glagoleva						
N. S. Goncharova	24	36	Tula	1898–1909		1914–
M. Kuznetsov-Vol'sky						
M. F. Larionov	24	36	Tiraspol	1898–1910		1914–
A. V. Lentulov	23	35	Penza	1907–1909		1911
S. I. Petrov						
V. V. Rozhdestvensky	21	33		1900–1911		
L. Survage	26	38	Moscow	1897–1907		1908–
G. B. Yakulov	21	33	Tiflis	1900–1902		
A. A. Exter	21	33	Belostok			1907–1914
MEAN AGE:	22	34				

*MAS = Moscow School of Painting, Sculpture, and Architecture

TABLE VIII

Jack of Diamonds Exhibit: 1910

Name	Age 1905	Age 1917	Birthplace	MAS	In Munich	In Paris
(Blue Rose)						
A. V. Fonvizin	23	35	Riga	1902–1904	1904–1906	
A. T. Matveev	27	39	Saratov	1899–1902		
(Garland, Link)						
D. D. Burliuk	23	35	Kharkov	1911–1913	1903–1904	1904–1905
V. D. Burliuk	19	31	Kherson		1903–1904	1904–1905
N. S. Goncharova	24	36	Tula	1898–1909		1914–
M. F. Larionov	24	36	Tiraspol	1898–1910		1914–
A. V. Lentulov	23	35	Penza	1907–1909		1911
L. Survage	26	38	Moscow			1908–
A. A. Exter	21	33	Belostok	1897–1907		1907, 1914
(NKVM)						
V. G. Bekteev	27	39	Moscow		1902–1906	1906–1914
E. Bossi						
V. V. Kandinsky	39	51	Moscow		1897–1914	1906–1907
A. Kanoldt	24	36	Karlsruhe		1900–?	
S. I. Lobanov	26	38	Moscow		?–?	
G. Münter	28	40	Berlin		1901–?	1906–1907
M. Verefkina	45	57	Tula		1897–1914	
A. Yavlensky	41	53	Tver		1897–1914	

TABLE VIII—*Continued*

Name	Age		Birthplace	MAS	In Munich	In Paris
	1905	1917				
(Golden Fleece)						
R. R. Falk	19	31		1905–1909		
P. P. Konchalovsky	29	41	Petersburg			1898, 1907–9
A. V. Kuprin	25	37		1906–1910		
I. I. Mashkov	24	36	Don Region	1900–1909		1908
V. S. Bart	18	30	Stavropol	1906–1911		
K. S. Malevich	27	39	Kiev	1902–?		
MEAN AGE:	26	38				

Other painters exhibiting: A. A. Morgunov, N. E. Rogovin, I. A. Skuie, S. I. Baudouin de Courtenay, V. R. Eiges, A. F. Mikuli, Savinkov, A. M. Samoilova, B. A. Takke, S. I. Yasinsky, I. V. Zaporozhtsev

TABLE IX

Proletkult Movement before 1914

Name	Joined Bolsheviks	Vologda	Capri	Bologna	Paris	Age (1911)
V. A. Bazarov (Rudnev)	1905	x	x			37
A. A. Bogdanov	1904	x	x	x		38
A. V. Lunacharsky	1904	x	x	x	x	36
Lunacharskaia		x	x	x	x	28
I. I. Skvortsev (Stepanov)	1904	x	x	x		41
G. V. Aleksinsky		x	x	x		32
V. A. Desnitsky (Stroev)			x	x		
M. Gorky			**x**	x		43
F. I. Kalinin			x	x	x	28
M. Liadov	1905		x			
M. N. Pokrovsky			x			43
N. E. Vilonov			x			26
S. Vol'sky			x			
N. P. Avilov				x		24
M. T. Stepanchikov				x		24
I. A. Khrushchev				x		21
M. N. Kokovikhin				x		26
Karl				x		25
Arkhip				x		25
T. S. Krivov				x		25
G. E. Fomin				x		25
D. Sobolev				x		21
P. A. Stiazhkina				x		20
P. K. Bessalko			x		x	24
M. P. Gerasimov			x		x	22
A. K. Gastev			x		x	29
P. I. Lebedev			x		x	30
					MEAN AGE:	29

TABLE X

The Russian Artists of La Ruche

Name	Born	Birthplace	To Paris	Age (1914)
N. Altman	1889	Vinnitsa	1911	25
A. Archipenko	1887	Kiev	1908	27
S. Bulakovsky	1880	Odessa	1909	34
M. Chagall	1887	Vitebsk	1910	27
M. Kikoine	1891	Minsk	1913	23
M. Kisling	1891	Cracow	1910	23
P. Kremegne	1887	Vilna	1912	27
J. Lipschitz	1891	Lithuania	1909	23
D. Shterenberg	1881	?	1907	33
C. Soutine	1893	Minsk	1913	21
O. Zadkin	1890	?	1911	24
			MEAN AGE:	26

TABLE XI

Tramway V and 0.10 Exhibits: 1915

Name	Age		Birthplace	TrV	0.10	In Paris
	1905	1917				
(Suprematists)						
K. Bogoslavskaya	13	25	Petersburg	x	x	1912–1913
I. Klyun	27	39		x	x	
K. Malevich	27	39	Kiev	x	x	
I. Pougny	11	23	Petersburg	x	x	1912–1913
M. Menkov				x	x	
(Others)						
L. Popova	16	28	Moscow	x	x	1912–1913
O. Rozanova	19	32		x	x	1913
V. Tatlin	20	31	Kharkov	x	x	1912–1913
N. Udaltsova	19	33		x	x	1907, 1914
A. Exter	21		Belostok	x		1907, 1914
A. Morgunov				x		
N. Altman	16	28	Vinnitsa		x	1910–1911
V. Kamensky	17	29			x	
A. Kirillova					x	
V. Pestel					x	
M. Vasileva					x	1907–1914
MEAN AGE:	19	31				

TABLE XII
M. M. Cheremnykh's ROSTA Poster Workshop: 1919

Name	Age (1919)	Birthplace	Art School	Satirikon	Budil'nik
P. A. Aliakrinsky	30				
L. G. Brodaty	29	Warsaw	Vienna Academy		
M. M. Cheremnykh	26	Tomsk	MAS 1911–1916		
V. N. Denisov (Deni)	19	Moscow	None	x	
B. E. Efimov	38	Kiev	None		
P. M. Kerzhentsev	30		None		
V. I. Kozlinsky	26				
A. M. Lavinsky	28		St. P. Academy 1910–1914	x	
V. V. Lebedev					
V. V. Mayakovsky	26	Bagdadi	Kelin; MAS	x	
I. A. Maliutin	28				x
D. Moor (Orlov)	36	Novocherkassk	Kelin		x
I. I. Nivinsky	39	Moscow	Stroganov		
A. M. Nurnberg					x
V. V. Voinov				x	
	MEAN AGE: 29				

Note: V. V. Voinov was a poet for *Satirikon*, not a cartoonist.

Some Workers of the Early Soviet Cinema

Group	Name	Birthplace	Age (1924)
Kuleshov's workshop	B. V. Barnet		22
	M. I. Doller		35
	V. P. Fogel		22
	P. S. Galadzhov		24
	A. S. Khokhlova		27
	S. P. Komarov		33
	G. S. Kravchenko		19
	L. V. Kuleshov	Tambov	25
	A. A. Levitsky		39
	L. L. Obolensky		22
	V. I. Pudovkin	Penza	31
	P. P. Repnin		30
	MEAN AGE:		27
Vertov's *Kino-eye*	I. I. Beliakov		27
	A. I. Bushkin	Kiev	28
	M. A. Kaufmann	Belostok	27
	I. P. Kopalin		24
	A. G. Lemberg		24
	P. K. Novitsky	Kiev	39
	E. Shub	Chernigov	30
	E. I. Svilova		24
	E. K. Tisse	Riga	27
	D. Vertov (Kaufmann)	Belostok	28
	P. P. Zotov		26
	MEAN AGE:		28
Factory of the Eccentric Actor (FEKS)	G. M. Kozintsev	Kiev	19
	L. Z. Trauberg	Odessa	22
	S. I. Yutkevich	Kiev	20
	MEAN AGE:		20
Eisenstein's Proletkult crew for *Potemkin*	A. P. Antonov		26
	G. V. Aleksandrov	Ekaterinburg	21
	S. M. Eisenstein	Riga	26
	A. I. Levshin		25
	M. M. Shtraukh	Riga	24
	E. K. Tisse	Riga	27
	MEAN AGE:		25

NOTES

Introduction

1. M. J. Lasky, "The Birth of a Metaphor: On the Origins of Utopia and Revolution," *Encounter*, XXXIV, 2 (February 1970), p. 39; J. L. Talmon, *Political Messianism: The Romantic Phase* (New York, 1960), pp. 35, 77.

2. R. Poggioli, *The Theory of the Avant-garde*, trans. G. Fitzgerald (Cambridge, Mass., 1968), pp. 66–67.

3. Ibid., pp. 65–66.

Chapter 1
Innovation, Revolution, and the Russian Avant-garde

1. On the history of the concept and term "avant-garde" see R. Poggioli, *The Theory of the Avant-garde*; D. Egbert, "The Idea of 'Avant-garde' in Art and Politics," *American Historical Review*, LXXIII, 2 (December 1967), pp. 330–36. On the use of the word in French journals see R. Estivals, J.-C. Gaudy, and G. Vergez, *L'Avant-garde* (Paris, 1968). Also H. E. Holthusen, "Kunst und Revolution," *Gestalt und Gedanke*, XI (1966), pp. 7–44; M. de Micheli, *Le avanguardie artistiche del Novocento* (Milan, 1959); P. Cabanne, *L'avant-garde au XXᵉ siecle* (Paris, 1969).

2. M. Cantor, *Max Eastman* (New York, 1970), p. 83; A. R. MacDougall, *Isadora: A Revolutionary in Art and Love* (New York, 1969), p. 194; H. Carter, *Spiritualism* (London, 1920), p. 12. Huntley Carter was a British journalist and drama critic who became an outspoken Soviet sympathizer in England in the 1920s and 1930s; his sometimes mystical language reflected his prewar interest in theosophy and spiritualism. See his *The New Theatre and Cinema of Soviet Russia* (New York, 1925) and his later *The New Spirit in the Cinema* (London, 1930).

3. R. Fueloep-Miller, *The Mind and Face of Bolshevism* (New York, 1927), pp. 2, 6, 24, 104, 120, and 132.

4. J. Billington, *The Icon and the Axe* (New York, 1966), pp. 517, 484–85, 486, 505, 547, and 476, respectively.

5. R. Jakobson, *Selected Writings* (The Hague and Paris, 1971), pp. 30–31; C. Gray, *The Russian Experiment in Art 1863–1922* (New York, 1970), p. 94; S. F. Starr, in the catalogue of the Hutton Gallery, New York, *Russian Avant-garde: 1908–1922* (New York, 1971), pp. 6, 8; J. Berger, *Art and Revolution* (London, 1969), pp. 28, 30–31; J. Bowlt, in *Russian Avant-garde*, pp. 10–13.

6. L. Trotsky, *Literature and Revolution* (1924) (Ann Arbor, 1960), pp. 157, 184, 224, 229.

7. See, for example, the excellent monograph by K. Rudnitsky, *Rezhisser Meierkhol'd* (Moscow, 1969); A. D. Alekseev et al., *Russkaia khudozhest-*

vennaia kultura kontsa XIX–nachala XX veka, 2 vols. (Moscow, 1968); D. Sarab'ianov, *Russkaia zhivopis' kontsa 1900-kh–nachala 1910-kh godov* (Moscow, 1971).

8. An exhibit of Malevich paintings was held at the Stedelijk Museum in Amsterdam in 1968, and another on El Lissitzky at the Van Abbe museum in Eindhoven the same year. Other exhibits include: "Avantgarde Osteuropa 1910–1930" in Berlin, (1967); "Russian Avant-garde: 1908–1922" at the Hutton Gallery in New York (1971); "Art in Revolution: Soviet Art and Design since 1917" at the Hayward Gallery in London (1971), and later in Frankfurt, Stuttgart, and Köln; and "Search for Total Construction: Art, Architecture, and Town Planning: USSR, 1917–1932," shown first at the University of Delft and then at Harvard University in 1971.

9. See Poggioli, *Avant-garde*, passim.

10. P. Gay, *Weimar Culture* (New York, 1968), p. xiv.

11. G. Tasteven, *Futurizm (na puti k novomu simvolizmu)* (Moscow, 1914), pp. 19–20.

12. On early Soviet architecture see especially A. Kopp, *Town and Revolution* (New York, 1970); O. A. Shvidkovsky, *Building in the USSR 1917–1932* (New York, 1971); E. Lissitzky, *Russia: An Architecture for World Revolution* (1930), trans. E. Dluhosch (Cambridge, Mass., 1970); E. A. Borisova, T. P. Khazhdan, *Russkaia arkhitektura kontsa XIX–nachala XX veka* (Moscow, 1971); V. Khazanova, *Sovetskaia arkhitektura pervykh let Oktiabria* (Moscow, 1970).

13. P. Klee, *The Diaries of Paul Klee; 1898–1918* (Berkeley and Los Angeles, 1964), p. 313.

14. W. James, *Human Immortality* (Boston and New York, 1898), pp. 12, 27.

15. J. Choron, *Death and Western Thought* (New York, 1963), p. 269.

16. B. Spinoza, *Ethics* (New York, 1955), p. 277.

17. G. Groman, "A History of Ideas about the Prolongation of Life," *Transactions of the American Philosophical Society, New Series* Vol. 56, Part 9 (December 1966), pp. 85, 88, 89.

18. C. Becker, *The Heavenly City of the Eighteenth-Century Philosophers* (New Haven, 1932), pp. 149, 150, 153.

19. E. Boutroux, *Science and Religion in Contemporary Philosophy* (London, 1909), pp. 149, 150, 153.

20. A. Radishchev, "On Man, his Mortality and Immortality," trans. F. Gladney, G. Kline, in J. Edie, J. Scanlan, M. Zeldin, eds., *Russian Philosophy*, I (Chicago, 1965), pp. 80, 99.

21. P. Pomper, *Peter Lavrov and the Russian Revolutionary Movement* (Chicago and London, 1972), p. 161; *The Communist International*, No. 30 (1924), p. 4.

22. B. Rosenthal, *Dmitri Sergeevich Merezhkovsky and the Silver Age: The Development of a Revolutionary Mentality* (The Hague, 1975), pp. 66, 92, 175.

23. G. Kline, *Religious and Anti-Religious Thought in Russia* (Chicago and London, 1968), pp. 112–14, 121.

24. E. Mechnikov, *The Nature of Man* (Paris, 1903), pp. 265, 302; see also his *The Prolongation of Life: Optimistic Studies* (New York, 1908).

25. N. Mandelshtam, *Hope against Hope* (New York, 1970), p. 165.

Chapter 2
From Positivism to Collectivism: Lunacharsky and Proletarian Culture

1. A. V. Lunacharsky, *Sobranie sochinenii*, II (Moscow, 1964), p. 230. Hereafter Lunacharsky, *Sobranie*. The previous quote in the paragraph is from S. Fitzpatrick, *The Commissariat of Enlightenment: Soviet Organization of the Arts under Lunacharsky* (Cambridge, England, 1970), pp. 1–2.

2. Fitzpatrick, *Commissariat*, p. 111.

3. M. Hitch, "Dietzgenism," *International Socialist Review*, VIII, 5 (November 1907), p. 298.

4. On the pre-1914 "intellectual revolution" see *inter alia* H. S. Hughes, *Consciousness and Society: The Reorientation of European Social Thought 1890–1930* (Cambridge, Mass., 1958), and J. Weiss, ed., *The Origins of Modern Consciousness* (Detroit, 1965).

5. H. Bergson, *Creative Evolution* (1907) (London, 1960), p. 271.

6. On positivism see especially the survey by L. Kolakowski, *The Alienation of Reason: A History of Positivist Thought*, trans. N. Guttermann, (New York, 1968).

7. Cited in J. T. Blackmore, *Ernst Mach* (Berkeley and Los Angeles, 1972), p. 20.

8. E. Mach, *The Analysis of Sensations and the Relation of the Physical to the Psychical* (Chicago and London, 1914), pp. 3–4, 10–12, 23–25.

9. G. Fechner, *Zend-avesta, oder über die Dinge des Himmels und des Jenseits*, 2 vols. (Hamburg and Leipzig, 1901).

10. K. Pearson, *The Grammar of Science* (London, 1900), p. 191.

11. Blackmore, *Mach*, p. 237.

12. M. Maeterlinck, *The Blue Bird* (London, 1920), pp. 62, 69, 168, 186.

13. E. Verhaeren, *Les Aubes* (London, 1898), pp. 81, 94, 99–100, 103.

14. A. Comte, *The Positive Philosophy* (New York, 1954), II, p. 221.

15. A. Goldman, and E. Sprinchorn, eds., *Wagner on Music and Drama* (New York, 1964), pp. 60, 66, 74.

16. J. Dietzgen, *Some of the Philosophical Essays on Socialism and Science, Religion, and Ethics, Critique-of-Reason and the World at Large* (Chicago, 1906), pp. 90, 91, 101.

17. N. V. Os'makov, *Russkaia proletarskaia poeziia 1890–1917* (Moscow, 1968), p. 13.

18. On European developments in industry and art see R. Banham, *Theory and Design in the First Machine Age* (London, 1960); E. and C. Paul, *Proletkult* (London, 1921). On the Darmstadt colony see A. Koch, ed., *Ernst Ludwig und die Ausstellung der Künstlerkolonie in Darmstadt von Mai bis Oktober 1901* (Darmstadt, 1901).

19. The best source on Lunacharsky's life is the series of autobiographies which he wrote, beginning in 1907: (1) "Avtobiograficheskaia zametka"

(Florence, 1907) in "A. V. Lunacharsky: Neizdannye materialy," *Litera-turnoe nasledstvo* (Moscow, 1970), pp. 550–53; (2) *Velikii perevorot* (Petro-grad, 1919), reprinted in N. A. Trifonov, ed., *Vospominaniia i vpechatleniia* (Moscow, 1968); (3) "Avtobiografiia" for the Lenin Institute in 1926, pub-lished in "V. I. Lenin i A. V. Lunacharsky," *Literaturnoe nasledstvo* (Mos-cow, 1971), pp. 736–43; (4) his 1932 recantation entitled "K voprosy o filosofskoi diskussii 1908–1910 g.g." in "Neizdannye," pp. 494–502. For a popular Soviet biography see A. Elkin, *Lunacharsky* (Moscow, 1967).

20. *Vospominaniia i vpechatleniia*, p. 19.

21. On the Vologda years of exile see especially I. P. Kochno, "Vologd-skaia ssylka Lunacharskogo," in "Neizdannye," pp. 603–20.

22. The best summary of Bogdanov's views may be found in D. Grille, *Lenins Rivale; Bogdanov und seine Philosophie* (Köln, 1966).

23. N. Berdyaev, *Dream and Reality* (New York, 1962), pp. 130–31.

24. Ibid., p. 125.

25. A. V. Lunacharsky, *Etiudy kriticheskie i polemicheskie* (Moscow, 1905), pp. 189–90, taken from his article "Russkii Faust" in *Voprosy filosofii i psikhologii*, May–June 1902, pp. 783–95.

26. Ibid., pp. 199, 206, taken from his article "Tragizm zhizni i belaia magiia," *Obrazovanie*, 1902, No. 9, pp. 109–28.

27. "V. I. Lenin i A. V. Lunacharsky," p. 739.

28. On Gorky's career at about this time see B. Wolfe, *The Bridge and the Abyss: The Troubled Friendship of Maxim Gorky and V. I. Lenin* (New York, 1967), pp. 43–49.

29. M. Liadov, *Iz zhizni partii v 1903–1907 godakh* (Moscow, 1956), pp. 71, 112; M. Karelina, *Bol'shevistskaia gazeta "Novaia zhizn'"* (1905 g.) (Moscow, 1955); Akademiia Nauk SSSR, *Letopis' zhizni i tvorchestva A. M. Gor'kogo. I. 1868–1907* (Moscow, 1958), pp. 436–635, passim.

30. *Piatyi (Londonskii) s"ezd RSDRP Aprel'–mai 1907 goda: Protokoly* (Moscow, 1963); A. P. Dudden, *Joseph Fels and the Single-Tax Movement* (Philadelphia, 1971), pp. 126–37; M. Gorky, *Days with Lenin* (New York, 1932), pp. 10, 20.

31. N. A. Trifonov, "A. V. Lunacharsky i Maksim Gorky (K istorii litera-turnykh i lichnykh otnoshenii do Oktiabria)," in K. D. Muratova, ed., *Maksim Gorky i ego sovremenniki* (Leningrad, 1968), pp. 124, 127, 133.

32. A. Bogdanov, *Empiriomonizm*, III (St. Petersburg, 1906), p. viii; V. D. Dubinsky-Mukhadze, *Shaumian* (Moscow, 1965), p. 156, on Stalin; V. I. Lenin, *Materializm i empiriokrititsizm* (1909), in his *Sobranie sochinenii*, Vol. XIII (Moscow, 1935), p. 98.

Among Dietzgen's translated writings were *Budushchee sotsial-demokratii* (St. Petersburg, 1906); *Religiia sotsial-demokratiia* (St. Petersburg, 1906); *Zavoevaniia (akvizit) filosofii i pis'ma o logike: Spetsial'no demokraticheskaia proletarskaia logika* (St. Petersburg, 1906). Plekhanov attacked Dietzgen as an idealist in his "Iosif Ditsgen," *Sovremennyi mir*, No. 8 (1907), pp. 59–75; his views were defended by N. Andreev, "Dialekticheskii materializm i filo-sofii Iosifa Ditsgena," *Sovremennyi mir*, No. 7 (1907), pp. 1–35, and by I. Gel'fond in "Filosofiia Ditsgena i sovremennyi pozitivizm," in *Ocherki po filosofi marksizma: Filosofskii sbornik* (St. Petersburg, 1908), pp. 243–90.

See also Ortodoks (L. Aksel'rod), "Osnovnye elementy filosofii Iosifa Dits-gena," *Nasha zaria*, No. 9 (1913), pp. 1–9, and the translation of Ernst Unter-mann's *Antonio Labriola i Iosifa Ditsgen* (St. Petersburg, 1907).

33. "K voprosu o filosofskoi diskussii 1908–1909 g.g.," pp. 497–98.

34. A. V. Lunacharsky, "Zadachi sotsial-demokraticheskogo khudozhe-stvennogo tvorchestva," *Vestnik zhizni*, 1907, No. 1, pp. 120–39, reprinted in *Kriticheskie etiudy (Russkaia literatura)* (Leningrad, 1925), especially pp. 6, 13–14, 17.

35. A. V. Lunacharsky, "Vystavka kartin 'Soiuz russkikh khudozhnikov,' " *Vestnik zhizni*, 1907, No. 2, reprinted in A. V. Lunacharsky, *Ob izobrazitel'-nom iskusstve* (Moscow, 1967), I, pp. 381–84; quotation from p. 381.

36. A. V. Lunacharsky, "Sotsializm i iskusstvo," in *"Teatr": Kniga o novom teatre* (St. Petersburg, 1908), pp. 26–27, 29.

37. *Ocherki po filosofi marksizma: Filosofskii sbornik* (St. Petersburg, 1908); V. A. Bazarov, "Mistitsizm materialisticheskii i realizm nashego vre-meni," ibid., pp. 38, 56, 66, 71.

38. Ibid., pp. 125, 155, 157, 159.

39. A. V. Lunacharsky, *Religiia i sotsializm* (St. Petersburg, 1908, 1911), I, p. 40; II, pp. 26, 139, 385.

40. A. V. Lunacharsky, *Three Plays*, trans. L. Magnus and K. Walter (London, n.d.), p. 134.

41. A. V. Lunacharsky, "Literaturnyi raspad i kontsentratsiia intelligent-siia," *Kriticheskie etiudy*, p. 121; originally "O XXIII sbornike 'Znanie,' " in *Literaturnyi raspad*, (St. Petersburg, 1909), II, pp. 84–119.

42. "V. I. Lenin i A. V. Lunacharsky," p. 39.

43. A. M. Gorky, *Pis'ma k pisateliam i I. P. Ladyzhnikovu* (Moscow, 1959), p. 190; *Arkhiv Gorkogo*, Vol. VII; also B. Kremenev, *Krasin* (Mos-cow, 1968), pp. 162–64. See also the April 1, 1909, report of the Paris section of the Okhrana to the Ministry of the Interior in St. Petersburg, reporting the plans for the Capri School (including Lenin as a lecturer); Okhrana Archive, Hoover Institution, Stanford, Calif., Box XXIVj, folder 2.

44. Elkin, *Lunacharsky*, pp. 44–46, 96.

45. Lenin to A. I. Elizarova, December 6, 1908, cited in Elkin, *Lunachar-sky*, p. 87.

46. On the Bologna school of 1910 see *Vospominaniia i vpechatleniia* (pp. 48–49). According to the Okhrana, Aleksinsky was able to obtain 10,000 francs from the party for the school; see the reports dated Darmstadt, Octo-ber 28, 1910 (No. 952); Paris, March 6, 1911 (No. 258); and Paris, April 17, 1911 (No. 469); in the Okhrana Archive, Box XVIb(2), folder C. See also S. F. Lifshits, "Partiinaia shkola v Bolon'e (1910–1911 g.g.)," in *Pro-letarskaia revoliutsiia*, Vol. III, No. 50 (1926), pp. 109–44.

47. A. Haskell, *Diaghileff: His Artistic and Private Life* (London, 1935), p. 161.

48. *Vospominaniia i vpechatleniia*, p. 49.

49. *Vpered: Sbornik statei po ocherednym voprosam*, 1 (July 1910), p. 1; 2 (February 1911), pp. 73, 82; 3 (May 1911), *passim*. See also *Proletarskoe znamia*, Nos. 2/3 (May/June 1910), p. 4. Both journals were published in Paris; copies of these issues are in the Houghton Library, Harvard University.

50. On Syrmus see S. Dreiden, *Muzyka revoliutsii* (Moscow, 1970), pp. 497–505. Syrmus once told Lenin he wanted to "help free the proletariat with my violin" (p. 499). Lunacharsky wrote an article about him for *Parizhskii vestnik*, No. 47 (November 23, 1912), republished in *Sovetskaia muzyka*, 1963, No. 11, pp. 46–48.

51. "Neizdannye," p. 288.

52. A. V. Lunacharsky, *Ob izobrazitel'nom iskusstve* (Moscow, 1967), Vol. I, pp. 160, 183, 185.

53. On "La Ruche" see Marevna (Vorubeva), *Life with the Painters of La Ruche* (London, 1972); J. Chapiro, *La Ruche* (Paris, 1960); I. Ehrenburg, *Men, Years, Life*. I: *Childhood and Youth 1891–1917* (London, 1962), pp. 86, 121, 143; J. Kessel, *Kisling 1891–1953* (Paris, 1971); J. Lipschitz, *My Life in Sculpture* (New York, 1972); M. Chagall, *My Life* (New York, 1960), pp. 106–16.

54. Marevna, *Painters*, p. 51; Ehrenburg, *Men, Years, Life*, p. 147.

55. A. V. Lunacharsky, "Molodaia Rossiia v Parizhe," *Kievskaia mysl'*, 1914, No. 37, republished in *Ob izobrazitel'nom iskusstve*, pp. 407–22.

56. A. Bogdanov, *Iskusstvo i rabochii klass* (Moscow, 1918), p. 78.

57. Fitzpatrick, *Commissariat*, p. 106.

58. On Altman see M. Etkind, *Natan Altman* (Moscow, 1971), and A. Efros, *Portret Natana Altmana* (Berlin, 1922).

59. F. Meyer, *Chagall* (New York, n.d.), p. 268.

60. For Lunacharsky's ideas on culture in the mid-1920s see especially his *Chemu sluzhit teatr* (Moscow, 1925), and *Desiatiletie revoliutsii i kultura* (Moscow and Leningrad, 1927).

61. A. V. Lunacharsky, *Sobranie sochinenii*, V (Moscow, 1965), pp. 334, 360, 388.

62. A. V. Lunacharsky, *Pochemu nel'zia verit v boga?* (Moscow, 1965), p. 106, from his lecture, "Idealism or Materialism," given on September 21, 1925, in Moscow.

63. Ibid., p. 25.

Chapter 3
Antagonism and Political Satire: The Cartoon and the Poster

1. On the World of Art circle see V. N. Petrov, "Mir iskusstva," *Istoriia russkogo iskusstva* (Moscow, 1968), X, 1, pp. 431–44; N. P. Lapshina, "Mir iskusstva," in *Russkaia khudozhestvennaia kultura kontsa XIX–nachala XX veka (1895–1907)* (Moscow, 1969), II, pp. 129–62; J. Bowlt, "Synthesism and Symbolism: The Russian World of Art Movement," *Forum for Modern Language Studies*, IX, 1 (January 1973), pp. 35–48, and his "The Early Years of Sergei Diaghilev," *Transactions of the Association of Russian-American Scholars in the USA*, VI (1972), pp. 94–114.

The origins of the founding members, mainly students at the May School in St. Petersburg who called themselves the "Nevsky Pickwickians," are indicated in Table IV. It was a close-knit group: Diaghilev's father and Filosofov's mother were brother and sister; Benois was Lanseray's uncle; Benois, Diaghi-

lev, Filosofov, and Nuvel all studied together at the Law Faculty of St. Petersburg University; only two studied at the Academy of Arts—Bakst and Benois —while Somov was an occasional auditor.

On the "left wing" of the World of Art see S. V. Golynets, ed., *I. Ya. Bilibin* (Leningrad, 1970); O. I. Pobedova, *E. E. Lansere 1875–1946* (Moscow, 1961); V. M. Lobanov, *Knizhnaia grafika E. E. Lansere* (Moscow, 1948); "Braz, O. E.," in *Khudozhniki narodov SSSR: Biobibliograficheskii slovar'* (Moscow, 1972), II, p. 58; O. I. Pobedova, *I. E. Grabar* (Moscow, 1964); I. E. Grabar, *Moia zhizn': Avtobiografiia* (Moscow and Leningrad, 1937); O. I. Pobedova, *D. N. Kardovsky* (Moscow, 1957). Braz, Grabar, and Kardovsky all studied at the Academy in the 1890s and worked under Repin, as did Bilibin independently; except for Lanseray, the entire "left wing" studied in Munich with Ažbe or Holloçy.

2. A. G. Rashin, *Naselenie Rossii za 100 let, 1811–1913* (Moscow, 1956), pp. 93–96; W. Parker, *An Historical Geography of Russia* (London, 1968), p. 308. On education see N. Hans, *History of Russian Educational Policy (1701–1917)* (London, 1931), Tables 32, 34, 35, and P. Alston, *Education and the State in Tsarist Russia* (Stanford, 1969), pp. 160, 167. On the Academy see N. Moleva, E. Beliutin, *Russkaia khudozhestvennaia shkola vtoroi poloviny XIX–nachala XX veka* (Moscow, 1967), p. 162.

3. The exodus of Repin's students from the Academy is discussed in O. I. Pobedova, *D. N. Kardovsky*, and in the collection *D. N. Kardovsky ob iskusstve: Vospominaniia, stat'i i pis'ma* (Moscow, 1960), pp. 63–82.

4. A. A. Rylov, *Vospominaniia* (Leningrad, 1960), p. 85.

5. K. S. Petrov-Vodkin, *Khlynovsk: Prostranstvo evklida; Samarkandiia* (Leningrad, 1969), pp. 393, 395.

6. L. Schneider, "Die russische Studentenkolonie und das Echo des revolutionären Russlands in München vor 1914," in K. Bösl, ed., *Bayern im Umbruch* (Munich, 1969), p. 78.

7. The statistics are from B. Brachmann, *Russische Sozialdemokraten in Berlin 1895–1914* (Berlin, 1962), pp. 101–2, 196–97, and the Okhrana Archive, Hoover Library, Palo Alto, California, Box 191, XVIb(3), folder 5e. On the Ažbe and Holloçy schools see N. Moleva, and E. Beliutin, *Shkola Anton Ashbe* (Moscow, 1958), and A. Tikhimirov, "Shimon Kholloshi i ego russkie ucheniki," *Iskusstvo*, 1957, No. 8, pp. 49–52.

8. Moleva and Beliutin, *Shkola*; see note 7.

9. On Russian graphics at the turn of the century see A. A. Sidorov, *Russkaia grafika nachala XX veka* (Moscow, 1969). Sidorov was a student of the art historian Heinrich Wölflin in Munich in 1912, and has written widely on graphics. See also his *Russkaia grafika za gody russkoi revoliutsii (1917–1922)* (Moscow, 1923), and *Istoriia oformleniia russkoi knigi* (Moscow, 1964). Sidorov concludes that "Russian artistic culture in the nineteenth century did not know graphics in its precise or specific sense" (*Russkaia grafika nachala*, p. 39). The graphic artist A. P. Ostroumova-Lebedeva also admits that "graphics as an art form did not exist in Russia at that time" (*Avtobiograficheskie zapiski* [Leningrad, 1935], p. 209).

10. On Russian satirical graphics in 1905, the best work is still P. Dul'sky,

Grafika satiricheskikh zhurnalov 1905–1906 g.g. (Kazan, 1922), who concludes (p. 85) that "Russian graphics in the period 1905–1906 joined with politics for the first time, choosing satire for this goal." Other works on the subject include V. Botsianovsky and E. Gollerbakh, *Russkaia satira pervoi revoliutsii 1905–1906* (Leningrad, 1925); E. P. Gomberg-Verzhbinskaia, *Russkoe iskusstvo revoliutsii 1905 goda* (Leningrad, 1960); A. A. Sidorov, "Otrazhenie v iskusstve pervoi russkoi revoliutsii," *Russkaia khudozhestvennaia kultura*, II, pp. 239–56.

Those Russian satirical journals which did exist in the nineteenth century were modeled after such European journals as *Punch, Fliegende Blätter,* and *La Caricature*; see N. Yu. Zograf, "Satiricheskaia grafika 1860-kh godov. P. M. Shel'kov," in *Istoriia russkogo iskusstva* (Moscow, 1968), IX, i, pp. 43–75.

Finally, a contemporary artist, N. K. Kuzmin, noted in 1913 that " 'Grafika' was still a new word associated with the names of Alexander Benois, K. Somov, E. Lanseray, M. Dobuzhinsky, I. Bilibin, with the journal *Mir iskusstva* where they all published, and also with the militant satirical journals of 1905–1906—*Zhupel* and *Adskaia pochta*—in which many of them participated"; S. V. Golynets, ed., *I. Ya. Bilibin* (Leningrad, 1970), p. 173.

11. The major source concerning Dobuzhinsky's life is his autobiography, published in the émigré journal *Novyi zhurnal* as follows: "Derevnia," 26 (1951), pp. 107–28; "Novgorod," 15 (1947), pp. 249–60; "Iz vospominanii," 52 (1958), pp. 109–39; "Sluzhba v ministerstve," 71 (1963), pp. 156–69; "Krug 'Mir iskusstva,' " 3 (1942), pp. 312–36; "O khudozhestvennom teatre," 5 (1943), pp. 23–62; "Vstrechi s pisateliami i poetami," 11 (1945), pp. 282–96. (I have arranged these chronologically in terms of Dobuzhinsky's life.)

See also S. K. Makovsky, F. F. Notgaft, *Grafika M. V. Dobuzhinskogo* (Berlin, 1924), and V. N. Petrov, "Mir iskusstva."

12. Dobuzhinsky, "Derevnia," p. 107.

13. On Munich life at the turn of the century see L. Hollweck, *München* (Munich, 1968); W. Rukwid, ed., *Geliebtes Schwabing* (Munich, 1961); G. Fuchs, *Sturm und Drang in München um die Jahrhundertwende* (Munich, 1936).

14. Dobuzhinsky, "Iz vospominanii," pp. 112, 114, 130.

15. On *Simplicissimus* see Rolf von Hoerschelmann, *Leben ohne Alltag* (Berlin, 1947), pp. 112 ff.; D. Gulbransson-Björnson, *Olaf Gulbransson: Sein Leben* (Pfullingen, 1967). Gulbransson noted (p. 57) that "the people of *Simpl* were all young—all under thirty—and all unmarried."

On *Simpl's* influence in Russia, opinion is divided. Dul'sky argues that "almost all of the most interesting Russian satirical journals in 1905–1906 were printed and edited under the influence of the Munich organ" (Dul'sky, *Grafika*, p. 9). Botsianovsky and Gollerbakh (*Russkaia satira*, p. 149) concluded only that *Zhupel* followed *Simpl* "to a significant degree" but was "clearly independent." But Sidorov in his recent work (*Russkaia grafika nachala*, p. 108) admits that the whole Munich experience played a "special role" in the development of Russian graphics at this time. In general, Soviet historians are loathe to admit the importance of foreign influence in this, as in other matters.

16. Dobuzhinsky, "Iz vospominanii," p. 121.

17. Ibid., p. 130.

18. Dobuzhinsky, "Sluzhba v ministerstve," pp. 160–61.

19. L. K. Erman, *Intelligentsiia v pervoi russkoi revoliutsii* (Moscow, 1966), pp. 51–57, 60–62.

20. *Zritel*, Vol. I, Nos. 2, 4, 5, 12, 18, 19, 21, 23; Vol. II, No. 1; *Maski*, I, 3 (February 16, 1906); *Signal*, January 8, 1906, p. 4. On file at the Houghton Library, Harvard University, Cambridge, Mass.

21. *Simplicissimus*, Vol. 10, No. 12 (June 1905), p. 141; Vol. 10, No. 13 (June 27, 1905), p. 154; Vol. 10, No. 19 (August 8, 1905), p. 225.

22. The best account of the organization of satirical journals in 1905 is M. Z. Karasik, "M. Gor'kii i satiricheskie zhurnaly 'Zhupel' i 'Adskaia pochta,' " in Akademiia Nauk, *M. Gor'kii v epokhu revoliutsii 1905–1907 godov: Materialy, vospominaniia, issledovaniia* (Moscow, 1957), pp. 357–87. See also the previously cited works by Dul'sky, Sidorov, Botsianovsky, and Gollerbakh.

23. Dul'sky, *Grafika*, p. 38.

24. L. Evstigneeva, *Zhurnal "Satirikon" i poetry-satirikontsy* (Moscow, 1968), p. 25; Sidorov, *Russkaia grafika nachala*, pp. 167–72.

25. J. Bowlt, "The Early Graphic Works of Mstislav Dobuzhinsky," *Transactions of the Russian-American Group of Scholars in the USA*, No. 9 (1975), pp. 264, 279; Lunacharsky's comment appeared in *Vestnik zhizni*, 1907, No. 1, p. 109.

26. The most complete collection of material on early Soviet posters is B. S. Butnik-Siversky, *Sovetskii plakat epokhi grazhdanskoi voiny 1918–1921* (Moscow, 1960). See also N. M. Chelodaeva, "Plakat," in I. Grabar, ed., *Istoriia russkogo iskusstva*, XI (Moscow, 1957), pp. 54–78.

27. On Moor's life and work see R. Kaufmann, *D. S. Moor* (Moscow, 1937); I. I. Khalaminsky, *D. Moor* (Moscow, 1961); D. Moor, *"Ya-Bolshevik!" Sbornik statei* (Moscow, 1967); M. Ioffe, *Desiat' ocherkov o khudozhnikakh-satirikakh* (Moscow, 1971), pp. 28–55.

28. Khalaminsky in Moor, *"Ya-Bolshevik!"*, p. 117. On Gulbransson see D. Gulbransson-Björnson, *Gulbransson*, passim.

29. Moor, *Bolshevik*, p. 124.

30. Ibid., p. 127.

31. On the agit-trains see I. Bibikova, "Rospis' agitpoezdov i agitparokhodov," in E. A. Speranskaia, ed., *Agitatsionno-massovoe iskusstvo pervykh let Oktiabria* (Moscow, 1971); see also V. N. Dokuchaeva, *Ivan Ivanovich Nivinsky* (Moscow, 1969).

32. On the ROSTA windows see Ioffe, *Desiat' ocherkov*, pp. 56–83; O. Sabostiuk, B. Uspensky, *M. M. Cheremnykh* (Moscow, 1970); N. A. Cheremnykh, *Khochetsia, chtoby znali i drugie . . . : Vospominaniia o M. M. Cheremnykhe* (Moscow, 1965); W. Duwakin, *Rostafenster* (Dresden, 1967).

33. Moor, *Bolshevik*, p. 142.

34. Ibid., p. 146.

35. Butnik-Siversky, *Sovetskii plakat*, p. 23.

36. V. Polonsky, "Die russische revolutionäre Plakat," *Russische Korrespondenz*, 2 (July–December 1922), p. 841; on the wartime posters see

M. Rickards, ed., *Posters of the First World War* (London, 1968), and B. Hillier, *Posters* (New York, 1968).

37. Hillier, *Posters*, p. 11.

38. Moor, *Bolshevik*, p. 152.

Chapter 4
From Naturalism to Symbolism: Meyerhold's Theater of the Future

1. The best single source on Meyerhold's early life is still N. D. Volkhov, *Meierkhol'd*, 2 vols. (Moscow and Leningrad, 1929). Like Volkhov, Ya. Brukson, in his *Teatr Meierkhol'da* (Moscow and Leningrad, 1925), emphasized the influence of new developments in European theater (Fuchs, Craig, and Appia) on Meyerhold before World War I. Other studies of Meyerhold include: *Teatral'nyi Oktiabr: Sbornik* (Moscow and Leningrad, 1926); A. A. Gvozdev, *Teatr imeni Meierkhol'da (1920–1926)* (Leningrad, 1927); B. V. Alpers, *Teatr sotsial'noi maski* (Moscow, 1931); Yu. Elagin, *Temnyi genii (Vsevolod Meierkhol'd)* (New York, 1955).

On February 2, 1940, Meyerhold was executed by the NKVD, or "illegally repressed," as Soviet historians now put it (*Teatral'naia entsiklopediia* [Moscow, 1964], III, p. 773). Since the publication of his correspondence with Chekhov in *Literaturnoe nasledstvo* in 1960 (Vol. 68), he has been rehabilitated, and a wealth of new material has appeared on Meyerhold. See A. A. Gladkov, "Meierkhol'd govorit," *Novyi mir*, 1961, No. 8, pp. 213–35; A. Fevral'sky, "Stanislavsky i Meierkhol'd," *Tarusskie stranitsy* (Kaluga, 1961); *Vstrechi s Meierkhol'dom: Sbornik vospominanii* (Moscow, 1967); A. Fevral'sky, *Vsevolod Emelianovich Meierkhol'd: Stat'i, pis'ma, rechi, besedy*, 2 vols. (Moscow, 1968), hereafter Fevral'sky, *VEM*.

Since the publication of these new materials, a number of important Soviet monographs on Meyerhold have also appeared, notably: B. I. Rostotsky, "Modernizm v teatre," in *Russkaia khudozhestvennaia kultura*, I, pp. 177–217; K. Rudnitsky, *Rezhisser Meierkhol'd* (Moscow, 1969); G. Khaichenko, "Tri stupeni k Meierkhol'du," *Teatr*, 1969, No. 4, pp. 81–86; P. Gromov, "Stanislavsky, Chekhov, Meierkhol'd," *Teatr*, 1970, No. 1, pp. 83–89.

In the West Meyerhold's writings have been translated and edited by E. Braun, *Meyerhold on Theater* (New York, 1969). See also J. M. Symons, *Meyerhold's Theater of the Grotesque* (Coral Gables, Fla., 1971), which focuses on the 1920s.

2. Symons, *Grotesque*, pp. 25, 28; Rostotsky agrees that "in Blok's *Balaganchik* Meyerhold for the first time expressed in a precise manner a conception of the tragic grotesque"; see his "V. E. Meierkhol'd i ego literaturnoe nasledie," in Fevral'sky, *VEM*, p. 13.

3. B. Hewitt, *History of the Theatre from 1800 to the Present* (New York, 1970).

4. A. Dukes, *The Scene is Changed* (London, 1942), p. 24. For an even more critical Russian view of Munich theater life see Z. Ashkinazi, "Miunkhenskaia teatral'naia zhizn'," in *Ezhegodnik imperatorskikh teatrov*, 1914, No. 3, pp. 98–117. For a more favorable view see N. V. Drizen, "Po Miunkhenskim teatram," *Apollon*, 1910, No. 11, "Khronika," pp. 4–17. The poet Andrei Belyi describes Munich life in 1906 in his *Mezhdu dvukh revoliutsii* (Leningrad, 1934), pp. 101–39.

5. On Fuchs see his *Sturm und Drang, passim*; also H. Kindermann, *Theatergeschichte Europas* (Salzburg, 1968), VIII, pp. 180, 231–33.

6. G. Fuchs, *Die Schaubühne der Zukunft* (Berlin and Leipzig, n.d.) (1906), pp. 34–36.

7. Ibid., p. 98.

8. G. Fuchs, *Die Revolution des Theaters* (Munich and Leipzig, 1909), translated by C. C. Kuhn as *Revolution in the Theater* (Ithaca, N.Y., 1959), p. 139.

9. Volkhov, *Meierkhol'd*, I, p. 21.

10. Ibid., p. 34.

11. V. Nemirovitch-Dantchenko, *My Life in the Russian Theatre* (Boston, 1936), p. 133.

12. Ibid., p. 122.

13. A. Chekhov, *Best Plays by Chekhov*, trans. Stark Young (New York, 1956), p. 81.

14. C. Stanislavski, *My Life in Art* (London, 1967), p. 332.

15. Fevral'sky, *VEM*, I, pp. 74, 77, 443; also "Chekhov i Meierkhol'd," in *Literaturnoe nasledstvo*, Vol. 68 (Moscow, 1960), p. 442, letter of Meyerhold to Chekhov dated Moscow, April 18, 1901.

16. "Chekhov i Meierkhol'd," p. 429. On the Society for New Drama in Kherson see also Volkhov, I, pp. 152 ff.; E. Krasniansky, *Vstrechi v puti* (Moscow, 1967), pp. 37 ff.; K. Rudnitsky, *Rezhisser Meierkhol'd*, pp. 28–42.

17. Rudnitsky, *Rezhisser*, p. 29. The actors quoted were F. K. Lazarev and I. N. Pevtsov.

18. Stanislavski, *My Life*, p. 400.

19. Ibid., p. 401.

20. On the Moscow Art Theater Studio of 1905 see especially N. P. Ulianov, *Moi vstrechi* (Moscow, 1959), pp. 131–37; M. N. Pozharskaia, *Russkoe teatral'no-dekoratsionnoe iskusstvo kontsa XIX–nachala XX veka* (Moscow, 1970), pp. 153–66; Rudnitsky, *Rezhisser*, pp. 43–69.

21. Stanislavski, *My Life*, p. 404.

22. *Vesy*, II, 1 (January 1905), pp. 42–43; III, 1 (January 1906), pp. 72–75. Remizov had introduced St. Petersburg readers to the Society for New Drama as early as the spring of 1904; see *Vesy*, I, 4 (April 1904), pp. 36–39. On Komissarzhevskaya see especially Rybakova, Yu., *Komissarzhevskaia* (Leningrad, 1971).

23. A. Blok, *Sobranie sochinenii*, VIII (Moscow, 1963), pp. 146–52.

24. Fevral'sky, *VEM*, I, pp. 93–94.

25. Volkhov, I, p. 240.

26. F. Reeve, *Alexander Blok: Between Image and Idea* (New York and London, 1962), p. 24.

27. G. Donchin, *The Influence of French Symbolism on Russian Poetry* (The Hague, 1958), pp. 91–92.

28. Reeve, *Blok*, p. 29.

29. C. Tschöpl, *Vjaceslav Ivanov* (Munich, 1968), pp. 25–48.

30. Volkhov argues that Fuchs's book made conscious and theoretical what Meyerhold had been working toward on his own; see Volkhov, I, pp. 240–44. Yurii Elagin (*Temnyi genii*, p. 110) claims that the book was a "real discovery" for Meyerhold, providing him with an "organizing principle"

which "crystallized his own style in the art of the theater." Eduard Braun (*Meyerhold*, p. 21) concludes that "the extent of Meyerhold's quotations from Fuchs is proof of the influence which this work exerted on him. As well as corroborating his own rejection of naturalism and his efforts to reveal the hidden 'sub-text' of a play, it opened his eyes to the significance of the proscenium stage, the lessons to be learned from the Oriental theater in the use of rhythmical movement, and the inherent contradiction between the two-dimensional scenic backcloth and the three-dimensional figure of the actor."

Soviet historians tend to deemphasize the influence of Fuchs on Meyerhold. For example, Rudnitsky (*Rezhisser*, p. 77) does not analyze this influence but merely notes that the book "produced a strong impression on Meyerhold."

31. On the conception and production of *Balaganchik* see T. Rodina, *Aleksandr Blok i russkii teatr nachala XX veka* (Moscow, 1972), pp. 127 ff. The author concludes that the play was "the kernel of Meyerhold's future directing" (p. 275). Also see N. Gorchakov, *The Theater in Soviet Russia* (New York, 1957), pp. 60 ff.

32. A. Blok, *Zapisnye knizhki 1901–1920* (Moscow, 1965), pp. 78–84.

33. A number of actors in Meyerhold's Society for New Drama followed him from the provinces to the capitals. Ten of them formed the nucleus of the Moscow Studio Theater of the MAT in 1905; nine actors and actresses from the Kherson seasons were still with Meyerhold during his second year with Komissarzhevskaia in St. Petersburg in 1907–1908. On this movement of theater people from province to city see Volkhov, *Meierkhol'd*, Vol. I, pp. 153, 169, 183–184, 199–200, 208, 255, 323–324; also his memoirs *Vstrechi s Meierkhol'dom*, pp. 32, 44.

34. Fevral'sky, *VEM*, p. 176; cited from Meyerhold's pamphlet *O teatre* (St. Petersburg, 1913), reproduced here on pp. 101–229. Meyerhold refers to both *Die Schaubühne der Zukunft* and to the more recent *Revolution des Theaters* (Munich and Leipzig, 1909). Fuchs's ideas were available to Russian readers in translation as well; see "Miunkhenskii khudozhestvennyi teatr," *Apollon*, 1909, 2, pp. 47–53, and 1910, 11, pp. 43–51, translated from *Revolution des Theaters*; also *Ezhegodnik imperatorskikh teatrov*, 1913, 4, pp. 81–93, and A. Dolinov, "Teatr khudozhnikov v Miunkhene," *Teatr i iskusstvo*, 1910, 2, pp. 32–34.

35. N. Volkhov, *Teatral'nye vechera* (Moscow, 1966), p. 61.

36. Fevral'sky, *VEM*, p. 310. Taken from an autobiography written by Meyerhold in 1921 in connection with an early party purge. Meyerhold joined the Bolsheviks in 1918 and received party membership number 225,182.

37. N. Berdyaev, *Dream and Reality* (New York, 1962), p. 142.

38. Rudnitsky, *Rezhisser*, p. 69; from Meyerhold's diary for December 1905.

Chapter 5
Theosophy and the Fourth Dimension: Malevich's Suprematism

1. S. Lissitzky-Küppers, *El Lissitzky* (London, 1968), p. 327.

2. Ibid., p. 330.

3. E. Fry, *Cubism* (London, 1966), p. 137.

4. C. G. Jung, *The Collected Works.* IV. *Freud and Psychoanalysis* (1932) (Princeton, 1961), p. 326; *Two Essays on Analytical Psychology* (Princeton, 1953), p. 77; *Civilization in Transition,* (Princeton, 1964), p. 90.

5. The literature on theosophy is enormous. An excellent guide is R. Galbreath, "The History of Modern Occultism," *Journal of Popular Culture,* V, 3 (Winter 1971), pp. 98–126. The essential theosophical work on art is A. Besant, and C. Leadbeater, *Thought Forms* (London, 1901).

6. On Steiner see A. P. Shepherd, *Scientist of the Invisible* (London, 1954), and G. Wachsmuth, *The Life and Work of Rudolf Steiner* (New York, 1955). Steiner's writings are voluminous. A good summary of "anthroposophy" may be found in K. Galling, ed., *Die Religion in Geschichte und Gegenwart* (Tübingen, 1957), Vol. I, pp. 426–32. See also R. Galbreath, "Traditional and Modern Elements in the Occultism of Rudolf Steiner," *Journal of Popular Culture,* III, 3 (Winter 1969), pp. 451–67.

7. Steiner, R., *Macrocosm and Microcosm* (London, 1968), pp. 11, 36, 57, 163. A translation of eleven lectures given by Steiner in Vienna between March 21 and 31, 1910.

8. R. Steiner, *Life between Death and Rebirth,* trans. R. M. Querido (N.Y., 1968), pp. 14, 18, 28, 39, 48–49, 64, 82, 296.

9. Helena Pisareff, "Brief Sketch of the Theosophical Movement in Russia (1903–1918)," unpublished manuscript (Udine, 1933), in the Archives of the Theosophical Society International Headquarters, Adyar, Madras, India.

10. F. Bowers, *Scriabin* (Tokyo and Palo Alto, 1969), II, pp. 52, 63, 266.

11. A. Turgeneva, "Andrei Belyi i Rudol'f Shteiner," *Mosty,* 1968, p. 245.

12. M. Woloschin, *Die grüne Schlange* (Stuttgart, 1954), pp. 143–48, 158, 212.

13. On the theosophical origins of Kandinsky's abstract painting see S. Ringbohm, *The Sounding Cosmos* (Abo, Finland, 1970), and R. C. Williams, "Concerning the German Spiritual in Russian Art: Wassily Kandinsky," *Journal of European Studies,* I (1971), pp. 325–36. Also Rose-Carol Washton-Long, "Kandinsky and Abstraction: The Role of the Hidden Image," *Artforum,* X, 10 (June 1972), pp. 42–49.

14. V. Kandinsky, *Concerning the Spiritual in Art* (New York, 1947), pp. 24–26, 29–31, 33–35, 39–40, 50.

15. V. Kandinsky, "O dukhovnom v iskusstve (zhivopis')," *Trudy vserossiiskago s"ezda khudozhnikov v Petrograde dekabr' 1911–ianvar' 1912* (St. Petersburg, 1912), I, pp. 47–76.

16. E. Abbott, *Flatland* (London, n.d.), p. 3.

17. Ibid., dedication.

18. Letters from Hinton to William James are in the Houghton Library, Harvard University; the citations come from Hinton's letters of Oct. 8, 1892, Oct. 18, 1895, and July 10, 1897.

19. C. H. Hinton, *A New Era of Thought* (1888) (London, 1900), p. 86; *The Fourth Dimension* (New York, 1904), p. 2. See also the collection of Hinton's stories and essays entitled *Scientific Romances* (London, 1884). Hinton edited *Chapters on the Art of Thinking* (London, 1879) and wrote *Stella, and an Unfinished Communication* (London, 1895) and *An Episode of Flatland* (London, 1907).

20. Fry, *Cubism*, p. 119.

21. C. Bragdon, *Projective Ornament* (1915) (New York, 1927), p. 6; also his *Architecture and Democracy* (Freeport, N.Y., 1918) and *The Frozen Fountain* (Freeport, 1924). Bragdon also wrote a fascinating autobiography entitled *More Lives than One* (New York, 1938).

22. His Chicago lectures of 1909 were later published as C. Jinarajadasa, *First Principles of Theosophy* (Adyar, 1956). See also his *Theosophy and Modern Thought* (Adyar, 1915), where he noted that the painter "seizes on a supreme moment" when he creates, and the viewer "sees not only with his eyes but senses with his intuition" (p. 111).

23. C. Bragdon, *A Primer of Higher Space: The Fourth Dimension, to which is added Man the Square, A Higher Space Parable* (1913) (New York, 1923), pp. 30, 68.

24. C. Bragdon, *Four Dimensional Vistas* (New York, 1916), p. 95.

25. Art historians have only recently begun to recognize the importance of Hinton and Uspensky, but not Bragdon, for Malevich's art and work. Charlotte Douglas in her article "Birth of a 'Royal Infant': Malevich and 'Victory over the Sun,'" *Art in America*, Vol. 62, No. 2 (March–April 1974), pp. 45–51, mentions Hinton only in a footnote. S. Compton, in "Malevich and the Fourth Dimension," *Studio*, Vol. 187, No. 965 (April 1974), pp. 190–95, cites Uspensky's *Tertium Organum* as an influence, but notes that "by itself it seems unlikely to have led to the use by Malevich of simple, geometric forms" (p. 191). Compton does not identify Bragdon or theosophy as a source of influence on either Uspensky or Malevich. For a more general consideration of Hinton's influence on "cubism" see L. D. Henderson, "A New Facet of Cubism: 'The Fourth Dimension' and 'Non-Euclidean Geometry' Reinterpreted," *The Art Quarterly*, Vol. 34, No. 4 (1971), pp. 410–33.

26. T. Andersen, *Malevich* (Amsterdam, 1970), p. 61. Camilla Gray, in her pioneering study *The Russian Experiment in Art, 1863–1922* (London, 1962), concluded that "it is probable that Malevich began working out his Suprematist system in 1913, as he claimed" (p. 160). For a more recent sketch of Malevich, see John E. Bowlt, "The Semaphors of Suprematism: Malevich's Journey into the Non-Objective World," *Art News*, December 1973, pp. 16–22.

There is no biography of Malevich, but Troels Andersen has collected some of his voluminous writings in K. S. Malevich, *Essays on Art 1915–1933*, 2 vols. (New York, 1971). See also Malevich's later theoretical work, *The Non-Objective World* (Chicago, 1959), originally published in 1927 by the Bauhaus.

Articles on Malevich include: E. Kallai, "Kasimir Malewitsch," *Das Kunstblatt*, II, 10 (1927), pp. 264–66; P. Habesque, "Documents inédits sur les début du suprématisme," *Aujourdhui*, I, 4 (September 1955), pp. 14–16; M. Welish, "The Spiritual Modernism of Malevich," *Arts Magazine*, November 1971, pp. 45–48; D. Judd, "Malevich: Independent Form, Color, Surface," *Art in America*, Vol. 62, No. 2 (March–April 1974), pp. 52–58; D. Kuspit, "Malevich's Quest for Unconditioned Creativity, Part I," *Artforum*, Vol. XII, No. 10 (June 1974), pp. 53–58.

27. B. Lifshits, *Polutoraglazyi strelets* (Leningrad, 1933), p. 70; T. Andersen, *Moderne Russisk Kunst 1910–1925* (Copenhagen, 1967), p. 63.

28. V. A. Nikolsky, *P. P. Konchalovsky* (Moscow, 1936), p. 38; on Konchalovsky see also M. L. Neiman, *P. P. Konchalovsky* (Moscow, 1967). Konchalovsky himself later recalled that visiting Frenchmen "noted the national 'Slavic' character of my painting, which in Moscow then had a reputation of being purely French. I could certainly be 'French' only from a Muscovite point of view" (Nikolsky, p. 59).

29. L. F. Diakonitsyn, *Ideinye protivorechie v estetike russkoi zhivopisi kontsa 19–nachala 20 v.v.* (Perm, 1966), p. 204. On Russian painting of the time see also V. Marcade, *Le Renouveau de l'art pictural russe* (Lausanne, 1971).

30. Malevich, *Essays*, I, p. 148; O. Matiushina, "Prizvanie," *Zvezda* (March 1973), p. 148.

31. A. Gerasimov, *Zhizn' khudozhnika* (Moscow, 1963), p. 68. On the Moscow School see N. Dmitrieva, *Moskovskoe uchilishche zhivopisi, vaianiia, i zodchestva* (Moscow, 1951).

32. On the Blue Rose movement see J. Bowlt, "Russian Symbolism and the 'Blue Rose' Movement," *Slavonic and East European Review*, LI, 123 (April 1973), pp. 161–81. Also Diakonitsyn, *Protivorechie*, pp. 132–33; Marcade, *Renouveau*, pp. 113, 281–82, Grabar, *Istoriia*, pp. 88 ff. Monographs on individual members of the Blue Rose include: A. Rusakova, *V. E. Borisov-Musatov*, (Moscow, 1966); A. G. Romm, *P. V. Kuznetsov* (Moscow, 1960); M. V. Alpatov and E. A. Gunst, *N. N. Sapunov* (Moscow, 1965); M. Saryan, *Iz moei zhizni* (Moscow, 1970).

33. On the emerging "southern" avant-garde see W. George, *Larionov* (Paris, 1966); M. Chamot, *Goncharova* (Paris, 1972); K. Dreier, *Burliuk* (New York, 1944); *Survage: Exposition Retrospective* (Paris, 1966). The Garland and Link painters were slightly younger (mean age, 26) than the Blue Rose (eight of whom also exhibited), and they came mainly from the towns of southern Russia. (See Table VII.)

34. The Munich Russians of the *Neue Künstler-Vereinigung* (New Artists' League) were generally of the older generation of aesthetes; in 1909 Kandinsky was 43, M. V. Verefkina was 49, and Aleksei Yavlensky was 45.

35. Marcade, *Renouveau,* p. 325. On Léger see R. L. Delovoy, *Léger* (Paris, 1962).

36. The Union of Youth was organized in 1910 in St. Petersburg by Nikolai Kulbin, an army doctor, and the violinist Mikhail Matiushin. It sponsored painting exhibits in 1910 (Riga and St. Petersburg), 1911 (St. Petersburg), 1912 (Moscow), and 1913–1914 (St. Petersburg). See Marcade, *Renouveau*, pp. 242–53.

37. V. Kandinsky, F. Marc, eds., *Der Blaue Reiter* (1912) (Munich, 1965), pp. 279, 282.

38. H. Berninger and J.-A. Cartier, *Pougny* (Tubingen, 1972), pp. 12–13.

39. Ibid., p. 42.

40. Bowers, *Scriabin*, II, p. 254; P. Uspensky, *In Search of the Miraculous* (New York, 1949), pp. 3, 6. During World War I Uspensky became a follower of another mystic philosopher, George Gurdjeff, in Moscow. In 1919 he became the Russian correspondent of A. R. Orage's journal *The New Age*; Orage was a former theosophist and leading literary critic and editor whom Uspensky met in London in 1913–1914. In exile in England after 1917

Uspensky and Gurdjeff were enormously popular among some British intellectuals, among them the writer Katherine Mansfield. See W. Martin, *The New Age under Orage* (New York, 1967), p. 268; P. Mairet, *A. R. Orage: A Memoir* (New York, 1966), p. 80. Paul Selver of the *New Age* circle described Uspensky as "monumentally boorish" in his *Orage and the New Age Circle* (London, 1959), p. 72.

Another *New Age* member, Carl Bechofer-Roberts, knew Uspensky from theosophical circles in England, India, and Russia and described him more sympathetically as "an authority on such subjects as the fourth dimension"; C. E. Bechofer, *In Denikin's Russia and the Caucasus 1919–1920* (London, 1921), p. 81. Bechofer had apparently accompanied Uspensky to Petrograd in 1914; see C. E. Bechofer, "The Forest Philosophers," in *The Century*, 108, 1 (May 1924), p. 67.

Rom Landau dates Uspensky's interest in theosophy back as far as 1907 and says that Uspensky spent six weeks at Adyar in 1913, where he met Annie Besant; R. Landau, *God is my Adventure* (New York, 1936), p. 214. According to another Englishman with Russian interests, Stephen Graham, there was also an active concern with India among Moscow theosophists in 1914–1915 (*Part of the Wonderful Scene* [London, 1964], pp. 88–89).

Such evidence suggests that while Uspensky's early life is as vague and mysterious as that of Malevich, he derived the bulk of his mysticism from English theosophy prior to World War I.

41. P. Ouspensky, *Tertium Organum* (1911) (New York, 1970), p. xv. Uspensky was born the same year as Malevich, 1878, and grew up in Moscow. In 1915 he translated Hinton's *The Fourth Dimension* from English to Russian as *Vospitanie voobrazheniia i chetvertoe izmerenie* (Petrograd, 1915).

42. P. Uspensky, *A New Model of the Universe* (1931) (New York, 1969), pp. 10, 72, 86, 375, 376.

43. Ouspensky, *Tertium Organum*, p. 31.

44. Ibid., p. 103.

45. R. Bucke, *Cosmic Consciousness: A Study in the Evolution of the Human Mind* (New York, 1901), pp. 3–4, 10–11.

46. Berninger and Cartier, *Pougny*, pp. 51–52, 57.

47. K. Malevich, *Ot kubizma i futurizma do suprematizmu: Novyi zhivopisnyi realizm*, 3d ed. (Moscow, 1916), p. 28.

48. Berninger and Cartier, *Pougny*, p. 74. Cited in a review of the exhibit in the newspaper *Den'*, January 14, 1916.

49. F. Bowers, *The New Scriabin: Enigma and Answers* (New York, 1973), pp. 92, 96–97, 122, 125. Scriabin was also in London in the spring of 1914 with his young theosophical follower, Alexander Brianchaninov. Scriabin himself performed yoga exercises, and may have derived his idea of a great Mysterium in India from the London theosophists.

50. The reference to Uspensky came in a letter to Alexander Benois; the quotation is from Malevich's article "Secret Vices of the Academicians" (1916); see Malevich, *Essays*, I, p. 17.

51. Ibid., pp. 68, 118. The art program was announced in Vitebsk on November 15, 1919, after Malevich had replaced Chagall as director of the local art school.

52. Malevich manuscript dated January 25, 1924, in the Van Riesen Archive, Stedelijk Museum, Amsterdam, entitled "Iz knigi o Bezpredmetnosti." Adolf Van Riesen was a Russian-German friend of Malevich who inherited many of his papers when the artist came to Germany in 1927. He donated them to the Stedelijk Museum in 1970.

53. Undated manuscript by Malevich entitled "Suprematist mir," Van Riesen Archive.

54. Volkhonsky's remark was recorded in *Trudy vserossiiskago s"ezda khudozhnikov v Petrograde, dekabr 1911–ianvar 1912* (St. Petersburg, 1912), Vol. I, p. 75. Matiushin cited Hinton and Uspensky in his essays in *Obshchestvo khudozhnikov 'Soiuz molodezhi'*, Nos. 1–3 (St. Petersburg, April 1912, July 1912, and March 1913); see especially No. 3, pp. 16, 25–34. On Matiushin's interest in Uspensky and *Tertium Organum*, see John E. Bowlt, "The 'Union of Youth,'" in G. Gibian and H. W. Tjalsma, eds., *Russian Modernism: Culture and the Avant-garde 1900–1930* (Cornell, 1976), p. 176.

Chapter 6
Immortalizing the Revolution: The Poetry of Mayakovsky

1. I. Franko, *Sochineniia*, VII (Moscow, 1958), pp. 7–8. "Vechnyi revoliutsioner—/Dukh, stremliashchii telo k boiu/Za progress, dobro, za voliu,—/On bessmertiia primer."

2. Translated from Alexander Blok's "Dances of Death" (1912–1914) by Franklin Reeve in *Alexander Blok: Between Image and Idea* (New York and London, 1962), p. 131.

3. From N. F. Fedorov, *Vopros o bratstve* (St. Petersburg, 1906), as cited in J. Edie, J. Scanlan, and M. Zeldin, eds., *Russian Philosophy* (Chicago, 1965), Vol. III, p. 26. Translated by A. E. Moorhouse and G. Kline.

4. Ibid., p. 45.

5. K. Chukovsky, *Sobranie sochinenii*, II (Moscow, 1965), pp. 349–50. On the influence of Whitman on Mayakovsky see also K. Chukovsky, *Moi Uitmen* (Moscow, 1966), pp. 252–66; S. Stepanchev, "Whitman in Russia," in G. W. Allen, ed., *Walt Whitman Abroad* (Syracuse, 1955), pp. 144–55; D. Petersen, "Mayakovsky and Whitman: The Icon and the Mosaic," in *Slavic Review*, 28, 3 (September 1969), pp. 416–25. Chukovsky continually emphasized that Whitman was the "first futurist poet" and "transformed democracy into a universal cosmic force"; see M. Petrovsky, *Kniga o Kornee Chukovskom* (Moscow, 1966), pp. 92–93, 97. Petersen emphasizes the differences between the two poets, and E. J. Brown, *Mayakovsky: A Poet in the Revolution* (Princeton, 1973), provides the most balanced assessment (hereafter Brown, *Poet*). On Whitman himself see *inter alia* R. Asselineau, *The Evolution of Walt Whitman* (Cambridge, Mass., 1962), and J. E. Millar, *Walt Whitman* (New Haven, 1962).

6. A. A. Mayakovskaia, "Detstvo i iunost' Vladimir Mayakovskogo," *Mayakovsky v vospominaniakh rodnykh i druzei* (Moscow, 1968), p. 10.

The literature on Mayakovsky is extensive. E. J. Brown's biography emphasizes literary criticism, but is also excellent in describing the events of the poet's life. W. Woroszylski, *The Life of Mayakovsky* (New York, 1970), is a useful collection of the most important source materials about Mayakovsky,

with judgment suspended. The important primary sources are V. V. Maya-
kovsky, *Polnoe sobranie sochinenii* (Moscow, 1955–1961), and the collection
"Novoe o Mayakovskom," *Literaturnoe nasledstvo*, LXV (Moscow, 1958),
hereafter "Novoe." Memoirs about him are in V. Shklovsky, *Zhizn' s Maya-
kovskym* (Moscow, 1940), translated by L. Feiler as *Mayakovsky and his
Circle* (New York, 1972), and on his early years, *V. V. Mayakovsky: Ma-
terialy i issledovaniia* (Moscow, 1940), hereafter *Materialy*.

7. Woroszylski, *Mayakovsky*, p. 24.

8. B. Lifshits, *Polutoraglazyi strelets* (Leningrad, 1933), p. 57.

9. Woroszylski, p. 37.

10. N. Khardzhiev, "Mayakovsky i zhivopis'," in *Materialy*, p. 343 ff.

11. Woroszylski, p. 79.

12. Shklovsky, *Circle*, p. 28; Brown, *Poet*, pp. 253–56.

13. G. Daniels, trans., *The Complete Plays of Vladimir Mayakovsky* (New
York, 1968), pp. 21–38.

14. N. Khardzhiev, "Turne kubo-futuristov 1913–1914 gg.," *Materialy*,
pp. 401–27.

15. A. A. Mgebrov, *Zhizn' v teatre* (Moscow and Leningrad, 1932), II,
p. 188. On life at the Stray Dog see also Lifshits, *Strelets*, pp. 257–79.

16. Woroszylski, p. 161.

17. Ibid., p. 168.

18. Ibid., p. 176.

19. The best account of Mayakovsky in 1917 is E. A. Dinershtein, "Maya-
kovsky v fevrale–oktiabre 1917," in "Novoe," pp. 541–70. The author indi-
cates (p. 551) that Mayakovsky received 1,625 rubles in payment for six
lubki done for Z. I. Grzhebin's publishing house between March and August
1917.

20. Shklovsky, *Circle*, p. 95.

21. V. V. Mayakovsky, "Ya sam," in *Polnoe sobranie sochinenii*, I, (Mos-
cow, 1955), p. 25.

22. A. Fevral'sky, *Pervaia sovetskaia pesa "misteriia-buff" V. V. Maya-
kovskogo* (Moscow, 1971), pp. 18, 20, 52. Quotations from the play itself are
taken from Daniels, *Plays*, pp. 39–139.

23. Ibid., pp. 63, 66, 96.

24. *Iskusstvo kommuny*, 1 (December 7, 1918), p. 1; 2 (December 15,
1918), p. 1; 3 (December 22, 1918), p. 1; 4 (December 29, 1918), p. 1;
5 (January 5, 1919), p. 1.

25. Ibid., 6 (January 12, 1919), pp. 1–2; 9 (February 2, 1919), p. 1;
17 (March 30, 1919), p. 1.

26. Woroszylski, pp. 272–75.

27. Ibid., pp. 296–97.

28. On Vkhutemas see especially E. Semenova, "Vkhutemas, LEF, Maya-
kovsky," in *Uchenye zapiski tartuskogo gosudarstvennogo universiteta*, IX
(1966), "Trudy po russkoi i slavianskoi filologii," pp. 288–306.

29. On the Berlin colony in 1922 see R. C. Williams, *Culture in Exile*
(Ithaca, N.Y., 1972), pp. 242–81. The Van Diemen Gallery exhibit included
704 works by 157 Russian artists; see *Vystavki sovetskago izobrazitel'nogo
iskusstva. Spravochnik. I. 1917–1932 gg.* (Moscow, 1965), pp. 107–8. On

Pougny in Berlin see E. Steneberg, *Russische Kunst Berlin, 1919–1932* (Berlin, 1969), p. 14.

30. *Veshch*, Nos. 1–2 (March–April 1922), *passim*.

31. H. Kliemann, *Die Novembergruppe* (Berlin, 1969); H. Richter, *Dada: Art and Anti-Art* (London, 1965), pp. 101–35.

32. R. Hausmann, *Am Anfang war Dada* (Giessen, 1972), p. 45; see also J.-F. Bory, *Raoul Hausmann* (Paris, 1972).

33. F. de Graaf, *Sergej Esenin* (The Hague, 1966), p. 117; also Woroszylski, pp. 334–38.

34. Steneberg, *Kunst*, p. 23; S. Lissitzky-Küppers, *El Lissitzky* (London, 1968), p. 25; A. Uschakow, "Majakowski und Grosz," *Sinn und Form*, XX, 6 (1968), pp. 100, 109.

35. "Novoe," pp. 129–30.

36. "Pro eto" first appeared in *LEF*, No. 1 (March 1923), pp. 65–103. For a careful analysis of the poem as literature see Brown, *Poet*, pp. 219–59. A translation is given in H. Marshall, ed., *Mayakovsky* (New York, 1965), pp. 157–230.

37. V. Pertsov, *Mayakovsky*, I, p. 179.

38. *LEF*, No. 1 (March 1923), p. 9.

39. Woroszylski, p. 368.

40. Ibid., pp. 410, 418, 421, 425.

41. S. Bojko, *New Graphic Design in Revolutionary Russia* (New York, 1972), p. 22; from Rodchenko's personal archives.

42. In 1923, for example, Mayakovsky was thirty as was Shklovsky; Aseev was thirty-four, Brik thirty-five, Rodchenko thirty-two, and Pasternak thirty-three.

43. Woroszylski, p. 472.

44. Ibid., p. 501.

45. Ibid., pp. 392, 526, 530.

Chapter 7
Constructivism: Tatlin's Monument and Eisenstein's Montage

1. On the geometric tradition in art see M. Ghyka, *The Geometry of Art and Life* (New York, 1946); E. Moessel, *Die Proportionen in Antike und Mittelalter* (Munich, 1926); J. Hambidge, *The Elements of Dynamic Symmetry* (New York, 1926).

The Golden Section was a division of a line into two segments, a and b, such that $(b/a)^2 = b/a + 1$, an equation solved for $b=1$ and $a=1.618$. Put in another way, "the ratio between the greater and the smaller part is equal to the ratio between the whole and the greater part." (Ghyka, pp. 3–4.)

2. On Semper see H. Winkler, ed., *Gottfried Semper: Wissenschaft, Industrie und Kunst* (Mainz, 1966). On Peter Behrens, see F. Hoeber, *Peter Behrens* (Munich, 1913), and the exhibition catalogue *Peter Behrens (1868–1940)* (Kaiserslautern, 1966–1967).

3. M. Franciscono, *Walter Gropius and the Creation of the Bauhaus in Weimar* (Urbana, Chicago, London, 1971), pp. 90, 93, 95; E. Mendelsohn,

Briefe eines Architektur (Munich, 1961), p. 36; also S. King, *The Drawings of Eric Mendelsohn* (Berkeley, 1969).

4. P. Scheebart, *Glasarchitektur* (Berlin, 1914), edited and translated by D. Sharp (New York and Washington, D.C., 1972), pp. 52, 74. Also K. Junghans, *Bruno Taut 1880–1938* (Berlin, 1970).

5. The earliest account of Tatlin and his work is by his friend Nikolai Punin, *Tatlin* (Petrograd, 1921); this pamphlet, appropriately laudatory, credits Tatlin with anticipating cubism, while telling us almost nothing about him. The best account of Tatlin's life and art is Troels Andersen, *Vladimir Tatlin* (Stockholm, 1968). See also the more recent exhibition catalogue *Tatlin's Dream* (London, 1973), compiled by Andrei B. Nakov, and the section on Tatlin in C. Gray, *The Russian Experiment in Art: 1863–1922* (London, 1970), pp. 167–83. On the monument see J. Elderfeld, "The Line of Free Men: Tatlin's 'Towers' and the Age of Invention," *Studio*, 178, 916 (November 1969), pp. 162–67.

6. Gray, *Experiment*, p. 168.

7. A. G. Chiniakov, *Brat'ia Vesniny* (Moscow, 1970), p. 38.

8. V. Manin, "Front khudozhestvennoi revoliutsii," *Prometii*, 1967, 4, pp. 394–406.

9. On revolutionary festivals see especially E. A. Speranskaia, *Agitatsionno-massovoe iskusstvo pervykh let Oktiabria* (Moscow, 1971). Tatlin was chairman of the Moscow section of IZO-Narkompros and S. D. Dymshits-Tolstaia was secretary. Beside the painters Falk, Mashkov, Kuznetsov, and Kandinsky, the group included four of Tatlin's compatriots from his prewar days (Malevich, Morgunov, Udaltsova, and Olga Rozanova), the sculptors B. D. Korolev and S. T. Konenkov, and four other artists. Korolev, who had studied with Rodin in Paris in 1913, saw his cubist monument to Bakunin torn down; see L. Bubnov, *B. D. Korolev* (Moscow, 1968), p. 65. The list of artists is given in Speranskaia, p. 126, n.90.

10. H. Wölfflin, *Principles of Art History* (New York, 1932), p. 234; originally the Munich, 1915, compilation of his prewar lectures. See also *Gabo* (London, 1957), p. 54, and N. Gabo, *Of Divers Arts* (Princeton, 1962).

11. Andersen, *Tatlin*, p. 57.

12. Ibid., p. 51. The manifesto was signed by Tatlin, Shapiro, Meierzon, and Paul Vinogradov, a student who worked on the model.

13. Ibid., p. 58; A. V. Lunacharsky, "Neizdannye materialy," *Literaturnoe nasledstvo* (Moscow, 1970), p. 241, n. 35. Taken from *Izvestiia*, November 29, 1922.

14. S. Eisenstein, *Notes of a Film Director* (1939) (New York, 1970), p. 61.

15. Y. Barna, *Eisenstein* (Bloomington, 1973), p. 73; N. Gornitskaia, ed., *Iz istorii Lenfil'ma*, II (Leningrad, 1970), p. 249. On the cinema in its early years see R. Stephenson and J. Debrix, *The Cinema as Art* (Baltimore, 1969), and L. Jacobs, ed., *Introduction to the Art of the Movies* (New York, 1960); also D. Talbot, ed., *Film: An Anthology* (Berkeley and Los Angeles, 1967).

16. *Kinomatograf: Sbornik statei* (Moscow, 1919), p. 7. For Lunacharsky's later views on cinema see his pamphlet *Kino na zapade i u nas* (Leningrad, 1928). On Soviet cinema the best survey is Jay Leyda, *Kino: A History*

of the Russian and Soviet Film (London, 1960). For the Soviet view see the first volume in the series *Istoriia sovetskogo kino 1917–1967* (Moscow, 1969), covering the period 1917–1931 and edited by the Institute of Art History of the USSR Ministry of Culture. Also U. Gregor, "Der sowjetische Film der Zwanziger Jahren; 'Revolution des Auges' und 'Poesie der Fakten,' " in *Kunst und Revolution* (Frankfurt, 1972). More recently L. and J. Schnitzer, eds., *Cinema in Revolution*, trans. D. Robinson (London, 1973), a collection of Soviet memoirs.

17. On Dziga Vertov see S. Drobashenko, ed., *Dziga Vertov: Stat'i, dnevnik, zamysli* (Moscow, 1966); N. A. Abramov, *Dziga Vertov* (Moscow, 1962); M. Enzensberger, "Dziga Vertov," *Screen*, 13, 4 (Winter 1972–1973), pp. 90–107.

18. S. P. Hill, "Kuleshov: Prophet without Honor?" in *Film Culture*, Spring 1967, p. 10.

19. The best biography of Eisenstein is by a Rumanian scholar, Y. Barna, *Eisenstein* (Bucharest, 1966), translated by Lise Hunter (Bloomington, 1973). The older biography by Marie Seton, *Sergei M. Eisenstein* (London, 1952), combines personal knowledge with considerable speculation. A recent Soviet biography-memoir by a man who knew Eisenstein well is Viktor Shklovsky, *Eizenshtein* (Moscow, 1973). Eisenstein's voluminous writings and lectures on film have been collected as *Izbrannye proizvedeniia*, 6 vols. (Moscow, 1964–1971), hereafter *IP*, and include some "autobiographical notes" written during and after World War II (*IP*, I, pp. 203–540).

20. *Sovetskii teatr: Dokumenty i materialy* (Leningrad, 1968), p. 450.

21. Seton, *Eisenstein*, p. 479; taken from Eisenstein's brief autobiographical note published in *Internatsional'naia literatura* (Moscow, 1933), No. 4.

22. On Proletkult and the theater see *Sovetskii teatr*, *passim*, and P. Gorsen, "Der revolutionäre Kulturkampf der Übergangsgesellschaft in Sowjetrussland (1917–1922)," *Kunst und Revolution* (Frankfurt, 1972).

23. On Meyerhold's early productions for the First RSFSR Theater see *Vstrechi s Meierkhol'dom* (Moscow, 1967), p. 184; N. Volkhov, A. M. Ripellino, *Maiakowski et le théâtre russe d'avant-garde* (Paris, 1965).

24. E. Dobin, *Kozintsev i Trauberg* (Leningrad and Moscow, 1963), p. 10.

25. According to Yutkevich, in Schnitzer, *Cinema*, p. 32.

26. Barna, *Eisenstein*, p. 60.

27. S. Eisenstein, "Montazh attraktsionov," *LEF*, 3 (June–July 1923) pp. 70–75; reprinted in *IP*, II, pp. 269–73. In the article Eisenstein makes specific mention of Grosz, Rodchenko, and photomontage, as well as the Théâtre Guignole (pp. 71–72).

28. On Shklovsky and the linguistic contribution to montage, see his *Eizenshtein* (pp. 136–45). See also Shklovsky's memoirs, *Zhili-byli* (Moscow, 1966), where he notes (p. 450) that "montage was created in the American cinema, but it was understood in the Soviet cinema."

29. Yutkevich in Schnitzer, *Cinema*, p. 17.

30. Shklovsky, *Eizenshtein*, p. 136.

31. Leyda, *Kino*, p. 164.

32. E. Shub, *Krupnym planom* (Moscow, 1959), p. 67.

33. P. M. Jensen, *The Cinema of Fritz Lang* (New York, 1969), pp. 34–46.

34. Shub, *Krupnym planom*, p. 69.

35. Barna, *Eisenstein*, p. 83.

36. Ibid., p. 84.

37. *Bronenosets "Potemkin"* (Moscow, 1969), p. 24. On the making of *Potemkin*, see also I. G. Rostovtsev, *Bronenosets "Potemkin"* (Moscow, 1962); Barna, *Eisenstein*, pp. 90–113; *IP*, I, pp. 122–35.

38. *Bronenosets "Potemkin"* (1969), pp. 24, 50–51.

39. Ibid., p. 79.

40. Barna, *Eisenstein*, p. 104.

41. S. Eisenstein, *Film Sense*, p. 7; in *Film Form: The Film Sense* (Cleveland and New York, 1957).

42. Barna, *Eisenstein*, pp. 126–27; from a letter to Leon Moussinac.

43. Ibid., p. 151.

44. *Film Sense*, pp. 251–52.

45. Barna, *Eisenstein*, p. 185.

46. Ibid., p. 199.

47. Ibid., p. 241.

48. Ibid., p. 240; from unpublished manuscript in the Eisenstein archive in Moscow.

49. Written by Eisenstein in 1934 and reprinted in *Film Essays* (New York, 1970), p. 74.

50. S. Eisenstein, "Charlie the Kid" (1945), in ibid., p. 121.

51. Barna, *Eisenstein*, p. 264.

Chapter 8
The Russian Avant-garde and the Victory over Death

1. A. Shevchenko, *Neo-primitivizm* (Moscow, 1913); cited in J. Bowlt, *Russian Art of the Avant-garde: Theory and Criticism 1902–1934* (New York, 1976), pp. 47, 54.

2. K. Clark, *Provincialism* (London, 1962), p. 3.

3. K. Malevich, *Essays on Art 1915–1933*, ed. and trans. T. Andersen (New York, 1971), Vol. II, pp. 141–44.

4. Maeterlinck was immensely popular; there were eleven editions of *Monna Vanna*, nine of *Blue Bird*, and four of *Tintagiles* by 1918 in Russia. See R. Brucher, *Maurice Maeterlinck: L'Oeuvre et son audience; essai de bibliographie 1883–1960* (Brussels, 1972), p. 41. On Walt Whitman in Russia see S. Stepanchev, "Whitman in Russia," in G. Allen, ed., *Walt Whitman Abroad* (Syracuse, N.Y., 1955), pp. 145, 150. Also K. Chukovsky, "Russkaia Uitmaniana," *Vesy*, 1906, No. 10, pp. 43–45. On Steiner see the translations of his *Iz letopisi mira (Aus der Akasha Khronik)* (Moscow, 1914), and *Razmyshleniia o Gete* (Moscow, 1914).

5. A. Haskell, *Diaghileff* (London, 1935), p. 161.

6. Letter of Maxim Gorky to Leonid Andreev; cited in P. Yershov, ed., *Letters of Gorky to Andreev, 1889–1912* (New York and London, 1958), p. 86.

7. V. Shklovsky, *Mayakovsky and his Circle* (New York, 1972), p. 55.

8. J. Rye, *Futurism* (London, 1972), p. 9.

9. P. Klee, *The Diaries of Paul Klee 1898–1910* (Berkeley and Los Angeles, 1964), p. 240.

10. There is a large amount of literature on the "mid-life crisis" or "generativity crisis" among males. With respect to artists, see especially E. Jacques, "Death and the Mid-Life Crisis," *International Journal of Psychoanalysis*, No. 4 (1965), pp. 502–14; reprinted in H. Ruitenbeek, ed., *The Creative Imagination* (Chicago, 1965). Also E. Erikson, *Identity: Youth in Crisis* (New York, 1968), p. 138; *Young Man Luther* (New York, 1958), p. 243; *Gandhi's Truth* (New York, 1969), p. 395.

A number of writers have associated innovation with the aging process and with an awareness of death. C. Lengyel in *The Creative Self* (Hague and Paris, 1971) speculates that "your weapon against death is your creative self" (p. 98) and that "the urge to create a durable work is part of the urge to survive, to create a degree of immortality" (p. 100). J. A. M. Meerloo, in his book *Creativity and Eternization* (Assen, 1967), notes that "the creative process is also a form of regeneration; it is an unconscious re-creation" (p. 15). "Art," he concludes, "is often one huge struggle with the shape of death" (p. 2). An intriguing psychohistorical case study of psychoneurosis in the lives of creative people (Darwin, Proust, Freud, *inter alia*) is George Pickering, *Creative Malady* (New York, 1974). An older and more statistical approach to creativity in both the arts and the sciences is H. C. Lehmann, *Age and Achievement* (Princeton, 1953), which concludes (p. 330) that "superior creativity rises relatively rapidly to a maximum which occurs usually in the thirties and then falls off slowly."

11. Andreev to Gorky, St. Petersburg, February 11, 1908; *Letters*, pp. 96–97.

12. E. Mechnikov, *The Nature of Man*, p. 129.

13. Cited in "Freud/Jung: Letters," *Encounter*, XLII, 6 (June 1974), p. 22.

14. O. Rank, "Life and Creation" (1932), in *Creative Imagination*, pp. 75, 79.

15. On the architect Konstantin Melnikov and his concern with death and immortality see S. F. Starr, *Melnikov: Solo Architect in Mass Society* (Princeton, 1977).

16. E. Semenova, "Vkhutemas, *LEF*, Mayakovsky," in *Uchenye zapiski tartuskogo gosudarstvennogo universiteta*, IX (1966), p. 294; L. and J. Schnitzer, eds., *Cinema in Revolution* (New York, 1973), p. 13.

SELECTED BIBLIOGRAPHY

I. General Works

Andersen, Troels. *Moderne Russisk Kunst 1910–1925*. Copenhagen: Borgen, 1967.

Billington, James H. *The Icon and the Axe*. New York: Alfred A. Knopf, 1966.

Bowlt, John E., ed. *Russian Art of the Avant-garde: Theory and Criticism 1902–1934*. New York: Viking Press, 1976.

Choron, Jacques. *Death and Western Thought*. New York: Macmillan Co., 1963.

————. *Death and Modern Man*. New York: Macmillan Co., 1964.

Diakonitsyn, L. *Ideinye protivorechiia v estetike russkoi zhivopisi kontsa 19–nachala 20 v.v.* Perm, 1966.

Fueloep-Miller, René. *The Mind and Face of Bolshevism*. New York: Putnam's, 1928.

Gibian, George and Tjalsma, H. W., eds. *Russian Modernism: Culture and the Avant-garde 1900–1930*. Ithaca, New York: Cornell University Press, 1976.

Gray, Camilla. *The Russian Experiment in Art, 1863–1922*. New York: Abrams, 1972.

Jacques, Elliott. "Death and the Mid-Life Crisis," *International Journal of Psychoanalysis* 4 (1965): 502–514.

Lengyel, Cornel. *The Creative Self*. The Hague and Paris, 1971.

Leyda, Jay. *Kino: A History of the Russian and Soviet Film*. London: Allen and Unwin, 1960.

Marcade, Valentine. *Le Renouveau de l'Art pictural russe*. Lausanne: L'Age d'Homme, 1971.

Pickering, George. *Creative Malady*. New York: Oxford University Press, 1974.

Poggioli, Renato. *The Theory of the Avant-garde*. Translated by G. Fitzgerald. Cambridge, Mass.: Harvard University Press, 1968.

Ruitenbeek, Hendrik M. *The Creative Imagination*. Chicago, 1965.

Sidorov, A. *Russkaia grafika nachala XX veka*. Moscow, 1969.

II. Lunacharsky

Bogdanov, A. *Empiriomonizm*. Vol. III. St. Petersburg, 1906.

Elkin, A. *Lunacharsky*. Moscow, 1967.

Fitzpatrick, Sheila. *The Commissariat of Enlightenment: Soviet Organization of the Arts under Lunacharsky*. Cambridge, England: Cambridge University Press, 1970.

Grille, Dietrich. *Lenins Rivale: Bogdanov und seine Philosophie*. Cologne: Wissenschaft und Politik, 1966.

Lunacharsky, Anatoly Vasilievich. *Etiudy kriticheskie i polemicheskie*. Moscow, 1905.

———. *Kriticheskie etiudy (Russkaia literatura)*. Leningrad, 1925.

———. *Ob izobraziteľnom iskusstve*. Moscow, 1967.

———. *Pochemu neľzia verit v boga?* Moscow, 1965.

———. *Religiia i sotsializm*. St. Petersburg, 1908 (Vol. I) and 1911 (Vol. II).

———. *Sobranie sochinenii*. 6 vols. Moscow, 1964.

———. *Velikii perevorot*. Petrograd, 1919.

Ocherki po filosofii marksizma: filosofskii sbornik. St. Petersburg, 1908.

III. Dobuzhinsky and Moor

Botsianovsky, V., and Gollerbakh, E. *Russkaia satira pervoi revoliutsii 1905–1906*. Leningrad, 1925.

Bowlt, John E. "The Early Graphic Work of Mstislav Dobuzhinsky," *Transactions of the Russian-American Group of Scholars in the U.S.A.* 9 (1975): 249–286.

Butnik-Siversky, B. *Sovetskii plakat epokhi grazhdanskoi voiny 1918–1921*. Moscow, 1960.

Dobuzhinsky, M. "Iz vospominanii," *Novyi zhurnal* 52 (1958): 109–139.

Duľsky, P. *Grafika satiricheskikh zhurnalov 1905–1906 g.g.* Kazan, 1922.

Karasik, Z. "M. Gorʼkii i satiricheskie zhurnaly 'Zhupelʼ i 'Adskaia pochta,' " in Akademiia nauk, *M. Gorʼkii v epokhu revoliutsii 1905–1907 godov; materialy, vospominaniia, issledovaniia*. Moscow, 1957: 357–387.

Kaufmann, R. *D. S. Moor*. Moscow, 1937.

Khalaminsky, I. *D. Moor*. Moscow, 1961.

Makovsky, S. and Notgaft, F. *Grafika M. V. Dobuzhinskogo*. Berlin, 1924.

Moor, D. *"Ya—Boľshevik!": Sbornik statei*. Moscow, 1967.

IV. Meyerhold

Braun, Edward, ed. *Meyerhold on Theater*. New York: Hill and Wang, 1969.

Elagin, Yury. *Temnyi genii (Vsevolod Meierkhoľd)*. New York: Chekhov, 1955.

Fevralʼsky, A. *Vsevolod Emelianovich Meierkhoľd: Statʼi, pisʼma, rechi, besedy*. 2 vols. Moscow, 1968.

Fuchs, Georg. *Die Schaubühne der Zukunft*. Berlin and Leipzig [1906].

Rudnitsky, K. *Rezhisser Meierkhoľd*. Moscow, 1969.

Symons, James M. *Meyerholdʼs Theater of the Grotesque*. Coral Gables, Fla.: University of Miami Press, 1971.

Volkhov, N. *Meierkhoľd*. 2 vols. Moscow and Leningrad, 1929.

———. *Teatraľnye vechera*. Moscow, 1966.

V. Malevich

Andersen, Troels. *Malevich*. Amsterdam, 1970.

Bowlt, John E. "The Semaphors of Suprematism: Malevich's Journey into the Non-Objective World," *Art News*, December 1973: 16–22.

Bragdon, Claude. *A Primer of Higher Space: The Fourth Dimension, to which*

is added Man the Square, A Higher Space Parable. New York: Alfred A. Knopf, 1923.

Compton, Susan, "Malevich and the Fourth Dimension," *Studio* 187 (1974): 190–195.

Douglas, Charlotte. "Birth of a 'Royal Infant': Malevich and 'Victory over the Sun,' " *Art in America* 62 (1974): 45–51.

Hinton, Charles Howard. *The Fourth Dimension.* New York, 1904.

Malevich, Kazimir. *Essays on Art 1915–1933.* Edited by Troels Andersen. Translated by Xenia Glowacki-Prus and Arnold McMillin. 2 vols. New York: Wittenborn, 1971.

———. "Iz knigi o Bezpredmetnosti." Unpublished manuscript dated January 25, 1924. Van Riesen Archive, Stedelijk Museum, Amsterdam.

———. *The Non-Objective World.* (1927) Chicago, 1959.

———. *Ot kubizma i futurizma do suprematizmu: Novyi zhivopisnyi realizm.* Third edition. Moscow, 1916.

Nakov, Andrei. "The Iconoclastic Fury," *Studio* 187 (1974): 281–288.

Ouspensky, P. D. *Tertium Organum.* (1911) New York: Random House, 1970.

VI. Mayakovsky

Brown, Edward J. *Mayakovsky: A Poet in the Revolution.* Princeton: Princeton University Press, 1973.

Fevral'sky, A. *Pervaia sovetskaia pesa "Misteriia-buff" V. V. Mayakovskogo.* Moscow, 1971.

Lifshits, B. *Polutoraglazyi strelets.* Leningrad, 1933.

Mayakovsky, Vladimir. *V. V. Mayakovsky: Materialy i issledovaniia.* Moscow, 1940.

———. *Polnoe sobranie sochinenii.* Moscow, 1955–1961.

———. "Novoe o Mayakovskom," *Literaturnoe nasledstvo,* LXV (Moscow, 1958).

Semenova, E. "Vkhutemas, *LEF,* Mayakovsky," in *Uchenye zapiski tartuskogo gosudarstvennogo universiteta* 9 (1966), 288–306.

Shklovsky, Victor. *Zhizn' s Mayakovskym.* Moscow, 1940.

Woroszylski, Wiktor. *The Life of Mayakovsky.* Translated by Boleslaw Taborski. New York: Orion, 1970.

VII. Tatlin and Eisenstein

Andersen, Troels. *Vladimir Tatlin.* Stockholm, 1968.

Barna, Yon. *Eisenstein.* Translated by Lise Hunter. Bloomington: Indiana University Press, 1973.

Bronenosets "Potemkin." Moscow, 1969.

Eisenstein, Sergei. *Film Form: The Film Sense.* Cleveland and New York, 1957.

———. *Film Essays.* New York: Praeger, 1970.

———. "Montazh attraktsionov," *LEF,* 3 (1923), 70–75.

———. *Notes of a Film Director.* (1939) New York: Dover, 1970.

Elderfield, John. "The Line of Free Men: Tatlin's 'towers' and the Age of Invention," *Studio* 178 (1969): 162–167.

Punin, Nikolai, *Tatlin*. Petrograd, 1921.
Rostovtsev, I. *Bronenosets "Potemkin."* Moscow, 1962.
Seton, Marie. *Sergei M. Eisenstein*. London: Bodley Head, 1952.
Shklovsky, Victor. *Eizenshtein*. Moscow, 1973.
Shub, Esfir. *Krupnym planom*. Moscow, 1959.
Tatlin's Dream. London, 1973.

INDEX

Abbott, Edwin A., 108
"About That" (*Pro Eto*), by Mayakovsky, 128, 141, 145–47, 150
Adventures of Oktiabrina [film], 169
aesthetes, generation of: 9–10ff, 18, Table I, II, III; Lunacharsky, 35; Dobuzhinsky, 71, 73; Meyerhold, 82, 85, 187
Agadzhanova-Shutko, Nina, 173
aging, and avant-garde, vii, 185, 227n10
agitation technique, 14–15
agit-trains, 76–77, 164
Akhmatova, Anna, 136
AKhRR (Association of Artists of Revolutionary Russia), 141–42
Akselrod, Paul, 36
Aleksinsky, G. A., 50, 51, 209n46, Table IX
Alexander III, 10, 38
Alexander Nevsky [film], 178
Alexandrov, G. V., 174, Table XIII
Aliakrinsky, P. A., Table XII
All-Russian Central Executive Committee (VTsIK), 77
Altman, Nathan, 56, 143, 156, Table VI, X, XI
Andersen, Troels, 111
Andreev, Leonid N., 185–86
Andreeva, Maria, 44, 50
Annenkov, Yu., Table VI
antagonism technique, 14, 80
anthroposophy, 104–6
Antonov, A. I., 35–36
Apollinaire, Guillaume, 52, 109
Appia, Adolphe, 83
Arapov, A. A., Table VI, VII
Archipenko, Alexander P., Table VI, X
architecture, Soviet, 15
Arkhip, Table IX
"Art and Revolution," by Wagner, 33
Art Nouveau, 12, 34, 60
art schools, 10, 56, 60, 62–63, 66, 88, 114, 124, 136, 141, 157, 220n51
Aseev, Nikolai, 136, 146, 223n42
Association of Artists of Revolutionary Russia (AKhRR), 141–42
Atasheva, Pera, 178
Aubes, Les (*The Dawn*), by Verhaeren, 31–32, 168, 183
avant-garde: defined, 3; and Revolution,

3–4ff, 15–16, 182–84; view of immortality, 15–21, 184; view of death, 20–21, 186–87; diversity, 180; death of, 188
Avenarius, Richard, 23, 28, 37, 46, 48
Avilov, N. P., Table IX
Ažbe, Anton, 62–63, 66

Baikova, Z. A., Table VII
Bakst, Leon N., 211n1, Table IV
Balaganchik (*The Fairground Booth*), by Blok, 21, 82, 93, 95–98, 99, 184, 216n31
Baranov-Russine, D., Table VI, VII
Barnet, B. V., Table XIII
Bart, V. S., Table VIII
Bathhouse, The, by Mayakovsky, 149–50
Baudelaire, Charles, 10, 94
Baudouin de Courtenay, S., Table VIII
Bauhaus, 34
Bazarov, V. A. (Rudnev), 46, 49, Table IX
Beardsley, Aubrey V., 60, 65, 72
Bechofer-Roberts, Carl, 220n40
Becker, Carl L., 17
Bedbug, The, by Mayakovsky, 149
"Before and Now," poster by Moor, 77
Bekteev, V., Table V, VIII
Beliakov, I. I., Table XIII
Belyi, Andrei, 12, 94, 106, 214n4
Benois, Alexander N., 156, 210n1, 212n10, Table IV
Berdyaev, Nikolai A., 5, 38–39, 40, 41, 99
Berger, John, 6–7
Bergman, Ingmar, viii
Bergson, Henri, 16–17, 26–27
Berlin: Russian artists in, 142–43, 222n29
Besant, Annie, 103, 104, 107, 183, 220n40
Bessalko, P. K., 52, 56, Table IX
Bilibin, Ivan Y., 62, 65, 69, 93, 211n1, 212n10, Table IV, V
Billington, James, 6
biomechanics, 15, 81, 82, 168
Birth of Tragedy, The, by Nietzsche, 33, 96
Blavatsky, Elena P., 103, 106, 110, 183

233